Rubens before 1620

RUBENS BEFORE 1620

Edited by John Rupert Martin

The Art Museum, Princeton University

Distributed by Princeton University Press

Designed by Richard Hendel

Printed by Princeton University Press

Library of Congress Catalogue Card Number 72-77735

International Standard Book Number 0-691-03885-6

Distributed by Princeton University Press, Princeton, New Jersey 08540

Contents

List of Illustrations

Catalogue

Preface

When Malcolm S. Forbes kindly consented to allow his painting of *Cupid Suppli-cating Jupiter* by Rubens to be shown publicly for the first time at The Art Museum of Princeton University, it was decided that the work should form the nucleus of a small exhibition to be entitled "Peter Paul Rubens before 1620." To mark the opening of the exhibition, which was held during the month of October 1971, three distinguished scholars were invited to participate in a symposium. The speakers took as their general theme the crucial period of Rubens's career in Ant-werp, beginning with his return from Italy in 1608, up to about 1620, when he had already achieved international recognition.

The present volume is intended to serve as a record of the exhibition and of the papers presented in conjunction with it. The first paper, which deals specifically with the painting from the Forbes collection, was read by the editor on the occa-sion of the preview of the exhibition on October 1, 1971. It is followed by the three papers delivered at the symposium on the following day, by Wolfgang Stechow, Professor Emeritus of Oberlin College; Julius S. Held, Professor Emeri-tus of Barnard College, Columbia University; and Frans Baudouin, Keeper of the Art-Historical Museums of the City of Antwerp. The illustrated catalogue of the works shown at the exhibition was prepared by David W. Steadman, who has also contributed the introductory essay to the catalogue.

The exhibition and the accompanying series of lectures could not have taken place without the generous support and continuing assistance given us by Mal-colm Forbes, to whom we express our deepest gratitude. We are also indebted to Clyde Newhouse, who took an active interest in the project and contributed in no small measure to its success. The good will and helpful cooperation of Jacob Bean, Erik Fischer, A. Hyatt Mayor, and Charles Ryskamp are gratefully acknowledged.

Our thanks go also to the curators who facilitated the loan of drawings from the following galleries and collections: the Allen Memorial Art Museum of Oberlin College; the Museum of Fine Arts, Boston; the National Gallery of Canada, Ottawa; the Royal Museum of Fine Arts, Copenhagen; the Fogg Art Museum of Harvard University; the Metropolitan Museum of Art, New York; and the Pierpont Morgan Library, New York. The publication of this volume has been made possible by a grant from the Publication Fund of the Department of Art and Archaeology of Princeton University.

I should like, finally, to extend my thanks to Claudia Lazzaro Bruno, who gave me valuable assistance in the preparation of the paper on the Rubens painting, and to Virginia Wageman, who took responsibility for the copy-editing of this volume.

<div align="right">JOHN RUPERT MARTIN</div>

Rubens before 1620

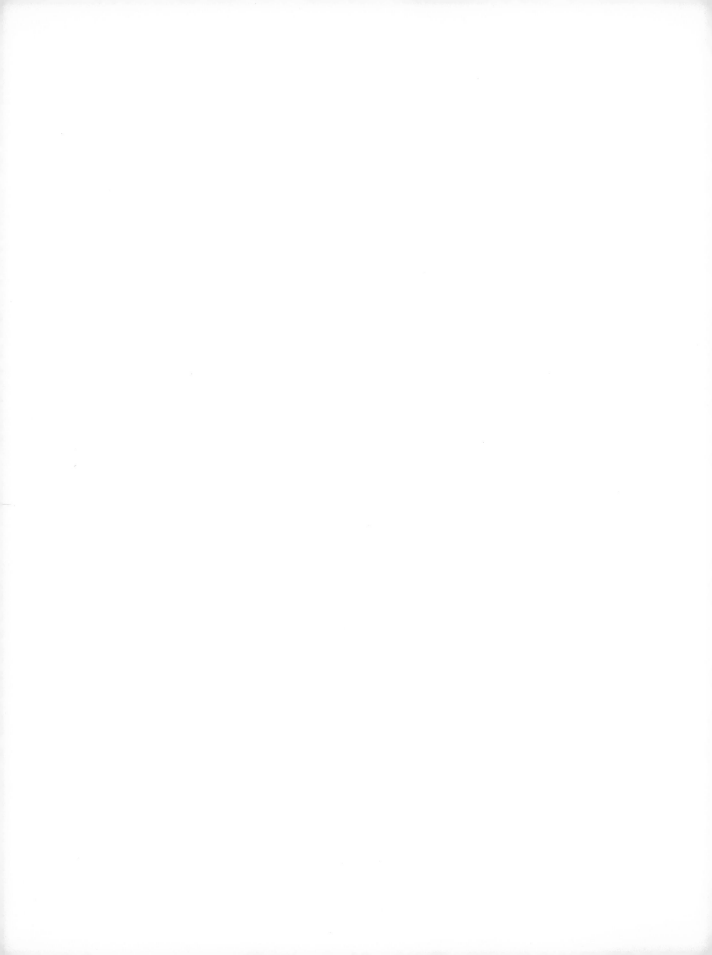

Rubens's *Cupid Supplicating Jupiter*

John Rupert Martin & Claudia Lazzaro Bruno

To Millard Meiss

In 1953 the National Gallery of Canada acquired a splendid chalk drawing by Rubens (cat. 2).[1] About its authorship there has never been any doubt, but the precise subject and purpose of the drawing were not at once understood. It was not until some ten years later, in 1963, that Ludwig Burchard and R.-A. d'Hulst identified the sheet as a study "for a lost composition by Rubens representing *Cupid Supplicating Jupiter's Consent to His Marriage with Psyche.*"[2] If the original painting (as the authors believed) was no longer in existence, it was at least possible to form an idea of its appearance from a drawing in Copenhagen, made in the studio of Rubens, which they rightly recognized as a faithful copy (cat. 3).[3] Burchard and d'Hulst further surmised that the Copenhagen sheet, because of its tonal richness, was copied not from a drawing but from a painting. The correctness of this deduction was confirmed not long afterwards when Rubens's "lost" painting, which had seemingly lain unnoticed in a private collection, finally came to light again (cat. 1). The rediscovered canvas now forms part of the collection of *Forbes* magazine, New York.

The painting has undergone some alterations. A broad strip of canvas, extending somewhat below the top of Jupiter's head, has been added to the upper part of the picture, no doubt because of damage to this section. In the process of repaint-

1. A. E. Popham and K. M. Fenwick, *European Drawings in the Collection of the National Gallery of Canada* (Ottawa, 1965), p. 98, no. 141.

2. L. Burchard and R.-A. d'Hulst, *Rubens Drawings* (Brussels, 1963), pp. 190–91.

3. The statement by Gregory Martin that the Copenhagen drawing has been "clearly reworked by Rubens" ("Rubens and Buckingham's 'fayrie ile,' " *Burlington Magazine*, 108 [1966]: 617, fig. 24) can be safely disregarded.

ing, the head of Jupiter was made uncomfortably flat. The Copenhagen copy shows that the god's head not only had a more rounded shape but was placed close to the upper edge of the composition. It is also evident from the cropped wings of Cupid and the eagle that the canvas has been somewhat cut down on either side. In its original state the picture must have been almost square, measuring about 2 meters on each side. It is thus to be associated with several mythologies of similar size and shape painted by Rubens in the period 1612 to 1613, notably the *Drunken Hercules* in Dresden and the *Ganymede* in the Schwarzenberg Collection in Vienna (fig. 12).[4] A date in the early part of the second decade is also indicated by the classicizing, relief-like treatment of the figures, which is especially characteristic of the mythological subjects of these years.

The literary source of the *Forbes* picture is to be found in the romance of Cupid and Psyche, as it is told in the *Metamorphoses* of Apuleius (6. 22). The mortal maiden Psyche is beloved by the god Cupid, and the story relates the severe tribulations that she is made to undergo before she can be wedded to her celestial lover and herself achieve deification. Rubens selects the moment when Cupid appeals to Jupiter to admit Psyche to Olympus, and the father of the gods, having listened to the boy's words, consents—rather grudgingly—to his marriage with a mere mortal. The impressive golden eagle that fills the foreground space spreads his wings in a way that echoes and reinforces the actions of the two deities.

It is impossible to look at this brilliant and striking canvas without being reminded of Raphael: here the mute dialogue between the two masters, the Italian and the Fleming, may be sensed with particular clarity. For it was Raphael who, about a century before, had invented the canonical interpretation of the fable of Cupid and Psyche in the Villa Farnesina in Rome, where the celestial climax of the story is unfolded in airy and lyrical fashion on the frescoed ceiling of the Sala di Psiche. That Rubens's imagination was stimulated by these frescoes is confirmed by several kinds of evidence, among which we may cite the red chalk drawing of *Psyche Offering the Jar of Proserpine to Venus*, now in the Pierpont Morgan Library (cat. 10), which is a copy by Rubens, perhaps after an engraving, of the Raphaelesque painting of the same subject in the Farnesina. It is obvious, furthermore, that in the composition of his *Cupid Supplicating Jupiter* Rubens has paid homage not only to the Farnesina fresco of *Jupiter Kissing Cupid* (fig. 1), which illustrates the identical moment in Apuleius's romance, but also to the scene of

4. The *Drunken Hercules* (Gemäldegalerie, Dresden [*KdK* 122]) measures 2.04 x 2.04 m; the *Ganymede*, 2.03 x 2.03 m.

1. Raphael (School),
Jupiter Kissing Cupid.
Fresco. Villa Farnesina, Rome
(photo: Anderson).

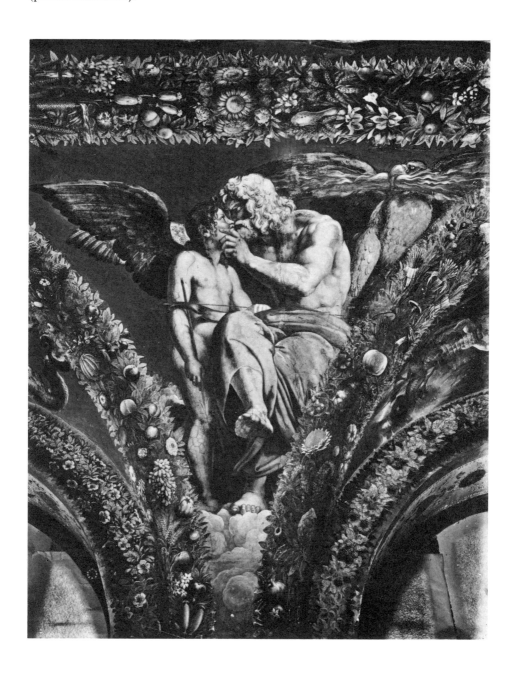

2. Raphael (School),
Venus Appealing to Jupiter.
Fresco. Villa Farnesina, Rome
(photo: Alinari).

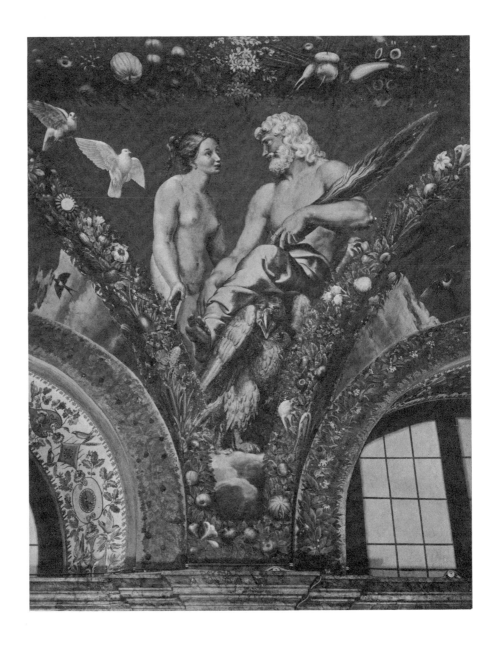

Venus Appealing to Jupiter from the same cycle (fig. 2), in which the eagle takes up his position beneath the seated god.

Yet if the ultimate inspiration is Italian and classical, the Flemish artist has imparted to the confrontation of the two deities a new passion and a new Baroque sensuousness. Cupid and Jupiter are engaged in what is plainly a contest of will, a contest made quite explicit by the audacious gesture with which the winged boy seizes Jove's thunderbolt and by the hesitant movement of the latter's hand as he seeks to recover it (fig. 3). (This crucial passage is carefully analyzed in the preparatory study in Ottawa.)

Why does Cupid hold the thunderbolt? There is no mention of such an act in Apuleius. Cupid's weapon is the bow, as is duly shown in the Raphaelesque fresco (fig. 1); the thunderbolt, on the other hand, is the instrument of Jove's power and authority and may be carried either by the god himself or by the eagle. But in Rubens's painting, Cupid has unmistakably taken the fiery bolt in his own hands, leaving the thunderer nonplussed.

The motif has a venerable ancestry, and examples abound in both ancient literature and art. Plutarch relates that Alcibiades carried a shield that bore as its device an Eros with a thunderbolt;[5] and Pliny (*Nat. Hist.* 36.28) speaks of a statue of Cupid holding a thunderbolt that stood in the Hall of Octavia. The subject is also known on ancient gems.[6] The passage in Pliny was frequently commented upon by the mythographers of the sixteenth century, among them Lilio Giraldi and Vincenzo Cartari. A woodcut in Cartari's *Imagini de i Dei* (Lyons, 1581) offers three likenesses of Cupid (fig. 4), one of which shows him with the lightning bolt. In the accompanying text Cartari explains that the god carries this attribute as a sign of the irresistible force of love, which can overcome and set on fire even the hardest heart.[7] Raphael, in the Farnesina, pictures flying amoretti with the weapons of the gods—the spoils of their victories over the immortals—and one of these playful putti carries the thunderbolt on his shoulders, while Jupiter's eagle nervously hovers in the air beside him. A similar idea is expressed by Claudian when, in his poem "The Magnet," he asks Cupid: "Cruel boy, is aught beyond thy powers? Thou dost master the mighty thunderbolt; thou canst force the Thunderer to leave the sky and bellow amid the waves."[8]

5. See P. H. von Blanckenhagen, "The Shield of Alcibiades," in *Essays in Memory of Karl Lehmann*, ed. Lucy Freeman Sandler (New York, 1964), pp. 38–42. (This article was brought to our attention by Professor Evelyn Harrison.)

6. A. Furtwängler, *Die Antiken Gemmen*, 3 vols. (Leipzig-Berlin, 1900), 1, pl. XLIII, no. 55.

7. Vincenzo Cartari, *Le Imagini de i Dei de gli antichi* (Lyons, 1581), p. 432.

8. *Claudian*, trans. M. Platnauer, Loeb Classical Library, 2 vols. (London, 1922), 2:239.

3. Rubens,
Cupid Supplicating Jupiter (detail).
Forbes Magazine Collection
(photo: Nelson).

9

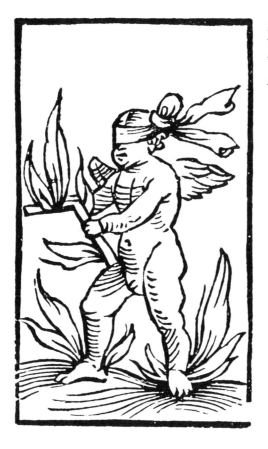

5. *Cupid Breaking the Thunderbolt.*
Woodcut from Andrea Alciati, *Emblemata*, 1531.

There is another antique topos that expresses the universal power of love even more graphically. It is found in the epigram "On Eros" in the *Greek Anthology*, which reads: "See how winged Love breaks the winged thunderbolt, to show that there is a fire stronger than fire."[9] This conceit, of which there are also representations on antique gems,[10] was taken up and elaborated by the emblem-writers of the sixteenth century, notably by the father of them all, Andrea Alciati. Reproduced here is Alciati's emblem *Vis Amoris* (fig. 5), from the first edition of his *Emblematum Liber*, published at Augsburg in 1531. The modest little woodcut shows Cupid (blindfolded in this instance) breaking the thunderbolt in his hands, in a literal illustration of the Latin distich below, which is a translation of the Greek epigram.

9. W. R. Patton, trans., *Greek Anthology*, Loeb Classical Library, 5 vols. (London, 1918), 5: 309, no. 250.
10. Furtwängler, *Die Antiken Gemmen*, 1, pl. xxx, no. 31.

Rubens's curly-headed boy (fig. 3) does not, of course, break the bolt that he has seized; but there is no doubt that he wields "a fire stronger than fire." It is characteristic of the artist that he alludes to this theme in order to add a new dimension to the narrative: Cupid, as if to remind Jupiter that the power of Love can sway even the immortals, has impudently grasped the divine attribute, while the frowning father of the gods reluctantly yields to the boy's demand ("supplication" is hardly a strong enough word) that Psyche be admitted to Olympus. Yet none of this is inconsistent with the tenor of the tale told by Apuleius, who makes Jupiter acknowledge Cupid's supremacy over him by addressing him as "Domine fili"—my lord and son. Nor should it escape our notice that in Cupid's hands the massive thunderbolt, the engine of destruction, appears already to be transforming itself into the slender curving bow of Amor. Thus does Rubens insinuate that Jupiter's fire and lightning are made part of the arsenal of Love.

The attitude of Jupiter, supporting himself on one arm against the billowing red drapery that rises behind him like the back of a throne, recalls that of Isaac sitting up in his bed to bless his son Jacob in Agostino Veneziano's engraving after Raphael (fig. 6).[11] The similarity may not be due to mere chance, for there is a significant parallel between the biblical patriarch whose son obtains by deceitful means the blessing intended for his elder brother, and the father of the gods who is compelled to submit to a wily boy. It might be noted, too, that Cupid rests one knee on the base of Jupiter's cloud-throne, an act of mock subservience that echoes the kneeling posture of Jacob in the Raphaelesque composition.

The eagle, as the king of birds, is uniquely qualified to be the sacred bird of Jupiter, father and king of gods and men. Surpassing all other feathered creatures by the keenness of its vision and by the range and swiftness of its flight,[12] it aptly expresses the all-seeing power and might of the supreme ruler. For Rubens, as for Raphael, the eagle is the normal companion of Jupiter. But Raphael, true to the anthropocentric outlook of Renaissance humanism, is content to render the sacred bird as a kind of heraldic beast (figs. 1 and 2), whereas Rubens has painted a living creature, instinct with energy and concentrated force, a creature moreover that threatens to dominate the scene (fig. 7). There is no question but that the artist has

11. The engraving (Bartsch XIV, 7, 6) reproduces Raphael's fresco of this subject in the Vatican Loggie. The relation of Rubens's Jupiter to the scene of Isaac and Jacob was observed by Burchard and d'Hulst (*Rubens Drawings*, p. 191), who, however, through some oversight did not mention the Raphaelesque composition.

12. Cesare Ripa says of the eagle that it possesses "la vista acutissima e il volo di gran lunga superiore a gl'altri animali volatili" (*Iconologia* [Siena, 1613], *s.v.* "Ingegno").

6. Agostino Veneziano,
after Raphael,
Isaac Blessing Jacob.
Engraving, 1524
(photo: Warburg Institute).

looked closely at the golden eagle, has drawn it from the life, has grasped the particulars of its appearance and sensed the ferocity of the bird of prey.

This lifelikeness, and this vitality, are to be attributed to the fundamental naturalism of the Baroque, the period in which even symbols are customarily visualized in realistic and concrete terms. And Baroque naturalism, in turn, is surely related to the growth of the scientific spirit in the seventeenth century, above all to the new emphasis on the observation of nature. In this connection, Evers[13] has drawn attention to an important work of natural history—the monumental *Ornithologia* published in 1599 in three volumes by the Italian naturalist Ulisse Aldrovandi.[14] The first volume opens, appropriately, with a long and richly illustrated account of the eagle (fig. 8), in which the author passes, without a break, from careful description and scientific observation to such fanciful topics as the place of the bird in mythology, folklore, heraldry, emblematics, and the like. As Evers remarks, this curious mixture of the scientific and the mythical was still possible in the seventeenth century, and Rubens himself would certainly have seen nothing unusual or illogical in such a view of the world.

It is this duality that raises Rubens's eagle above the level of mere visual transcription. If he looked attentively at a living specimen of *Aquila chrysaëtos*, he did not fail at the same time to consult the classical conception of the king of birds. The pose of the eagle, for example, seems to have been taken from a drawing made by the artist after a Roman marble sculpture, a drawing now known to us only through a pupil's copy (fig. 9).[15] In placing the great bird directly beneath the seated Jupiter, Rubens may have drawn inspiration from an antique source in which the god is figured as carried upon the eagle's back.[16] But what is perhaps even more likely, in

13. Hans Gerhard Evers, *Peter Paul Rubens* (Munich, 1942), pp. 106–7, with reference to Rubens's *Ganymede* (our fig. 12).

14. *Vlyssis Aldrovandi Ornithologiae hoc est de avibus historiae libri XII*, 3 vols. (Bologna, 1599), 1: 17–168.

15. The connection has been noticed by Julius S. Held (*in literis*) and by Michael Jaffé, "Rubens and Jove's Eagle," *Paragone*, 21, no. 245 (1970): 22, pl. 29.

16. Jupiter borne on the back of a flying eagle is represented in the pediment relief of the Capitol of Thugga (mod. Dougga) in North Africa (see Theodor Kraus, *Das römische Weltreich* [Berlin, 1967], pl. 222). (This and other examples of the kind were pointed out to us by Dorothy Burr Thompson.) The motif was well known in Renaissance art: see, for instance, the miniature of Jupiter seated on the eagle in the fifteenth-century copy of the Aratea made for Ferdinand of Aragon, King of Naples, now in the Vatican Library (Cod. Barb. lat. 76) (F. Saxl, *Verzeichnis astrologischer und mythologischer illustrierter Handschriften des lateinischen Mittelalters in römischen Bibliotheken, Sitzungsberichte der*

7. Rubens,
Cupid Supplicating Jupiter (detail).
Forbes Magazine Collection.

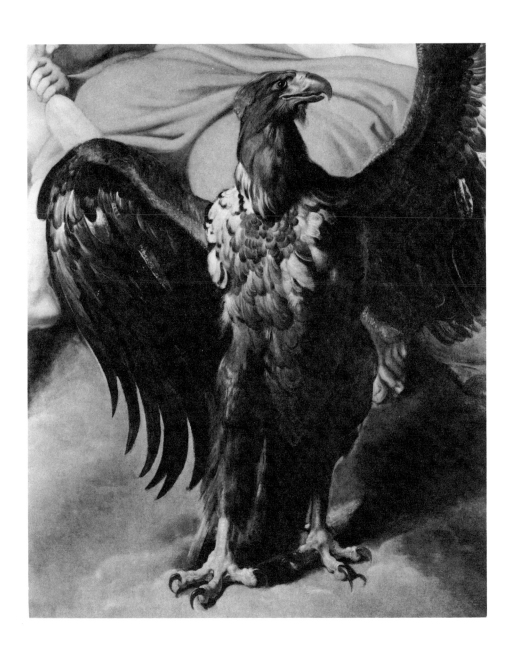

8. *Eagle*.
Engraving from Ulisse Aldrovandi,
Ornithologia, 1599.

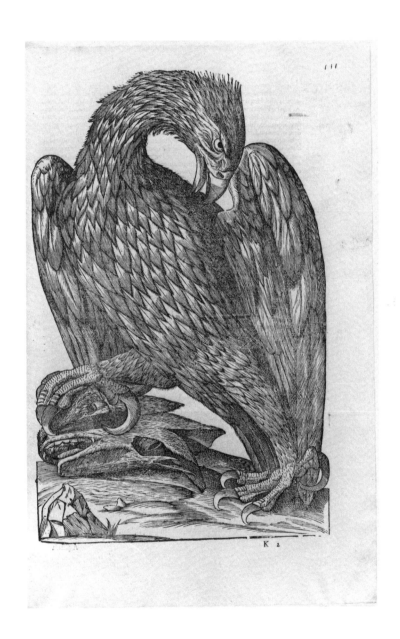

9. Copy after Rubens,
Two Views of an Eagle.
Drawing. Royal Print Room,
Copenhagen.

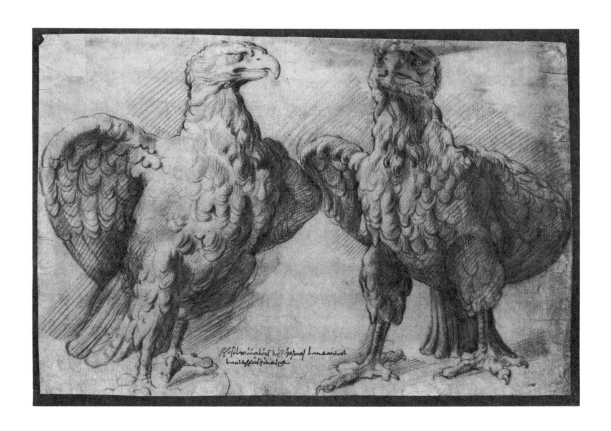

view of the extraordinary prominence given to the sacred bird, is that he has had recourse to a related iconographical type—the Roman apotheosis motif. The type may be illustrated by the cameo in the Bibliothèque Nationale in Paris known as the "Apotheosis of Germanicus" (fig. 10),[17] which represents the deified emperor seated on an eagle with outspread wings, while a flying Victory proffers a laurel wreath. The formal resemblance to Rubens's *Cupid Supplicating Jupiter* is so striking that it is not difficult to imagine that a work such as this might have served as the basis for his adaptation of the apotheosis formula. Despite the fact that in the painting Jupiter is not, for obvious reasons, actually borne aloft by the eagle, the intimate association of the two is not dissolved. Far from being simply a bird of prey, Rubens's eagle reveals itself as the messenger of Zeus, the great pinions conveying the divine power of soaring flight, and the piercing eye symbolizing the keen vision and insight that belong to the ruler of gods and men.

Yet in the end it is precisely the noble and majestic aspect of Jove's eagle that underlines the irony of the situation: the lord of Olympus is subject to the mischievous god of Love.

There are two other paintings by Rubens—both datable early in the second decade of the seventeenth century—in which an eagle plays a similarly conspicuous part. One is the *Prometheus Bound* in the Philadelphia Museum (fig. 11), with its menacing eagle tearing at the victim's liver.[18] But the huge bird in this work, though it follows Rubens's design, was executed by Frans Snyders (and we have Rubens's own word for this), whereas the eagle in the *Forbes* canvas is unquestionably by the hand of the master himself.

The second painting, even more directly apposite to our subject, is the *Ganymede* in the collection of Prince Schwarzenberg in Vienna (fig. 12),[19] in which the youth

Heidelberger Akademie der Wissenschaften, Philosophisch-historische Klasse [1915], pp. 4–5, fig. VIII); cf. also Jan Sadeler's engraving, *The Choice of Hercules*, after F. Sustris (reproduced in Erwin Panofsky, *Hercules am Scheidewege* [Leipzig-Berlin, 1930], fig. 57).

17. E. Babelon, *Catalogue des camées antiques et modernes de la Bibliothèque Nationale* (Paris, 1897), p. 139, no. 265, pl. XXIX. The emperor glorified here is probably Claudius rather than Germanicus (see F. Eichler, "Der Adler-Cameo in Wien," in *Jahrbuch der Kunsthistorischen Sammlungen in Wien*, N. F. Sonderheft 1 [1926]: 7). It is unlikely that Rubens could have known this particular cameo, which, until its purchase by Louis XIV in 1684, is said to have been in the monastery of Saint-Evre de Toul.

18. Julius S. Held, "Prometheus Bound," *Philadelphia Museum of Art Bulletin*, 59 (Autumn 1963): 17–32.

19. Svetlana Alpers, "Manner and Meaning in Some Rubens Mythologies," *Journal of the Warburg and Courtauld Institutes*, 30 (1967): 273–75. The *Ganymede* is generally dated 1611–12, probably because it is thought to be the painting mentioned in a poem by Do-

10. *Apotheosis of Germanicus.*
Cameo. Bibliothèque Nationale,
Paris.

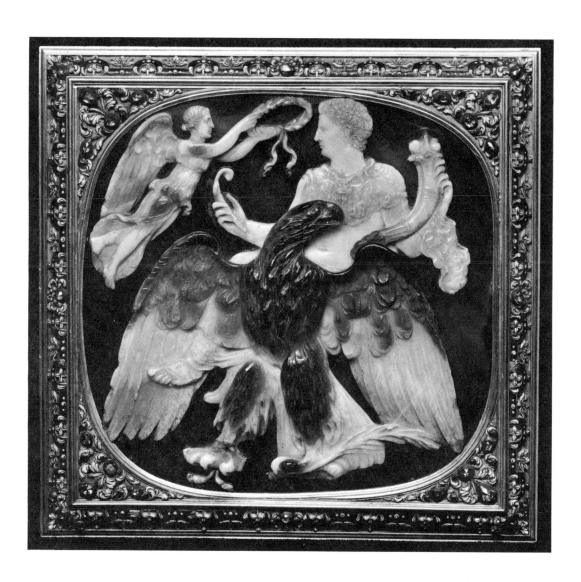

11. Rubens,
Prometheus Bound.
Philadelphia Museum of Art.

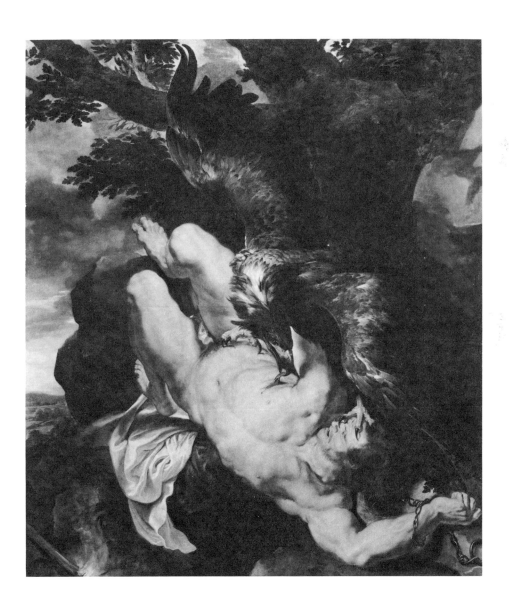

12. Rubens, *Ganymede*.
Prince Schwarzenberg Collection,
Vienna (photo: Kunsthaus, Zurich).

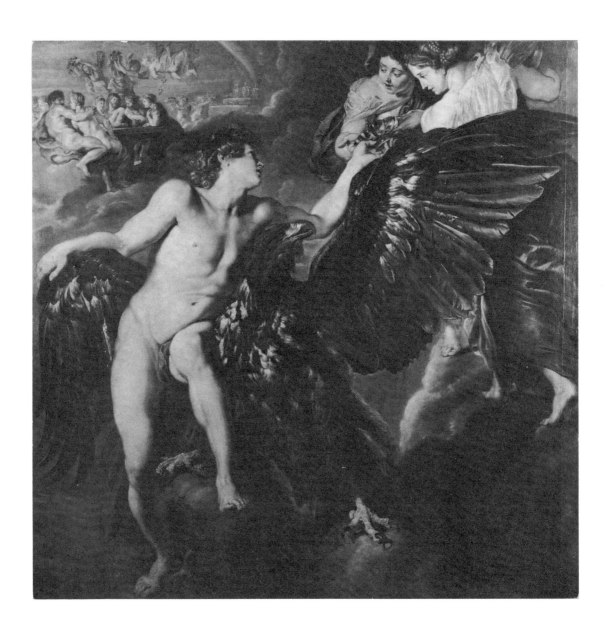

is abducted by an eagle that is astonishingly like that in the picture under discussion. There are, to be sure, obvious differences in handling. The *Cupid Supplicating Jupiter* has not been carried to the same degree of finish as the *Ganymede*, and thus lacks both the enamel-like polish and the careful elaboration of detail seen in the latter. That the *Forbes* canvas was executed more rapidly is also evident from certain thinly painted passages, such as the left arm and shoulder of Jupiter, large portions of the red drapery, and the thunderbolt (especially at the point where it passes in front of Jupiter's legs). Yet these differences cannot obscure the many significant points of resemblance between the two pictures.

It is important to remember, first of all, that the *Forbes* canvas, which originally measured about 2 x 2 meters, was of the same size and format as the Schwarzenberg picture.

In both works the eagle forms the central and dominant feature of the composition. The birds themselves are virtually identical—in the upraised left wing with plumage in full spread, in the imperious turn of the head, in the rendering of the talons, and, most important of all, in the arrangement and markings of the feathers.

No less revealing is a comparison of the heads of Cupid and Ganymede, which have surely been painted from the same model. In both we recognize the upturned gaze of the eyes, the curly hair falling in ringlets at the back, and the play of light and shadow over the profiles. The facial features, though represented at slightly different angles, are incontestably similar; indeed one feels that the Ottawa drawing (cat. 2) might almost have served, in its rendering of the neck and throat of Cupid (a passage largely suppressed in the definitive painting), as a preliminary study for the head of Ganymede.

These formal analogies plainly indicate that the *Ganymede* and the *Cupid Supplicating Jupiter*, if they do not in fact spring from the same creative impulse, are at least closely contemporary. In the firm, sculptural modeling, in the luminous colors enriched by strong reflections in the shadows, and in the pressure of the powerful forms against the frame, both paintings are typical of the works produced by Rubens in Antwerp during the years 1612 to 1615.[20]

minicus Baudius of April 11, 1612 (cf. Max Rooses and Charles Ruelens, *Correspondance de Rubens*, 6 vols. [Antwerp, 1887–1909], 2: 56). But the *Ganymede* praised by Baudius may be another work altogether, for he speaks of it as containing barking dogs. This detail might, admittedly, be due only to faulty recollection on Baudius's part, for most artists do in fact follow Virgil's account (*Aeneid* 5. 252 ff.) by including the watchdogs who bark in vain as Ganymede is abducted. A date about 1612 cannot, in any event, be very far from the truth.

20. We confess that we are unable to follow Michael Jaffé ("Rubens and Jove's Eagle," pp. 22–23) in placing the *Cupid Supplicating Jupiter* as late as 1625.

13. Rubens,
Paracelsus?.
Musée des Beaux-Arts,
Brussels (photo: A.C.L.).

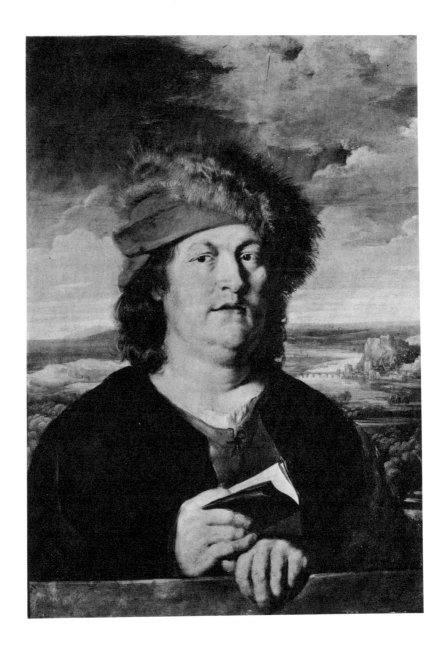

Some Thoughts on Rubens as a Copyist of Portraits, 1610–1620

Wolfgang Stechow

I should like to discuss some examples and some basic aspects of Rubens's activity as a copyist[1] of portraits, and of its *raison-d'être*, during the second decade of the seventeenth century. Little has been said about these works in the vast recent literature on Rubens, and in a few cases the question of date seems to remain open. As I collected material for this presentation I was prompted by previous opinions to consider the fascinating case of Rubens's copy after Raphael's *Count Castiglione* since it has usually been dated about 1620; but its fortunate owner, Count Seilern in London, was kind enough to send me proofs of the forthcoming addenda to the catalogue of his collection in which he adopted the date of circa 1630 proposed by Christopher Norris[2]—a date that I, too, had suspected and find entirely corroborated by the splendid photograph Count Seilern sent me. This picture is in the same group and of the same date as the *Thomas More* after Holbein in the Prado, with which it also shares some significant deviations from the original (I agree with Count Seilern—versus Imdahl[3]—that the hands of Castiglione were added by Rubens rather than copied from a hypothetical former state of the original).

Generally speaking, the portrait copies of the period seem to fall into two groups: those made for the artist's personal use and those made on commission. However, such a separation is much more difficult to document than one would at first suspect. Who can tell whether the magnificent *Mulay Ahmed* in Boston,[4] a copy after Jan

1. In addition to copies proper I shall include "adaptations," and shall call attention to the extent of fidelity in each case.
2. In his review of the catalogue of Count Seilern's collection, *Burlington Magazine*, 97 (1955): 398.
3. Max Imdahl, "Raffaels Castiglionebildnis im Louvre . . . ," *Pantheon*, 20 (1962): 38–45.
4. Julius S. Held, "Rubens' 'King of Tunis' and Vermeyen's Portrait of Mūlāy Ahmad," *Art Quarterly*, 3 (1940): 173–80.

Vermeyen, was painted for Rubens's own satisfaction and use or for somebody intensely interested in the history of Charles v long before Rubens painted the *Battle of Tunis* now in Berlin?[5] Was Rubens himself so fascinated by Paracelsus—provided the latter was indeed the sitter[6]—that he copied (fig. 13) a contemporary portrait,[7] or was this copy commissioned to him by some admirer of the man represented in the great Brussels portrait? We do not know. The most intimate of these copies, and the most enigmatic in some respects, is the picture now in Munich (fig. 14) which Rubens copied from the original by Willem Key now in Berlin (fig. 15).[8] Note that this is a small copy of a small original and that both appear in Rubens's estate in 1640, the original as "a portrait of a man with a black beret,"[9] the copy as "the head of a young man with a black beret," listed in the group of pictures "painted by the late Mynheer Rubens in Spain, Italy and elsewhere after Titian as well as other famous masters."[10] The original, painted on paper mounted on a panel, is with great probability identical with a picture that in 1642 was in the estate of the same Herman de Neyt[11] who owned the *Mulay Ahmed*, together with

5. Gemälde-Galerie, Berlin-Dahlem (no. 798 G), now usually dated ca. 1620.

6. On the doubts concerning the identification see Gert von der Osten, "Paracelsus—ein verlorenes Bildnis von Wolf Huber?," *Wallraf-Richartz-Jahrbuch*, 30 (1968): 201–14.

7. It has not been sufficiently stressed (though briefly noted by Julius S. Held, "Artis Pictoriae Amator: An Antwerp Art Patron and His Collection," *Gazette des Beaux-Arts*, 50 [1957]: 63, n. 22) that the picture reproduced in 1628 in Willem Haecht's painting of the Gallery C. van der Geest, formerly in the van Berg Collection in New York (cat. 1947, unpaged, with detail), and now in the Rubenshuis in Antwerp (illustrated in Max J. Friedländer, *Early Netherlandish Painting*, 14 vols. [Leyden-Brussels, 1924–36], vol. 7, *Quentin Massys*, trans. H. Norden [1971], pl. 135d), cannot be identical with the Brussels picture. The latter was almost certainly the one that in 1635 (i.e., at the time when the other version was still in the van der Geest Collection, see Jan Denucé, *Inventare von Kunstsammlungen zu Antwerpen im 16. u. 17. Jahrhundert* [Antwerp, 1932], p. 53) was owned by the Duke of Buckingham ("Rubens, The Picture of Paracelsus"; see Randall Davis, "An Inventory of the Duke of Buckingham's Pictures," *Burlington Magazine*, 10 [1907]: 379). The lost original has been variously attributed to Quentin Massys (Friedländer, vol. 7) and Wolf Huber (von der Osten, "Paracelsus"). On the copy in the Louvre see E. Michel, *Catalogue Raisonné des . . . peintures flamandes . . . Musée National du Louvre* (Paris, 1953), pp. 212–13, also on additional versions (the list is still incomplete).

8. The Berlin picture measures 44½ x 34½ cm; the Munich copy, 41 x 33 (not 43) cm. What do the letters "L" (or "I") and "C" on the rings—the former black, the latter red—on the Munich picture mean? The original has nothing of the sort.

9. No. 187 (Denucé, *Inventare*, p. 64).

10. No. 39 (ibid., p. 58).

11. Ibid., p. 105: "Een tronie gemaect van Key, van pampier op paneel geplact, in een achtcantige lyste."

14. Rubens,
after Willem Key,
Portrait of a Young Man.
Alte Pinakothek, Munich.

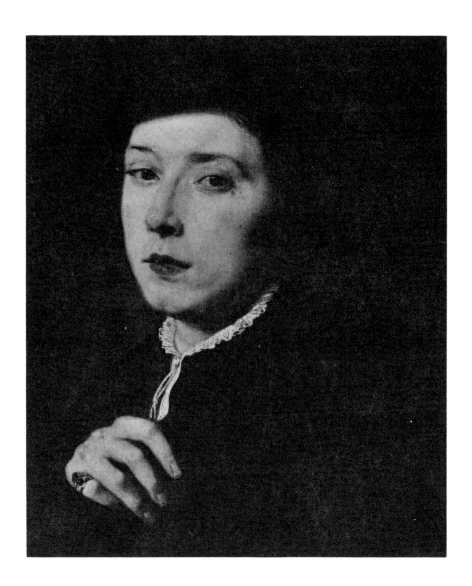

15. Willem Key,
Portrait of a Young Man.
Staatliche Museen,
Berlin-Dahlem
(photo: Steinkopf).

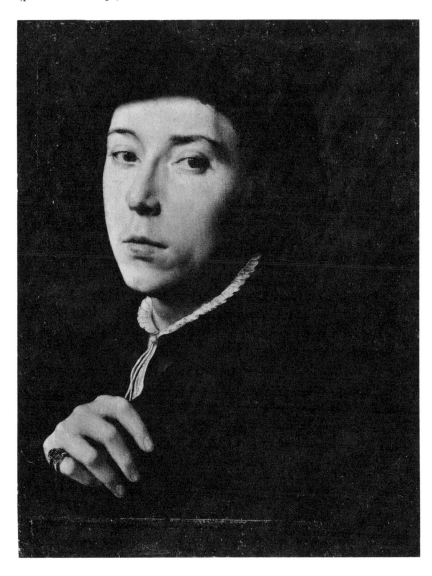

several other paintings by Willem Key; in 1798 it was in the collection of the Duke of Marlborough at Blenheim Castle, where Walpole saw and praised it; and in 1886 it appeared in the sale of that collection as "painted in the style of Leonardo da Vinci"![12] I shall not dwell on the aesthetic aspects of the marvel that is the Munich copy of this picture but I submit that Friedländer's complaint that it "does not do any justice at all to the spiritual expressiveness of the original,"[13] understandable though it may be, misses a main point of this extraordinary work.

Vermeyen and Key (as well as Massys) were fellow Flemings; the works adapted by Rubens, a select group of native antecedents. True, pictures by Massys and Key also appear frequently in other Antwerp collections of Rubens's time; the de Neyt inventory of 1642[14] contains a considerable number of paintings by Key, Floris, "Sotte Cleef," and Pourbus. But the point here is that the portraits by Willem Key, of which Rubens owned one other example,[15] anticipate a surprising number of features of Rubens's portrait style,[16] quite particularly of the period from 1610 to 1620. Whatever Rubens's special motives were for making these copies, they were part and parcel of a general stylistic trend in his work of that time; the sixteenth-century Flemish tradition reasserted itself in what Rudolf Oldenbourg used to call the master's "classicistic" religious and mythological compositions of that period[17] and also in his portraits from life. Looking at portraits of that phase of Rubens's art we are reminded again and again of portraits by Willem Key and by Floris; and

12. Sale in London, July 31, 1886, no. 242, sold for £35.14 to Sedelmeyer. I cannot explain why the size of the (otherwise clearly described) picture was there given as only 11½ x 9¼ inches; this would not even correspond to the size of the picture minus its enlargements. Dr. Wilhelm Koehler kindly informs me that Friedländer's assumption (vol. 13, *Anthonis Mor und seine Zeitgenossen* [1936], p. 102) of an originally octagonal framing of the Berlin picture is not borne out by a renewed investigation; this makes its identification with the painting in the de Neyt Collection (Denucé, *Inventare*, p. 105) a bit less certain.

13. Friedländer, vol. 13, pp. 101–3. The picture was formerly attributed to Joos van Cleve the Younger.

14. Denucé, *Inventare*, pp. 94–112. The Duke of Buckingham also owned several pictures by Willem Key (Davis, "Duke of Buckingham's Pictures," pp. 381–82).

15. Denucé, *Inventare*, p. 66, no. 224.

16. See the splendid *Pietà* at Unkel (Friedländer, vol. 13, pl. L), and the portrait of 1543 in Antwerp (ibid., pl. LIV). For Rubens's intimate connection with the *fifteenth*-century Flemish tradition see Colin Eisler, "Rubens' Uses of the Northern Past, the Michiels Triptych and Its Sources," *Musées Royaux des Beaux-Arts de Belgique Bulletin*, 16 (1967): 43–79.

17. *Peter Paul Rubens* (*Abhandlungen*) (Berlin-Munich, 1922), pp. 80–87.

looking at Floris's marvelous *Lady* in Caen we think at once of Rubens's *van Thulden* in Munich.

Turning to commissioned copies of that period, I must be brief regarding the ten pieces that Rubens made for his friend Balthasar Moretus between March 17, 1613, and May 2, 1616, and for which he was paid 144 guilders on July 1 of the latter year.[18] Most of them are now in the Museum Plantin-Moretus in Antwerp. I have not seen them, and some have not even been reproduced, but the customary view that they are more or less negligible workshop pieces is open to some doubt, although it may be true that none rises to the heights of the *Christoph Plantin* (fig. 16), which Rubens adapted from a copy of a portrait painted by an unknown (Leyden?) master in 1584.[19] What exactly was the reason for the choice, made in these ten portraits, not only of Plantin's son-in-law and successor, Jan Moerentorf (Moretus), and Plato, Seneca, and Justus Lipsius, but also of Lorenzo de' Medici and Leo X, Alfonso of Naples, Matthias Corvinus, and Pico della Mirandola?[20] Jan Moretus died only in 1610; why did Rubens paint his portrait for his brother Balthasar after a work by somebody else?[21] How is it related to the (unpublished!) portrait that Rubens placed over the altarpiece he painted for Jan Moretus's tomb in the Antwerp Cathedral? We have no answers to these questions.

This leaves one other main group to be considered, and I believe that it must be viewed in connection with important but only very partially executed plans for a dynastically oriented series commissioned by Albert and Isabella.

Rubens was not appointed court painter to the illustrious couple until 1609, and we must ask what is known of previous plans for a Burgundy-Brabant iconography. It is very little, but we do have a few indubitable facts, most of which are connected with the person of Antonio de Succa.[22] This elusive artist—not one fully authenticated painting of his is known—was a grandson of a secretary to Charles V in Brus-

18. Hans Gerhard Evers, *Rubens und sein Werk, Neue Forschungen* (Brussels, 1943), p. 44; H. F. Bouchery and Frank van den Wijngaert, *P. P. Rubens en het Plantijnsche Huis* (Antwerp, 1941), pp. 21–31.

19. All three reproduced in Bouchery and van den Wijngaert, *Rubens*, figs. 5, 6, 11. (My thanks to Mr. Frans Baudouin for the beautiful detail photograph, fig. 16.)

20. The latter four were taken from prints published in various works by Paolo Giovio (ibid., p. 28, n. 4).

21. Ibid., p. 23; *Les Collections du Musée Plantin-Moretus* (Antwerp, 1925), p. 6.

22. The most important information on de Succa was provided by Marguerite Devigne in the *Biographie Nationale de Belgique* (Brussels, 1926–29), 24, cols. 233–35. The present account is largely based on that article. The short chapter on de Succa in Marcel De Maeyer, *Albrecht en Isabella en de Schilderkunst* (Brussels, 1955), pp. 191–92, is disappointing.

16. Rubens,
Portrait of Christoph Plantin (detail).
Museum Plantin-Moretus,
Antwerp (photo: A.C.L.).

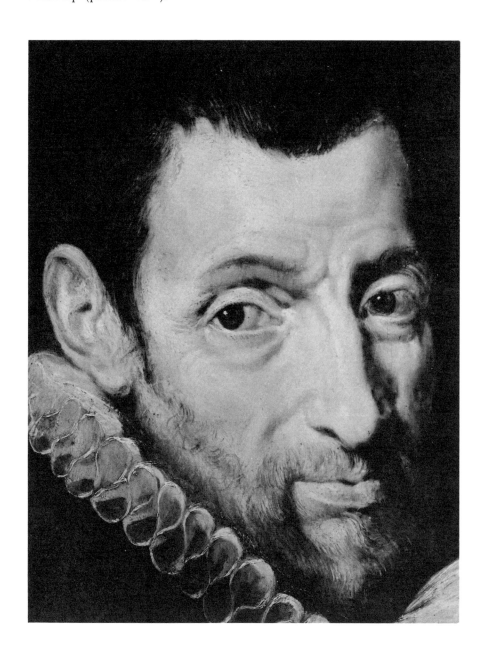

sels. His father was in the service of the Count of Mansfeld, who governed the Netherlands between Alexander Farnese and Archduke Ernst, that is, from 1592 to 1594. In 1598 de Succa's name appears, immediately after that of Rubens, in the list of the Antwerp Painters Guild. About his activity before 1600 I shall report later. On October 11, 1600, that is in the year of Rubens's departure for Italy, he was appointed "portraitist-genealogist" of the Archdukes Albert and Isabella; from 1601 to 1604 we find him traveling all over Flanders, making sketches of monuments and portraits connected with the Burgundian House wherever he went and keeping a book of *Mémoriaux*, which is partly preserved in the Royal Library in Brussels; and it is well known that the so-called *Book of Costumes* in the British Museum contains copies made by Rubens after de Succa's drawings.[23] In 1604 de Succa bought a house in Antwerp, in which he established a gallery with historical portraits. For the town hall he painted a series of portraits of former rulers of the Spanish Netherlands. These turned out to be so popular that at one time de Succa decided to sue the guardian of the town hall for permitting those portraits to be copied. In 1607, he sold to the art dealer Jan Gooaert a series of copies of his painted portraits, with the proviso that they should not be "imitated." He constantly had to fight encroachments upon his copyrights.

When de Succa died on September 8, 1620, his inventory listed, in addition to lots of other precious items, fifty-seven portraits of princes painted on wood, thirty painted on canvas, eighty-six done on paper, a series of figures of Burgundian, Austrian, and English princes put together on two scrolls of canvas, and many other paintings, including ten more canvases with pictures of rulers. All this was in addition to the large series placed in the town hall, which disappeared only after 1685.

Now this is indeed big business in patriotism, and it is perhaps not to be wondered at that nothing of it has survived. Of the attributions of paintings more recently made to de Succa's hand, not a single one has more than a slight chance of being acceptable. His name never appears in the long lists of inventories and the dealers' correspondence made accessible to us by Denucé. One wonders how many of his portraits were peddled under greater names. Or were they so poor that nobody bothered with them?

Rubens was in Italy when de Succa collected, between 1601 and 1604, the vast material that he milked continuously later on. Julius Held was therefore probably right when he insisted, against others, on a date after 1609 for Rubens's copies after

23. A. M. Hind, *Catalogue of Drawings by Dutch and Flemish Artists in the British Museum*, 5 vols. (London, 1915–32), 2 (1923): 36 ff., no. 119. A critical publication of the Brussels *Mémoriaux* is an urgent desideratum.

de Succa's drawings of Burgundian and other costumed figures that the *Mémoriaux* contains,[24] including the beautiful full-length ones of the parents of Charles v, Philip the Handsome and Joanna the Mad, which the master himself identified.[25] Although, as we shall see, some of de Succa's Burgundian material had been collected before 1600, the bulk of it cannot have been accessible to Rubens until 1609, and it is logical to assume that Rubens's interest in those ancestors of Albert and Isabella, and the interest of the archdukes in Rubens as a possible chronicler of their ancestors, dates from the time after his appointment as court painter.

He now faced across the easel, as it were, Antonio de Succa, by all odds a very mediocre painter, who, as we have seen, stubbornly clung to his briefed rights as a painter of the princely lineage. One small example of Rubens's abilities in this field, possibly even those drawings after de Succa in the London *Costume Book*, would have sufficed to convince the archdukes of his immense superiority over the man they had appointed in Rubens's absence to do that job.[26] One can savor their feelings across an interval of three hundred and sixty years, and also the feelings of Rubens himself who ran into de Succa's portraits every time he visited the Antwerp town hall. What was there to do? Was there any way of circumventing de Succa?

If one was found we hear nothing about it from documents. The day when Rubens was called upon to design the title pages for the two volumes of F. Verhaer's (Haraeus's) *Annales Ducum Brabantiae*[27] was still quite some time off: this happened in 1622 and 1623, after de Succa's death in 1620. On the other hand, Albert had by then also died (1621), and although collections with Burgundian portraits remained popular, Rubens had almost nothing to do with them. In fact, the most important of them, the *Duces Burgundiae* with prints after Soutman's design by Suyderhoef and Louys dates from after Rubens's death.[28] The only case known to me of a connection with Rubens in one of these series occurs in the *Pourtraicts de tous les souverains princes et ducs de Brabant*[29] which Jan Meyssens published in Antwerp (no year given but probably in the 1660s); and this occasions the following observations.

24. *Rubens, Selected Drawings*, 2 vols. (London, 1959), 1: 160.

25. Justus Müller Hofstede, "Rubens und Tizian: Das Bild Karls v," *Münchner Jahrbuch der bildenden Kunst*, 18 (1967): 34–35.

26. Julius S. Held, "Rubens' Pen Drawings," *Magazine of Art*, 44 (1951): 288.

27. Evers, *Rubens*, pp. 179–80 and figs. 91, 95.

28. 1644; J. Wussin, *Jonas Suyderhoef* (Leipzig, 1861), pp. 77–78.

29. This is the engraved subtitle page of the volume by Jan Meyssens entitled *Les Effigies des Souverains Princes et Ducs de Brabant, avec leurs chronologie, armes et dévises* (Antwerp, n.d.).

The copy by Rubens that seems to fit most readily into a dynastic enterprise of this sort was most probably painted soon after his appointment as court painter. This is the extraordinary double portrait in Vienna known under the name of *Pipin and Bega* (or *Begga*) (fig. 17).[30]

This rather large panel (94 x 76 cm) was sold by Rubens to the Duke of Buckingham in 1625 and therefore does not appear in his own inventory of 1640. In the Buckingham sale of 1649 it is listed under number 10 as "The Dutchesse of Brabant and her Love(r)";[31] it was in the imperial collection by 1718. A print after it was made in reverse by Frans van den Steen (ca. 1624–72);[32] the text identifies the two figures as "S. Pipini, I. Brabantiae ducis, ejusque Filiae, S. Beggae, Ducis III . . . effigies"; but it also calls them "A Pietro Paullo Rubenio, Equite, e priscis tabulis delineatas," and contains a dedication to Philip van Valkenisse, secretary and archivist of Antwerp, who had the print published by Frans van den Wyngaerde. Were the *priscae tabulae*, old pictures, from which Rubens adapted this subject identical with the two listed in his inventory of 1640 as "Two portraits, husband and wife, by Jan van Eyck"?[33] The hope that the appearance of these two panels is preserved for us in two prints published by Theodor Matham[34] (one of them is shown in fig. 18), which show the two ducal figures separately and are inscribed "H. [*sic*] van Eyck pinxit," must be abandoned; the engraver carefully covered up Bega's *décolleté* and gave her crosses and a rosary instead of jewelry, but his image certainly goes back to Rubens's painting or even van den Steen's print (which it reverses). Another *Bega* alone, engraved by Pieter de Jode II (fig. 19),[35] has the *décolleté* of the Vienna picture and the van den Steen print intact, but its pearl necklace ends in a cross and both hands are eliminated. Neither van Eyck nor Rubens are mentioned here but the print was surely fashioned after the latter. It is this engraving that together with a Pipin differing widely from Rubens's male figure was included in the aforementioned series of *Pourtraicts de tous les souverains princes et ducs de*

30. Max Rooses, *L'oeuvre de P. P. Rubens*, 5 vols. (Antwerp, 1886–92), 2, no. 479.

31. Davis, "Duke of Buckingham's Pictures," p. 380 ("Love"); Max Rooses and Charles Ruelens, *Correspondance de Rubens*, 6 vols. (Antwerp, 1887–1909), 5: 293 ("Lover").

32. Frank van den Wijngaert, *Inventaris der Rubeniaansche Prentkunst* (Antwerp, 1940), no. 651; reproduced in Rooses, *P. P. Rubens*, 2, pl. 163.

33. Denucé, *Inventare*, p. 64, nos. 179, 180.

34. Van den Wijngaert, *Inventaris*, nos. 439, 440. (My thanks to Dr. F. Koreny of the Albertina for his help with photographs and information.)

35. Ibid., no. 332.

17. Rubens,
Ansegisus and Bega.
Kunsthistorisches Museum,
Vienna.

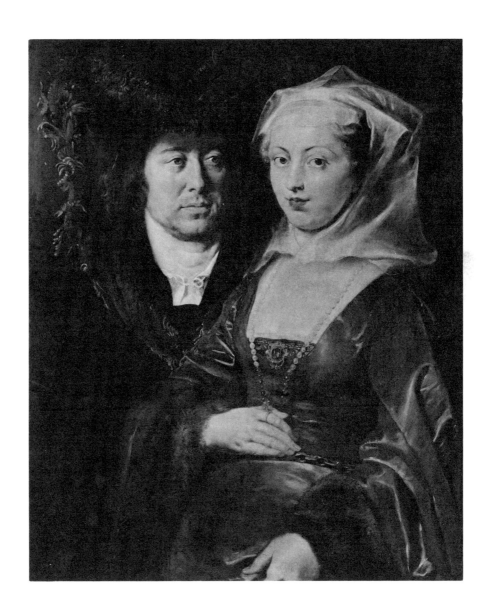

18. Theodor Matham,
after Rubens, *Bega*.
Albertina, Vienna.

19. Pieter de Jode II,
after Rubens, *Bega*.
Albertina, Vienna.

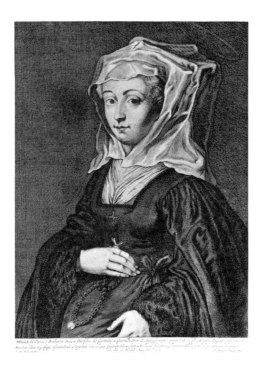

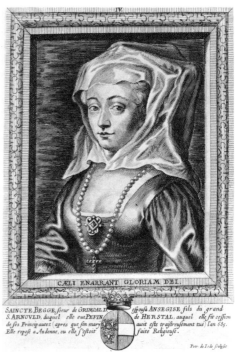

Brabant published by Jan Meyssens. So much for the post-Rubens iconography of this pair.[36]

What do we have here? Mere fiction or some truth? It is of course a hopeless task to find out whether the *priscae tabulae* were intended to represent Pipin and Bega, but there is little doubt that Rubens's adaptation to a double portrait—thus no longer a strict copy—speaks against an interpretation of the pair as father and daughter. As mentioned before, the oldest description calls it "The Dutchesse of Brabant and her Love(r)," and indeed one can see that the man (who does not look so much older than the woman) puts his left hand around her waist while she places her right hand upon her body. This is not a representation of *paternal* love, and I had supposed that Rubens actually had Bega and her *husband* in mind even before I encountered the extraordinary engraving reproduced in figure 20.

This print occurs in a volume entitled: *Ducum | Brabantiae | Chronica | Hadriani Barlandi, | Item | Brabantiados Poema Melchioris Barlaei: | Iconibus nunc primum illustrata, | Aere ac studio Ioan. Bapt. Vrienti: | Operâ quoque Nob. viri Antoni de Succa. | Ad | Serenissimos Principes | Albertum et Isabellam | Brabantiae Duces. | Antwerpiae, | In Officina Plantiniana, | Apud Ioannem Moretum. | Anno Saeculari Sacro MDC*; the *Approbatio* at the end is dated "Id. Septembris. Anno 1599."[37] In this volume, completed even before de Succa was appointed to his post at the court—and most probably the very cause of that appointment—Barlandus's notes on individual ancestors of the archdukes from Pipin I to Albert and Isabella, are accompanied by engravings which are, with one exception,[38] unsigned. But in addition to the information given in the title of the book, we learn from de Vriendt's long preface that he decided to publish this book in spite of qualms:

36. The single *Bega* attributed to Rubens in the Rabinowitz Collection in New York (Lionello Venturi, *The Rabinowitz Collection* [New York, 1945], p. 75, no. 36, with an abominable color plate) can hardly be anything but a partial copy of the Vienna double portrait, but I have not seen it.

37. I used the copy of this rare book which is owned by the Beinecke Rare Book and Manuscript Library of Yale University and contains excellent impressions from the copper plates. Most of the prints were reused in *Chroniicke van de Hertoghen van Brabant, verciert met hunne figuren nae t'leven* [!] . . . , *Vergadert uyt diverse Historie-schrijvers, ende overgheset door Laurens van Haecht Goidsenhoven* (Antwerp: Plantijn, 1612). The dedication in the foreword (signed L. V. Haecht) is to Eduardos Ximenex Pereta and is dated Aug. 6, 1606; a copy is in the Public Library in New York. It contains no reference to de Succa or de Vriendt.

38. This is the double portrait of Albert and Isabella, which is inscribed: "Otho Vaenius inuent.—Ioan. Woutneel excudit.—Ioan. Collaert Sculp."

20. Anonymous,
Ansegisus and Bega.
Engraving from *Ducum Brabantiae
Chronica,* Antwerp, 1600.

"adscito in laboris partem Nob. viro Antonio de Succa, artis pictoriae, Belgicaeque antiquitatis in primis gnaro."[39]

The print in question is unambiguously inscribed: "Ansegisus et Begga Brab. Duces." It is preceded by one representing "Pipinus Senior Brabantiae Dux i," a full-length figure of an old man holding his raised sword in his right and his coat of arms with his left hand, which is utterly unlike Rubens's male figure. While the *Pipin* is a fancy figure with a nondescript building on the left and a landscape on the right, the couple stands in an interior immediately reminiscent of that of Jan van Eyck's Arnolfini double portrait, accompanied by a very Burgundian greyhound and a very Eyckian dog. With the exception of the two coats of arms, an underlying Eyckian model seems very probable indeed, and it is still tempting to think of the "Two Portraits, husband and wife, by Jan van Eyck," which appear in Rubens's inventory of 1640, not only as being identical with the *priscae tabulae* mentioned in van den Steen's print after the Vienna picture, but also as resembling closely the print of 1600 (fig. 20), in spite of their physical separation (the inventory lists them as two items), on which one could speculate endlessly. The "H. van Eyck pinxit" on Matham's print (fig. 18) still vaguely reflects the Eyckian origin, although the engraver worked from Rubens's adaptation. One is also at once vividly reminded of the two drawings of Dukes of Brabant, Philip (the Good?) (destroyed) and John IV (Rotterdam), which Friedländer considered works by Jan van Eyck himself;[40] Philip, too, holds a falcon on his hand, as does the sitter of van Eyck's Frankfurt drawing.[41]

Thus, Rubens's Vienna double portrait, a brilliant adaptation of its fifteenth-century source, certainly represents Bega and her husband Ansegisus[42] (or Adalgiselus; probably a son of Saint Arnulf), who later was called, not quite properly, Duke of Brabant and in any case ruled over a territory roughly coinciding with it. Bega became the mother of Pipin II (and thus the grandmother of Charles Martel).

39. A contract between de Succa and de Vriendt concerning "Le Livre des ducs de Brabant" is mentioned (without date) by Marguerite Devigne, *Biographie Nationale de Belgique*, 24, col. 234.

40. Friedländer, vol. 1, *The van Eycks and Petrus Christus*, trans. H. Norden (1967), pls. 100, 101.

41. Ibid., pl. 66. It may be added that the "Ansegise, alias Anchise" in Meyssens's work (*Effigies des Souverains Princes et Ducs de Brabant*) is not connected with the Ansegisus shown in fig. 20.

42. Note also that a large painting in the sale " (P.) Servais, Brussels, (August 24,) 1775," was called *Sigisius et Begghe* (Rooses, *P. P. Rubens*, 2: 336).

She is seen here as the future mother of that third Duke of Brabant, and I think we can assume that Rubens reinterpreted the fifteenth-century fashion of a protruding stomach as maternal expectancy. After Ansegisus had been murdered by an adopted son, Bega fled from the assassin to Hesbaie and subsequently to Italy.[43] Upon her return she built seven churches (after the seven basilicas of Rome) in Andenne-sur-Meuse that were still standing in Rubens's time. In 692 she erected a convent there. Saint Bavo was believed to have been a relative of Bega and Gertrude and to have inspired them to live purer lives. For this reason the sisters are shown on the left side of Rubens's London sketch for the altarpiece with Bavo's acceptance of the monastic habit, which was painted circa 1611–12 (fig. 21), thus exactly in the very years to which one can assign the Vienna double portrait on stylistic grounds.[44] The individual identification of the two sisters on the London sketch is probably an impossible task. One of them is removing her necklace, and she is usually taken to be Gertrude on the point of entering the convent of Nivelles.[45] Unfortunately, a cogent physiognomical resemblance with the lady in the Vienna panel cannot be established for either of them, but the connection is anything but excluded.

Here, then, is an early ancestor of the Brabant-Burgundy dynasty to which Albert and Isabella belonged. It is possible that Rubens consulted de Succa on this matter even if he did not acquire his "van Eyck" pair from him. In de Succa's collection were several other Eyckian images, including those of Michelle de France, the first wife of Philip the Good of Burgundy, drawn by him in 1601 in Tournai,[46] and Isabella of Portugal, third wife of the same Duke of Burgundy, who looks quite a bit like the presumed original of Rubens's *Bega*.[47] In short, we may well have here a very early example of the kind of painting with which Rubens, Albert, and Isabella may have wished to supplement, or to outdo, de Succa's relentlessly growing gallery of Burgundian ancestors. It may be pertinent to recall that the London sketchbook is inscribed by an eighteenth-century hand: "Un volume d'études dessinées par P. P.

43. I am here following again the *Biographie Nationale de Belgique* (2 [1868], cols. 107–9, and 1 [1866], col. 326); and I have also consulted *Van Brabant die excellente Cronike* . . . (Antwerp: Jan van Doesborch, 1530), and Johannes Molanus, *Militia Sacra Ducum et Principum Brabantiae* (Antwerp: Plantijn, 1592).

44. Gregory Martin, *National Gallery Catalogues: The Flemish School circa 1600–circa 1900* (London, 1970), pp. 126–33, no. 57, with full literature.

45. Ibid., pp. 127–28.

46. W. H. J. Weale, *Hubert and John van Eyck* (London-New York, 1908), p. 179 and plate.

47. W. H. J. Weale and M. W. Brockwell, *The van Eycks and Their Art* (London-New York, 1912), p. 213 and pl. xxxiv. Jan van Eyck painted her in 1429.

21. Rubens,
Saint Bavo Accepting the
Monastic Habit (detail).
National Gallery, London.

Rubens pour son histoire des Contes de Flandre." Although Hind correctly stated that there is at present no evidence of any such book by Rubens,[48] it is possible that there existed a reliable tradition in the eighteenth century that pointed to some such effort on his part.

Was this the only example of such a group of works? A few other pictures should be considered here. One naturally thinks first of Charles v, who was repeatedly painted by Rubens and who was the grandfather of both Albert (via Maximilian II's wife Maria) and Isabella (via Philip II). Although these paintings by Rubens are inseparable from his dialogue with Italian artists, a connection with a series planned in the second decade is not entirely out of the question. I am not thinking of the allegorical portrait after Parmeggianino nor of the double portrait of Charles and Isabella after Titian. But the single portrait engraved by Lucas Vorsterman about 1617–18 is an image combined from two Titian portraits of the representational type and may possibly have been intended for a dynastic series.[49] For the portrait of Anna of Hungary, who as the wife of Ferdinand I, the younger brother of Charles v, became the grandmother of the fourth wife of Philip II of Spain, Rubens availed himself of a painting by Hans Maler of Schwaz which he copied faithfully and yet brilliantly.[50] But then, there are also the two large, splendid, and enigmatic portraits of Charles the Bold and Maximilian I in Vienna, about which one finds next to nothing in the Rubens literature. True, these are certainly *not* copies in the strict sense, even less so than the double portrait.

Maximilian I (fig. 22)[51] is represented with Burgundian and Austrian arms below his waist and a fillet between helmet and crown in the colors of the Burgundian coat of arms. There is no question but that he appears here, not as the Hapsburg emperor, but as the consort of Mary of Burgundy. When Cornelis Visscher made an engraving of the head of this picture he called it that of Philip the Good of Burgundy, and it is noteworthy that two panels with the portraits of Philip the Good

48. Hind, *Dutch and Flemish Artists*, 2: 37.

49. van den Wijngaert, *Inventaris*, no. 731; Müller Hofstede, "Rubens und Tizian," pp. 45, 56–57, 86, and figs. 5, 16.

50. Coll. O. R. Bagot, Exh. Manchester 1960, no. 75; and Benedict Nicolson, "Old and Modern Masters at Manchester," *Burlington Magazine*, 102 (1960): 461. (Michael Quick called my attention to this picture.) Mentioned in Rubens's inventory of 1640 (Denucé, *Inventare*, no. 145).

51. Kunsthistorisches Museum, Vienna, cat. 1958, p. 107, no. 307; there is little of Maximilian's characteristic physiognomy here, but the Austrian arms in the lower center (the others are Burgundian-Brabantian) *seem* to settle the matter; see J. Wussin, *Cornelis Visscher* (Leipzig, 1865), no. 88 (as after Jan van Eyck!).

22. Rubens,
Maximilian I.
Kunsthistorisches Museum,
Vienna.

and Charles the Bold were listed together in Rubens's inventory of 1640,[52] suggesting the possibility that even then the *Maximilian* was interpreted as representing Philip the Good. I cannot indicate a source for this likeness, either iconographically or stylistically, and it was not used in portrait engravings by Vorsterman, P. de Jode, and Suyderhoef;[53] nor do I know for certain when it was shipped to Austria.[54] The picture was dated about 1618 by both Glück and Burchard.

The *Charles the Bold* (fig. 23) is usually identified with one of the portraits of the duke mentioned in Rubens's inventory of 1640.[55] Glück dated it first before 1620, later 1624 (Rooses had proposed a date of circa 1635 for both pictures,[56] which is certainly much too late). The reputation of Charles the Bold has always been great in spite of the disastrous role he played in the history of Burgundy; in a letter of January 17, 1620, addressed to Rubens's friend Jan Caspar Gevaerts, Peiresc asked him about the monograph written on the duke by Thomas Basin.[57] Several copies after Rubens's splendid picture exist.[58] Whether Rubens here harked back to any older likeness of Charles the Bold is hard to tell. The inspiration for this work certainly came from a more recent master portrait, namely Titian's *Duke of Urbino*.[59]

These are idealized images of the two princes, and the memory of de Succa's archaeological material has almost completely faded. That the *Maximilian* and the *Charles the Bold* belong together can hardly be doubted. True, the former is considerably higher than the latter (1.40½ versus 1.18½ m), but their width is within half a centimeter the same (1.01½ versus 1.02 m), and it is therefore highly probable that they formed part of a planned series of ancestors of the ruling archdukes,

52. Denucé, *Inventare*, p. 60, nos. 95, 96.

53. See van den Wijngaert, *Inventaris*, nos. 344, 661, 736.

54. A "Keyzer Maxemilian," apparently from Rubens's estate, is estimated at 17½ guilders in 1640 (Jan Denucé, *Na Peter Pauwel Rubens* [Antwerp, 1949], p. 3); a "konterfyetsel van den Kayser Maesiemilian van Ruebens" occurs in Frans Synders's estate in 1659 (estimated at 50 guilders; ibid., p. 188); and a "manskonterfeytsel van Rubbens met een slachsweert" was sent to Vienna in 1669 by the firm of Forchoudt in Antwerp, priced again at 50 guilders (Jan Denucé, *Kunstausfuhr Antwerpens im 17. Jahrhundert. Die Firma Forchoudt* [Antwerp, 1931], p. 104).

55. Denucé, *Inventare*, pp. 60–61, nos. 96, 107.

56. Rooses, *P. P. Rubens*, 4, nos. 913, 990.

57. Rooses and Ruelens, *Rubens*, 2: 241.

58. Max Rooses, "L'oeuvre de Rubens: Addenda et Corrigenda," *Bulletin Rubens*, 5, no. 4 (1910): 314.

59. This work by Titian had already been utilized by Rubens for his *Portrait of Charles V with Two Pages*, dated ca. 1612–13 by Müller Hofstede ("Rubens und Tizian," pp. 69 ff.), in which the *vertical* baton already appeared.

23. Rubens,
Charles the Bold.
Kunsthistorisches Museum,
Vienna.

which was perhaps started immediately after de Succa's death in 1620 and left unfinished upon the death of Albert one year later. In fact, both of these pictures were left unfinished. Nothing seems to have come of these tentative beginnings, and we recall here that Rubens did not hesitate to include the double portrait in the group he sold to the Duke of Buckingham a few years later (fig. 17). One year after Albert's death, Rubens was already deeply involved in his work for another ruler: Maria de' Medici.

Altars and Altarpieces before 1620

Frans Baudouin

In homage to Professor J. G. van Gelder,
on the occasion of his seventieth birthday

The first part of this paper deals with altarpieces painted by Rubens during the first years after his return from Italy, near the end of 1608. New archival evidence has recently come to light concerning some of these paintings.

In the second part I should like to make some brief remarks concerning altars designed by Rubens before 1620, their place in the evolution of the altar in Antwerp, and the interrelation between the subjects of the altarpieces and the decoration of the framework in which the paintings were placed.

I

Within the ten or eleven years after his return to Antwerp, Rubens painted more altarpieces than in any other period in his career. This should not come altogether as a surprise. It has indeed repeatedly been stressed that the painter's return to the Scheldt city came at a singularly auspicious time. When, at the end of 1608, he came home, there were high hopes of peace negotiations, and it was only a few months later, on April 9, 1609, that the Twelve-Years' Truce was signed. This meant a fairly long period of comparative peace. In spite of the fact that the river Scheldt remained closed to free overseas shipping, the truce spelt the dawn of renewed prosperity, a major factor in artistic efflorescence.[1] Now at last, after a protracted period of anxiety and poverty, peace had returned, and it was only natural to think of re-

1. For a survey of the economic situation see J. A. Van Houtte, *Economische en Sociale Geschiedenis van de Lage Landen* (Zeist, 1964), pp. 137 ff.

storing or building anew the churches that, throughout the periods of religious strife and war, had been neglected, damaged, and in most cases robbed of their art treasures. In addition, work could be resumed on churches that had been left unfinished, such as Saint James's and the Dominican Church (now Saint Paul's).

In 1611, the city council, which had repeatedly granted subsidies for such works of restoration and building, decided that "alms shall be collected during high masses and sermons for the purpose of restoring or repairing the churches."[2] The religious orders, returning to Antwerp or just settling there, could think of erecting new churches, mostly as replacements for chapels that they had outgrown. Many cornerstones were laid at this time: in 1611 that of the Capuchins' church; in 1614, the Jesuits' "Marble Temple"; in 1615, the Augustinians' church; and one year later, the convent of the Annunciades, with a number of others to follow.

This flowering of new and restored churches meant a need for paintings and statues. In this connection, the guilds, crafts, and fraternities went to work with a will. They wanted the altars that they erected to be decorated with paintings which, in size and subject, would echo both the spirit of the Counter Reformation and the taste for monumentality and decorative exuberance that was the hallmark of the new century.[3] All this resulted, in the years immediately after the Twelve-Years' Truce, in a pressing demand for altarpieces and large religious paintings.

Rubens, who in fact had still to begin his Antwerp career, could look forward to great commissions. Indeed, some ten years later he wrote that he "was better fitted to execute large works than small curiosities."[4] For the time being, however, the southern Netherlands evinced no great interest in large-size paintings of a mythological, historical, or allegorical nature. But commissions for monumental altarpieces gave him an opportunity to give full scope to his inclination for "large works." These altarpieces were of great significance in establishing his reputation as an artist. In the churches in which they were erected, everyone could see and admire them—even foreigners, for it is a known fact that, once peace was restored, travelers

2. Quoted by F. Prims, "Rubens' Antwerpen, Geschiedkundig en economisch geschetst" in *Rubens en zijne Eeuw* (Brussels, 1927), p. 18.

3. Ibid., pp. 19–20; idem, "Altaarstudiën," *Antverpiensia*, 12 (1938): 286–339, and *Antverpiensia*, 13 (1939): 300–447. From the last-quoted work it appears that some guilds and trades, which already had ordered a new altar to replace the one damaged or destroyed during the troubles, after 1610 again erected another altar that was more adapted to the artistic conceptions of the time.

4. ". . . je confesse d'estre par un instinct naturel plus propre à faire des ouvrages bien grandes que des petites curiosités" (Max Rooses and Charles Ruelens, *Correspondance de Rubens*, 6 vols. (Antwerp, 1887–1909), 2: 286.

flocked to the southern Netherlands. As a result, these paintings contributed greatly to the spreading of his fame far beyond the country.

Since contemporary archives and other documents enable us to accurately date a number of these altarpieces, they supply us with a useful basis both for a general critical study of Rubens's style and for dating, at least approximately, a number of his works concerning which we have no chronological data. It is necessary, however, as will be seen, that every effort should be made to collect, identify, and correctly interpret every possible piece of documentary evidence.

An exchange of letters beginning in 1611, published in 1965 by A. Monballieu,[5] proves that shortly after his return to Antwerp, Rubens was already considered the most capable painter then active in the city. When the governing authorities of the city and the castellany (*châtellenie*) of Bergues-Saint-Winoc (now in the Département du Nord, France) decided to provide an altarpiece representing the *Last Supper* for the high altar of the local Benedictine abbey, they requested a merchant friend in Dunkirk to enquire of a colleague of his in Antwerp about "the best master" to be entrusted with this commission. On March 12, 1611—this date is not without importance, for it was then only slightly more than two years that Rubens had come back from Rome—Jan Le Grand, the Antwerp merchant, replied: "We have here a good master who is called the god of painters, Peeter Rubbens, he is the painter of His Highness [Archduke Albert]." And to give more weight to his recommendation, Le Grand adds: "He has made here various pieces that are held in high esteem, as to wit in the town hall, in Saint Michael's, at the Dominicans', and in the Castle Church, and they are beautiful."[6]

This letter is of some importance, as it enables us to settle the *terminus ante quem* of some of the works painted by Rubens shortly after his return to Antwerp. In some cases, the document confirms datings made hitherto on purely stylistic grounds.

It should be pointed out, however, that the painting referred to by Jan Le Grand as being "in Saint Michael's" (i.e., at the abbey of Saint Michael) was made before Rubens returned to Antwerp (fig. 24). In fact, he had painted it in Rome in 1607–08 for the high altar of Santa Maria in Vallicella, but he had taken it back when it proved that light reflections in the choir made the painting almost invisible.[7] He

5. A. Monballieu, "P. P. Rubens en het 'Nachtmael' voor St.-Winoksbergen (1611), een niet uitgevoerd schilderij van de meester," *Jaarboek Koninklijk Museum voor Schone Kunsten Antwerpen* (1965), pp. 183–205.

6. Ibid., pp. 195–96, doc. 2.

7. Max Rooses, *L'oeuvre de P. P. Rubens*, 5 vols. (Antwerp, 1886–92), 1: 273, 2: 273–75,

24. Rubens,
Madonna and Child Adored by Saints.
Musée de Peinture et de Sculpture,
Grenoble (photo: Piccardy).

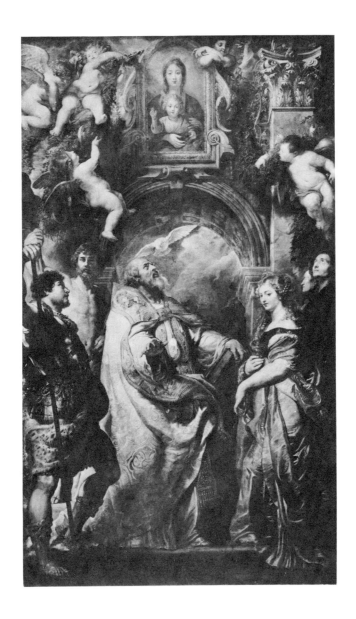

then substituted for it three panels painted on slate, which are still extant in the choir of this church. Rubens intended to sell the rejected altarpiece to Vincenzo Gonzaga, Duke of Mantua, whose court painter he was, but the duke rejected the offer. As a result, when Rubens hastily left the Eternal City in October 1608, he had no option but to take the painting along. Once in Antwerp, he was to hang it as a lasting *memento* above the grave of his mother Maria Pijpelinckx, who had died shortly before his return and had been buried in Saint Michael's abbey. According to Sweertius's *Monumenta* (1613) the painting was placed in Saint Michael's on September 29, 1610.[8] It is now in the Grenoble Museum.

This work was probably not without importance for the beginning of Rubens's career in Antwerp. Indeed, it may seem surprising that important commissions should be given to a young artist barely back from Italy when there were available a number of established masters, major works by whom could be seen in both churches and private collections. One instinctively thinks, in this respect, of Otto van Veen, Adam van Noort—both of whom, incidentally, had taught Rubens—and Ambrosius Francken. Alternatively, one could have resorted to younger contemporaries, like Abraham Janssens and Hendrik van Balen, who had already won their spurs.[9] Max Rooses and, after him, a number of authors have rightly pointed out that, on his return, Rubens could confidently lean on the recommendations of several influential persons, notably his own brother Filips, who had just been appointed town clerk of the city; his father-in-law Jan Brant, who for many years had held the post of recorder; Nicolaas Rockox, who had repeatedly sat as alderman or burgomaster; and Cornelis van der Geest, a wealthy merchant. Yet these influential citizens would have carried little weight if they had not been in a position to show some important work by their protégé. It is true that some private galleries in Ant-

no. 441; Rudolf Oldenbourg, *Klassiker der Kunst, P. P. Rubens* (Berlin, 1921), p. 23 (hereafter cited as *KdK*). More recent publications that mention new documents are Michael Jaffé, "Peter Paul Rubens and the Oratorian Fathers," *Proporzioni*, 4 (1963): 209–41; and, with addenda and corrigenda, G. Incisa della Rocchetta, "Documenti editi e inediti sui Quadri del Rubens nella Chiesa Nuova," *Atti della Pontificia Accademia Romana di Archeologia*, 3, Rendiconti 35 (1963): 161–83. See also Justus Müller Hofstede, "Rubens' First Bozzetto for Sta. Maria in Vallicella," *Burlington Magazine*, 106 (1964): 442–50; and idem, "Zu Rubens' zweiten Altarwerk für Sta. Maria in Vallicella," *Nederlands Kunsthistorisch Jaarboek*, 17 (1966): 1–78.

8. F. Sweertius, *Monumenta Sepulchralia et inscriptiones publicae privataeq. Ducatus Brabantiae* (Antwerp, 1613), pp. 143–44; quoted by Monballieu, "Rubens," pp. 186–87.

9. For a recent survey of those contemporaries of Rubens see H. Gerson and E. H. ter Kuile, *Art and Architecture in Belgium 1600 to 1800* (Harmondsworth, 1960).

werp included a number of paintings made by Rubens before his departure for Rome, but these were only the work of a beginner and, as such, were not sufficient to establish the painter's supremacy over his Flemish contemporaries. It is quite probable that Rubens had brought back sketches made for the works painted in Italy, but the finished altarpiece made in Rome undoubtedly had a far more decisive effect. The very sight of it must have convinced everyone of the mastery Rubens had acquired during his Italian years. In its majestic composition, bold chiaroscuro, and powerful colors, it towers over the productions of Rubens's contemporaries in Antwerp.

The painting located by Jan Le Grand "in the town hall" is undoubtedly the *Adoration of the Magi* (fig. 25), which hung then in the so-called Hall of the States.[10] The Records of the Council of Aldermen include two orders of payment for this work. Dated April 19 and August 4, 1610, they show that Rubens was paid a total of 1,800 guilders. Another document, the order of payment for the gilding of its frame, shows that the painting was finished in 1609. There are, in fact, good reasons for assuming that it was already completed in the first months of that year and hence that it was commissioned by the city almost immediately after Rubens's return. This can be deduced from the circumstances under which the painting originated. When, in the course of 1608, it was announced that the negotiations that were to lead to the Twelve-Years' Truce would be held in Antwerp, the governing authorities of the city took steps to ensure that the delegates would be welcomed and accommodated in a suitable manner. One of the large rooms in the town hall, heretofore called the Representation Room (*Staetiekamer*) and henceforth to be named Hall of the States (*Statenkamer*), was earmarked for the purpose. In order to decorate it fittingly, the city bought a number of works of art, among which were Abraham Janssens's allegorical *Scaldis et Antverpia* and the work by Rubens under review.

A link can be established between the peace negotiations and the subjects of both Janssens's work and Rubens's large painting. *Scaldis et Antverpia* alludes to the hopes of the city that the river Scheldt might be reopened to free shipping, with all the attendant prosperity and abundance. On the other hand, the *Adoration of the Magi* expresses the agelong desire of the provinces for lasting peace. The negotiators

10. Rooses, *P. P. Rubens*, 1: 203–7, no. 157; *KdK*, p. 26; C. Norris, "Rubens' Adoration of the Kings of 1609," *Nederlands Kunsthistorisch Jaarboek*, 14 (1963): 129–36. The painting was donated by the city council to Don Rodrigo Calderon Conde d'Oliva and belonged, since 1623, to the collection of the king of Spain. During his stay in Madrid in 1629–30, Rubens enlarged and partly reworked the canvas.

who were to sit in the Hall of the States could more or less identify themselves, or their royal masters, with the three Kings who came from the East to offer their presents to the divine Child who is the "Prince of Peace." Like the Magi who had traveled from near and far to adore Him, the representatives of a number of European rulers had journeyed from their several countries to Antwerp, there to serve the cause of peace. Such, at least, were the hopes of the peace-loving citizens of Antwerp, and there is small doubt that the wise and shrewd city fathers insisted with both artists that their paintings be finished in time for the opening of the negotiations.

It is now established that the negotiators arrived in Antwerp in the course of January and February 1609,[11] after which they initiated the conference that was to result in the Twelve-Years' Truce, which was solemnly proclaimed in the town hall on April 9. As a consequence, it is quite probable that the *Adoration of the Magi* was finished in the first months of 1609, and that the powerful sketch, at present in Groningen (fig. 26), which Rubens made in preparation for this painting, was done almost immediately after his return from Italy.

According to Jan Le Grand, Rubens's mastery was also to be admired as early as March 1611 in the Dominican Church. He unfortunately gives no particulars about the relevant paintings. Still to be seen, however, in the Dominican Church (now Saint Paul's) are two paintings by Rubens which, on the basis of stylistic analysis, should be reckoned among the earliest works he painted after his return.

Concerning one of them, the *Adoration of the Shepherds* (fig. 27), there are no contemporary documents, so that we do not know who commissioned it or when it was hung in the church. There is evidence, however, that in the eighteenth century it hung at the spot in the transept where it still was when, on the night of April 3, 1969, fire broke out in the church. About 1748, Jacob de Wit described the painting as follows: "High up on the Wall, next to the Altar of the Rosary, hangs a beautiful painting, being a Christmas, or Birth of Christ, painted by P. P. Rubens, *very Capitally and Beautifully ordered.* The Figures are larger than Life."[12] Towards the end of the same century, however, F. Mols expressed doubts about Rubens's authorship, and the painting remained for a long time under a shadow,[13] until, only within the last few decades, it was reinstated by both Ludwig Burchard and Leo van Puyvelde.[14]

11. Hans Gerhard Evers (*Peter Paul Rubens* [Munich, 1942], pp. 66 and 486, n. 66) refers to *Antwerpsch Archievenblad,* 6 (n.d.): 260, 300–320.
12. Jacob de Wit, *De kerken van Antwerpen,* ed. J. de Bosschere (The Hague, 1910), p. 58.
13. Ibid.
14. Leo Van Puyvelde, "Rubens' Aanbidding door de Herders te Antwerpen," *Jaarboek Koninklijk Museum voor Schone Kunsten Antwerpen* (1942–47), pp. 83–87.

25. Rubens,
Adoration of the Magi.
Museo del Prado, Madrid.

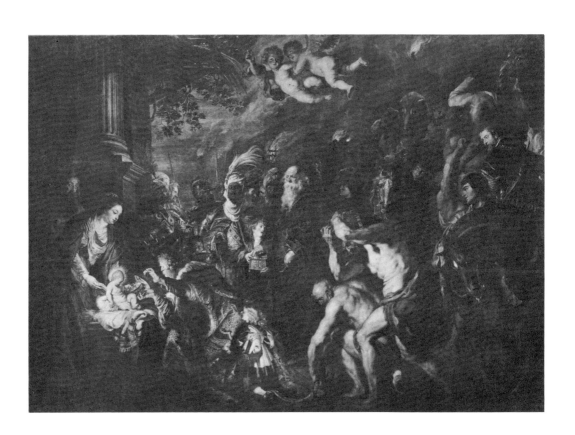

26. Rubens,
Adoration of the Magi. Oil sketch.
Museum van Oudheden, Groningen,
Hofstede de Groot Collection
(photo: Frequin).

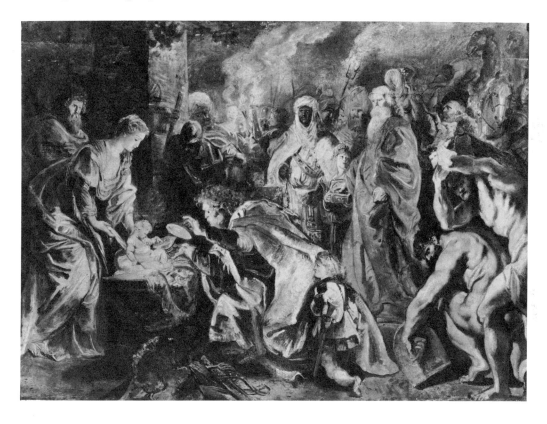

In this large painting, which has not so far enjoyed the attention it deserves, Rubens takes up again a composition that he had designed in Italy for the altarpiece painted in 1608 for the Oratorians' church in Fermo. This time, however, he endowed it with a monumental character. Attitudes and gestures have both become freer and more pliant. In addition, the recent restoration of the painting after the fire in April 1969 has revealed a glorious wealth of colors that was hardly to be suspected beneath the former thick and yellowed layers of varnish. The painting has thus regained its pristine splendor of radiating and contrasting colors which remind one of the Venetian School and Correggio, while both the folk-types and the strong chiaroscuro contrasts seem to echo the art of Caravaggio. On the other hand, the gleaming brownish flesh-color of the figures and the flickering, palpitating touches of light on the draperies are also characteristic of Rubens's style during the first few years in Antwerp after his homecoming from the south.

A second painting in Saint Paul's also shows the characteristic stylistic traits of the same years in Rubens's career. Bellori mentioned it in 1672 as one of the first paintings by Rubens from that period.[15] It is frequently called *The Disputa*, but it should preferably be described as the *Glorification of the Holy Eucharist*, or even the *Real Presence of the Holy Sacrament* (fig. 28), which is the title given to it in the inventory, drawn up on July 24, 1616, of the possessions of the Fraternity of the "Holy Sweet Name of Jesus and of the Holy Eucharist."[16] There is no doubt that the latter description agrees most closely with the intentions of those who commissioned the painting. Indeed, the Fathers of the Church and theologians depicted are assembled as it were to "warrant" the great "reality"—Christ's real presence in the Holy Sacrament, a Roman Catholic article of faith that had been rejected by the Protestants.

Was the painting commissioned by the Confraternity of the Holy Sacrament and paid for out of its communal funds? Or was it given to the Confraternity by a donor? Apparently no documents have remained that would enable us to answer this question. It is, however, not irrelevant to mention the fact that Cornelis van der

15. "In San Domenico nell'altare del Sacramento li quattro Dottori, che parlano del Divino pane" (G. P. Bellori, *Le Vite de' Pittori, Scultori et Architetti Moderni* [Rome, 1672], p. 223).

16. P. Rombouts and T. Van Lerius, *De liggeren en andere historische archieven der Antwerpsche Sint Lucasgilde, onder zinspreuk "wt ionsten versaemt". I. Liggere van 1453–1615, volledige rekeningen van 1585–1586 en 1588–1589, rekeningen en ontvangsten van 1616–1629* (Antwerp, 1872?), p. 402, n. 1; Rooses, *P. P. Rubens*, 2: 196–99, no. 376; H. Vlieghe, *Saints (Corpus Rubenianum Ludwig Burchard)*, 2 vols. (Brussels, 1972), 1, nos. 56–58, fig. 99.

54

27. Rubens,
Adoration of the Shepherds.
Saint Paul's Church, Antwerp
(photo: A.C.L.).

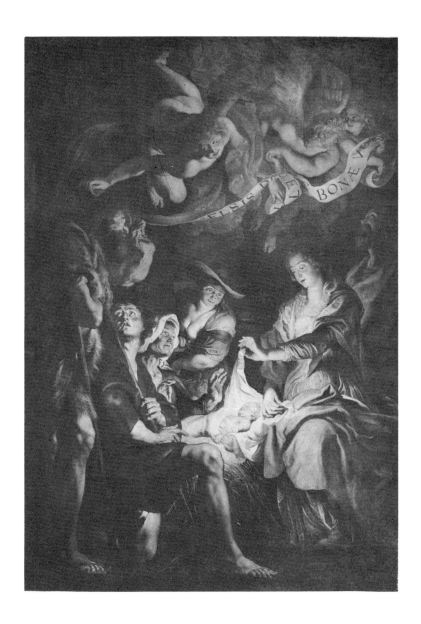

28. Rubens,
Real Presence of the Holy Sacrament.
Saint Paul's Church, Antwerp
(photo: A.C.L.).

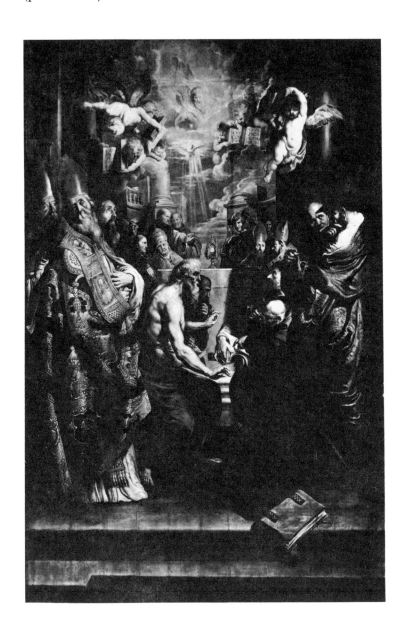

Geest, a great admirer of Rubens, seems to have been in close relationship with the Confraternity.[17] This does not necessarily mean that he paid for the painting, but it makes it likely that he had some influence on the choice of the painter.

In this work also, the links with Italy are clearly discernible. The somewhat elongated figures in the foreground, their brownish skins, the Venetian blue-green in the background, the strong architectural accents endowing the composition with a stable structure, all these are traits that this work has in common with paintings that Rubens had produced towards the end of his Roman period, between 1606 and 1608. Moreover, the putti hovering in the clouds above the groups of Fathers and theologians are the twins of those who fly about in the paintings at Grenoble and in the choir of Santa Maria in Vallicella in Rome.

Cornelis van der Geest's name is also mentioned in a document pertaining to another work of Rubens, the famous *Raising of the Cross* (fig. 29) painted for the Castle Church (*Borchtkerk*) or Church of Saint Walburgis.[18] It was to be seen there, above the high altar, until about the beginning of the French Revolution. Before the church was pulled down at the beginning of the nineteenth century, the painting was transferred to the cathedral, where it now hangs as a glorious pendant to the *Descent from the Cross*. An unfortunately incomplete copy of the lost original Records of the Church shows that, on May 17, 1610, the vicar and the church wardens made a collection "with a view to decorating and painting the High Altar." In June 1610, a banquet was given at the Little Zealand inn, in the course of which "agreement was made with Peeter Rubbens, painter, concerning the painting of the High Altar, present being the reverend Vicar and Cornelis van der Geest and churchwardens."[19]

There must have been a special reason for mentioning, together with the parish authorities, an outsider (even though he was a parishioner) in the Records. An explanation is to be found in the inscription of the large engraving by Witdoeck after the *Raising of the Cross* that Rubens published in 1638, shortly after Cornelis van der Geest's decease. The text, which was signed by Rubens, mentions Cornelis van

17. Cornelis van der Geest settled the remnant of the Confraternity's debt, still due to Hans van Mildert for supplying the "garden" or enclosure of the choir of the Holy Sacrament, by giving a quantity of alabaster, with a value equal to the last three installments.
18. Rooses, *P. P. Rubens*, 2: 68–84, nos. 275–85; *KdK*, pp. 36–37. The most recent study on this work, with an extensive bibliography and quotations from the literature of art, is by John Rupert Martin, *Rubens: The Antwerp Altarpieces, The Raising of the Cross/The Descent from the Cross* (New York, 1969).
19. Rooses, *P. P. Rubens*, 2: 79–80.

29. Rubens,
Raising of the Cross.
Triptych.
Antwerp Cathedral (photo: A.C.L.).

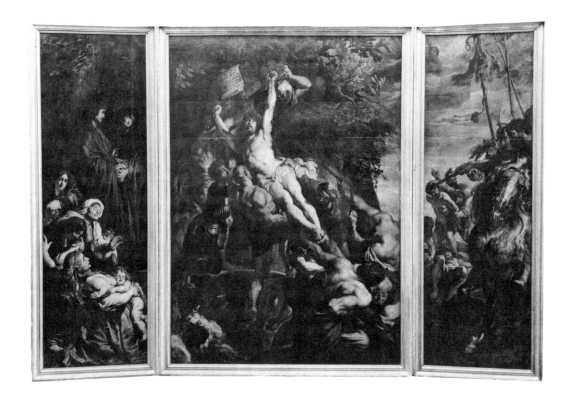

der Geest, as "the first to conceive" the painting in the Church of Saint Walburgis, "which he so zealously supported."[20] This testimony shows that the initiative for the painting came from Cornelis van der Geest, and also would seem to indicate that he must have given the undertaking special financial support.

On the other hand, Jan Le Grand, in his letter dated March 12, 1611, mentions the triptych in the Castle Church among Rubens's works "which are held in high esteem," so that we can assume it was then to be seen in the church and, if not completely finished, at least largely so.

The *Raising of the Cross* unites all the stylistic traits characteristic of Rubens's art in the first years after his homecoming, and can be considered as their most perfect synthesis. It is quite probable that the artist remembered Tintoretto's powerful paintings of the Passion (especially the broad *Crucifixion*) that he had seen in Venice, when he worked out the subject into a single composition, divided though it is in three panels. It is possible, in this triptych, to identify a number of reminiscences of works of art that he had zealously studied in Italy. But, over and above these echoes of the works of Italian masters, the power of plastic creation, the pliant, fluid body forms, the attitudes of figures leaning forward and backward, the passionate gestures, the powerful chiaroscuro, the shimmering touches of light on rather dark garments, the luxuriant waves of the women's hair, all these are traits that together characterize Rubens's impetuous style in the first few years after his return from Italy, in what R. Oldenbourg called his youthful "Sturm und Drang" period.[21] It looks indeed as if the young master, now that he had conquered all the lessons of his long years of apprenticeship, gave full rein to his bravado, as if to demonstrate his facility.

As John R. Martin correctly observed, whoever beholds this work is confronted with an unfinished action, a movement that calls for a further crescendo. On the other hand, the *Descent from the Cross* (fig. 30), in the same cathedral in Antwerp, strikes one by a controlled balance that is in sharp contrast with the "momentary situation," the kind of dynamic suspense evoked by the other triptych. Martin writes: "It is not merely that the agony of the Crucified is over and that horror has been supplanted by grief: in addition, the suppression of receding diagonals and the consolidation of the figures into a composition lying essentially on one plane give to this work a quality of discipline and restraint that may properly be called

20. Ibid., p. 83; Julius S. Held, "Artis Pictoriae Amator: An Antwerp Art Patron and His Collection," *Gazette des Beaux-Arts*, 50 (1957): 54–55.
21. Rudolf Oldenbourg, *Peter Paul Rubens* (Munich-Berlin, 1922).

59

30. Rubens,
Descent from the Cross.
Triptych.
Antwerp Cathedral (photo: A.C.L.).

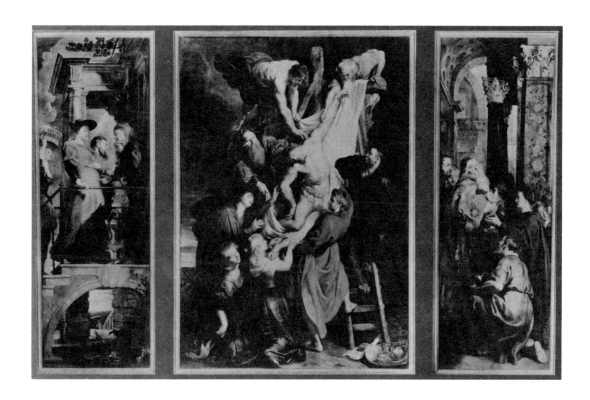

Classical."[22] This triptych heralds the beginning of a further evolution in Rubens's art of what is called his classical period. Discipline takes the place of youthful exuberance. Much has been written about the *Descent from the Cross*, and the accounts pertaining to it have been published repeatedly.[23] Further research in the archives, however, now makes it possible to add some significant data to our store of knowledge.

The first hitherto unpublished document to be mentioned is a request from the Guild of Harquebusiers to the magistrates of Antwerp.[24] This stresses the fact that the guild had repeatedly been encouraged by the Chapter of the Cathedral to commission a new altar for the guild that might sustain comparison with the altars recently erected in the cathedral by other guilds. They were not, however, in a position to afford such an altar, which was to cost an estimated eight thousand guilders. For this reason they invoked a precedent under which some other guilds had formerly been allowed to enroll a number of "wepelaers" (persons exempted from certain public duties), who, in return for payment of a fairly large sum, would be granted "perpetual exemption from watch duty, as also from all duties within the same Guild, and also from the duties of churchwarden, borough-warden and dean of their craft, and further from all service under the Banners of the city militia." With a view to contributing towards the cost of the altar, the Harquebusiers requested permission to enroll twelve such "wepelaers"; but on April 22, 1611, the Board of Burgomaster and Aldermen granted them only nine: four who had not yet been enrolled in "the Watch," and five who, while already enlisted "under the Banners," were allowed to buy full exemption. From the accounts of the guild, it is known that each such "ransomer" paid a lump sum of four hundred guilders when enlisting and a further yearly three or four guilders.[25] Additional financial means came from the members' yearly subscriptions, annual subsidies from the city as compensation for service "under the Banners," occasional gifts, and the like.

22. Martin, *Rubens*, p. 48. See also the recent publication by Michael Jaffé, "Un chef-d'oeuvre mieux connu," *L'Oeil*, 43–44 (1958): 14–21, 80.

23. Recently by J. Van den Nieuwenhuizen, "Histoire matérielle de la Descente de Croix de Rubens," *Bulletin Institut Royal du Patrimoine Artistique*, 5 (1962): 40–44.

24. Antwerp, Stadsarchief, *Privilegie Kamer*, 700 (*Rekwestboek 1611*) fo 95 vo, 96 ro. Probably this request was drafted in consequence of the assembly of the "Camer," held on March 13, 1611, when "opt maecken van den nieuwen aultaer" was discussed (Van den Nieuwenhuizen, "Histoire," p. 40, appendix 1).

25. Antwerp, Stadsarchief, *Gilden en Ambachten*, 4665 (Rekeningen van de Kolveniersgilde 1604–1630), fo 88, vo, fo 98 vo, fo 100 vo, fo 102 ro, fo 104 ro, fo 109 vo, fo 113 vo, fo 117, etc.

Once the deans of the guild had sufficiently auspicious financial prospects to assume the risk of the undertaking, they arranged, on September 7, 1611, a meeting "with the painter P. Rubbens, to whom, in the presence of the Chairman, the commission of the painting was offered."[26] This chairman was none other than Nicolaas Rockox, a friend and great Maecenas of Rubens, whom he was later to entrust with personal commissions.

It is an established fact that one year after this agreement, the central panel of the triptych was already finished because it was transferred to the cathedral from Rubens's atelier, then still in the house of his father-in-law Jan Brant, in the "Kloosterstraat," not later than September 17, 1612.[27] The two side panels were to be delivered some eighteen months later, on February 8 and March 6, 1614, respectively.[28] This delay was probably due to certain difficulties experienced in procuring the appropriate wood for the panels,[29] but it may also have resulted from the fact that Rubens was, in the meantime, entrusted with other commissions.

In the literature concerning the *Descent from the Cross*, repeated mentions are made of the fact that Rubens was paid a first sum of one thousand guilders and, years later, another sum of four hundred Flemish pounds. A close scrutiny of the relevant archives shows, however, that he was paid more than was assumed hitherto. Shortly after the delivery of the central panel and not later than December 25, 1612, he was in fact paid a first installment, the amount of which, however, it is impossible to determine because the sum was included under a hitherto unknown heading that consolidated under one total the sums paid out, not only to the painter but also to the "image-carvers" (sculptors) and the "panelmaker."[30] In the course of

26. Van den Nieuwenhuizen, "Histoire," p. 40, appendix 2.
27. Ibid., appendix 4.
28. Ibid., p. 41, appendix 7.
29. Ibid., appendices 5, 6.
30. After having recorded on f° 100 v° the "ontfanck vande Wepelaers innegenomen om te vervallen de oncosten van den aultaer" and having mentioned on f° 101 that the total sum, together with the "penningen" received from Dean Oistendoren (minus 35 guilders) amounts to 3,900 guilders, the "Rendant" noted: "De Betaelingen bijden Rendant *aenden schilder*, beeltsnyders, ende taeffereelmaecker daermede gedaen, bedragen luijt de specificatie ende quittancien daer aen gehecht tot n° 5 . . . III m VIII c XXXVIII gul. VI st. [In the margin]: "bij de particuliere specificatien ende quittancien" (Antwerp, Stadsarchief, *Gilden en Ambachten*, 4665, f° 101 r°).

Since these entries are mentioned in the accounts beginning on December 25, 1611, and ending on December 25, 1612, it is certain that Rubens received a first payment before this last date, probably after the completed central panel was transported to the cathedral, no later than September 17, 1612.

1615, some time after the side panels were delivered, Rubens received, as mentioned above, a further one thousand guilders, and his wife Isabella Brant a pair of gloves, the latter probably a gesture whereby the Harquebusiers wanted to give a token of their satisfaction.[31] However, Rubens was to wait another six years, until February 13, 1621, before full payment was completed.[32]

The reference to the panelmaker in the above-mentioned entry in the 1612 book of accounts points to the solution of a problem that has some importance for the accurate dating of the central panel. In order to fully grasp its significance, however, one must realize that it was customary for the person or group who commissioned a painting to order the panel(s) direct from the panelmaker and thus to pay the latter. Now, in the hitherto published accounts concerning the *Descent from the Cross*, the only payments traced concern the making and delivery of panels for the two side panels of the triptych. Some authors have deduced from this fact the rather surprising conclusion that the central panel already existed as a separate painting, or at least that it had already been started on when the Harquebusiers approached Rubens.[33] Their commission would then have consisted merely of ordering two side panels to be affixed to an existing centerpiece in order to make up a triptych. Some authors have gone a step further and managed to find great contrasts in both conception and execution between the central panel and the sides. It has even been asserted that Rubens was quite reluctant to enlarge his initial composition into a triptych. But the recently discovered 1612 record of payment, showing that, together with Rubens, the panelmaker was paid for making and delivering the central panel, makes it obvious that all these assumptions were quite unnecessary: in fact, the *entire* triptych was painted on commission from the Guild of Harquebusiers.

According to accepted tradition, we have mentioned the *Descent from the Cross* in chronological order, immediately after the *Raising of the Cross*. It is indeed quite certain that Rubens received the commission for the former shortly after completing the triptych for Saint Walburgis. Mention should however be made of another commission that he received before he was asked to paint the *Descent from the*

31. Van den Nieuwenhuizen, "Histoire," p. 43, appendices 10, 12.

32. Ibid., appendix 14.

33. N. Verhaegen, "Iconographie," *Bulletin Institut Royal du Patrimoine Artistique*, 5 (1962): 22 and n. 5; A. and P. Philippot, "Examen stylistique," *Bulletin Institut Royal du Patrimoine Artistique*, 5 (1962): 94–95. Martin (*Rubens*, p. 45) made the following remark: "But against this hypothesis must be placed the fact that the iconography of the triptych, with its clever allusions to the name 'Christopher,' presupposes a plan carefully thought out in advance."

Cross. This was for a painting for the high altar of Our Lady's Church, the Antwerp Cathedral. Data concerning this commission are to be found in some documents which, although they were published some time ago, have so far escaped the notice of Rubens scholars. In fact, the records of the meetings of the Chapter of Our Lady's Church in Antwerp state that on March 24, 1611, the canons received a painter named Octavio, who was none other than Octavio or Otto van Veen. He showed them a sketch for a painting, destined for the high altar, which depicted *Christ Inviting Mary to Her Coronation.* The canons agreed with the way the artist had conceived the painting, but it never came to a commission. It was decided to entrust the dean, Canon Joannes Del Rio, and the treasurer with the task of discussing, together with the churchwardens of Our Lady's, the choice of a painter for the high altar.[34] One may wonder whether, even at that early date, one of the chapter members— and possibly even the dean himself—did not point out that a better painter than Master Octavio could be found in Antwerp.

In any case, some four weeks later, on April 22, 1611, Vriendt, one of the churchwardens, appeared before the chapter. On behalf of Rubens—who later attended the meeting himself—Vriendt showed two sketches depicting, in two different compositions, the Assumption of the Virgin. Considering that the sketches "gave rise to no objections and were not opposed to the traditions of the Church," the canons liked them but did not make a choice between the two "excellent paintings."[35] We know nothing of the further course of events, but there is no doubt that Otto van

34. "24 Martii 1611 Comparuit D. Octavio, pictor istius civitatis, et exhibuit dominis projectum sive modellum certae picturae et historiae (quae Dominum nostrum Sponsam suam de Libano provocantem ad coronam continet) in summo altari chori nostri ponendae, et placuit dominis idem projectum et historia, et deputatus est cum Domino decano dominus thesaurarius ad agendum desuper cum aedituis istius ecclesiae, acturi insuper super electione pictoris dictam tabulam picturi" (Antwerp, Archief Onze-Lieve-Vrouwekerk Antwerpen, *Acta Capitularia,* 3: 71–72; published by L. Philippen, "Le Culte de Notre-Dame 'op 't Stocxken' à Anvers 1474–1580," *Annales de l'Académie Royale d'Archéologie de Bruxelles,* 72 [1924]: 324; and by P. J. Goetschalckx, *Geschiedenis der Kanunniken van O.L.V. Kapittel te Antwerpen 1585–1700* [Antwerp, 1929], p. 76).

35. "22 Aprilis 1611. Exhibita sunt a N. Vriendts Aedituo ecclesiae nostrae Petri Rubenii pictoris (qui etiam postea in capitulo comparuit) duo modella continentia historiam Assumptionis B. Mariae Virginis, diverso modo depicta, quae tanquam nihil inhonestatis aut ecclesiae traditionibus continentia, placuerunt dominis, mansuris nihilominus in optione eligendi praestantissum pictorum (Antwerp, Archief van Onze-Lieve-Vrouwekerk Antwerpen, *Acta Capitularia,* 3: 75; published by Philippen, "Notre-Dame," p. 324; and by Goetschalckx, *Geschiedenis,* p. 77; corrections to these texts were made by C. Van de Velde, after checking them with the originals).

Veen's project was shelved: Rubens would be given the commission. Barely eighteen months after his return from Italy the brilliant apprentice was being selected in preference to his own master, now aging.

It would seem that at least one of the *modelli* shown by Rubens to the chapter in 1611 has survived: the *Assumption and Coronation of the Virgin* (fig. 31), now in the Hermitage Museum in Leningrad, can safely be identified with one of them.[36] This sketch has so far been given only scant attention, but some twenty years ago M. V. Dobroklonsky showed that it must have been painted in the first years after Rubens's return from Italy.[37] Until now, however, it has been impossible to determine the commission to which it was related. In any case, it was clear that it was a preparatory sketch for a large altarpiece, for the composition is both monumental and grand and includes a large number of figures. Such a sketch would not have been painted without at least the possibility of its serving as a model for a large altarpiece. Moreover, the composition corresponds with the theme that most probably was set for the altarpiece in Our Lady's Church, "Christ meeting his Mother in order to crown her." Such at least was the subject of the *modello* shown by Otto van Veen: "Sponsam de Libano provocantem ad coronam."[38]

From the above-mentioned record of the chapter meeting on April 22, 1611, however, we know that Rubens produced a second sketch, depicting the same subject in another manner. It is not altogether improbable that in this case he depicted the Assumption of Mary in the way in which he later consistently drew and painted it: the Holy Virgin seated on a cloud surrounded and supported by a great number of putti, while her glance is directed heavenwards. I have looked in vain, however, among the many sketches of Assumptions and Coronations of Mary from Rubens's hand, for a *modello* with the same stylistic traits as the Leningrad one. It is quite possible that the sketch in question became, in one way or another, the victim of time. It is, however, equally possible that Rubens only made a variation on the upper part of the Leningrad sketch. This hypothesis finds some support in the fact that in the Albertina in Vienna there is a drawing representing the ascending Virgin (fig. 32), in which the nimble touch, the light and shade contrasts, and the nervous rendering of folds would justify dating it at about the same time as the Leningrad sketch, that is, the spring of 1611. Therefore, it is not unlikely that this drawing could have been a preliminary study for an oil sketch of the upper half of the

36. Rooses, *P. P. Rubens*, 2: 189, no. 364.
37. M. V. Dobroklonsky, "The 'Coronation of the Virgin' in the Hermitage," *Studies of the Hermitage*, 3 (1949): 17–24 (in Russian).
38. See note 34, above.

31. Rubens,
*Assumption and Coronation of
the Virgin.*
Hermitage Museum, Leningrad.

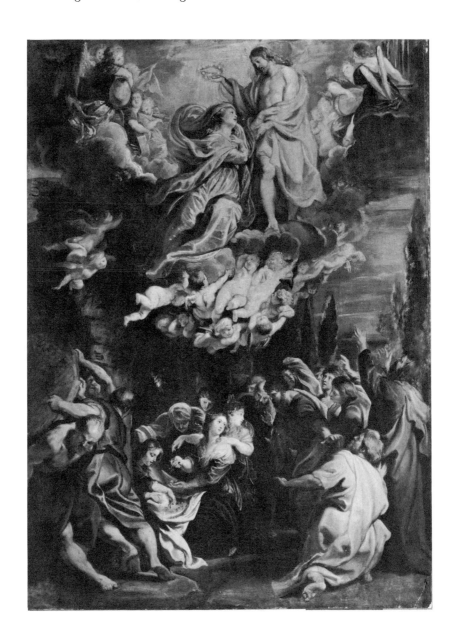

32. Rubens,
Assumption of the Virgin.
Drawing.
Albertina, Vienna.

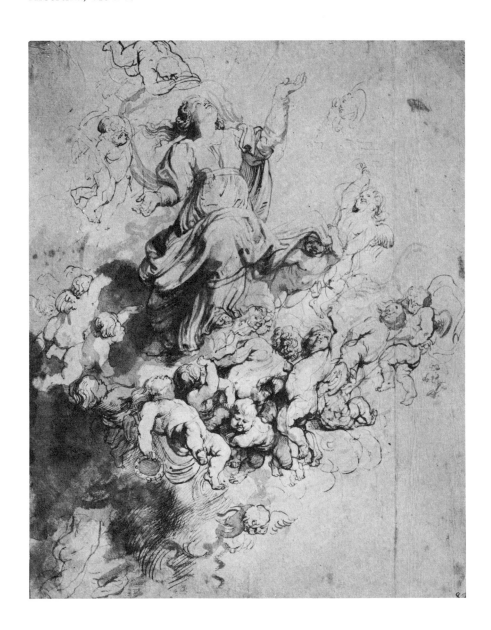

Assumption of Mary, the painting destined for the high altar of Our Lady's Church. Further support for this hypothesis is afforded by the existence, also in Vienna, of an *Assumption of the Virgin* (fig. 33) painted by Rubens,[39] the lower half of which reproduces the composition of the Leningrad sketch, while the soaring Virgin is depicted in a manner closely similar to that of the Albertina drawing.[40] While Mary is admittedly represented in the reverse sense and has been somewhat modified, the group of angels supporting her in the clouds is largely identical with that in the Albertina drawing.

It is known that the painting under review, before it was transferred to Vienna in 1776, hung above the altar of the Mary Chapel (also called the Houtappel altar) in the Jesuit Church in Antwerp. Since this chapel was built after 1620,[41] most authors have ascribed approximately the same date to the altarpiece.[42] Ludwig Burchard's sharp eye had already observed, however, that the style of the painting made this hypothesis untenable. He suggested dating it about 1614–15,[43] but it does not seem altogether improbable that the painting might have been made a couple of years earlier still. It is obvious, in any case, that it must have existed long before the Mary Chapel was built. There is a possibility that the painting remained for a long time in Rubens's atelier before it found a place in the chapel, perhaps after some retouching. Such a hypothesis gives rise to a number of other suppositions. Did Rubens, shortly after he had shown his two oil sketches, on April 22, 1611, make a start on the full-scale altarpiece because he was convinced that the final commission would follow without delay? Was he perhaps overconfident regarding the support that some of the canons or churchwardens may have promised him? There is no evidence in this connection, but one fact may tend to support our hypothesis: at the time

39. *KdK*, p. 206.
40. Julius S. Held (*Rubens, Selected Drawings*, 2 vols. [London, 1959], 1: 108–9, no. 35; 2, pl. 38) dates this drawing 1614–15; according to L. Burchard and R.-A. d'Hulst (*Rubens Drawings* [Brussels, 1963], pp. 121–22, no. 73) it is a project for the upper half of the *Assumption of the Virgin* in Vienna, based on a *modello* in Buckingham Palace that was made before 1615, and perhaps already existed in 1611—although this year seems somewhat early to me.
41. Alfred Poncelet, *Histoire de la Compagnie de Jésus dans les anciens Pays-Bas. Etablissement de la Compagnie de Jésus en Belgique et ses développements jusqu'à la fin du règne d'Albert et d'Isabelle*, 2 vols. (Brussels, 1927), 1: 475.
42. *KdK*, p. 206.
43. Communication to S. T. Madsen, December 1952 (S. T. Madsen, "Some Recently Discovered Drawings by Rubens," *Burlington Magazine*, 95 [1953]: 304); see also Burchard and d'Hulst, *Rubens Drawings*, p. 121.

33. Rubens,
Assumption of the Virgin.
Kunsthistorisches Museum,
Vienna.

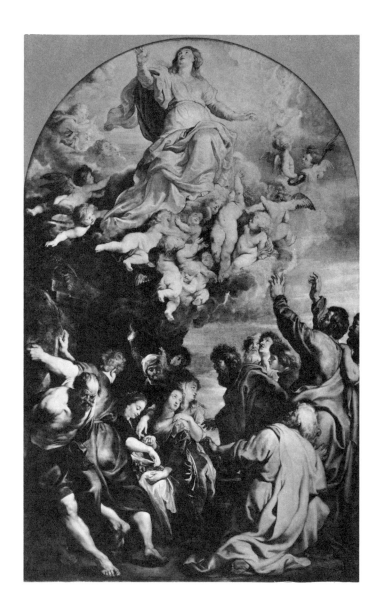

when van Veen and Rubens were offering their *modelli*, the high altar of the church was surmounted by a painting by Frans Floris, the *Adoration of the Shepherds*, now in the Royal Museum of Fine Arts.[44] This work originally hung above the altar in the chapel of the Guild of Gardeners, but in 1585, when the Church of Our Lady was being rebuilt after the capture of the city by Alessandro Farnese, it was transferred to the high altar, where it replaced an *Assumption of the Virgin*, by the same artist, that had been lost or destroyed during the fighting. The above-mentioned records of the chapter meetings show that on April 26, 1613, the governors of the Guild of Gardeners had recently submitted a request to the chapter with a view to recovering their painting.[45] This suggests that at that time there was reason to expect that the painting would be replaced above the high altar by a new altarpiece. This replacement, however, was not effected, probably owing to financial difficulties. It is indeed a recorded fact that the altarpiece later to be delivered by Rubens was not paid for by the chapter or the governors of the church as such, but out of the private purse of Dean Joannes Del Rio. However, the contract made personally by the latter with Rubens is dated November 12, 1619,[46] some eight years after the painter had shown his first *modelli*. On February 16, 1618, he had submitted to the churchwardens two sketches of the proposed altar above which his painting was to be placed.[47] It is quite clear that the Gardeners Guild once more closely followed the business: probably towards the end of 1617 or in the very beginning of 1618, they repeated their request for repossession of their altarpiece. Whereupon, on January 12, 1618, the chapter, while not acknowledging in so many words that the painting belonged to the Gardeners, replied that they would take steps for the

44. Panel, 249 x 193 cm; C. Van de Velde, "De Aanbidding der Herders van Frans Floris," *Jaarboek Koninklijk Museum voor Schone Kunsten Antwerpen* (1961), pp. 59–73, fig. 1.
45. "Ad lectum libellum supplicem porrectum ex parte Magistratorum Altaris hortulanorum in ista ecclesia quo petierunt quod tabulam hactenus in summo altari, pretendentes illam spectare ex donatione Francisci du Terne, quondam thesaurarii ad altare B. Mariae quod vocant op stocxen in quo ipsi nunc suum servant altaris officium, . . ." (Antwerp, Archief Onze-Lieve-Vrouwekerk Antwerpen, *Acta Capitularia*, 3: 183; published by Philippen, "Notre-Dame," pp. 324–25; and Van de Velde, "Floris," p. 70).
46. Antwerp, Rubenshuis (D.23); Rubenshuis, Antwerp, 1958, *Herinneringen aan P. P. Rubens*, no. 49; published by Max Rooses, "L'Assomption de la Vierge: Tableau du Maître-Autel de la Cathédrale d'Anvers," *Bulletin Rubens*, 1 (1882): 70–71; idem, *P. P. Rubens*, 2: 175–76.
47. Rooses, "Assomption de la Vierge," pp. 68–69; idem, *P. P. Rubens*, 2: 175; Philippen, "Notre-Dame," p. 325; Goetschalckx, *Geschiedenis*, p. 77; M. Casteels, *De beeldhouwers De Nole te Kamerijk te Utrecht en te Antwerpen* (Brussels, 1961), p. 122.

erection of a new high altar and that afterwards Floris's painting would be returned to its rightful owners.[48]

All these facts tend to show that the intention to commission Rubens to paint an altarpiece was never given up, but that certain difficulties arose that resulted in the commission being postponed. Its later history is so well known that it should suffice here to mention that it was completed only in 1626.[49] Not only did the erection of the marble high altar take up a number of years, but the painter himself was fully occupied with a number of other activities, the result being an inordinately long delay. The commission for which Rubens, then competing with Otto van Veen, submitted the first sketches in 1611 was completed only fifteen years later! In the meantime, however, his art had gone through a far-reaching evolution, and the composition of the final altarpiece (fig. 34) no longer reflects that of the early Leningrad sketch.[50] As mentioned above, he had in the meantime given his initial painting another destination. He no doubt thought that this "old work" was good enough for a side chapel in a church where a number of his more recent paintings were to be seen. For the high altar of the cathedral, however, he must obviously have resolved to achieve an altarpiece—incidentally, of still larger size—in which he could give full play to his creative powers as the years had developed and matured them.[51]

48. "Exhibita per Notarium publicum Supplicatione Hortulanorum petentium suo altari restitui tabulam quae nunc est in summo altari, pridem eorum altari per D. du Terne concessam et (non concesso quod tabula praefata pertineat ad hortulanos, sed potius ad fabricam ecclesiae) placuit ordinari aedituis ecclesiae ut proximo opere curent fieri novum altare maius et deinde praefata tabula dimittatur ad opus jus habentium" (Antwerp, Archief Onze-Lieve-Vrouwekerk Antwerpen, *Acta Capitularia*, 3: 367–68; published by Philippen, "Notre-Dame," p. 325; and Van de Velde, "Floris," p. 71).

49. Rooses, *P. P. Rubens*, 2: 173–80, and Casteels, *De beeldhouwers De Nole*, pp. 122–24.

50. Before painting the full-scale altarpiece he made the *modello*, formerly in the collection of Colonel F. T. Davies, London, and since 1957 at the Mauritshuis in The Hague (Cat. 1958, no. 926; Wildenstein & Co., London, 1950, *Sir P. P. Rubens*, no. 2; Museum Boymans, Rotterdam, 1953–54, *Olieverfschetsen van Rubens*, no. 51). There is another sketch in the National Gallery in Washington (Cat. 1965, no. 1393; *Paintings and Sculpture from the Samuel H. Kress Collection* [Washington, D.C., 1959], p. 293, plate), but its attribution to Rubens seems to me rather questionable.

51. The fate of the commission for the painting of the high altar in the Antwerp Cathedral recalls that of the high altar of Saint Bavo in Ghent, representing the *Conversion of Saint Bavo*. In 1611, or at least in the first months of 1612, Rubens painted the *modello*, at present in the National Gallery, London. The full-scale altarpiece was only painted in 1622–24. But this likewise shows a composition that is different from the one he had made more than ten years before (see Vlieghe, *Saints*, 1, nos. 71–72).

34. Rubens,
Assumption of the Virgin.
Antwerp Cathedral
(photo: A.C.L.).

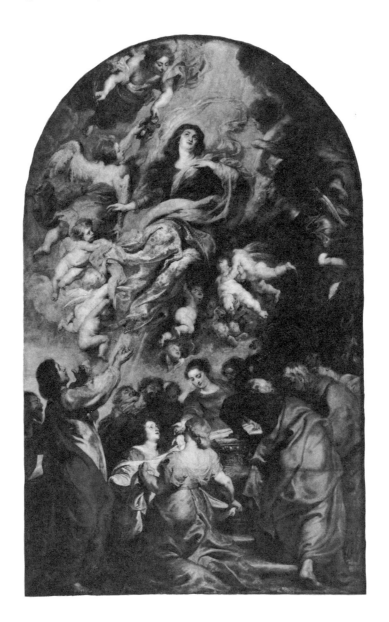

II

We know that Rubens attached much importance to the altars themselves above which the paintings were intended to be placed. This is evident, for example, from Rubens's letter to the Archduke Albert, dated March 19, 1614, concerning the altarpiece for Saint Bavo in Ghent, for which he had made sketches in 1611 and 1612. He writes that he had to put "considerable effort into drawing up the plan for the entire work, *as much for the marble ornamentation* as for the picture."[52] Other letters, dated 1619 and 1620, show his concern for the ornamental framing of the altarpieces he painted for the Duke Wolfgang-Wilhelm of Neuburg.[53]

Unfortunately, the altars for the above-mentioned early Antwerp paintings are no longer in existence, nor is there much information available about them. However, there is one exception. From a painting by Anton Gheringh representing the interior of the Church of Saint Walburgis (fig. 35), preserved in the Church of Saint Paul in Antwerp, we know how the high altar looked on which the *Raising of the Cross* was placed.[54] Above the central panel of this triptych was a niche containing a painting of God the Father. On each side of it stood an angel dressed in *mouvementé* drapery—the angels were painted on wood and cut along the outlines. On top of the niche there was a pelican, in gilded wood, symbolizing the significance of the subject represented on the central panel: the death of Christ for the salvation of mankind.

As Max Rooses pointed out, the God the Father in the niche was not merely a decorative subject. It was to him that the Christ in the central panel raised his eyes. He thus "filled an effective part in the drama."[55] In fact, the painted decoration above the altar formed a single scene with the triptych. This interrelation between the painting and the upper ornamentation is an important element in Rubens's

52. Rooses and Ruelens, *Rubens*, 2: 69–74; R. S. Magurn, *The Letters of Peter Paul Rubens* (Cambridge, Mass., 1955), p. 56.

53. Rooses and Ruelens, *Rubens*, 2: 227–30, 237–39, 252–53; R. S. Magurn, *Rubens*, pp. 72–73, 75.

54. A. Janssen and C. Van Herck, *Kerkelijke Kunstschatten* (Antwerp, 1949), p. 78, no. 241, fig. 241. The painting is also reproduced by Martin, *Rubens*, pl. 2; a detail, representing the altar, pl. 3.

55. Max Rooses, *Rubens* (London, 1904), p. 130; see also the excellent comments by Katharine Fremantle, *The Baroque Town Hall of Amsterdam* (Utrecht, 1959), pp. 126–27.

35. Anton Gheringh,
*Interior of Saint Walburgis Church
in Antwerp.*
Saint Paul's Church, Antwerp.

conception of the role of the altar, as we shall see from other examples. It seems clear that the decoration of the upper part was Rubens's own invention. But did he also design the architectural shape of the high altar itself, which was most probably a structure in wood? If so—but this seems unlikely—he must have adapted his design to the type of altar belonging to what we may call in general terms the Cornelis Floris-Hans Vredeman de Vries tradition.

The survival of the sixteenth-century tradition, as well as the further evolution of the arrangement of the altars in the early seventeenth century in Antwerp, still requires much investigation. As most of the altars are no longer in existence, having been later replaced or destroyed during the French Revolution, pictures of that period representing church interiors can be useful for this purpose. However, as Nora De Poorter has pointed out, not all of them are reliable.[56] Therefore a careful study of other available sources is needed.

Reproduced here is an *Interior of Antwerp Cathedral* (fig. 36), painted before 1625 by an anonymous artist (present whereabouts unknown), which seems to give a rather faithful rendering of the situation at that time.[57] We are concerned here with the first altar on the left of the painting, the altar of the Antwerp Barbers and Surgeons Guild, above which there is a triptych painted about 1590 by Ambrosius Francken. As the altar was in all probability erected about the same time, it can be considered as an example of the traditional type during the last decade of the sixteenth century. The arrangement is rather simple and corresponds, for example, to the altar of the *Wounds of Christ*, in the Saint Leonard Church in Zoutleeuw (Belgium), for which the triptych was probably commissioned from Frans Floris in 1555.[58] It has above the central panel the same triangular pediment in which appears a painting representing God the Father. However, there is a difference. In the altar of the Antwerp Barbers and Surgeons Guild, there are, on top and on both sides of the pediment, pedestals supporting sculptures. But these were added later, shortly after 1610.[59] The wings of the triptych by Francken, as well as those that Floris painted for the altar in Zoutleeuw, are fixed directly to each side of the frame

56. Nora De Poorter, "De Kunstwerken van het Antwerpse Barbiers- en Chirurgijnsambacht" in *Liber Memorialis 350 Jaar Collegium Medicum Antverpiense, 25 Jaar Geneeskundige Dagen van Antwerpen* (Antwerp, 1970), pp. 124–25.

57. Canvas, 116 x 158 cm; auction at R. Lepke, Berlin, May 3, 1910, cat. no. 33, as "Hendrik Steenwyck," reproduced in the catalogue, pl. 11; De Poorter, "Kunstwerken," p. 125, fig. 9.

58. L. Wilmet, *Léau, la ville des souvenirs* (Brussels, 1938), pl. 56; C. Van de Velde, "Frans Floris (1519/20–1570), Leven en Werken," 4 vols. (diss., University Ghent, 1970), 2: 55–59.

59. De Poorter, "Kunstwerken," p. 131.

36. Anonymous,
Interior of Antwerp Cathedral.
Present whereabouts unknown.

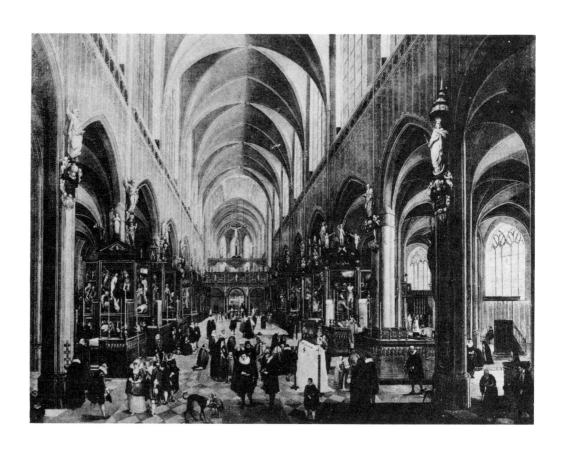

of the central panel. And this is still the case in Rubens's *Raising of the Cross.*

On another, also anonymous painting,[60] representing the same church interior (fig. 37) but dating somewhat later, we see the same altar of the Barbers and Surgeons Guild, but now with closed wings. At the same time, we can distinguish, on the right, altars of somewhat different type, and also dating a few years later. Here the upper part is more decorated, and there are niches containing sculptures, which remind us somewhat of the niche on the high altar of the Church of Saint Walburgis. Another new feature is the appearance of columns separating the wings of the triptychs from the central panel, which give the altar a more monumental aspect. This innovation, however, made it necessary to fix the wings on the altars with iron bars and hinges so that they could pass over the columns when the triptychs were to be opened or closed. We know that they were mostly closed on weekdays and opened only on Sundays and on the quite numerous holidays. Some of these altars can be identified and dated. The second one on the right side of the last-named painting is the altar of the *Jonge Voetboog* (the Young Archers Guild). On the upper part of it there appears a broken pediment and an ornamentation of a more outspoken Renaissance style. We know that, on February 16, 1598, Otto Venius was present at the meeting of the deans of the guild when the erection of the new altar was discussed. He may have been largely responsible for the general arrangement of the altar, which was executed in the following years by the sculptors Jan and Robrecht Colyns de Nole.[61]

Even more monumental and more decorated is the next one (the third on the right counting from the first column in the foreground), the altar of the *Meerseniers* (dealers in silk and textiles). From the accounts of this guild we know that the painter Marten de Vos gave his "advice on the design and the model." An agreement for the building of the structure was made on July 3, 1598, with the same sculptors Jan and Robrecht Colyns de Nole. It is, however, possible that the original arrangement of the altar was changed, for it appeared later that the measurements of the triptych painted by Otto Venius, which was to be placed above it, did not correspond with those specified in the agreement.[62]

The two above-mentioned altars, both designed shortly before Rubens's departure for Italy, represented a more "modern" type, already announcing the so-called

60. Panel, 74 x 103 cm; in 1907? in the Heinemann Gallery in Munich (2159), ascribed to Peter Neefs. A photograph is in the Rijksbureau voor Kunsthistorische Documentatie, The Hague. Published by De Poorter, "Kunstwerken," pp. 125 ff., fig. 8.
61. Casteels, *De beeldhouwers De Nole*, pp. 108–9.
62. Ibid., p. 106.

37. Anonymous,
Interior of Antwerp Cathedral.
Present whereabouts unknown.

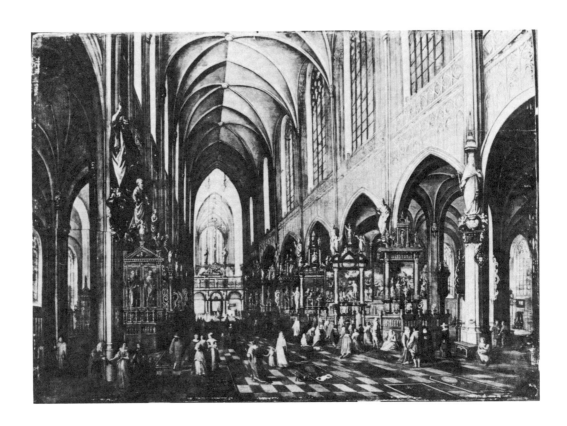

Baroque portico altar in the southern Netherlands. From this it seems questionable whether Rubens himself introduced this new type. But it remains true, as we shall see, that he somewhat later gave it its most developed form.

Compared with the altars of the Young Archers and the *Meerseniers* Guild, the high altar in Saint Walburgis Church was of a more traditional conception—which confirms our doubts about Rubens's authorship of its arrangement. But the angels flanking the niche already give a somewhat Baroque flavor to its decoration. The movement of their drapery prefigures the angels hovering over the pediments of later altars designed by Rubens.

Unfortunately, no picture or other documents have been discovered that could give an accurate idea of the arrangement of the altar of the Harquebusiers, for which Rubens painted the *Descent from the Cross*. From the surviving accounts of the guild, it is not clear whether his advice was asked for the arrangement of the altar. His name does not appear in the first entry, dated February 24, 1612, in which Jan and Robrecht Colyns de Nole are mentioned, who were responsible for the stonework.[63] Part of the altar seems to have been made of wood, the commission being given to Peeter Verstegen.[64] From still unpublished accounts of the Guild of the Harquebusiers we learn that as early as 1624 the ironwork of the triptych had to be reinforced.[65] In this connection, it is interesting to notice that, probably owing to the difficulties resulting from the rather complicated and ineffective mounting by means of iron bars and hinges, most of the wings in the *Interiors of Antwerp Cathedral* (figs. 36 and 37) were finally removed during the second half of the seventeenth century and stored in the respective guildhouses.[66]

We can take it for granted that even in the first years after his return to Antwerp Rubens would have preferred another type of altar for his paintings to the one erected for his *Raising of the Cross*. He would surely have chosen a more monu-

63. ". . . ende den xxvi^n februari [1612] vergadert in de Camer met Capitein Jan Nole, mr Robert synen broeder beyde beeltsnyders" (Antwerp, Stadsarchief, *Gilden en Ambachten*, 4665, f^o 102.) That they made the stonework of the altar appears from the following entry: "Item aen Robert ende Jan de Nole die het steenwerck vanden Aultaer enden thuyn hebben gemaeckt op Rekeninge van tgene hen vande Gulde compt in drye Reysen tsamen luydt henne drye quictancien over een gebrecht geteekent nr 17 1^m gul." (ibid., f^o 134).

64. Ibid., f^o 134^vo.

65. "Item betaelt aen henrick geerts groffsmit voort maecken van twee ysere steunen aende deuren vanden aultaer om daer oppe te rusten soo van loot ende den steenhouwer luyt syne rekeninge ende quictancie gequoteert n^o 3" (ibid., f^o 259^vo).

66. De Poorter, "Kunstwerken," p. 133.

mental type, corresponding to examples he had seen in Italy and at the same time continuing the line suggested by the two more "modern" altars in the Antwerp Cathedral, mentioned above, which had been designed before his departure for Italy. But as a young artist whose career was only beginning, he doubtless had to comply with the more traditional conception of those who charged him with commissions.[67] A few years later, when his fame was rapidly growing, he seems to have found the opportunity to realize what he had in mind. But the new altars he designed, with their much heavier and more monumental columns, made it impossible to attach the wings of triptychs to them. Furthermore, the new arrangement required new proportions for the paintings to be placed above the altars. It is interesting that after about 1615 Rubens's altarpieces grow in height, while at the same time the number of his triptychs rapidly diminishes. There are, of course, some exceptions, but for these there may have been special reasons. For example, concerning the triptych representing *The Miraculous Draught of Fishes*, in the Church of Onze-Lieve-Vrouw over de Dijle in Mechlin (Malines), painted in 1618–19, we know that the panels existed a few years before Rubens received the commission to paint the triptych.[68]

As far as I know, the earliest surviving example of the new type of altar erected according to Rubens's design is the high altar of the Kapellekerk (Notre-Dame de la Chapelle) in Brussels (fig. 38). It was transferred in 1870 to the Church of Sint-Joost-ten-Node near Brussels, where it still stands. For the dating of this structure we can refer to an entry in a register, kept in the archives of the Kapellekerk, published in 1941 in an article on the Antwerp sculptor Hans van Mildert by Isidore Leyssens. From this we learn that the contract concerning the high altar "can be found among the accounts dating 1616–1617."[69] Unfortunately, the contract itself is now lost. But, in the chronicle of the same church we read the following (translated from the Latin): "Anno 1618. In the choir has been erected the altar in marble, after the designs by Rubens, on which has been placed the ascending Virgin, painted by the said famous painter."[70]

67. That Rubens had to comply with the conservative tastes of those who commissioned triptychs from him shortly after his return from Italy was suggested by G. Glück ("Rubens' Kreuzaufrichtungsaltar" in P. Clemen, *Belgische Kunstdenkmäler*, 2 vols. (Munich, 1923), 2: 163).

68. Rooses, *P. P. Rubens*, 2: 24–25; reproduced in *KdK*, p. 172.

69. "Het contract over het stichten van den hoogen authaer in marbel is te vinden in de rekeningen van 1616–1617" (Brussels, Archives of the Kapellekerk, reg. 37, f° 41; published by I. Leyssens, "Hans van Mildert [158?–1638]," *Gentsche Bijdragen*, 7 [1941]: 117).

70. "Anno 1618. Erigitur in choro, altare marmorum juxta prototytam Rubeniam, in quo

38. Hans van Mildert?, after a design by Rubens,
High Altar of the Kapellekerk in Brussels.
In the Church of Sint-Joost-ten-Node, Brussels
(photo: A.C.L.).

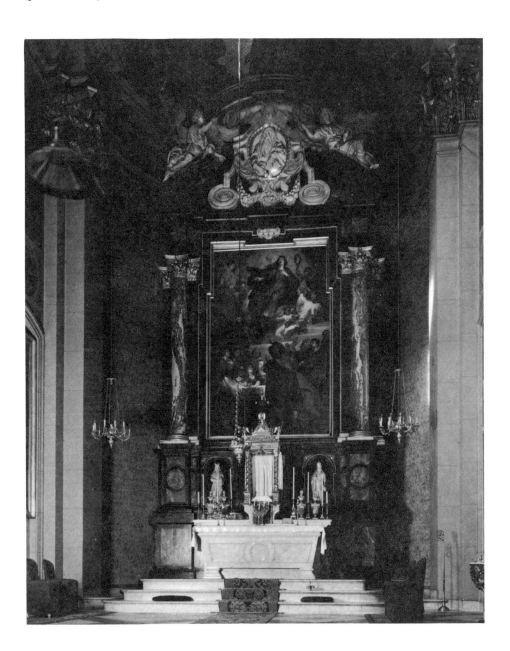

About 1700, Rubens's *Assumption of the Virgin* (fig. 39) was sold to Johann-Wilhelm von Pfalz-Neuburg and removed to Düsseldorf.[71] There it can be seen now in the Kunstmuseum.[72] The above-mentioned documents as well as the style of this picture make it possible to date it about 1616–18 (and not 1618–20, as proposed by R. Oldenbourg).[73] After its removal, the original was replaced by a copy by the Brussels painter Van der Borght, which is to be seen at present above the altar in the Church of Sint-Joost-ten-Node.

On the altar, Rubens's painting was flanked on each side not only by one column (as in the above-mentioned altars in the Antwerp Cathedral) but also by a composition of columns and receding pilasters, decorated with Corinthian capitals. Above the broken pediment there are angels. Between them is a relief representing God the Father. As in the altar of the *Raising of the Cross*, there is a relation between the painting and the ornamentation of the upper part of the altar: God the Father welcomes the ascending Virgin in Heaven. We find the same interrelation again, but in a more elaborate form, in the high altar of the Antwerp Cathedral, for which Rubens painted the *Assumption of the Virgin* (fig. 34). The altar no longer exists, having been replaced in the early nineteenth century by a new one, the same we see at present in the church. But the features of the original structure are known from an engraving by A. Lommelin (fig. 40).[74] In 1618 Rubens submitted two sketches for this altar, which may have served ultimately as models for its erection by Jan and Robrecht Colyns de Nole.[75] On the basis of the engraving, an excellent description of this altar was given by Katharine Fremantle:

Sculptured angels, resting on a broken pediment above the frame of the pic-

exponitur Assumpta Virgo depicta a praefato famoso pictore" (Brussels, Archives of the Kapellekerk, reg. 38; published by Leyssens, "Hans van Mildert," p. 117).

71. T. Levin, "Beiträge zur Geschichte der Kunstbestrebungen in dem Hause Pfalz-Neuburg, Teil III: Johann Wilhelm," *Beiträge zur Geschichte des Niederrheins*, 53 (1911): 30–33.

72. Rooses, *P. P. Rubens*, 2: 170–72, no. 700; *KdK*, p. 193. H. Peters (*Meisterwerke der Düsseldorfer Galerie* [Honnef/Rhein, 1955], p. 32, no. 19) suggested that the altarpiece may have been higher and originally arched on top; this is however excluded by the shape of the altar.

73. *KdK*, p. 193.

74. The engraving was published in *Théâtre des plans de toutes les villes des Pays-Bas* (Amsterdam, n.d.); it is reproduced by Fremantle, *Baroque Town Hall*, fig. 146.

75. Casteels, *De beeldhouwers De Nole*, pp. 122–25, and the documents, some of them unknown before this publication, pp. 367–70, no. 203; pp. 370–71, no. 204; p. 371, no. 205; p. 384, no. 216; pp. 390–92, no. 225; p. 393, no. 226; pp. 397–98, no. 232.

39. Rubens,
Assumption of the Virgin.
Kunstmuseum, Düsseldorf.

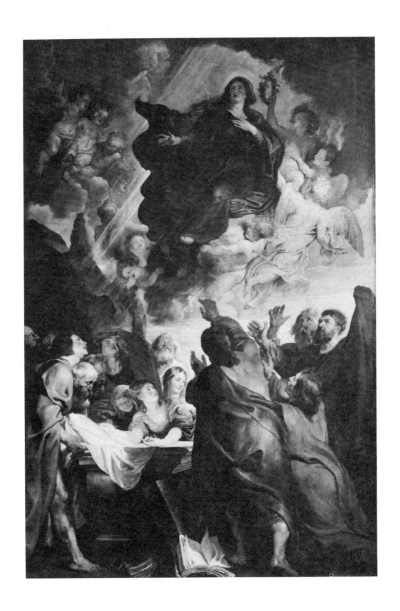

40. A. Lommelin,
High Altar of Antwerp Cathedral.
Engraving. Printroom of the
Royal Library Albert I, Brussels.

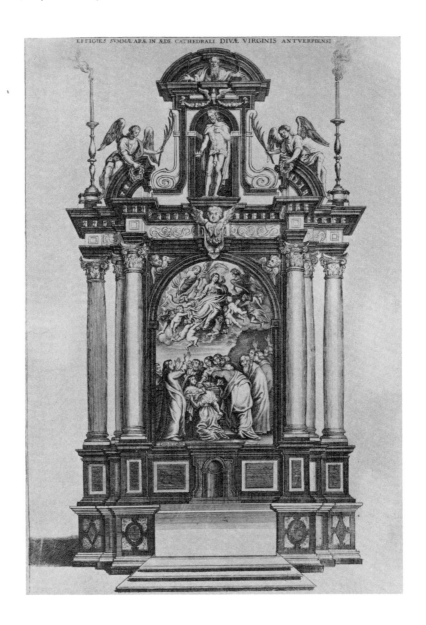

EFFIGIES SVMMÆ ARÆ IN ÆDE CATHEDRALI DIVÆ VIRGINIS ANTVERPIENSI

84

ture, leant down with palm branches and with wreaths in their hands, as another angel does within the painting, proffering them to the ascending Virgin depicted below, while Christ was represented in sculpture in a niche in the centre of the pediment, looking down towards her and offering her a crown which, as she ascended, she held steadily in view. The crown was evidently the most firmly established point in the painting's turbulent composition, though it was outside the picture itself. Above the figure of Christ—which seems to have been slightly larger in scale than the figures in the painting but would have been in keeping with them when seen from below—the Holy Spirit appeared in the form of a dove, and higher still, in the tympanum of the pediment which surmounted the centre of the altarpiece, God the Father was represented, holding his hands open and outstretched as though in a gesture of welcome. Here it is clear that architecture and sculpture were used not as frame for a painting but as an integral part of a unified composition; the meaning of the painting was emphasized and completed by the sculpture and by the architectonic arrangement of the altarpiece as a whole, and the assumption of the Virgin was shown not simply as a take-off for heaven (as, looking at the painting only, one might assume) but in its entirety, and as though it were taking place not in fictive space beyond a picture-frame, but in the very presence of the worshippers in the church.[76]

The most important altar, and the most decorated of all, for which Rubens made the designs is the high altar of the Antwerp Jesuit Church, now Saint Charles-Borromeo (fig. 41). Some of the preparatory drawings for it are still extant. As they are well known, having been studied in several recent publications, it is not necessary to deal here with them at length.[77] It should be sufficient to recall that they establish Rubens's authorship—in collaboration with the architect Brother Peter Huyssens—of the splendid surviving high altar. Furthermore, there exists in a private English collection an oil sketch on panel by Rubens (fig. 42), which is surely a design for the upper part of the altar and the sculptures on top of it.[78] It shows, in the

76. Fremantle, *Baroque Town Hall*, pp. 127–28. For additional evidence in literary sources concerning this altar see ibid., p. 127, n. 2.

77. They are: (1) a design for the high altar in the Albertina, Vienna (G. Glück and F. M. Haberditzl, *Die Handzeichnungen von Peter Paul Rubens* [Berlin, 1928], no. 130; L. Burchard and R.-A. d'Hulst, *Tekeningen van P. P. Rubens* [Antwerp, 1956], no. 70); (2) *An Angel Carrying a Candelabrum*, in the Berlin Printroom, a design for the angel on the right above the present high altar (Glück and Haberditzl, *Rubens*, no. 132).

78. In 1961 lent by the Hon. Lady Beckett to the exhibition *Oil Sketches and Smaller Pictures by Sir Peter Paul Rubens, In Aid of The King's Lynn Festival Fund*, Thos. Agnew & Sons, Ltd., London, 1961, no. 15.

41. Hans van Mildert, after a design by Rubens,
High Altar of the Antwerp Jesuit Church,
now Saint Charles-Borromeo
(photo: A.C.L.).

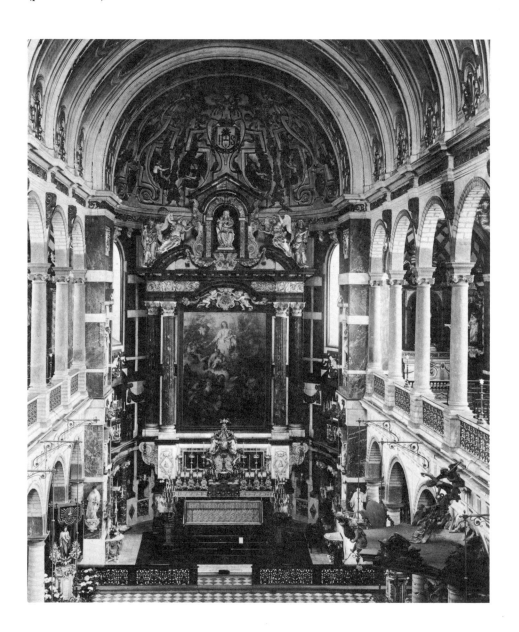

42. Rubens, *Design for the Upper Part of the High Altar of the Antwerp Jesuit Church, now Saint Charles-Borromeo.*

Oil sketch. Private collection, England.

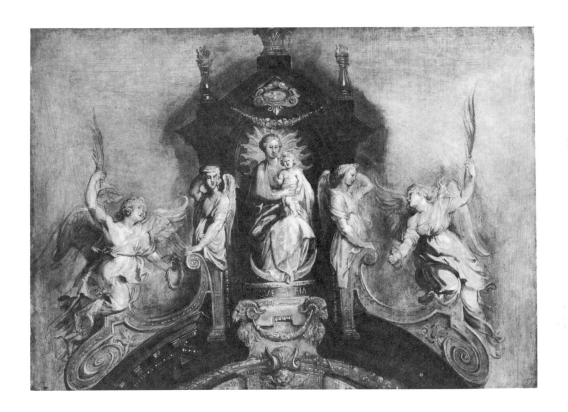

middle, the Virgin and Child sitting in a niche, as they do on the altar itself, though in a somewhat different attitude. Underneath this sculptured group there is a small decorated socle of the same type as the one that was executed in marble. On both sides of the niche we see angels with fluttering draperies who are already very close to those who now recline on the pediment of the altar. There are certain other elements, however, that do not correspond with the high altar as it was finally constructed, and these seem to indicate that the oil sketch represents an early stage in the design of the altar. Particularly striking is the arched form of the cornice and, most probably also, of the framing of the picture to be placed above the altar. From this we may assume that the oil sketch was painted by Rubens before he made the *modelli* for the altarpieces representing the *Miracles of Saint Ignatius of Loyola* and the *Miracles of Saint Xavier*, both in the Gemäldegalerie of the Kunsthistorisches Museum in Vienna; for these, like the full-scale altarpieces themselves, have a rectangular shape. As the *modelli* were painted about 1617,[79] it seems possible that the oil sketch for the upper part of the altar originated a short time before that date. Technical difficulties, and perhaps also financial reasons, might explain why the rectangular form was finally chosen.[80]

79. Frans Baudouin, *Rubens en zijn Eeuw* (Antwerp, 1972), p. 115 (a revised reprint of the article "De datering van twee Schilderijen van Rubens voor het hoofdaltaar van de Antwerpse Jezuïetenkerk en enkele Aantekeningen over Hans van Mildert," *Miscellanea Jozef Duverger*, 1 [1968]: 301–28).

80. However, altars were erected later, from Rubens's designs, for which the arched form of the cornice and the upper part were adopted.

The first one to be mentioned is the altar of the so-called Houtappelkapel (or Mary Chapel) in the Antwerp Jesuit Church—a chapel built after 1621 (reproduced by S. Leurs, *Barokkerken te Antwerpen [Ars Belgica*, II] [Antwerp, 1935], pl. XVII, no. 24). Although thus far we know only a drawing by Rubens, in the Albertina in Vienna, of the stucco ceiling of this chapel, it seems quite reasonable to assume that the major part of the whole decoration of the chapel was designed by Rubens. It is interesting to notice the resemblance of the arched form of the altar in the chapel to the crowning arch on the *Sketch for the Stage of Welcome*, in the Hermitage in Leningrad, for the Triumphal Entry of the Cardinal-Infante Ferdinand (John Rupert Martin, *The Decorations for the Pompa Introitus Ferdinandi*, Corpus Rubenianum, XVI [Brussels, 1972], fig. 3).

The arched form of the upper part also appears on Rubens's design for the high altar in the Church of the Carmelite Fathers (Grands Carmes) in Antwerp. This oil sketch, at the Metropolitan Museum in New York, was most probably painted ca. 1625–28 (reproduced in Wildenstein, New York, 1951, *A Loan Exhibition of Rubens*, no. 20). The structure of the altar itself, in white and black marble, was erected only in 1637–38 by Hans van Mildert. It is interesting to note that the sketch in New York shows volutes at the top, over which originally were hovering angels, of whom we see now only the legs: these

These two altarpieces, now also in Vienna, which were displayed alternately according to liturgical seasons, were placed above the high altar in an architectural framework, with two pairs of columns on either side supporting the cornice. Above this, in the middle of the broken pediment, is a niche in which are represented the Virgin and Child (fig. 43). This marble statue is supported by a richly decorated socle, terminating on each side in the head of a putto. Above the Virgin, in the middle of the arched top of the niche, is a dove, representing the Holy Ghost, carved in high relief. The central group is enclosed on both sides by angels. Two of them seem to fly above the ends of the broken pediment. Over the outer columns, which are set back a little, are two standing angels bearing torches. The whole altar, built entirely of marble, is characterized by the richness of its motifs and carved decorations.

Do we find here an interrelation between the two paintings placed above the high altar and the sculptured figures above it, like that which we have observed on other Rubensian altars? Although the saints in these altarpieces are not represented with eyes turned upwards, the answer is still affirmative. First of all, it must be pointed out that the flying angels above the pediment originally held wreaths and palm branches above the Jesuit saints. These symbols point to their martyrdom and sanctity.[81] But there is more to be noticed. The crown on the head of the Virgin indicates that she is represented here as a queen, more precisely as the *Regina Sanctorum*, the queen of the saints—of all the saints, moreover, not only of the Jesuit saints represented in the paintings beneath but also of all the others painted on the ceilings of the aisles of the church.[82] And she is queen also of all the faithful in the church, whose goal is sanctity. Indeed, as Katharine Fremantle has remarked, here too there is an interrelation between the worshippers in the church and the scene represented on the upper part of the altar. The Virgin sitting on the throne, in an attitude that recalls somewhat the medieval type of the *Sedes Sapientiae*, holds the Child upright, standing on her knees. He "raises his hand in blessing, but as he does so, quite unmistakably, he looks down at the members of the congregation, making

volutes remind us of those that appear on the design for the upper part of the high altar in the Antwerp Jesuit Church (fig. 42).

81. Similarly, in the Church of Saint Donatian in Bruges three paintings were shown successively during the year on the high altar, erected by Hans van Mildert in 1628 (Leyssens, "Hans van Mildert," p. 92). Perhaps for this usage the Antwerp Jesuit Church was taken as an example.

82. John Rupert Martin, *The Ceiling Paintings for the Jesuit Church in Antwerp*, Corpus Rubenianum, I (Brussels, 1968), pp. 122–87.

43. Hans van Mildert, after a design by Rubens, *Sculptures of the Upper Part of the High Altar of the Antwerp Jesuit Church, now Saint Charles-Borromeo* (photo: Courtauld Institute of Art).

it clear that, in particular, he is blessing them. This small figure, placed high above the altar, cannot escape notice because of its position and gesture, and because the outstretched arms of the hovering angels follow and emphasize the surrounding curves of the half dome, concentrating the attention on this central point within it."[83]

For a long time there has been uncertainty about the sculptor who realized this magnificent high altar, and more precisely the statues high above it. Tentatively the names of Colyns de Nole and of Hans van Mildert have been successively advanced. I have made it clear, I think, that the latter is to be considered as the artist who executed this splendid group of sculptures.[84] In a book of accounts concerning the building of the Antwerp Jesuit Church, which is now at the Rubenshuis in Antwerp, Hans van Mildert is mentioned on five occasions, whereas the name of Colyns de Nole does not appear at all. Unfortunately, the entries in the cashbook do not specify the works for which he was paid. But it seems evident that some part of the considerable amounts due him were for the high altar. From other entries it appears that this altar was probably finished in 1620, long before the church was consecrated on September 12, 1621.[85]

When we survey the evolution of the altar, starting with the rather simple one for the Barbers and Surgeons Guild of about 1590, we realize that a considerable development took place within some thirty years. Although, as we have seen, Rubens was not the first to introduce in Antwerp the "new type" of altar, he surely played an important role in this process. The high altar of the Jesuit Church in Antwerp can be considered the first surviving example of the High Baroque portico altar, a type much more "advanced" in style than what was realized even in Italy at that moment.

83. Fremantle, *Baroque Town Hall*, p. 129.
84. Baudouin, *Rubens*, pp. 116–18.
85. Ibid., pp. 117–18.

Rubens and the *Vita Beati P. Ignatii Loiolae* of 1609

Julius S. Held

To Millard Meiss

As in all human activities there are fashions in the history of art. This paper is concerned with one branch of art of the past that has become rather unfashionable despite the fact that the artist involved is one of the most zealously investigated of all the great masters. Recent scholarship has dealt by preference with Rubens's drawings and oil sketches because they are unquestionably the works through which his genius speaks to us most directly. His large paintings and tapestries are perhaps a shade less popular, but they, too, have received a good deal of attention. By contrast, scholars have become rather silent in regard to one area which in the eighteenth and early nineteenth centuries occupied the center of the stage for all the admirers of the Flemish painter: the engravings made from Rubens's designs. Even Jakob Burckhardt's *Erinnerungen aus Rubens*, written in 1896 and recently again called "the finest of all the books on the master,"[1] grew largely out of the contemplation of prints made of his pictures. Catalogues of these prints were drawn up since the eighteenth century, beginning with Hecquet and Basan, and culminating in the lists published by C. G. Voorhelm Schneevoogt (1873), Eugène Dutuit (1885), and Max Rooses (1890).[2] The last, unfortunately flawed, effort to catalogue the prints made of Rubens's compositions was a book by Frank van den Wijngaert

1. Wolfgang Stechow, *Rubens and the Classical Tradition* (Cambridge, Mass., 1968), p. 95.
2. R. Hecquet, *Catalogue des estampes gravées d'après Rubens* (Paris, 1751); F. Basan, *Catalogue des estampes gravées d'après Rubens* (Paris, 1767) (based on Hecquet, but considerably enlarged); C. G. Voorhelm Schneevoogt, *Catalogue des estampes gravées d'après P. P. Rubens* (Haarlem, 1873); Eugène Dutuit, *Manuel de l'amateur d'estampes, Ecoles flamande et hollandaise*, 4 vols. (Paris, 1885), vol. 6; Max Rooses, *Catalogue de l'oeuvre de Rubens en gravure et en photographie exposé au Musée des Beaux-Arts à Anvers* (Antwerp, 1890).

93

(1940).[3] A few writers have tried to survey the field in a historical manner, but their works, too, belong largely to the last century: Henri Hymans (1879) and Adolf Rosenberg (1888).[4] A lecture given by Louis Lebeer before the Société royale d'Archéologie de Bruxelles in 1941 is the last serious effort I know of to provide an overall view of this aspect of Rubens's oeuvre.[5]

The observations presented here did not grow from an irresistible desire to make up for the long neglect; nor do they propose to do more than throw some light on a very limited area. Indeed, it was only the accidental discovery of a Rubens drawing hitherto overlooked, though preserved in no less visible a place than the Cabinet des Dessins of the Louvre, that prompted me to look afresh at a group of prints that have had little attention from modern Rubenists.

The drawing (fig. 44) is number 1614 of the anonymous drawings in Frits Lugt's great catalogue of the Flemish drawings of the Louvre.[6] It is very small, measuring only 114 x 98 mm, and was described by Lugt as *Homme en extase, dans un paysage*. Lugt mentions that an old attribution on the mat gives it to Cornelis Poelenburgh but the drawing reminded him also of the manner of Herman van Swanevelt. Despite these associations with two Dutch artists, Lugt—wisely—kept the drawing with those of the Flemish school.

As far as I know, the drawing has never been mentioned in any other context, nor, for that matter, had Lugt considered it worthy of a reproduction. It does not seem to have attracted the attention of the scholars who like to record their opinions on the mats of drawings for the benefit of later generations. And yet, though modest in size, the drawing is a work of a curiously compelling beauty. Alone in a clearing of a wooded landscape, illuminated by the pale sickle of the moon, the kneeling figure

3. Frank van den Wijngaert, *Inventaris der Rubeniaansche Prentkunst* (Antwerp, 1940).
4. Henri Hymans, *Histoire de la gravure dans l'école de Rubens* (Brussels, 1879); Adolf Rosenberg, *Der Kupferstich in der Schule und unter dem Einflusse des Rubens (Die Rubensstecher)* (Vienna, 1888).
5. Louis Lebeer, "Pierre-Paul Rubens et l'art de la gravure," *Annales de la Société royale d'archéologie de Bruxelles*, 45 (1941): 181–212. (An exhibition of "Prints after Rubens" was held at the Ackland Art Center in Chapel Hill, N. C., in March and April, 1968.)
6. Frits Lugt, *Inventaire général des dessins des écoles du nord, Ecole flamande*, 2 vols. (Paris, 1949), 2: 98. The entire entry reads: "Anonymes, 1614 (22.239) Homme en extase, dans un paysage. Plume et lavis de bistre.—H. 113 mm; L. 98 mm. Collé en plein.—Marque du Louvre L. 1886. Ancienne attribution à Corn. Poelenburg, sur la monture. Rappelle aussi la manière de H. Swanevelt." (I am indebted to Mlle R. Bacou for the permission to publish the drawing and to Mme G. Monnier for having provided me with a photo.)

44. Rubens,
*Saint Ignatius Contemplating
the Heavens.*
Drawing. Louvre, Paris.

—hardly "en extase"—looks with worshipful intensity to heaven while crossing his hands before his chest. His is a sharply cut, clean-shaven face; his hair is cropped closely to the head. He wears the long cassock with high collar characteristic of the Jesuits. In fact, he is none other than Ignatius of Loyola, the founder of the order.

This identification is not a matter of guesswork. The drawing is simply the model for an engraving depicting the same scene, now only in reverse (fig. 45), and forming part of a richly illustrated *Life of Ignatius*, published in Rome in 1609.[7] The full title of the book is *Vita Beati P. [atris] Ignatii Loiolae Societatis Iesv Fvndatoris*; the scene depicted here is plate 68, of a total of seventy-nine numbered pages. Although probably printed in a fairly large edition, this book has become a very rare item; the librarian of the Antwerp municipal library once wrote to me that he had never seen a copy.

The action of plate 68 is fully described in the five lines of the Latin caption, engraved, like all the texts accompanying the plates, on the same copperplate as the image. Ignatius, so it says, often shed heavy tears at the marvelous sight of the sky and used to exclaim: "How paltry is the earth when I behold the heavens." And when the flood of tears caused him to almost lose the sight of his eyes, he obtained from God the special favor of being able to control the gift of tears *(donum lacrimarum)*. The readiness to cry at any appropriate occasion and particularly as a sign of contrition is a well-known aspect of the spiritual life of the Counter Reformation.[8] Yet the words put here into the mouth of Ignatius, combining the old theme of the *contemptus mundi* with the awe of the visible sky, may well find a sympathetic echo even in our own time. That the illustration published in 1609 was designed by a contemporary of Galileo and Kepler gives to it a particularly piquant historical interest.

This contemporary was indeed no other than Peter Paul Rubens. Although there are other arguments that can be quoted in support of his authorship, I prefer to substantiate the attribution in the conventional manner by comparing the drawing with accepted works of the master. This task is made relatively easy because of the known date of the book in which it was used. The Louvre drawing must have been made in 1609 or not long before that year, and hence need only be compared with drawings or paintings of this early period. My first witness is a delicate pen-and-

7. In 1609 Herman Swanevelt, of whom Lugt felt reminded, was two years old.

8. See B. Knipping, O.F.M., *De Iconografie van de Contra-Reformatie in de Nederlanden*, 2 vols. (Hilversum, 1939), 2: 95–97. The phrases "vim lacrimarum profundere" and "oculos perdere," being of Ciceronian origin (Rep. 6, 14 and Har. Resp. 18, 37), are obviously used to demonstrate literary elegance.

45. *Saint Ignatius Contemplating the Heavens.*
Engraving from the *Vita Ignatii* of 1609 (plate 68),
after a design by Rubens.
Metropolitan Museum of Art, Harris Brisbane Dick Fund.

wash drawing in the British Museum depicting Saints Domitilla, Nereus, and Achilleus (fig. 46).[9] It must have been done early in 1608 when Rubens had obtained the permission to replace the single picture he had painted for the Chiesa Nuova in Rome with three paintings, executed on slate, to cut down an irritating glare. The London drawing is a study for the painting to the right of the high altar, anticipating the final version fairly closely.[10] Besides analogies in the rendering of drapery folds and the treatment of the hands, it is particularly the sharply outlined profile of Saint Achilleus that can be compared with the head of Saint Ignatius. A very similar head had been painted by Rubens before in the first version of the altar for the Chiesa Nuova, now in the museum in Grenoble.

Since the Louvre drawing is a model for an engraving, a proper demonstration in support of its attribution to Rubens should include drawings that had the same function. Rubens must have made drawings for the engravings by Cornelis Galle I that adorn the *Electorum Libri II*, written by his brother Philip and published in 1608. Yet none of these drawings has been preserved. (Even if we had them, they would probably be of little use since they were renderings of classical sculptures, probably not much different from the various chalk drawings after classical sculptures that are still extant.)[11] Thus we must turn to drawings of a slightly later date. Among the first drawings of a narrative content, made by Rubens specifically to be engraved as illustrations in a book, are the drawings made between 1612 and 1613 for the Plantin edition of the Roman Breviary. Looking at the splendid drawing of the *Adoration of the Magi* (cat. 11) done for this project, we see clearly how little the manner of making such models for engravings had changed in the intervening years.[12] Both drawings are similar in the striking mixture of freedom and control in the use of the pen and in the judicious application of thin washes. The technique of accentuating foliage by a few lines penned over the washed areas and the short-

9. A. M. Hind, *Catalogue of Drawings by Dutch and Flemish Artists in the British Museum*, 5 vols. (London, 1915–32), 2 (1923): 56 (there attributed to Van Dyck). The drawing was first given to Rubens by G. Glück and F. M. Haberditzl, *Die Handzeichnungen von Peter Paul Rubens* (Berlin, 1928), no. 52.

10. See Michael Jaffé, "Peter Paul Rubens and the Oratorian Fathers," *Proporzioni*, 4 (1963): 209–41, and Justus Müller Hofstede, "Zu Rubens' zweiten Altarwerk für Sta. Maria in Vallicella," *Nederlands Kunsthistorisch Jaarboek*, 17 (1966): 1–78. The sketch in the collection of Dr. Kurt Rossacher, Salzburg (ibid., fig. 8) follows the London drawing and represents the last preparatory phase before Rubens painted the large paintings.

11. See Stechow, *Rubens*, and the literature cited there.

12. See Julius S. Held, *Rubens, Selected Drawings*, 2 vols. (London, 1959), no. 139, pl. 151.

46. Rubens,
Saints Domitilla, Nereus, and Achilleus.
Drawing. British Museum, London
(photo: Macbeth).

hand devices to characterize trees and shrubs are generally very much alike. And here, too, is found a head strikingly similar to that of Ignatius in the Louvre drawing: it is the oldest of the three kings who tilts his head slightly inward and whose features and fervid expression are rendered in similarly economic lines. Shorn of his curly hair and beard, he would look quite like the great Jesuit.

There is no need to carry this demonstration to greater lengths. The Louvre drawing, I am confident, will be accepted as an authentic work of the master, even without reference to the book for which it was made.

The addition of this modest drawing to the body of Rubens's oeuvre has consequences far out of proportion to its size and seemingly marginal interest. To begin with, it permits us to reconsider a problem that Rubens scholars, if they admitted its existence at all, have tended to sweep under the rug. This is the question of whether or not Rubens participated in the illustrations of the *Vita Ignatii* of 1609, and if so, how many of its illustrations can be attributed to his hand.

Published presumably to coincide with the beatification by Pope Paul v of the founder of the Company of Jesus on July 27, 1609, and surely also to aid his eventual canonization (March 12, 1622), the *Vita Ignatii* provides no bibliographical clues of any kind. We do not know who designed the illustrations or who engraved them; nor do we know who wrote the legends or who was the publisher. The only thing we can tell from its title page is that it was published with the official approbation of the Jesuit authorities since the formula "superior[um] licentia" printed at the bottom is common in Jesuit-sponsored publications.

The most comprehensive early vita of Ignatius of Loyola is a book by Pedro de Ribadaneyra (1527–1611), first published in 1572. Originally the only miracle attributed to Ignatius by the Spanish author was the founding of the Society of Jesus itself. Yet in the early years of the seventeenth century, probably moved by his desire to aid in the drive for Ignatius's canonization, Ribadaneyra himself enriched the founder's life with appropriate incidents, a fact reflected also in the *Vita Ignatii* under discussion, which abounds with accounts of miraculous appearances, interventions, cures, and the like. To what extent this book is actually based on Ribadaneyra's huge compendium I am not prepared to say, but I am certain that many of the incidents illustrated are indeed derived from the Spanish book.[13] Several of

13. For the complex story of the various editions and translations of Ribadaneyra's book, see Candidus de Dalmasco S.J., ed., *Fontes Narrativi de S. Ignatio de Loyola . . . IV, Vita Ignatii Loyolae auctore Petro de Ribadaneyra* (Rome, 1965). (I am indebted to Professor Robert E. McNally, S.J., of Fordham University for references provided in this connection.) (See also below, note 49.)

these events were also illustrated in a series of fourteen prints, each one depicting more than one incident, published in Antwerp in 1610. This series was derived from compositions by Juan de Mesa, who took all his stories from Ribadaneyra's biography.[14]

However that may be, there is a tradition remounting to the early eighteenth century linking Rubens's name with some or even all of the engravings of the 1609 *Vita Ignatii*. It begins with P. J. Mariette (1694–1774), the famous collector and connoisseur, but even he may have relied on still older sources. There are several entries in Mariette's notes, published long after his death as his *Abecedario*, which relate to this subject.[15] The longest entry deals with a set of proof-prints in Mariette's own collection, some of which had corrections, occasionally clarified by small marginal drawings that Mariette claimed to be Rubens's own. These proof-prints are now in the Bibliothèque Nationale in Paris.[16] Mariette obviously wavered in his judgment of these engravings. At one point he maintained that at least seventeen of the prints were designed by Rubens and that the artist must have had a hand in a good many more. Yet when it came to identifying the individual prints designed by Rubens, Mariette admitted that there were only eight about which he had no doubts. He listed eleven others as likely to have been by Rubens, for a total of nineteen engravings. He also stated that he himself owned three drawings by Rubens made for plates 64, 67, and 69 of the book, and that he knew of still another one, for a rare additional plate,[17] which at the time of his writing was in the collection

14. Twelve of the fourteen prints of this edition are reproduced in P. Tacchi Venturi, S.J., *S. Ignazio di Loiola nell' arte dei secoli XVII e XVIII* (Rome, 1929). This book appeared simultaneously in Italian, French, and Spanish. The only book known to me containing illustrations of some of the prints of the 1609 *Vita Ignatii* is Geoffrey de Grandmaison's *Saint Ignace de Loyola* (Paris, 1930). Among the nine plates taken from the *Vita* is also pl. 68 (p. 17) with the caption: "La vue du ciel inspire à saint Ignace le mépris de la terre." For a single illustration of the additional, unnumbered, plate of the saint's beatification see note 17, below.

15. P. J. Mariette, *Abecedario*, in *Archives de l'Art Français* (Paris, 1858–59), 5: 102–3.

16. B. N. Estampes, .Cc 34.j Rés. The set of prints was acquired for the Cabinet d'Estampes at the sale of the "Cabinet de feu M. Mariette" in November 1775 (the catalogue of the sale being the work of F. Basan); see Joseph Guibert, *Le Cabinet des Estampes de la Bibliothèque Nationale, Histoire des Collections suivie d'un guide du Chercheur* (Paris, 1926), p. 101. (I am grateful to Mlle Marie Thérèse d'Alverny, Mlle M. Hébert, and M. Jean Adhémar for assistance given to me in connection with the study of these prints.)

17. This print was reproduced by Hymans (*Histoire*, after p. 30). Although the layout is the same as with all other prints of the book, the space provided for a legend remained empty, giving rise to doubts whether the scene depicted the saint's beatification or canon-

of Crozat (1665–1740). Mariette may have repurchased that fourth drawing since in the catalogue of the sale of his collection, lot 1004 lists "4 sujets de la Vie de St. Ignace."

Mariette's view is reflected—with some differences to which we shall return—in the catalogues of Hecquet and Basan, and on the strength of these sources has filtered down into most of the later publications listing the prints made from Rubens's designs.[18] (Schneevoogt, who is generally cited as the chief reference work for these prints, literally copied Basan's text, including its mistakes.) The first skeptical voice was Dutuit's, followed by Hymans, Rooses, and, most emphatically, by van den Wijngaert, who stated flatly that the prints of the *Vita Ignatii* can in no way be connected with Rubens.[19]

With the discovery and identification of the Louvre drawing, the whole question of the *Vita Ignatii* of 1609 must evidently be faced anew. That Rubens was in some way connected with this book can no longer be doubted. Moreover, given the existence of one authentic Rubens drawing for one of the engravings, credence should not be denied to Mariette's claim of having owned several such drawings. Since the Louvre drawing served as model for print number 68, it is an additional one to the four quoted by Mariette that were for different pages.

In the absence of other original drawings, we are forced to ask whether Rubens's style can be distinguished in any of the other engravings. As a first step in this direction, we must define as precisely as possible the relationship between the Louvre drawing and the print derived from it (figs. 44 and 45). Even a casual glance will show that the engraver had considerable difficulties translating his model into the language of lines familiar to his burin. Most obvious are the changes made in the head of the saint. The shape of the cranium is more rounded in the print than in the drawing; the forehead slants backward more rapidly, lending to the head an

ization. According to Mariette, it had been intended as the last plate (80) but was never added to the series: "on ne la trouve jamais à la suite de cette vie" (*Abecedario*, 5: 103).

18. Hecquet, *Catalogue*, pp. 109–10, no. 8; Basan, *Catalogue*, p. 206, no. 8; Schneevoogt, *Catalogue*, p. 213, no. 12; L. Cicognara, *Catalogo Ragionato dei libri d'arte e d'antichità posseduti dal Conte Cicognara*, 2 vols. (Pisa, 1821), 1: 369–70; A. von Wurzbach, *Niederländisches Künstlerlexikon* (Vienna-Leipzig, 1906–11), 1: 565 (C. Galle I, no. 64); M. Funck, *Le livre Belge à gravures* (Paris-Brussels, 1925), p. 238, no. 2; F. W. H. Hollstein, *Dutch and Flemish Etchings, Engravings and Woodcuts* (Amsterdam, n.d.), 7: 57, nos. 169–249.

19. Dutuit, *Manuel*, 6: 26; Hymans, *Histoire*, pp. 27 ff.; Max Rooses, *L'oeuvre de P. P. Rubens*, 5 vols. (Antwerp, 1886–92), 2: 293, no. 455[bis]; van den Wijngaert, *Inventaris*, p. 28, no. 15.

almost simian shape. The head in the print is in profile, while in the drawing it in-clines slightly towards the right shoulder. Ignatius's face in Rubens's drawing is ascetic, with sharply defined features; the lines indicating the eye suggest a glance of intense concentration. In the print, the eye is opened more widely but lacks the emotional stress suggested in the drawing. Instead, the engraver emphasized the tears of the saint falling from his eyes, in accordance with the text inscribed below the image. And, whereas Rubens sketched the celestial bodies rather perfunctorily, the engraver elaborated the moon and the stars in pedantic detail.

There are still other differences. That the engraver depicted a detail like the Jesuit's belt, which Rubens had hidden under some folds, is perhaps less important than his inability to do justice to the subtle variations in light and shade on the gown, which in Rubens's drawing gave coherence and three-dimensional movement to the material. One gets the impression that the engraver, bound by traditional conventions of the technique, was ill-prepared to translate Rubens's personal style into the printed medium. This view finds a striking confirmation when we look at the landscape. Here the engraver was evidently trapped by established and famil-iar routines in rendering branches, twigs, and foliage, and hence lost much of the life and spontaneity of Rubens's design. And yet, no matter how insensitive in de-tail, the engraved landscape still retains some of the dramatic and idealized concep-tion of Rubens's Louvre drawing, owing mostly to the presence of the grandly twisting tree, a harbinger of many other such trees in Rubens's later landscapes, not to mention its kinship to the tree in the drawings connected with the portrait of the Duque de Lerma of 1603.[20]

The somewhat lengthy comparison between Rubens's Paris drawing and the cor-responding print of the *Vita Ignatii* has been necessary to demonstrate that any effort to identify other prints as based on Rubens's design must make allowance for a less than adequate translation of the drawing into the graphic medium. Evidently, a line will have to be drawn somewhere, but scholars may well differ from each other as to when to blame an observed ineptitude on the designer or the engraver. There should be no serious objection, however, to the statement that Rubens's authorship should be suspected wherever the conception of the whole suggests the presence of an artist of superior power of invention, or where individual figures are markedly more vivid in motion or expression than comparable figures in other sec-tions of the book.

20. See Held, *Rubens*, no. 71, pl. 83; see also L. Burchard and R.-A. d'Hulst, *Rubens Drawings* (Brussels, 1963), no. 30.

The *Vita Ignatii* opens with a title page whose complex iconographic program is superimposed upon a sturdy architectural structure (fig. 47). From a base recessed in the center rise two Ionic columns backed by similar pilasters. They support a tripartite entablature, equally recessed in the center and surmounted on either side by what looks like the cornersections of a broken segmental pediment. The crowning moldings of these pieces incline towards the center, ending in tightly rolled volutes. Two putti holding flowers and scrolls recline on them in a manner popular since Michelangelo's Medici-tombs. Various Jesuit martyrs, alone or in groups, are depicted in medallions or cartouches applied to, or suspended from, the architecture. The title is inscribed on a fringed cloth that fills most of the space between the columns, and many other inscriptions help to clarify the meaning of each of the details.[21]

Compared with title pages known to have been designed by Rubens—all of them later in date—the title page of the *Vita Ignatii* is structurally relatively simple.[22] Confronted, however, with the title page of a very similar book, the *Vita et Miracula S. P. Dominici*, engraved and published in 1611 by Theodoor Galle in Antwerp (fig. 48), the clarity and force of the title of the *Vita Ignatii* become immediately apparent. In contrast to the paper-thin architecture of the Saint Dominic title (where the saint resembles a juggler as he keeps aloft medallions with images of the Virgin and other saints), that of the *Vita Ignatii* betrays an acquaintance with, and understanding for, the principles of the muscular early Baroque in Rome. More important in the context of this study is the fact that there are tangible similarities with elements found in Rubens's decorative designs, such as the cartouches, done in 1612, for the small marginal scenes of the page *Ad tertiam Missam In Die Nativitatis Domini* of the Roman Missal.[23] The recessed base containing compositions, or in-

21. The inscriptions on the scrolls held by the putti read "Floribvs eivs nec rosae / nec lilia desvnt." The three portraits on the entablature are of "B. Aloysivs Gonzaga," "B. Stanisla[vs] Kostka," and in the center "B. Francisc[vs] Xaverivs." Below the latter, in a cartouche, is "B. Rodvlphvs Aqvaviva cvm sociis." Suspended at the left are the portraits of "B. Antoni[vs] Criminalis," "B. Abraham Georgivs," and a group of martyrs inscribed simply "Plvres in Anglia." The corresponding inscriptions on the right are "B. Edmvndvs Campianvs," "B. Iac. Salesivs et Gvlielm[vs] Saltom," and "Plvres in India." In the recessed center one reads (below a seascape with two large boats) "Qvadraginta Martyres," and at the left "In Iapone," at the right "In Florida."

22. For Rubens's designs of title pages see the basic study by Hans Gerhard Evers, *Rubens und sein Werk, Neue Forschungen* (Brussels, 1943), pp. 167–93.

23. See *Drawings and Oil Sketches by P. P. Rubens from American Collections*, Fogg Art Museum, Harvard University, and The Pierpont Morgan Library, 1956, no. 10.

47. Title page of the
Vita Ignatii.
Engraving, after Rubens?
Metropolitan Museum of Art.
Harris Brisbane Dick Fund.

48. Title page of the
Vita Dominici of 1611.
Engraving.

scriptions, on their frontal surfaces occurs frequently in later Rubens titles, such as the one of Franciscus Aguilonius's *Opticorum Libri Sex* (1613), the *Annales Sacri* by Augustinus Torniellus (1620) (fig. 49), and Matthieu de Morgues's *La Defense de la Royne-mere* (1637).[24] The suspended curtain holding the title itself was used by Rubens in three title pages: Heribertus Rosweydus's *'t Vaders Boeck* (1617), Thomas a Jesu's *De Contemplatione Divina* (1620), and volume 3 of Franciscus Haraeus's *Annales Ducum Brabantiae* (1623).[25] Last but not least, the two putti whose heads extend into the blank margin of the copperplate are of a very Rubensian amplitude even though they are slightly more lethargic than the flying angels of his early altarpieces. In short, I consider it likely that we have here the first title page designed by Rubens. His original drawing may have resembled his drawing for the Richardot tomb done in 1609, though it was probably much simpler, in keeping with the more modest function it had to fulfill.[26]

The title page is followed by a full-page print containing a finely cut portrait of Ignatius inside an oval frame fitted into an architecturally enriched structure with lateral volutes (fig. 50). They support platforms on which two kneeling angels lift a curtain revealing the monogram of Christ in a glory of light.[27] Although this page is also superior to the corresponding one in the 1610 *Vita Dominici*, the rather conventional design of the angels and the outsize cherub's head under the oval frame are difficult to reconcile with Rubens's style. At best this is a questionable piece.

The title page and the one with the saint's portrait are unnumbered. They are followed by seventy-nine numbered pages, each one illustrating another episode from the saint's life.[28] They begin with his birth in a stable (where his mother, out of

24. See Evers, *Rubens*, figs. 75, 89, 120.
25. Ibid., figs. 84, 88, 95.
26. See Held, *Rubens*, no. 171, fig. 36.
27. A cartouche at the bottom contains a text alluding to passages in Jesus Sirach (47: 9, "In omni opere dedit confessionem Sancto") and Isaiah (66:20, "Et adducent omnes fratres vestros").
28. As is the case with many books of this kind, copies differ from one to another. If descriptions of the book are at variance, the fault may be with the particular example the writer worked from. According to Hecquet (*Catalogue*), the book has seventy-nine prints and a frontispiece. He did not mention the page with the saint's portrait. Basan (*Catalogue*), whose description was the most influential, maintained that the book consists of seventy-eight numbered pages, plus a frontispiece and a title. According to him the frontispiece contains the portraits of the principal Jesuits; the title has the actual text of the title "Vita Beati P. Ignatii. . . ." It is quite clear from his text that he considers these as two different plates, while actually it is only one. He too does not mention the page with

49. Title page,
Augustinus Torniellus,
Annales Sacri, 1620.
Engraving after Rubens.

50. *Portrait of Saint Ignatius*
from the *Vita Ignatii.*
Engraving.
Metropolitan Museum of Art,
Harris Brisbane Dick Fund.

piety, wanted to be delivered) and end with a scene depicting the disciples assembled around the open coffin filled with stars, while they hear the sound of heavenly music and are reassured by the sight of a supernatural glory that their beloved leader has been assumed by the heavens. As mentioned before, there exists an additional plate, unnumbered, and rarely, if ever, bound with the others, depicting the beatification of Ignatius by Pope Paul v. That page is the only one Hymans had found worthy to be reproduced in his book, since he felt that it, more than any other, might explain why Rubens had been credited with some of the designs—though, as we have seen, he did not give credence to this tradition.

As Mariette and Basan had already noticed, the style of these seventy-nine (or eighty) prints is far from homogeneous. The great majority appears to have been drawn by an artist (or artists?) capable of telling a story clearly in its appropriate setting; yet many of these prints, undeniably, are quite dull. One rarely finds any meaningful differentiation of features and expressions; gestures are conventional and the settings are often routinely divided between a few rudimentary scenic devices in the foreground and a panoramic backdrop in the distance.

There are, however, some pages to which this critique clearly does not apply. Among them are a few that lend themselves to a comparison with scenes belonging to what we may call the run-of-the-mill illustration. An instructive case is furnished by the comparison between plates 56 and 64 (figs. 51 and 52). The first illustrates the confirmation of the Society of Jesus by Pope Paul iii; the second the foundation, by Pope Julius iii, and upon the urgings of Ignatius, of the Germanic College in Rome. In each print a good many people watch as Saint Ignatius kneels before the enthroned pope. In plate 56, two seated figures (cardinals?) are used as repoussoirs; in plate 64 there is one such figure. Despite these superficial similarities, the two prints differ from each other fundamentally. In plate 56, Ignatius is rendered in profile and except for his place near the center has been given little prominence. In plate 64, Ignatius stands out not only because he is noticeably larger than the other figures but also because he is drawn in a fluid and expressive contrapposto as he pleadingly introduces to the pope a group of youthful Northerners. The intensity of his expression is made conspicuous by the radiance around his large head—a head, incidentally, that greatly resembles the one seen in plate 68 (fig. 45). Comparing the seated repoussoir figure at the left in plate 56 with the one at the right

the portrait of the saint. Although he differs from Hecquet in speaking of only seventy-eight numbered pages, his total comes to the same, namely eighty. The copy from which this writer has been working has seventy-nine numbered pages (in accordance with Hecquet's entry) but two additional plates (title and portrait) for a total of eighty-one.

51. *Confirmation of the*
Society of Jesus by Pope Paul III.
Engraving from the *Vita Ignatii*
(plate 56).

Paulus III Pont. Max. Societatis Iesu insti-
tutum ab Ignatio oblatum postquam legisset,
DIGITVS inquit, DEI EST HIC. Socie-
tatemque confirmat anno salutis 1540.

56

52. *Foundation of the Germanic College.* Engraving from the *Vita Ignatii* (plate 64).

Ignatij in Septemtrionis res apprime intenti
studio, ac precibus Iulius III. Pont. Max. Collegium
Germaniæ iuuentutis non minori Ecclesiæ Romanæ
ornamento, quam Germaniæ præsidio Romæ condit.

64

in plate 64, we notice how rigidly the former sits, his costume arranged in a few unimaginative folds, while the one in plate 64 assumes a relaxed and yet impressive pose, his ample gown adding dignity and grandeur. Similar observations could be made about the figures of the Popes, the baldachins of the thrones, and other details, but it may suffice to examine the setting itself. It features in each case a long, barrel-vaulted corridor ending in an open door. In plate 56, this part of the architecture forms a separate element; in plate 64, it is closely integrated with the action. (I might mention in passing that the third head from the left in plate 64 looks like an actual portrait which could perhaps still be identified.) In view of the stylistic differences and the marked superiority of plate 64, it should not come as a surprise that it is one of the illustrations of the *Vita Ignatii* for which Mariette owned the preliminary drawing—a drawing that he was sure was from the hand of Rubens!

The second of Mariette's drawings was for plate 67—a print so strikingly Rubenesque that it alone should have set to rest all doubts about the participation of the great master in this project (fig. 53). It represents the chastisement by demons, often experienced by Ignatius while he prayed or slept. In a bare room three muscular demons attack the sleeping Jesuit with a vicious fury that brings to mind the ordeal of Grünewald's Saint Anthony; a disciple watches the event from behind an open door. Connections with Rubens's work are easy to make: the foremost of the demons has a counterpart in the early sketch of the Martyrdom of Saint Stephen in the man at the right heaving a rock above his head (fig. 54).[29] The one with bat's wings recurs with only minor variations in several compositions by the master, for instance as an avenging angel, also relying on his bare fists, in the 1622 *Fall of the Rebel Angels* in Munich (*KdK* 241). In sheer dramatic power this print surpasses not only all other engravings in the *Vita Ignatii* but should by rights take an important place in any study of Rubens's early approach to the theme of violence.[30]

It may suffice to introduce one more scene and a "control" example from the non-Rubens group of the 1609 engravings. Plate 77 depicts the scene of Ignatius's death and the ascension of his soul to heaven, an event witnessed in the background by a noble lady from Bologna (fig. 55). In the group of mourners around the saint's

29. See Susanne Heiland, "Two Rubens Paintings Rehabilitated," *Burlington Magazine*, 111 (1969): 421–27, fig. 13.

30. According to Mariette (*Abecedario*, 5: 103) this print was copied in an etching by Gérard Audran, who assumed, however, that it was a composition by Raphael! Mariette ends with the terse remark: "Je ne comprends pas comment M. Audran a pu tomber dans un pareil écart." A copy of this print (0.12 x 0.099 mm) is in the Metropolitan Museum of Art. (Information kindly provided by Miss Mary L. Myers.)

*53. Saint Ignatius Attacked
by Demons.*
Engraving from the
Vita Ignatii (plate 67).

*Sæpe noctu inter orandum, aut qui=
escendum à Dæmonibus verberatur.*

67

54. Rubens, *Martyrdom of Saint Stephen*. Oil sketch.
Collection of His Majesty the King of Belgium, Brussels
(photo: A.C.L.).

bed is one, holding a crucifix, whose movement is reminiscent of the contrapposto of Ignatius in the founding of the Germanic College (fig. 52). The two men at the left are particularly expressive in their grief, and there is no parallel to such figures in the non-Rubensian part of the series. Yet it is the angels flying above that lend themselves to a comparison with a non-Rubens plate. In plate 9, where an almost simpering Ignatius accepts the Virgin's chastity as her perpetual gift, the two angels holding the scroll inscribed "Donum Castitatis" are of nearly quattrocentist brittleness (fig. 56); the two angels in the death scene by contrast are depicted in fluid and complex motions. While the angels of plate 9 are arranged in dull symmetry, those of plate 77 fly heavenward in a graceful correspondence of linear movement, carried along by their billowing draperies as much as by their wings. They are near relatives of such Rubens angels as the one seen flying in the Brussels sketch of the Martyrdom of Saint Stephen (fig. 54).

The proof-print of plate 77 in the Bibliothèque Nationale (there numbered 75)[31] is one of the several proofs that bear corrections done in pen and ink. In this particular case the correction is very minor: it consists of a few lines across the dying man's chest, suggesting the upper end of the blanket that covers him. Although never extensive, and occasionally supported by a rapid marginal sketch in chalk, these corrections are invariably meaningful. Thus on plate 74 (72 of the proofs), depicting the miraculous cure by Ignatius of Alexander Petronius, the cape of the saint was lengthened, perhaps for the sake of decorum, so as to extend beyond his left heel, and an additional layer of shadow was drawn across the adjoining part of the cassock which logically had now to be in shade (figs. 57 and 58).

Some interesting corrections can be observed on plate 66 (65 of the proofs) where Ignatius, seated on a chair converts an "obstinate Jew" by addressing to him only the words: "Stay with us, Isaac" (*Mane nobiscum Isaac*) (figs. 59 and 60). In the proof-print Isaac had appeared walking towards the saint, and in a first change the artist had made his stride still more emphatic by placing the left leg farther back. On second thought, however, he decided differently and sketched the new position on the right margin. He now put the feet close together, as an obvious demonstration of the saint's power to immobilize the Jew, and this version was adopted, with some further modifications, in the final print. Nor was the correction of Isaac's legs the only one. The outlines of Ignatius's knees and the folds of the cassock on his left thigh were also changed, and clearly for the better.

31. The numbers of the proof-prints do not always agree with those of the final edition. There are two prints numbered 43 and two 68, which necessitated some later adjustments. Plate 77 of the book bears number 75 in the proofs.

55. *Death of Saint Ignatius.*
Engraving from the
Vita Ignatii (plate 77).

Romæ sanctissime moritur, eodemque
puncto temporis beata eius anima, ingenti
splendore conspicua, Bononiæ a nobili,
sanctaq foemina ferri in coelum aspicitur.

75

56. *Saint Ignatius Receives
the Gift of Chastity.*
Engraving from the
Vita Ignatii (plate 9).

In eodem itinere, B.Virginis amore, atque
imitatione succensus voto se illi castitatis
obstringit; eiusdemq̃ castitatis, omni extincto
impuritatis sensu, perpetuum donum accipit.

9

57. *Miraculous Cure of*
Alexander Petronius.
Engraving from the
Vita Ignatii (proof, number 72).

Alexandri Petronij morbo laborantis cu-
biculum aduentu suo, magno repente
fulgore collustrat: ægrum colloquio sanat;
ac sæpe alios inuisens itidem sanat.

72

58. *Miraculous Cure of*
Alexander Petronius.
Engraving from the
Vita Ignatii (plate 74).

Alexandri Petronij morbo laborantis cu=
biculum aduentu suo, magno repente
fulgore collustrat: ægrum colloquio sanat;
ac sæpe alios inuisens itidem sanat.

74

59. *Conversion of
Isaac the Jew.*
Engraving from the
Vita Ignatii (proof, number 65).

Obstinatum Iudæum tribus hisce verbis
conuertit. MANE NOBISCVM ISAAC.

65

60. *Conversion of Isaac the Jew*.
Engraving from the *Vita Ignatii* (plate 66).
Metropolitan Museum of Art, Harris Brisbane Dick Fund.

Obstinatum Iudæum tribus hisce verbis
conuertit. MANE NOBISCVM ISAAC.

66

In order to establish the extent of Rubens's contribution to the illustration of the 1609 *Vita Ignatii* it is advisable to return once more to the eighteenth-century connoisseurs, Mariette, Hecquet, and Basan.

The name of Rubens (in the abbreviated form "Rub.") is inscribed on twenty of the proof-prints that came from the collection of Mariette.[32] Yet Mariette himself accepted in the end only eight of the prints as indubitably the work of the master. They are numbers 43, 49, 54, 64, 67, 69, 77, and 78. Hecquet lists only seven as based on Rubens's designs: 43, 55, 56, 64, 67, 69, and 78. Basan's list is somewhat longer; fourteen in all, they are numbers 13, 43, 46, 49, 50, 55, 56, 64, 67, 69, 73, 74, 77, and the unnumbered plate of the saint's beatification (which Mariette and he took to be his canonization). Although there is a core of drawings accepted by all three experts (43, 64, 67, 69—the last three vouched for by original drawings in Mariette's collection), it is obvious that already in the eighteenth century the decision "Rubens or not Rubens" had to be made on the basis of style.

Moreover, neither the presence in, nor the absence from Mariette's, Hecquet's, or Basan's lists can be taken as evidence for or against Rubens's authorship of any particular design. The print of plate 68, which served as our point of departure and is today the only one for which an original drawing has come to light, does not figure in any of these lists. Plate 56, by contrast (fig. 51), which both Hecquet and Basan accepted as one designed by Rubens, falls far short, as we have seen, of the standards set, for instance, by plate 64 (fig. 52).

In view of the difficulties that still persist of recognizing Rubens's hand in the disguise of uncongenial engravings, and as an admission of my own sense of doubt in a number of cases, I consider it prudent to draw up two lists. The first (group A) comprises those prints where the attribution to Rubens can be made on strong stylistic evidence and/or is supported by other factors (drawings extant or reported to have been known in the eighteenth century); the second (group B) is of borderline cases, where some elements of style or design suggest Rubens's intervention but where the attribution of the whole composition remains uncertain.

Group A: Plates 64, 66, 67, 68, 69, 73, 74, 77, 78, and the title page, a total of ten prints.

32. The following is a list of those plates that carry the inscription "Rub." (the numbers in parentheses are those of the proof-prints, wherever they differ from the final edition): 13, 14, 34, 43 (43a), 46 (45), 48 (47), 49 (48), 50 (49), 54 (53), 55 (54), 56 (55), 64 (63), 69 (68²), 73 (71), 74 (72), 76 (74), 77 (75), 78 (76), 79 (77), and unnumbered (78). Mlle Hébert informed me that the inscriptions identifying Rubens as author might have been added by Joly, keeper of the Cabinet des Estampes du Roi.

Group B: Plates 17, 27, 43, 46, 48, 49, 71, 79, and the unnumbered plate of the beatification, a total of nine prints.

It will be seen that of the eight prints listed by Mariette, five are in group A, and two in group B; of the seven itemized by Hecquet, four remain in group A, and one in group B; of Basan's fourteen, six are in group A, three in group B. Completely eliminated were one from Mariette's list, two from Hecquet's, and five from Basan's. Figuring for the first time in this author's list are the title page and plates 66 and 68.

If I am correct in crediting to Rubens all the prints of group A, it means that Rubens's early work for the illustration of books should be increased by ten items, not counting the possibility that he may have had a hand in several, if not all, the prints of group B.

Having established, I hope with a fair degree of certainty, that the eighteenth-century connoisseurs were correct when they asserted that Rubens had been involved in the preparation of the *Vita Ignatii* of 1609, we must now pose the intriguing question of whether his drawings for the book were made while he was still in Italy or after he had returned home. Since the book was published in Rome, it is only natural to assume that his work for it was done during his last period in Italy when, owing to his work for the Roman Oratorians, he was stationed in that city for about two years. (Basan, in fact, stated point-blank that the prints are based on drawings that Rubens had made "étant à Rome.") It is true that he had left the city precipitously on October 28, 1608, but this hardly creates any difficulties since it is obvious that the production of a book containing eighty-one delicately engraved copperplates (not counting the print of the beatification produced separately) must have taken a considerable period of time.

Plausible though it is, this theory runs into a number of difficulties as soon as we look at it more closely. The problem involves, first of all, the possible identity of the engraver(s).[33] Two names have figured prominently in previous accounts. Hecquet, Basan, Cicognara, Schneevoogt, Dutuit, Wurzbach, and Hollstein attributed the

33. It was not at all uncommon for several engravers to be employed in the production of one book. The fourteen prints of the Life of Ignatius of 1610 (see above p. 101 and note 14) were engraved by four different artists: Theodoor Galle, Cornelis Galle, Adriaen Collaert, and Carolus de Mallery. So similar is the style of their work that were it not for the fact that each artist signed his own work, it would be most difficult to tell their prints apart. The *Vita D. Thomae Aquinatis*, after designs by Otto van Veen, published in Antwerp in the same year 1610, contains thirteen prints by C. Boel, thirteen by E. van Panderen, two by G. Swanenburgh, and two by C. Galle.

prints to Cornelis Galle I (1576–1650), probably because they knew him to have been the first engraver to work for Rubens and to have continued working for him, his specialty being the engraving of title pages. Hymans, Funck, and van den Wijngaert thought Jan Baptist Barbé (1578–1649) to have been the engraver. Mariette appears to have changed his mind: in one section of the *Abecedario* he gave the prints to Barbé; in another to Cornelis Galle. (In Thieme-Becker's *Künstlerlexikon* the book is listed, with admirable impartiality, among the works of Barbé [II, p. 466] *and* of Galle [XIII, p. 106].)[34] No one, at any rate, has ever suggested that the engravings might have been done by an artist of another than the Flemish school, and the prints are indeed characteristic products of the Antwerp school of engraving. Many Flemish engravers spent some time in Italy, but if the book was actually produced in Rome, Cornelis Galle's name must be dropped since he had returned to Antwerp no later than 1604, and probably before that date.[35] Barbé may still have been in Italy in 1608–09 (he was inscribed as free-master in the Antwerp guild in 1610), and his style of engraving is not incompatible with that found in the *Vita Ignatii*.

Yet we must not overlook the fact that still another question is here involved—the identity, or at least the nationality, of the designer of the majority of the illustrations in the *Vita Ignatii*. This man, too, must have been a Fleming. His work, even though inferior to that of Rubens, is typical of the kind of book illustration produced in Antwerp in the early seventeenth century.[36] If we persist in accepting Rome as the place of actual *production* of the book, we are forced to assume that in the critical period, i.e., before Rubens's departure, there was present in that city another artist capable of designing the bulk of the prints, in addition to one or several engravers, all of them of Flemish origin and training.

While it is obviously not impossible that the book was indeed produced by members of a Flemish artists' colony in Rome, we should perhaps seriously consider the

34. Hollstein (*Etchings, Engravings and Woodcuts*, 7: 57) lists Galle as the publisher of the book ("C. Galle excud."), although this information is found nowhere before and does not appear, as far as I know, in any copy of the book.

35. According to van den Wijngaert (*Inventaris*, p. 28) Galle returned to Antwerp in 1602–03.

36. Dutuit (*Manuel*), and following him van den Wijngaert (*Inventaris*), may have thought of this problem when they credited Barbé not only with the execution of the prints but also with their design. Yet Barbé worked almost exclusively from the designs of other masters, and we have no evidence that he would have been capable of a major project like the *Vita Ignatii*, even if it had been entrusted to him, which is most unlikely.

possibility that it was designed and engraved in Antwerp and then shipped to Rome, to be distributed directly from the office of the General of the Jesuit order. The highly irregular fact that no publisher's name is mentioned anywhere may find its explanation in such a somewhat unusual procedure.

The hypothesis of an Antwerp origin of the book can perhaps be supported by an additional observation. Despite some variations in the lists of Rubens's prints as given by Mariette, Hecquet, Basan, and this author, there is a general agreement that virtually all belong to the second half of the book. In my own list of group A, the last nine numbered prints out of eleven begin with plate 64! The title page should probably be counted among these last prints since we know that titles usually came late in the production schedule. It almost looks as if whoever was in charge of the undertaking took advantage of the recent return of Rubens from Italy to obtain from him sketches for plates that had not yet been designed, or not yet engraved. Rubens may also have been asked to make suggestions for the improvement of some of the earlier designs, which would explain the corrections, on some proof-prints in the Bibliothèque Nationale, of designs surely not done by Rubens in the first place.[37] It is well known that Rubens generally refused to get his own work combined, and possibly confused, with that of other artists. Yet he may have made an exception in this case, since he had always been close to the Jesuits in general, having painted important works for Jesuit churches in Mantua (1604–05) and Genoa (1606), and could well foresee that the Antwerp Jesuits might become important to him as future patrons. In fact, one of the first paintings done after his return from Italy was an Annunciation (Vienna) done for the Sodality of the Antwerp Jesuits. Soon thereafter he was asked to furnish a title page and six vignettes to the book on optics written by Franciscus Aguilonius, who in 1613 succeeded Carolus Scribanius as head of the Antwerp Jesuits. And in 1615 began the intense collaboration of Rubens and the Antwerp Jesuits leading to the famous decoration of the new Jesuit church with sculptures and paintings based on Rubens's designs.[38]

In conclusion I should like to touch briefly on two points of interest connected with Rubens's work for the *Vita Ignatii*. Although Rubens had contributed decorations for Jesuit churches in Italy, his chief patrons during the last years there had

37. I am inclined to attribute the design of the bulk of the illustrations to Peter de Jode (1570–1634), one of the most versatile designers of illustrations for devotional books published in Antwerp.

38. For Rubens's work for the new Jesuit church in Antwerp see John Rupert Martin, *The Ceiling Paintings for the Jesuit Church in Antwerp*, Corpus Rubenianum, I (Brussels, 1968), and this author's review in *Zeitschrift für Kunstgeschichte*, 32 (1969): 84–89.

been the Roman Oratorians. It is therefore worth mentioning that on plate 73 of the *Vita Ignatii*—one of the prints based, I believe, on Rubens's design (fig. 61)—we see a meeting between Ignatius of Loyola and Filippo Neri, the founder of the Oratory. We are told that Filippo Neri often saw Ignatius's face radiant in an extraordinary luminosity, and this he took to be a manifest sign of Ignatius's sanctity. By depicting an aqueduct in the distance, the artist probably wanted to indicate that the meeting takes place just outside the walls of Rome. In accordance with the purpose of the book, prominence is given to Ignatius, but it was certainly a highly meaningful idea to enlist the testimony of the popular head of the Oratory in a drive to canonize the great Jesuit. (It is said that the Jesuits had actually tried to persuade Filippo Neri to join their company.)

According to Justus Müller Hofstede, Rubens drew another portrait of Filippo Neri.[39] He recognized a drawing Lugt had listed among the works of the school of Rubens[40] as a portrait of Filippo Neri and argued that it had been drawn by Rubens himself around 1606 in Rome. In his study Müller Hofstede pointed out that portraits of Filippo Neri, whose modesty rendered him reluctant to pose, are based either on Neri's death mask, still preserved in the Camera di S. Filippo in Sta. Maria in Vallicella, or on a study painted between 1590 and 1595 by Cristoforo Roncalli (Il Pomerancio). If this is so, the portrait of Filippo Neri in the *Vita Ignatii* derives more likely from Roncalli's picture than from the death mask. At any rate, Neri's portrait in the *Vita Ignatii* may itself have contributed to establish an iconographic tradition, as may be seen from Algardi's bust (Palazzo Barberini) (fig. 62), which closely resembles Rubens's rendering in the print of 1609. It is in Algardi's bronze that we recognize again the lean, shrewd, and down-to-earth head of the founder of the Oratory which Rubens had so effectively contrasted, in the *Vita Ignatii*, with the highly intellectual and at the same time deeply emotional countenance of the Jesuit.[41]

It is only fair that at the end we return once more to the Louvre drawing (fig. 44), the piece that has triggered a minor avalanche of Rubensian problems. With its

39. Justus Müller Hofstede, "Rubens' Bildnis des Hl. Philip Neri," in *Kunstgeschichtliche Studien für Kurt Bauch* (Berlin, 1967), pp. 171–80.

40. Lugt, *Ecole flamande*, 2, no. 1242, pl. LXXV.

41. The more famous full-length marble of St. Filippo Neri with an angel that Algardi made ca. 1640 for Sta. Maria in Vallicella (see W. Vitzthum, *Alessandro Algardi* [Milan, 1966], pl. IV) renders the saint in a visionary pose and hence is less comparable to the Rubens print than the bronze bust in the Galleria Nazionale that stresses his down-to-earth appearance.

61. *Meeting of Saint Ignatius and Saint Filippo Neri.* Engraving from the *Vita Ignatii* (plate 73).

Sæpe B. Philippus Nerius illius faciem
insigni luce radiantem videt, illustri,
vt ipse dicebat, indicio sanctitatis.

73

62. Alessandro Algardi,
Portrait of Saint Filippo Neri.
Bronze. Palazzo Barberini,
Galleria Nazionale, Rome.

contribution to our knowledge of the *Vita Ignatii*, its importance for the student of Rubens's work is by no means exhausted. After all, it is not only the earliest-preserved drawing made by the master as a model for the engraver. It contains also Rubens's earliest, unquestionably authentic sketch of a landscape.

Admittedly, its function as model for an engraving sets it apart from Rubens's relatively few landscape drawings that are largely drawings of individual landscape motifs.[42] Nevertheless, it is easy to see that the setting for Ignatius's nocturnal contemplation of the glory of the heavens is in general harmony with landscape drawings done by Rubens about a decade later, such as the drawing with the fallen tree in the Louvre (fig. 63).[43] More important, however, than its kinship with other Rubens landscape drawings is the role this little piece may be destined to play in one of the still unsolved questions that have plagued modern research in this field. I refer to a group of landscape drawings often attributed to Rubens's early career. Michael Jaffé addressed himself to this problem,[44] and I also made a reference to it in the introduction to my book on Rubens's drawings.[45] The debate is about a group of nine drawings with views of Flemish farms, some of which bear identifying inscriptions and dates ranging from 1606 to 1610.[46] Jaffé rejected the attribution to Rubens of all sheets except one, in Berlin, rendering a farm near Roggeveld. I also admitted the possibility that not all these drawings were by the same hand but could not recognize Rubens's hand in any of them. I tentatively suggested Jan Wildens as a possibility but have since been informed by Wolfgang Adler, who wrote a dissertation on Wildens, that this theory cannot be sustained, and I am happy to withdraw it. In fact, Mr. Adler in a personal communication most spiritedly defended the stylistic cohesion of all these drawings and equally emphatically stated his conviction that Rubens was indeed the author of them all.

Since all scholars are agreed that the inscriptions on these drawings are not in Rubens's hand, and since in 1606—the date inscribed on two of them—Rubens was still in Italy, and since, moreover, there is no reason *prima facie* to question the

42. See Held, *Rubens*, 1: 34–46.
43. Ibid., no. 131, pl. 140.
44. "A Sheet of Drawings from Rubens' Second Roman Period and His Early Style as Landscape Draughtsman," *Oud Holland*, 72 (1957): 1–19.
45. Held, *Rubens*, 1: 8–9.
46. There are two drawings in Berlin, dated 1609 and 1610; one in Amsterdam, dated 1606; one in Antwerp, dated 1609; one in Basel, collection von Hirsch; two in London, dated 1606 and 1609 respectively; one in New York, Morgan Library; and one in Paris, dated 1609.

63. Rubens,
Landscape with a Fallen Tree.
Drawing. Louvre, Paris
(photo: A.C.L.).

genuineness and reliability of these dates and inscriptions, scholars who insist on Rubens's authorship carry a heavy burden of proof to show why this information should be disregarded. The Louvre drawing for the *Vita Ignatii* now provides, I believe, new ammunition against Rubens's authorship of the drawings of Flemish farms, even if one makes allowance for differences of size and function.

Some of the drawings of Flemish farms do not lend themselves for comparison primarily because they depict the landscapes at a time when the trees are bare. This is not the case, however, with one of the prettiest pieces of the series, the view of the *Keyzershof* in the Morgan Library (fig. 64). If it were by Rubens, the Morgan drawing would have to be dated around 1610—as was done reasonably enough in the 1956 catalogue of the Rubens exhibition held in Cambridge and New York[47]—in other words in very close chronological proximity to the Saint Ignatius drawing in the Louvre. Yet they are separated by fundamental differences of approach. These differences cannot be blamed on the different character of the two scenes, though there is surely little *qua* theme that connects the portrait of a Flemish farm with the lonely beauty of the setting for Ignatius's tearful contemplation. What really matters is that the artist of the Morgan drawing sacrificed three-dimensional solidity of tree trunks and foliage to a purely decorative and essentially flat treatment of these forms. Moreover, in all his painted landscapes, and in those drawings that are undoubtedly his, Rubens suggested movement of forms in nature by observing the interaction of wind and weather with the forces of growth (and decay) inherent in the plants themselves. This vision of nature is manifest in the Louvre drawing for the *Vita Ignatii*, but entirely absent in the drawing of the Morgan Library—and for that matter in all the other drawings belonging to this group.

In the article referred to above, Mr. Jaffé published several other landscape drawings that he thought were done by Rubens during his Italian period.[48] This is not the place to make a detailed examination of each of these drawings, but they, too, should be studied again in the light of the Louvre drawing for the *Vita Ignatii*. Granted that a certain flexibility of critical standards is necessary in measuring out the work of a great master. Yet it may well give food for thought when we see how

47. *Drawings and Oil Sketches by P. P. Rubens*, p. 15, no. 9.
48. Jaffé, "A Sheet of Drawings." These additional drawings are a sheet, drawn on both sides, owned by J. Q. van Regteren Altena; a drawing in the Albertina, showing the ruins of the Palatine in reverse and for that reason alone suspect (it had been rejected, I believe correctly, by Gustav Glück); and a landscape with a water mill in Oxford, an attribution in support of which Jaffé quoted a drawing in London (Hind, *Dutch and Flemish Artists*, 2, no. 88) in which I cannot see Rubens's hand.

64. Anonymous, ca. 1610,
Landscape with Farm Buildings.
Drawing. The Pierpont Morgan
Library, New York.

smoothly the landscape of the Louvre study of circa 1609 fits into the accepted body of Rubens's landscape drawings, while each one of the sheets reproduced in *Oud Holland* stands pretty much alone.[49]

49. I regret that only after the completion of this manuscript did I see Graham Smith's article "Rubens' Altargemälde des Hl. Ignatius von Loyola und des Hl. Franz Xaver für die Jesuitenkirche in Antwerpen," *Wiener Jahrbuch für Kunstgeschichte*, 29 (1969): 39–60. Smith refers several times to the 1609 *Vita Ignatii* (p. 51, n. 28; p. 55, n. 44; and p. 59, n. 51) and reproduces two of its prints (pls. 34 and 48, his figs. 32 [unfortunately printed with the caption for fig. 34] and 37). He seems to follow Hollstein in attributing the prints to Cornelis Galle I, and states that the incidents were "undoubtedly" taken from Ribadaneyra's book. In passing, he quotes a passage from Ribadaneyra, according to which Ignatius was so apt to cry profusely when celebrating mass that he almost lost his eyesight (p. 55). Unless Ribadaneyra himself repeated this formulation a second time when speaking about the saint's emotion contemplating the heavens, the curiously similar wording might indicate that the text of the 1609 book was at least in part the work of somebody else.

Catalogue

Introduction to the Catalogue

David W. Steadman

The year 1620 saw a major shift in Peter Paul Rubens's career. On March 29 of that year the 42-year-old artist signed a contract to execute the ceiling decorations in the Jesuit Church in Antwerp. This large commission was to be the first of many large decorative cycles that Rubens produced in the last twenty years of his life. In the 1620s he made the sketches for the Life of Maria de Medici, for the life of Henry IV, and for the series of tapestries of the *Triumph of the Eucharist*. In the final decade of his life he produced the designs for the ceiling of the Banqueting House in White-hall, for the triumphal entry of the Cardinal Infante Ferdinand, and for the Ovid-ian cycle in the Torre de la Parada.

These large commissions from the royal families of France, Spain, and England were very important in maintaining Rubens's fame as the leading painter in the southern Netherlands. However, we should remember that by 1611 Rubens had already reached maturity as an artist, a fact reflected in his growing reputation, and that his paintings of that decade include some of his very finest works.

We know only very few paintings by his hand prior to his departure from Ant-werp to Italy in 1600. In Italy he became the court painter to the Duke of Mantua, in whose service he traveled to Spain and Rome. Returning to Antwerp in 1608, he soon became the court painter to the rulers of the southern Netherlands, the Arch-dukes Albert and Isabella. For the Church of Saint Walburgis Rubens painted his first major altarpiece in the north (he had made several such works in Italy), the *Raising of the Cross* (fig. 29), which was followed a few years later (1611–14) by the great triptych of the *Descent from the Cross* (fig. 30). Among the many memorable works painted during the remainder of the decade are the *Fall of the Rebel Angels* and the *Battle of the Amazons*, both in Munich, the *Descent from the Cross* in Valenciennes, the *Adoration of the Magi* in Mechlin, *Daniel in the Lions' Den* in

the National Gallery of Art, Washington (fig. 66), and the *Last Communion of Saint Francis of Assisi*, now in the Royal Museum at Antwerp.

It was during the period from 1613 to 1615 that Rubens painted the central work in the exhibition, *Cupid Supplicating Jupiter* (cat. 1). By good fortune one of the preparatory drawings for this painting still exists (cat. 2), as does also a drawing after the painting by a member of Rubens's studio (cat. 3). This happy survival of painting and drawings was the nucleus of the exhibition at Princeton. The ideal exhibition would be one in which all the preparatory drawings and paintings by Rubens before 1620 could be brought together. Although this dream was obviously impossible to realize, The Art Museum was able to assemble fourteen drawings by Rubens from American and Canadian collections to show the range of Rubens's work during the first two decades of his career, to illustrate his working method as a painter, and to present in visual form his growth as a draftsman.

Some of Rubens's earliest drawings, such as the *Two Warriors* (cat. 4), are copies of paintings, drawings, or most often engravings by earlier artists. Rubens continued to make copies throughout his career. The *Psyche Offering the Jar of Proserpine to Venus* (cat. 10), a copy of an engraving after a composition designed by Raphael for the Villa Farnesina in Rome, was drawn circa 1611. Both of these works are among the several hundred surviving copies by Rubens. His choice of models among Italian masters was quite catholic: Raphael, Leonardo, Titian, Correggio, Del Sarto, Polidoro, Giulio Romano, Pordenone, Tintoretto, Muziano, Barocci, and others. Of the works by northern artists, only those after Peter Breughel the Elder are well known today. But Rubens copied Tobias Stimmer, Joost Amann, Stradanus, Burgkmair, and van Meckenem, among the lesser-known artists. His interest was therefore surprisingly wide and representative of the two traditions out of which he drew nourishment, the Italian Renaissance and northern sixteenth-century art.

These copies seem to have served several purposes. First of all, many early drawings such as the *Two Warriors* were learning exercises in which the young artist studied works of the past. Secondly, a collection of copies took the place of an art-reference library. It is probably for this reason that the mature Rubens commissioned younger artists to make copies for him. Finally, in an example like *Psyche Offering the Jar of Proserpine to Venus*, the addition of his own inner vitality to another artist's idea or motif became a way in which Rubens could invigorate other artists' compositions.

The tight control of line in the *Two Warriors* bespeaks the close and meticulous copying of a late-sixteenth-century engraving. In sharp contrast to the rigidity of

the copy are the rapid pen strokes of the *Mystic Marriage of Saint Catherine* (cat. 5), probably drawn only a year later. Here Rubens is trying to work out an entire composition for a painting, and it is the placement of the figures and their broad gestures that interest him. There is a marvelous feeling of spontaneity about the drawing, but complete control over anatomy and sureness of details are lacking.

In the *Triumphant Return of Horatius* (cat. 6) of the same years, we see a real hesitancy in the lines, which seem to meander and waver on the page. The use of shading is completely arbitrary, and although the basic composition of a line of figures is simple enough, the lower parts of the bodies are extremely confused. It is impossible to discern complete figures, except for that of Horatius himself. There are, however, marvelous passages in the heads, and it is the psychological reactions of the spectators that seem to interest the young Rubens.

The *Mystic Marriage of Saint Catherine* was, as we have noted, a study for the composition of a painting. No compositional studies have survived—we presume they were made—for his first large altarpiece in the north, the *Raising of the Cross* (fig. 29), now in the Antwerp Cathedral. There is, however, a compositional study of the *Presentation in the Temple* (cat. 9) for the right wing of the triptych, the *Descent from the Cross* (fig. 30), done in the years immediately following. The broad pen strokes seek to define essential positions and gestures of the figures. This element of search in the very process of drawing is particularly noticeable in Rubens's changes in the Virgin's torso and the head of the man on the left. The wash is used here to suggest both the volume of the figures and the pattern of light and shade within the composition.

Rubens's method of painting was, first, to work out the composition in rapidly executed drawings and then to make close studies after models for critical figures within the composition. The *Christ* in the Fogg Art Museum (cat. 8) is a study for the principal figure in the *Raising of the Cross* (fig. 29). If we compare this figure to the painted Christ, we can see how Rubens has studied a young model in the drawing and made the suitable alterations of age and beard in the painting. The musculature so surely and subtly defined in the drawing is made simpler and broader in the painting, but that change was a necessity in a painting that was to be seen from a great distance, as was the case in Saint Walburgis.

At the top right of the *Christ* there is an isolated thumb that we can quickly determine belongs to the figure's left hand. It is typical of Rubens's drawing method that if he runs out of space, he continues the missing fragment on another part of the same paper rather than stopping to enlarge the sheet by adding patches.

The *Adoration of the Magi* (cat. 11) illustrates the role that engravings came to

139

play in the total output of Rubens's drawings. Starting in 1611 he began a fruitful relationship with the Plantin-Moretus publishing house in Antwerp. For them he was to provide drawings for title pages and book illustrations during the rest of his career. The engravings made after his designs were protected by a royal patent (similar to our copyright) and could not be legally reproduced. Single engravings could also be thus protected, and Rubens employed the best engravers of his day to copy his paintings. As an employer he was able to retain artistic control of the engravings (short of doing the actual work himself) as well as to receive a not inconsiderable income from their sale. The control of quality was of great importance to him because it was through engravings that his works became widely known.

The *Adoration of the Magi* is a good example of a drawing sold by the artist to the Plantin-Moretus publishing house to be translated into an engraving. In all of the first drawings Rubens made for the purpose of reproduction, he tried to ensure a result as close to his intentions as possible. Thus this drawing is very highly finished. The outlines of the figures and setting are crisp; the open cross-hatching is to suggest to the engraver the most desirable direction of burin grooves, and the bistre washes indicate the areas of denser layers of shadows. Unfortunately the engraving (fig. 65), made by one of the better engravers of the seventeenth century, fails to capture the sparkle and life of the Rubens drawing.

The hesitancy of line and the lack of anatomical precision are completely overcome in the drawings of the mid-teens. The *Cupid* in Ottawa (cat. 2) shows Rubens at his full power as a draftsman. Every line is essential in the drawing. The outline of the face is so superbly drawn that it indicates both the sharpness of the nose and the fleshiness of the lips and chin. The plumpness of the youth's cheeks is economically indicated by the heavy shadow near the nose, and the strength of Jupiter's hand is captured with only a few quick strokes of black chalk and two touches of white gouache.

The *Two Studies of a River God* in Boston (cat. 13) appears to be both a compositional study and a study of individual figures. However, no composition after the drawing is known. The complete mastery of anatomical delineation of the river god in the foreground is typical of life-studies such as the *Cupid* and the *Daniel* (cat. 12), a study for the central figure in the painting *Daniel in the Lions' Den*, now in the National Gallery of Art, Washington (fig. 66).

All three drawings have great inner vitality and dignity. They are majestic both in shape and in spirit. All three, unlike the earlier drawings, are drawn on rough-textured paper with black chalk. The effect is to break up the hardness of line so prevalent in the earlier drawings and to suggest instead light and atmosphere

65. Theodoor Galle,
after Rubens,
Adoration of the Magi.
Engraving.
New York Public Library.

66. Rubens,
Daniel in the Lions' Den.
National Gallery of Art,
Washington, Ailsa Mellon Bruce Fund.

through the granular effects of texture and medium. In the *Daniel* there is an astonishing contrapuntal rhythm between the few crisp lines in the loincloth, hands, and face and the almost palpable softness of the shadows. The peculiarly moving combination of psychological tension and resignation in the figure is made visible both through the pose with its contrast between the casually crossed legs and the tightly clasped hands and through the subtlety of the contrasts in the delineation.

The sense of spontaneity and complete control that pervades the three life-studies of the mid-teens is present in the two drawings of an *Angel Blowing a Trumpet* (cat. 14 and cat. 15). These drawings, like the *Adoration of the Magi* (cat. 11), were intended to be used for a purpose other than painting, in this case as models for the sculpture above the main portal of the Jesuit Church in Antwerp (fig. 67). Like the *Daniel*, the power of the two drawings depends on Rubens's ability to capture simultaneously two seemingly contradictory moods. On the one hand, there is languid sensuality in the relaxed poses and the sweeping rhythms of the drapery and wings and, on the other, great vitality in the physical effort of blowing, as indicated by the straining necks and faces.

The *Saint Gregory of Nazianzus* (cat. 16) is a compositional drawing for one of the ceiling paintings in the Jesuit Church in Antwerp, the first of the large commissions that were to play so significant a role in his late years. As Julius S. Held has pointed out, in an unusual way it "combines the imaginativeness of a first study with the precision and the clarity of studies from life."[1] The two nude male figures have all the vigor and show the careful observation of the life-studies, while the rather chaotic passages of the saint's robe show the artist searching for a solution to the placement of the legs and garments. In the process of distilling a composition to its maximum effectiveness, Rubens was willing to sacrifice brilliant passages like these two nudes. If we compare the drawing with the oil sketch (fig. 68) which followed it, we can see that Rubens has deleted the two powerful males in order to achieve a composition better suited to an octagonal frame. An alternative compositional solution appears, however, in the drawing as well, showing that Rubens had thought through the problem in chalk before taking up the brush. The torso and legs of the small putto at the top originally went towards the right. Once the decision to omit the two figures was made, Rubens drew a second body for the putto, with the legs going towards the left, which is, in fact, drawn over the angel's wing. At the same time, the demon that was to replace the carefully delineated demon in the drawing is lightly drawn at the lower left.

The existence of a preparatory compositional drawing and oil sketch marks a

1. *Rubens, Selected Drawings*, 2 vols. (London, 1959), 1: 73–74.

67. *Main Portal of the*
Jesuit Church in Antwerp,
now Saint Charles-Borromeo.

68. Rubens,
Saint Gregory of Nazianzus.
Albright-Knox Gallery,
Buffalo.

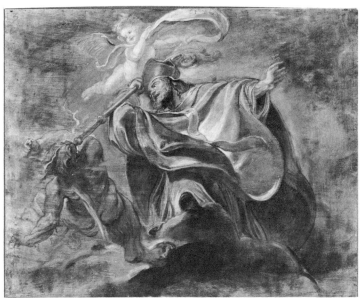

change in Rubens's method of creating a painting. During the remaining years of his life he was to make almost no compositional drawings, concentrating instead on the preliminary oil sketch. This change did not mean that Rubens abandoned drawing as a creative medium. There are many superb drawings from the last two decades of his career.

The fourteen drawings in the exhibition illustrate the many uses that drawings had for Rubens. Copies served as learning exercises; compositional drawings were the means of organizing a composition; life-studies aided in the creation of individual figures in paintings; and drawings served as models for engravings and sculpture. As we follow the drawings chronologically, we can see the growth of Rubens as an artist. There is in the drawings of the period between 1610 and 1620 a simplicity of means which captures an increasing complexity of content. Not only is he by that time in firm control of anatomy through lines and shading but also he is able to depict atmosphere and light as fully expressive elements. There is nothing superfluous in these drawings. Every line has something expressive to say. Above all, there is an inner spirit and intense sense of vitality in Rubens's mature drawings. The concentration and distillation of life and energy in them are, as in all great art, life-enhancing.

Key to Abbreviations Used in the Catalogue

BOOKS

Burchard and d'Hulst 1963 · L. Burchard and R.-A. d'Hulst, *Rubens Drawings*, Brussels, 1963.

Glück and Haberditzl 1928 · Gustav Glück and Franz Martin Haberditzl, *Die Handzeichnungen von Peter Paul Rubens*, Berlin, 1928.

Goris and Held 1947 · Jan Albert Goris and Julius S. Held, *Rubens in America*, New York, 1947.

Held 1959 · Julius S. Held, *Rubens, Selected Drawings*, 2 volumes, London, 1959.

EXHIBITIONS

Detroit 1936 · Detroit Institute of Arts, Detroit, 1936, *An Exhibition of Sixty Paintings and Some Drawings by P. P. Rubens.*

Cambridge-New York 1956 · Fogg Art Museum, Harvard University, Cambridge, and The Pierpont Morgan Library, New York, 1956, *Drawings and Oil Sketches by P. P. Rubens from American Collections.*

Antwerp 1956 · Rubenshuis, Antwerp, 1956, *Tekeningen van P. P. Rubens.*

1.

Cupid Supplicating Jupiter

Oil on canvas
2.41 x 1.93 m

Provenance:
Baron de Lanoye; de Lanoye family,
Zurich.

Literature:
Hans Gerhard Evers, "Rubens,"
Kindlers Malerei Lexikon, 5 (1968):
159; Michael Jaffé, "Rubens and Jove's
Eagle," *Paragone*, 21, no. 245 (1970):
22; John Rupert Martin, "Rubens's
Jupiter and Cupid: An Exhibition
at Princeton," *Apollo*, 94 (1971): 277–79.

The painting is discussed at length
by John Rupert Martin and Claudia
Bruno in their essay, "Rubens's *Cupid
Supplicating Jupiter*," in this volume.

Lent by Malcolm S. Forbes, the *Forbes
Magazine Collection*

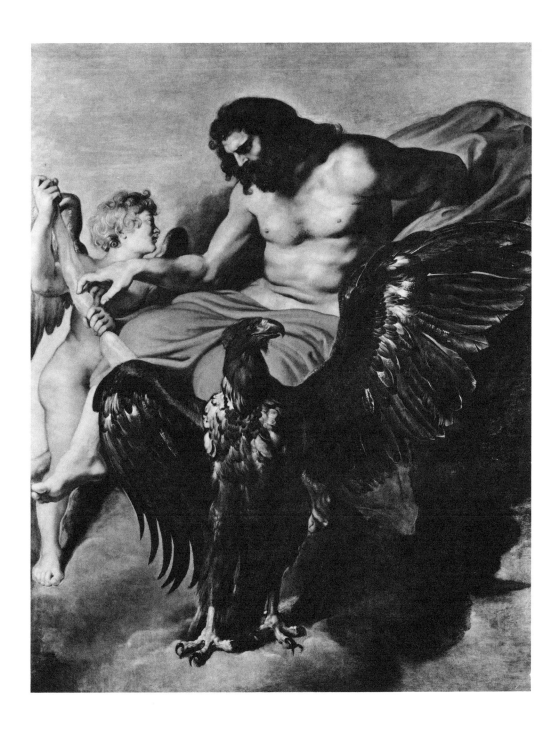

2.
Cupid Supplicating Jupiter

Black chalk,
heightened with white gouache
314 x 266 mm

Provenance:
The Hon. Mrs. Fitzroy-Newdegate;
Christie's, London, March 14, 1952, lot
249; Colnaghi, London.

Exhibitions:
Colnaghi, London, 1952, *Old Master
Drawings*, no. 13; Art Gallery of Ontario,
Toronto, 1968, *Master Drawings from
the Collection of the National Gallery
of Canada*, no. 32; Colnaghi, London,
1969, *European Drawings from the
National Gallery of Canada, Ottawa*,
no. 27.

Literature:
Burchard and d'Hulst 1963, no. 121;
Justus Müller Hofstede, "Review of
L. Burchard and R.-A. d'Hulst, *Rubens
Drawings*," *Master Drawings*, 4 (1966):
451; Kathleen M. Fenwick, "The Col-
lection of Drawings," *National Gallery
of Canada Bulletin*, 2 (1964): 8; A. E.
Popham and K. M. Fenwick, *European
Drawings in the Collection of the Na-
tional Gallery of Canada* (Ottawa,
1965), p. 98; Michael Jaffé, "Rubens
and Jove's Eagle," *Paragone*, 21, no. 245
(1970): 22; John Rupert Martin, "Ru-
bens's *Jupiter and Cupid*: An Exhibition
at Princeton," *Apollo*, 94 (1971): 277–78.

The relationship of this life-study to
the *Forbes* painting is examined by John
Rupert Martin and Claudia Bruno in
this volume.

Lent by the National Gallery of
Canada, Ottawa (6159)

148

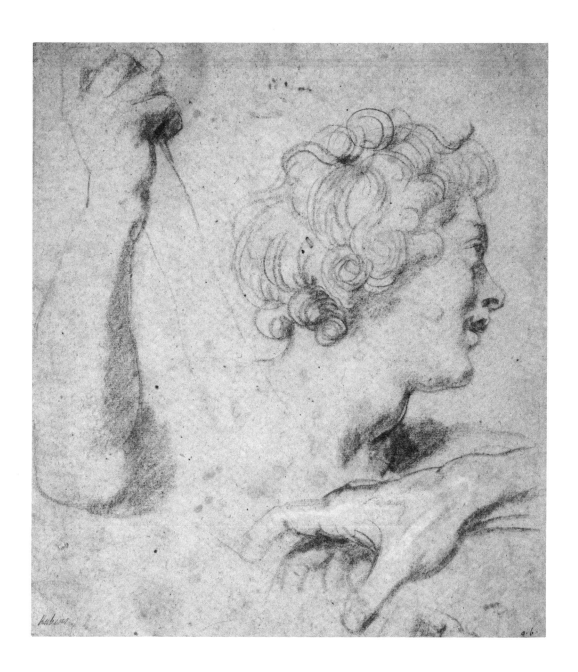

149

3.
Cupid Supplicating Jupiter

Red chalk, pen and ink
281 x 266 mm

Literature:
Burchard and d'Hulst 1963, p. 191;
Gregory Martin, "Rubens and Bucking-
ham's 'fayrie ile,'" *Burlington Maga-
zine*, 108 (1966): 617; Michael Jaffé,
"Rubens and Jove's Eagle," *Paragone*,
21, no. 245 (1970): 22; John Rupert
Martin, "Rubens's *Jupiter and Cupid:
An Exhibition at Princeton," *Apollo*,
94 (1971): 277.

This drawing by a member of Rubens's
studio has often been attributed to
Willem Panneels, although Gregory
Martin goes so far as to say that it is
"clearly by Rubens, over a workshop
drawing" ("Rubens and Buckingham's
'fayrie ile,'" p. 617). The relationship
of the drawing to the Ottawa drawing
and the *Forbes* painting is discussed by
John Rupert Martin and Claudia
Bruno in this volume.

Lent by the Royal Museum of Fine
Arts, Copenhagen (IV/44)

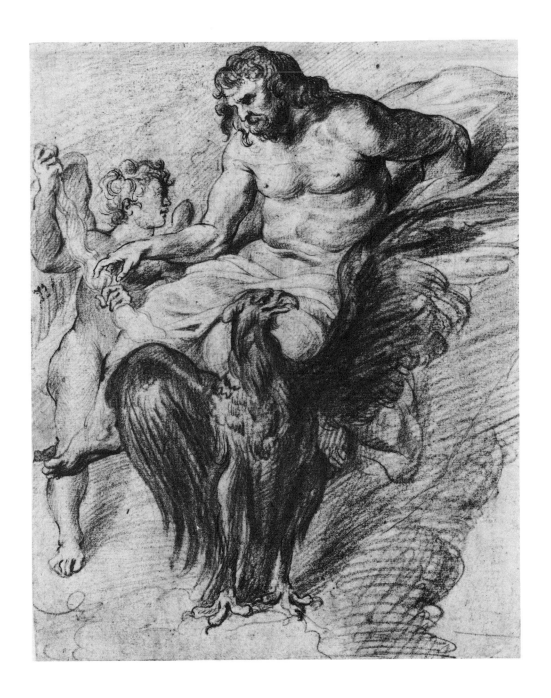

151

4.
Two Warriors

Pen and brown ink
160 x 104 mm

The attribution of this drawing to
Rubens has been upheld by both
Michael Jaffé (verbally to the owners)
and Julius S. Held (in a letter to David
Steadman, December 31, 1971). Both
agree that it was drawn early in the first
decade of the seventeenth century and
that it is probably a copy of an engraving.

Lent by Mr. and Mrs. A. Hyatt Mayor

153

5.
Mystic Marriage of
Saint Catherine

Pen and brown ink
158 x 217 mm

Exhibitions:
Cambridge-New York 1956, no. 3.

Literature:
Hans Vlieghe, *Saints I*,
Corpus Rubenianum, VIII
(Brussels, 1972), no. 76a.

The composition shows the strong
influence of Titian on Rubens during
his years in Italy. A painting after this
composition, attributed to Rubens,
was in the Rodman Wanamaker
Collection and is now on the New York
art market.

Lent by the Allen Memorial Art
Museum, Oberlin College (54,24)

155

6.

Triumphant Return of Horatius

Pencil, pen and ink
260 x 350 mm

Provenance:
P. H. Lankrink; J. Richardson, Sr.;
T. Hudson; Charles Rogers; Von S.
(sale, Berlin, Henrici, June 12, 1919,
no. 55); Harold K. Hochschild.

Exhibitions:
Cambridge-New York 1956, no. 4.

Literature:
H. W. Williams, "A Gift of Prints and
Drawings," *Metropolitan Museum
Bulletin*, 35 (1940): 156 (as van Dyck);
Julius S. Held, "Rubens' Pen Drawings,"
Magazine of Art, 44 (1951): 286; idem,
"Drawings and Oil Sketches by Rubens
from American Collections," *Burlington
Magazine*, 98 (1956): 124; Held 1959,
1, no. 6.

The drawing has been attributed to van
Dyck. It was first connected with Rubens
by P. Wescher (in a manuscript note)
and this attribution is upheld by Julius
S. Held, who dates it 1600–04 (Held
1959, 1: 95).

Lent by the Metropolitan Museum of
Art, Gift of Harold K. Hochschild
(40.91.12)

157

7.
Cephalus Lamenting the Death of Procris

Pen and brown ink
255 x 437 mm

Provenance:
J. Richardson, Jr.; Sir Joshua Reynolds;
Frank Jewett Mather, Jr.

Exhibitions:
Antwerp 1956, no. 51.

Literature:
Frank Jewett Mather, Jr., "Drawings
at Bowdoin College Ascribed to Northern
Schools," *Art in America*, 2 (1914): 108;
Julius S. Held, "The Authorship of the
Holy Family in the Walker Art Center,"
Gazette des Beaux-Arts, 85 (1943):
119–21; Goris and Held 1947, no. A91;
Burchard and d'Hulst 1963, nos.
84 and 85.

This drawing was attributed by Frank
Jewett Mather, Jr. to Anthony van
Dyck. The debatable attribution to
Rubens is due to L. Burchard and R.-A.
d'Hulst (Burchard and d'Hulst 1963,
p. 140), whose only support of their
attribution is iconographic: "In our
opinion, however, it shows the elaborate
mythological iconography that is typical
of Rubens." They date the drawing
1614–17.

The Art Museum, Princeton University,
Gift of Frank Jewett Mather, Jr. (51–98)

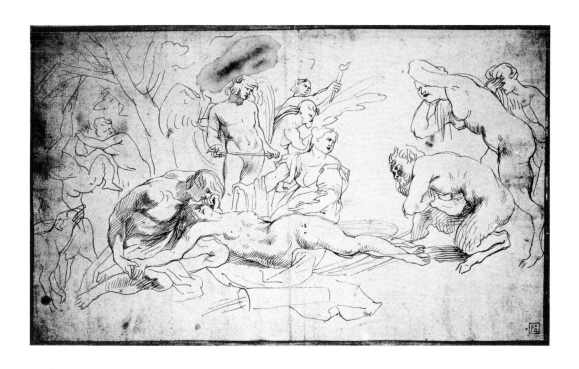

159

8.

Christ

Black chalk,
heightened with white gouache
400 x 298 mm

Provenance:
Jacob de Wit?; J. D. Bohm; Werner
Weisbach; Paul J. Sachs.

Exhibitions:
Albright-Knox Gallery, Buffalo, 1935,
Master Dawings, no. 40; Detroit 1936,
no. 5; Palace of Fine Arts, San Francisco,
Golden Gate International Exposition,
1940, *Master Drawings*, no. 91; Cam-
bridge-New York 1956, no. 8; Antwerp
1956, no. 34; Fogg Art Museum, Cam-
bridge, 1966, *Works of Art from the
Collection of Paul J. Sachs*, no. 19.

Literature:
Glück and Haberditzl 1928, no. 61;
Robert Allerton Parker, "Notes on
Drawings at the Fogg Museum," *Inter-
national Studio*, 95 (1930): 39; Gustav
Glück, *Rubens, van Dyck und ihr Kreis*
(Vienna, 1933), p. 70; Agnes Mongan
and Paul J. Sachs, *Drawings in the Fogg
Art Museum* (Cambridge, 1946), no.
483; Hans Tietze, *European Master
Drawings in the United States* (New
York, 1947), p. 120; Goris and Held
1947, no. 104; Paul J. Sachs, *Pocket Book
of Great Drawings* (New York, 1951),

pp. 67–68; Jakob Rosenberg, "Rubens
Oil Sketches and Drawings," *Art
Quarterly*, 19 (1956): 142; Burchard and
d'Hulst 1963, no. 55; Ira Moskowitz, ed.,
Great Drawings of All Times, 4 vols.
(New York, 1962), 2, no. 521; John
Rupert Martin, *Rubens: The Antwerp
Altarpieces, The Raising of the Cross/
The Descent from the Cross* (New York,
1969), p. 42.

The drawing is a study from life for the
figure of Christ in the central panel of
the triptych of the *Raising of the Cross*
(fig. 29), now in the Antwerp Cathedral
but painted for the Church of Saint
Walburgis in 1610–11.

Lent by the Fogg Art Museum, Harvard
University, Gift of Meta and Paul J.
Sachs (1949.5)

161

9.
Presentation in the Temple

Pen and brown ink, wash
217 x 150 mm

Provenance:
Janos Scholz.

Exhibitions:
Cambridge-New York 1956, no. 11.

Literature:
Otto Benesch, "Beiträge zum Werk des Rubens," *Alte und Neue Kunst,* 3 (1954): 8; Held 1959, 1, no. 28; John Rupert Martin, *Rubens: The Antwerp Altarpieces, The Raising of the Cross/The Descent from the Cross* (New York, 1969), p. 46.

This drawing is one of several studies executed in 1611 for the painting of the *Presentation in the Temple,* which forms the right wing of the triptych of the *Descent from the Cross* in the Antwerp Cathedral (fig. 30). The drawing was originally part of one large sheet with a drawing of the *Visitation* in Bayonne and another drawing of the *Presentation in the Temple* in the collection of Count Seilern, London.

Lent by the Metropolitan Museum of Art, Gift of Janos Scholz (52.214.3)

163

10.

Psyche Offering the Jar of Proserpine to Venus

Red chalk, pen and brown ink
310 x 229 mm

Provenance:
P. H. Lankrink; J. Richardson, Sr.;
C. Fairfax Murray.

Exhibitions:
Detroit 1936, no. 1; The Pierpont
Morgan Library, New York, 1939, *An
Exhibition Held on the Occasion of the
New York World's Fair*, no. 77; Cam-
bridge-New York 1956, no. 7.

Literature:
Goris and Held 1947, no. 110.

The drawing is a copy of Raphael's
fresco in the Villa Farnesina in Rome.
Julius S. Held believes that in this
instance Rubens copied an engraving
rather than the original work (Goris
and Held 1947, p. 43).

Lent by The Pierpont Morgan Library
(I,231A)

165

11.

Adoration of the Magi

Pen and brown ink, brown wash
293 x 192 mm

Provenance:
J. C. Robinson; C. Fairfax Murray.

Exhibitions:
Museum of Fine Arts, Montreal, 1953,
Five Centuries of Drawings, no. 13;
Cambridge-New York 1956, no. 12.

Literature:
C. Fairfax Murray, *J. Pierpont Morgan
Collection of Drawings*, 4 vols. (London,
1905), 1, no. 230; Glück and Haberditzl
1928, no. 68; H. F. Bouchery and F. van
den Wijngaert, *P. P. Rubens en het
Plantijnsche Huis* (Antwerp, 1941),
p. 61; Hans Gerhard Evers, *Rubens
und sein Werk, Neue Forschungen*
(Brussels, 1943), pp. 209–10; Otto
Benesch, *Artistic and Intellectual Trends
from Rubens to Daumier* (Cambridge,
Mass., 1943), p. 7; Goris and Held
1947, no. 102; Held 1959, 1, no. 139.

The *Adoration of the Magi* is one of the
first large-scale drawings made by Rubens
to serve as a model for an engraving.
Between 1612 and 1614 he finished
eleven full-page illustrations, of which
this is one for a new edition of the
Breviarium Romanum, published by
the house of Plantin-Moretus. The
Adoration of the Magi was printed in
the 1613 edition of the *Missale Romanum*
and in the edition of the *Breviarium*
of 1614.

In Rubens's attempt to maintain
high quality in the engravings (fig. 65),
he executed the drawing very carefully.

Lent by The Pierpont Morgan Library
(1,230)

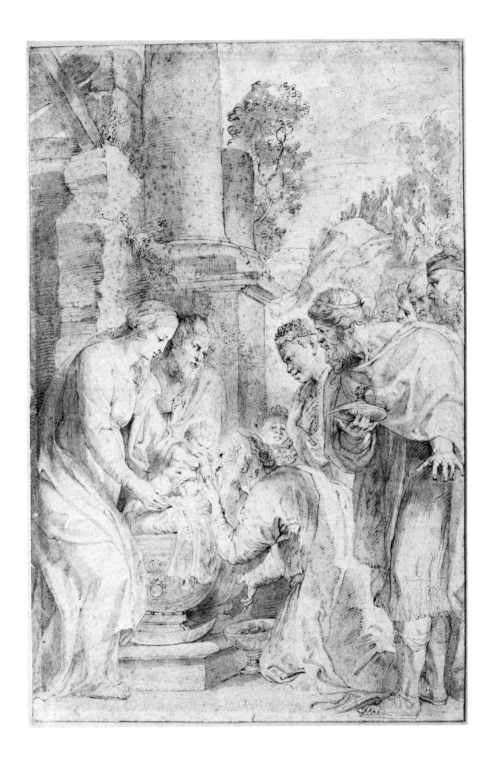

167

12.

Daniel

Black and white chalk
507 x 302 mm

Provenance:
William Bates; C. Fairfax Murray.

Exhibitions:
Detroit 1936, no. 4; Art Museum,
Worcester, 1948, *Art of Europe, XVIth
and XVIIth Centuries*, no. 41; Fogg
Art Museum, Cambridge, 1948, "Seventy
Master Drawings: Paul J. Sachs Anni-
versary Exhibition," no. 30; Cambridge-
New York 1956, no. 14; The Pierpont
Morgan Library, New York, 1957,
*Treasures from The Pierpont Morgan
Library, Fiftieth Anniversary Exhibition*,
no. 90.

Literature:
Emile Michel, *Rubens, sa vie, son œuvre
et son temps* (Paris, 1900), p. 190; C.
Fairfax Murray, *J. Pierpont Morgan
Collection of Drawings*, 4 vols. (London,
1905), 1, no. 232; Glück and Haberditzl
1928, no. 97; Goris and Held 1947, no.
95; Hans Tietze, *European Master
Drawings in the United States* (New
York, 1947), no. 61; Agnes Mongan,
One Hundred Master Drawings (Cam-
bridge, Mass., 1949), p. 70; Michael Jaffé,
"Rubens en de Leeuwenkuil," *Bulletin
van het Rijksmuseum*, 3 (1955), no. 3;

Held 1959, 1, no. 85; Burchard and
d'Hulst 1963, no. 110; Michael Jaffé,
"Some Recent Acquisitions of Seven-
teenth-Century Flemish Painting,"
*National Gallery of Art, Reports and
Studies in the History of Art 1969*,
p. 17, fig. 18.

The drawing is a life-study for the
figure of Daniel in the *Daniel in the
Lions' Den*, now in the National
Gallery of Art, Washington (fig. 66),
finished by 1617.
 The motif of the crossed legs was
known to Rubens from Raphael's
Jupiter in the Amor and Psyche cycle
in the Villa Farnesina, from which motifs
were taken both for the drawing of
*Psyche Offering the Jar of Proserpine
to Venus* (cat. 10) and the painting
Cupid Supplicating Jupiter (cat. 1).

Lent by The Pierpont Morgan Library
(1,232)

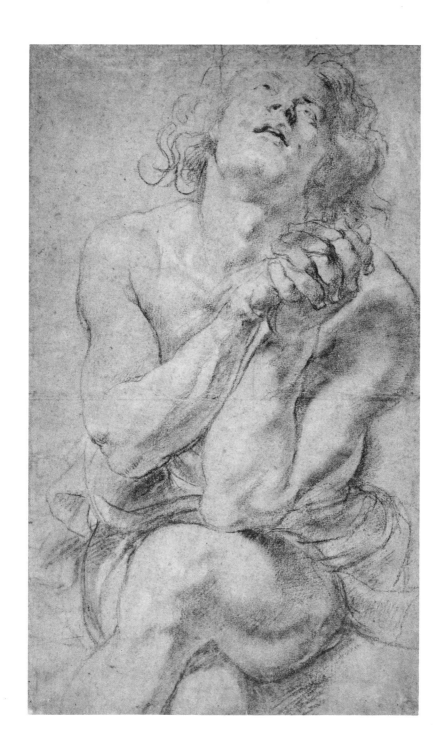

169

13.

Two Studies of a River God

Black chalk
414 x 240 mm

Provenance:
Howard Wicklow; F. T. P.; Henry
Adams; Mrs. Henry P. Quincy.

Exhibition:
Cambridge-New York 1956, no. 22.

Literature:
Held 1959, 1, no. 33; R.-A. d'Hulst,
*Olieverfschetsen van Rubens uit Neder-
lands en Belgisch openbaar bezit* (n.p.,
1968), p. 109; John Rupert Martin,
*The Decorations for the Pompa Introitus
Ferdinandi*, Corpus Rubenianum, XVI
(Brussels, 1972), no. 50b.

Neither of the two figures corresponds
exactly to any in Rubens's paintings.
Agnes Mongan (Cambridge-New York
1956, p. 23) suggests that the drawing
may have been intended for a tapestry.
Julius S. Held, who dates the drawing
1614–15, points out that similar figures
may be discovered in a number of paint-
ings, mostly in the period around 1620.
Michael Jaffé (as quoted in Cambridge-
New York 1956, p. 23) connects the
drawing with the study of the *Vestal
Tuccia* of circa 1622. Ludwig Burchard's
suggestion that the drawing is connected

with the Arch of the Mint in the
Pompa Introitus Ferdinandi is refuted
by John Rupert Martin.

Lent by the Museum of Fine Arts,
Boston (20.813)

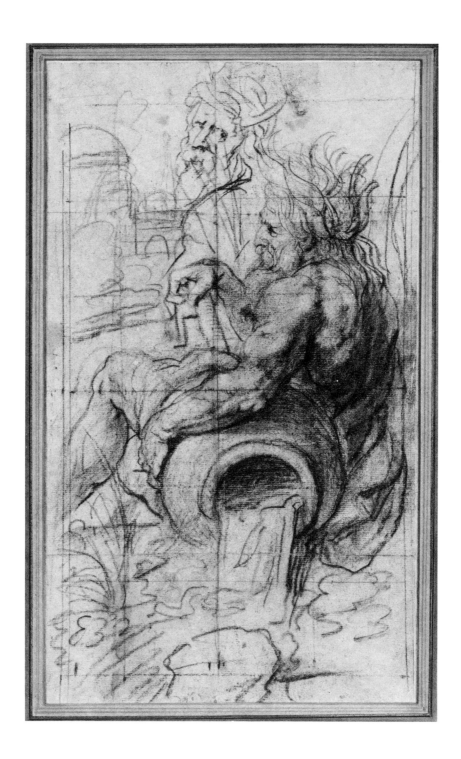

171

14.

Angel Blowing a Trumpet

Black and white chalk,
pen and ink
245 x 283 mm

Provenance:
J. Richardson, Sr.; C. Fairfax Murray.

Exhibitions:
Detroit 1936, no. 3; Cambridge-New
York 1956, no. 19; Antwerp 1956, no. 67.

Literature:
C. Fairfax Murray, *J. Pierpont Morgan
Collection of Drawings*, 4 vols. (London, 1905), 1, no. 233; Glück and
Haberditzl 1928, p. 128; Goris and Held
1947, no. 106; Julius S. Held, "Drawings
and Oil Sketches by Rubens from
American Collections," *Burlington
Magazine*, 98 (1956): 123; Held 1959,
1, no. 144; John Rupert Martin, *The
Ceiling Paintings for the Jesuit Church
in Antwerp*, Corpus Rubenianum, I
(Brussels, 1968), pp. 28–29; idem, *The
Decorations for the Pompa Introitus
Ferdinandi*, Corpus Rubenianum, XVI
(Brussels, 1972), p. 102.

This drawing and catalogue number
15 were made as models for two marble
reliefs to decorate the spandrels above
the main portal of the Jesuit Church
in Antwerp (fig. 67). The sculptor
followed Rubens's design closely, with
one necessary but unfortunate modification. The spandrel did not have as
much space as Rubens had assumed,
and the sculptor was thus forced to
show only one foot rather than the
relaxed crossed legs. The angels lose
the impression of standing freely,
seeming in the sculpture to place all
their weight on the archivolt of the
portal.

Lent by The Pierpont Morgan Library
(I,233)

173

15.
Angel Blowing a Trumpet

Black and white chalk,
pen and ink
251 x 274 mm

Provenance:
J. Richardson, Sr.; H. S. Reitlinger;
Martin B. Asscher.

Literature:
Held 1959, 1, no. 145; John Rupert
Martin, *The Ceiling Paintings for the
Jesuit Church in Antwerp*, Corpus
Rubenianum, I (Brussels, 1968), pp.
28–29; idem, *The Decorations for the
Pompa Introitus Ferdinandi*, Corpus
Rubenianum, XVI (Brussels, 1972), p. 102.

Lent by The Pierpont Morgan Library
(1957.1)

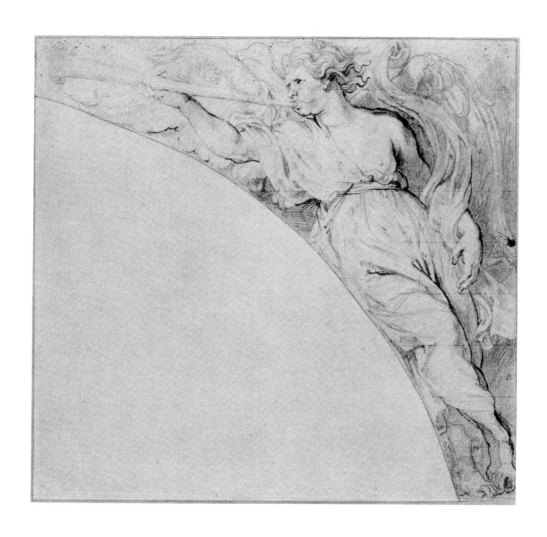

175

16.
Saint Gregory of Nazianzus

Black chalk,
heightened with white
411 x 476 mm

Provenance:
Sir Thomas Lawrence; John Hay;
Clarence L. Hay.

Exhibitions:
Cambridge-New York 1956, no. 20.

Literature:
Held 1959, 1, no. 47; John Rupert
Martin, *The Ceiling Paintings for the
Jesuit Church in Antwerp*, Corpus
Rubenianum, 1 (Brussels, 1968), pp.
140–43.

The drawing is for one of the ceiling
paintings in the Jesuit Church in
Antwerp. Although the octagonal
painting was destroyed by a fire in 1718,
the oil sketch of the composition sur-
vives and is now in the Albright-Knox
Gallery, Buffalo (fig. 68).

Lent by the Fogg Art Museum,
Harvard University, Bequest of
Clarence L. Hay (1969.168)

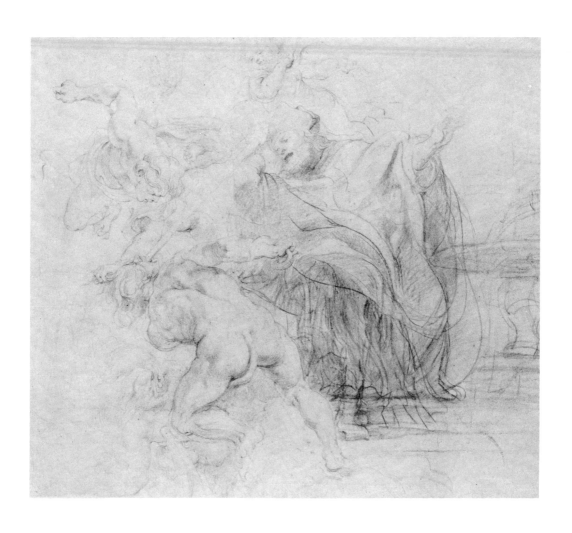

Index

1 BUILDING on FIRM FOUNDATIONS

REVISED EDITION

GUIDELINES FOR EVANGELISM AND TEACHING BELIEVERS

Trevor McIlwain

First Printing 2005

Building On Firm Foundations: Volume 1: Guidelines for Evangelism and Teaching Believers — Revised Edition
Copyright 2005 by New Tribes Mission
 1000 East First Street
 Sanford, FL 32771-1487

ISBN Number: 1-890040-40-1

Printed in the United States of America

Contents

Dedication

With thankfulness and praise to God, this series of books is dedicated to my parents who, by their words and godly example, taught me that the Written Word and the Living Word are the only solid and lasting foundations for this life and for eternity.

Foreword

Jesus Christ commanded us to preach the Gospel to all people. Many barriers impede progress as we seek to share Christ among those who speak a different language and whose cultural worldview is widely divergent from those of us who seek to share the Good News of Christ. One of the most critical is the communicative barrier which tends to shut out or severely distort the truth of the Word when it is presented. Whether one is teaching the Word to a group of professionals in downtown New York City or to a group of Palawano tribal people in the Philippines, the basic problem is how to teach the precepts of the Word in a clear and understandable way.

Trevor McIlwain has addressed the most important of all world evangelization tasks – the effective teaching of the Word of God. How we teach God's Word will have tremendous impact in terms of understanding or lack of understanding upon those who listen to God's Word.

In these volumes, Trevor McIlwain presents a soundly biblical approach to evangelism and discipleship. For years, missionaries, who have been taught by Trevor, have been applying this teaching. The results, to the glory of our Lord, have been exceptional. What Trevor presents in these volumes is not unproven theory, but a practical and proven approach to evangelism and the grounding of new believers and maturing believers. This is based on meticulously laying solid biblical foundations and then building on those foundations.

In these volumes Trevor not only demonstrates the need for establishing proper foundations, but he also details how these foundations are biblically laid. As he states, "...I will endeavor to show that the Scriptures were progressively revealed by God within the context and framework of history. Therefore, the best way to teach divine truth in any culture is God's way, within the chronological and historical framework of the Scriptures."

These volumes are written for any Christian who desires to know and teach the Scriptures. In a deeper sense, however, they are written by a missionary for missionaries. The barriers encountered in teaching the Word to people of other cultures are formidable. Trevor shows the way to penetrate these cross-cultural barriers by the careful and extensive use of Scripture. In evangelism, for example, the barriers will seldom be breached by attempts to lay the basics of the Gospel on whatever conceptual foundation the hearer may already possess. Such a shallow approach to evangelism has led to an abundance of those who profess, but do not possess, the truth of the Gospel of Grace. Even more sadly, shallow approaches have also unintentionally led to widespread reinterpretation of the Gospel. Such reinterpretation generates another gospel, as the Apostle Paul termed such error, together with another Jesus and another spirit (2 Corinthians 11:4). It is true that the unregenerate heart of man precludes the absolute elimination of error. However, the probability for the misunderstanding, misapplication, or reinterpretation of the Gospel will be vastly reduced if Trevor McIlwain's prescriptions for laying adequate biblical foundations are followed.

Those teachers of the Word who will most benefit from these volumes will be those who carefully note both the Scripture content to be taught and the biblical principles and precise techniques for teaching. Substantial lesson material is included for the instructional benefit of those who will teach. Trevor's intention for these lessons, however, is not that they should be used directly by the reader for teaching the Word. They are to be studied and digested and then used as resource material for the teacher's own preparation of lessons keyed directly to the individual or groups being taught. With some groups, the lessons may be applicable precisely as written. In general, however, adjustments will be necessary to accommodate variables such as culture, the discourse features of the language, education, age, existing biblical knowledge, and time constraints. Trevor would admonish us, however, to beware of shortcuts and to always keep in mind that the proof of teaching is not in what the teacher has said, but in what the people have actually learned. We are to teach so as to be used by the Spirit of God to clearly and firmly establish, in the minds of those being taught, the foundational principles of the Word necessary for salvation by grace, apart from works, and for living the Christian life.

In conclusion, dear Christian, I say read on, study, digest, pray over, and prove the content of these volumes in the light of Scripture. Then, above all, go teach and make disciples of Jesus Christ.

<div align="right">
Richard Sollis

New Tribes Mission
</div>

Foreword for Revision

"The unfolding of your words brings light" (Psalm 119:130, NIV).

1984 was the year of the unfolding of Light for the Gerai people of West Kalimantan, Indonesia.

Sometime along our journey to *become* the prepared vessels that God would use to reach out to them with the Gospel, we discovered that the Gerai had lived in this historic setting for more than two centuries. "Tang Ulu," which we estimated to have been under construction during the tumultuous years of the American revolution, was one of three remaining "longhouses" named for their long expanse of connected family dwellings under a single enormous roof. Even at our first sight of these imposing structures, we dreamed that one day the Gerai might gather on these huge connected verandas to hear the glorious Gospel of Christ.

We found it easy to love the Gerai people, but we were continually amazed at the complexity of their view of the world in which they lived. They believed in ever-present and unpredictable good and evil spirits, in numerous guardian beings and in the spirits of the dead. Their belief in multiple gods had effectively insulated the Gerai mind **against** any concept of one true and personal God.

Our missionary team of three families was one of several teams on the verge of sharing the Gospel with a previously unreached people group in this part of Indonesia. We all faced barriers to the people understanding the Gospel.

In God's providence and perfect timing, Trevor McIlwain came to teach a seminar. He shared with us the simple yet profound message of how the faithful and purposeful chronological unfolding of God's story of redemption lays the foundation of truth that allows the light to shine into even the darkest intellect.

We will never take lightly the privilege it was to witness firsthand the Gerai people being genuinely transformed by the unfolding of the truth. We still marvel. This message which at first seemed so strange to them found a home in the deepest part of their understanding. Their hearts turned in grateful response to the One who had loved them and sought them out before they even knew He existed.

Throughout the years since chronological teaching resources have been available, the story of how tribal peoples like the Gerai have turned to Christ could be repeated many times over.

Readers and teachers of the *Building on Firm Foundations* series will find many improvements in this revised edition.

- A more user-friendly format, whether you are teaching or reading for personal study.

- Easier adaptation to other languages and cultures around the world, a welcomed change for those in cross-cultural teaching.

- Improvements in style and presentation gleaned from the input of users worldwide and an excellent staff of revisers and reviewers.

As this revised edition is released, it goes forth with our sincere prayer that the message contained in these volumes will continue to impact a world which is still vastly unreached. In this ever-changing and complex world, the need for clear foundational teaching and the effective telling of His Story has never been greater.

Larry Goring
New Tribes Mission

Acknowledgments

I owe a debt of gratitude to my wife, Fran, who is my most patient and loving helper. Her encouragement through the process of writing the original and through the revision process has kept me at it when I felt the task was too great.

I am thankful to those who worked on the original *Building on Firm Foundations* series, including Peggy Tidman for typing and retyping the manuscript, Ruth Bean Brendle for her critique and the editing, and Dick Sollis for his constant encouragement and for agreeing to write the foreword.

My thanks also to all who are participating with me to revise the series. Thanks to Ruth Brendle without whom this revision would never have been possible. Thank you, Ruth, for all your hard work, helpful suggestions and patience. I also appreciate many others for their messages of encouragement and advice, including Carol Kaptain, Theo Enns, Mike Mikolavich, Don Pederson, Larry Goring, and my son and his wife, Paul and Linda McIlwain.

Finally, my deepest gratitude is to my gracious, heavenly Father for giving me the privilege of having a part in the world-wide ministry of preaching the Gospel to unevangelized people and the teaching of His Word to His Church.

Part 1

Why the Scriptures Should
Be Taught Chronologically

1

The Master Builder's Plan

With a thunderous sound, the walls cracked and crumbled. Timbers splintered. The roof buckled, falling into pieces. Floor after floor crashed one upon another, crushing, trapping, killing the tenants. In a few moments, the high-rise apartments were reduced to rubble.

How had the disaster happened? The building looked sturdy. Why would it collapse with no warning?

Subsequent investigations proved that the builder had not followed the proper building specifications and plans. Willing to gamble with the lives and the safety of human beings for the sake of money, he had cut corners and economized on many parts of the building.

The depth of the concrete had been reduced, and not all of the steel reinforcements required for the foundations had been laid down. Thus the foundations were inadequate for the height and weight of the building. The walls and floors lacked the necessary steel rods to hold and strengthen the building.

The builder had disregarded the design specifications that the architect and engineers provided. He had followed his own way because it was easier and quicker and brought him greater profit.

The results? Sorrow! Destruction! Death!

Just as this builder carelessly ignored construction standards and specifications, many Christians all over the world carelessly disregard the Master Builder's plans for building His Church.

In most instances, evangelism, whether mass evangelism or personal evangelism, is not being done according to the biblical plans given to the Church by the Divine Architect. Likewise with the preaching and teaching of the Word of God. Many who are engaged in the work of building the Church are so engrossed in their own ideas, schemes and passions that they do not stop to consider if they are working according to God's divine directions or whether their work will pass His final scrutiny.

God's work of building His Church

God is the Builder of His Church (Matthew 16:18). But He has chosen His earthly children to be partners together with Him (1 Corinthians 3:9).

The Christian's work in building the Church is similar to that of a building contractor. Just as a contractor is responsible to follow exactly the plans given to him by the owner of a building, so we are responsible to follow God's plans for building His Church.

God is the true builder of all things. *"For every house is built by someone, but He who built all things is God"* (Hebrews 3:4).

God builds everything according to His eternal plans. He will not change. He will never accommodate man's ideas or change His plans to go along with current trends. He will never permit any change in the specifications which He has laid down for all He has planned to do in what we call time. His work always has adequate foundations; He builds carefully, patiently and precisely. He refuses to take shortcuts in anything He does, and He never uses inferior materials or methods which are contrary to His holy and perfect nature.

The first account in Scripture of God's building work is when He created the heavens and the earth. *"By the word of the LORD the heavens were made, And all the host of them by the breath of His mouth....For He spoke, and it was done; He commanded, and it stood fast"* (Psalm 33:6, 9). God was the Creator Builder of all things, seen and unseen. The theory of evolution is Satan's lie, foisted on foolish, unbelieving man. The theory of evolution is contrary to the nature and character of God because God leaves nothing to chance. He is always in full and complete control of all His works. He created everything according to His perfect plan, and He declared that it was all good (Genesis 1:31).

Later in the Scriptures we have the account of God's command to Noah to build an ark. God did not command Noah to build the ark and then leave Noah to formulate his own plans. Rather, God told Noah exactly what must be done. Noah, God's faithful workman, did everything just as the Lord commanded him (Genesis 6:22).

When God chose to dwell with Israel, He commanded Moses to build the tabernacle. And how was Moses to build it? *"For He said, 'See that you make all things according to the pattern shown you on the mountain'"* (Hebrews 8:5). Every detail, from the silver sockets which were the foundations for the boards of the tabernacle to the outer coverings of badger skins, was to be made exactly according to the divine pattern shown to Moses on Mount Sinai. Scripture assures us that Moses was faithful to Him who appointed him (Hebrews 3:2).

God's work of building the heavens and the earth was done by the power of His Word. Noah and Moses followed the words of God in all that they built. Likewise, God's present work of building His Church is also being accomplished through His mighty Word. *"For it is the God who commanded light to shine out of darkness, who has shone in our hearts to give the light of the knowledge of the glory of God in the face of Jesus Christ"* (2 Corinthians 4:6).

The building of the universe was the work of God alone. He did not use any angelic or human agent. But the great work of building the Church, like the work of building the ark and the tabernacle, has been committed to His children. *"We have this treasure in earthen vessels"* (2 Corinthians 4:7). *"We are ambassadors for Christ"* (2 Corinthians 5:20). *"You shall be*

witnesses to Me... to the end of the earth" (Acts 1:8). God has chosen to bring His Church to completion through the teaching of His Word by the members of the Church.

If the ark and the tabernacle had to be built exactly according to God's plan, should not the Church also be built according to His plan? Surely the Bride of Christ is of even greater importance than the ark or the tabernacle. The use for the ark came to an end, and the tabernacle was superseded by the temple, but the Church is to last for eternity. Therefore, *"If anyone defiles the temple of God, God will destroy him. For the temple of God is holy, which temple you are"* (1 Corinthians 3:17). Every man's work, in relationship to the building of the Church, is going to be tried by fire. It will all come under the scrutinizing gaze of the Great Master Builder whose servants and co-laborers we are.

Whether we are seminary professors, pastors, missionaries, Bible class leaders, Sunday school teachers, youth workers, or concerned parents wishing to see our children taught the Word of God, *"We are God's fellow workers."* We must therefore be wise, taking careful note to see if we are doing our work as He has commanded (1 Corinthians 3:9-23).

Building as a wise master builder

Paul refers to himself as a wise master builder (1 Corinthians 3:10). He laid the foundations of the Gospel on which the Corinthians' faith and hope were built, and he warned the Bible teachers in Corinth to be careful how they built on those biblical foundations which he had laid (1 Corinthians 15:1-4).

As a new missionary, I had a similar responsibility as Paul had. I was responsible to lay the foundations of the Gospel and build up the individual members of the body of Christ in a remote island of the Philippines. I desired to be a wise master builder like Paul, but I wasn't sure how to be wise and careful as I built. I prayed for answers as the following questions gripped my mind and guided my search:

- By what standard did Paul judge his building methods and work and thus conclude that he was a wise master builder?

- How can all subsequent builders be sure that they are proceeding in the correct way and that their work will meet with divine approval?

- Has God only told us what to teach in His Word, or has He also shown us how to teach?

- Which is the clearest, most simple, and yet most comprehensive method of teaching the Word of God to prepare people for the Gospel and to teach them God's way of salvation?

- How can we be sure that the foundations we lay, on which others are to rest their faith, will see them safely into Heaven and stand firm in the great day of testing?

- How should we teach in order to build up God's children and lead them into the knowledge of the whole counsel of God?

- What checklist shall we use to determine if we are making headway and whether the building is being brought to completion in accordance with the divine plan?

- How can church planters know if they have done all that they should have done?

Years passed before I understood the answers to these questions. Why did it take so long? Because traditional Bible teaching methods influenced my thinking. I found the answers I needed when I finally looked to God's Word alone.

The effectiveness of biblical principles

After the Lord had shown me the biblical teaching principles that I present later in this volume, He then opened opportunities for me to share these principles with others who were also searching. In 1980, I taught a seminar for missionaries in the Philippines. These biblical teaching principles excited and gripped the hearts of my fellow missionaries who were struggling with problems identical to those I had faced in evangelism and in the planting and development of churches to spiritual maturity. These missionaries returned to their work with fresh enthusiasm, for they now had clearer guidelines and precise goals for their teaching ministry.

Seminars were also held in Bolivia, Indonesia, Papua New Guinea, Senegal, Thailand and the USA. These initial seminars majored on evangelism, and as missionaries returned to their work, they began to follow biblical guidelines for evangelism. The missionaries laid down firm foundations for saving faith in Christ by teaching a chronological overview of the Bible story, beginning in Genesis and concluding with the ascension of Christ.

The results were immediate and lasting. Many people from various tribal groups have come to a clear understanding of God's nature and character, their own sinfulness, helplessness and hopelessness, and Christ's all-sufficient saving work through His death, burial and resurrection. Their understanding of God's plan of salvation and the certainty of their faith far surpassed that of many others who had professed conversion previously. Furthermore, through chronological teaching, many sincere tribal people, who had previously professed Christianity, came to realize that they had misunderstood the missionaries' message when they were taught previously. They are now trusting in a message which they clearly understand.

One of the first reports of great blessing came from Bob Kennell and George Walker. They had followed these scriptural methods when teaching the story of the Bible to the primitive and previously unevangelized Bisorio tribe in the Sepik region of Papua New Guinea. The Bisorio people responded to a message which they clearly understood from the Scriptures. Theirs is no blind faith, based merely on what the foreigner said. Instead, it is based on a clear understanding of the God of the Bible and the history of redemption.

Confusion about laying foundations

Christ and His Gospel are the only foundations which God has ordained as a basis for the faith of guilty sinners (1 Corinthians 3:11; 15:1-2). Nevertheless, there is great confusion even among Christians regarding these foundations and the correct way to establish them through preaching God's Word.

In the construction of any building, the foundations are the first part of the structure to be prepared. The majority of Gospel preaching, however, is usually done with very little foundational preparation. This lack has contributed to a multitude of false professions and the uncertainty of many new Christians about the foundations of their faith.

Another mistake Bible teachers tend to make is failing to teach the Bible consistently as one book, just as God has prepared it for us through progressive revelation. Teachers of the Word carefully devise and prepare outlines, but few stop to consider that the Bible has an inbuilt teaching outline which, if followed, will give a clear, uncomplicated, comprehensive coverage of the entire Word of God.

Many teachers approach the Bible as if it were a treasure chest full of beautiful, precious gems. We assume that these jewels have not been given a definite pattern or design. We think that the responsibility is ours to arrange the jewels in some order which will enhance their beauty and cause them to be better appreciated. While recognizing the value of the Scriptures, many Bible teachers fail to see that there is a definite, divinely-given teaching outline which runs through the entire Word of God. We therefore proceed to arrange the Scriptures into what we consider to be comprehensive and lucid outlines. This is a basic mistake. Admittedly, good Bible teaching outlines are helpful; but too much time is spent developing methods and theories for Bible teaching, and insufficient time is given to simply teaching the Scriptures as they have been written.

The majority of Christian teaching emphasizes individual doctrines of the Bible rather than presenting the Bible as one complete, interdependent revelation of God. Heresies, misinterpretation, overemphasis of certain Scriptures, and denominationalism can, in most cases, be traced to this lack of chronological and panoramic Bible teaching.

After many years of listening to nonsequential, topical, doctrinal sermons, most of which are based on isolated texts, many church members still do not know the Bible as one book. Often-repeated verses and some doctrines may be known; but the Scriptures, according to their divinely-given historical structure, are seldom understood.

This is equally true in Sunday school programs. Children are usually taught stories from the Bible out of chronological order, and large portions of God's Word are never taught to them at all. Even a faithful Sunday school pupil is unlikely to graduate with an overall knowledge of the Bible.

The approach when teaching the Scriptures to people in other lands without previous Bible knowledge has been similar. Few changes are made to the methods used in the homeland. Insufficient time is generally given to teach the Old Testament background and foundations for the Gospel. Syncretism of heathen and Christian beliefs is often the sad result. Many in foreign lands who have professed Christianity do not understand the Gospel, nor do they understand the Scriptures as one book.

Many missionaries are so eager to preach the Gospel that they feel it is an unnecessary waste of time to teach tribal people too much of the historical portions of the Old Testament Scriptures. Nevertheless, these Old Testament historical sections form the basis for a clear understanding of the coming of Christ and the necessity of His death, burial and resurrection. The Old Testament Scriptures, correctly taught, will prepare the heart of the believing sinner to receive the Gospel in true repentance and faith.

Objective and overview

This book records my frustrations, my search, and also my joy at discovering divine teaching principles and guidelines in the Word of God. Additional volumes of *Building on Firm Foundations* contain clear, simple, yet comprehensive lessons for the unsaved and the children of God which follow the flow of biblical history from Genesis to the Revelation.

Through my own experiences, but more importantly, on the basis of the truth of God's Word, I will endeavor to show that the Scriptures were progressively revealed by God within the context and framework of history. Therefore, the best way to teach divine truth in any culture is God's way, within the chronological and historical framework of the Scriptures.

This and successive volumes present lessons which form an extensive program for evangelism and for teaching those who believe as you develop them into a mature church. The whole program is based on the complete revelation of God in the Scriptures. This teaching program developed through my experience of teaching the Scriptures both in Australia and on the mission field. The teaching program has been divided into seven phases:

Phase	Designed for	Scripture Covered	Purpose
Phase 1	Evangelism	Genesis to the Ascension	Bringing people to repentance before God and faith in the Lord Jesus as their Savior.
Phase 2	Teaching new believers	Genesis to the Ascension	Emphasizing the new believer's position of security in Christ and laying foundations for teaching Acts to Revelation.
Phase 3	Teaching new believers	Acts	Majoring on the pattern of the church in Acts for the development of the church
Phase 4	Teaching new believers	Romans to Revelation	Establishing the believers in the knowledge of their position and walk in Christ and function as a local church.
Phase 5	Teaching maturing believers	Genesis to the Ascension	Emphasizing God's revelation of Himself and His methods of sanctifying and demonstrating His life through the Old Testament saints as a challenge to the mature church.
Phase 6	Teaching maturing believers	Acts	Presenting a deeper and more detailed exposition
Phase 7	Teaching maturing believers	Romans to Revelation	Presenting a deeper and more detailed exposition.

This volume will lay out the biblical basis for the entire teaching program. Successive volumes will give the specifics for each teaching phase.

2

Check the Foundations

The Palawano tribe, living on the island of Palawan in the southwestern region of the Philippines, was downtrodden for centuries.

The proud, fierce Muslims who lived on the smaller islands lying off the coast of Palawan oppressed these timid, fearful jungle people for many years. Numerous stories, now part of Palawano folklore, tell of the massacres and molestations of the Palawano tribal people by the marauding Muslim sea warriors, called Moros.

Yet another oppression for the Palawanos came from Filipino settlers who migrated from other islands of the Philippines. They came seeking land for rice fields and coconut plantations and for timber from the virgin forests for export. Many of these settlers took advantage of the native people of Palawan. They found that these unassuming, uneducated jungle people were easily intimidated. Through fear of these aggressive new settlers, many Palawanos left their ancestral lands and coconut plantations close to the sea for the less hospitable foothills and mountains of the island's interior.

Then came a time of even greater sadness and tragedy. Their island home was invaded by the Japanese. This was a fearful era in the Palawanos' history. Women were molested, and children were brutally killed. Livestock was stolen and killed. Rice, their basic food, was often deliberately and maliciously scattered by the invaders as they knocked down the Palawanos' granaries. The suffering of these years surpassed all other segments of their inglorious history.

Then came an unexpected reprieve from their fear and degradation. The US liberation forces landed in Palawan. In all my years with the Palawano people, I heard only praise and admiration for these soldiers, never one word of reproach. While visiting in the homes of the tribal people, many of the older Palawano men asked me if I knew some particular officer by whom they had been befriended. They spoke of them with great affection. They obviously enjoyed remembering incidents when the "Amirikans" had warned the national Filipinos not to ill-treat the Americans' little Palawano brothers. The Palawanos saw it as a sad day when the US forces withdrew from Palawan and their future became uncertain once again.

Years passed, and then, quite unexpectedly for the Palawanos, another American came to their part of the island. He was even more generous than all the other Americans they had known previously. Meanness and anger are frowned on in Palawano society. This missionary displayed love and kindness. Through his ministry and the ministry of the missionaries who followed him,

several thousand Palawanos professed conversion to Christianity, not understanding what it meant. They were baptized, and organized into indigenous churches.

When we arrived years later, we questioned the Palawanos as to why they had so readily submitted to baptism. One man answered, "We would have done anything for that first missionary. If he had asked us to cut our fingers off, we would have gladly done it for him."

The danger always exists that previously rejected and exploited people will respond to the Christian missionary's message, not because they see their real need as sinners and understand the Gospel, but because of genuine appreciation for the missionary and a longstanding desire to escape their difficult and degraded sociological conditions. This was the major reason for the people movement to Christianity which took place almost immediately when the first New Tribes missionary preached to the Palawanos.

Confusion regarding the Gospel

Following this major people movement to Christianity, more missionaries arrived to assist in the work. They faithfully taught the duties of believers to those who had professed conversion. Unknown to the missionaries, the majority of the Palawano church members interpreted the responsibilities of believers in the only way that they could as unsaved people. They thought the duties of the believer were the things they must do so they could continue to be "in God."

"In God" was the term the Palawanos usually used to describe their conversion to Christianity. They had come into God by their acceptance of Christ through faith, baptism, church attendance, singing, prayer, not stealing, and not committing adultery. For the truly dedicated, abstinence from alcohol, betel nut, and tobacco were also understood as being necessary to guarantee their continued position "in God."

During their church meetings, they sometimes spoke of Christ and His death. More frequently, however, they testified of their faithfulness to the Lord by abstaining from sinful works and by church attendance. Obviously missing was praise to God for their salvation by Christ through His unmerited favor alone. Even though salvation by faith through grace alone had been taught, the majority had not clearly understood. They were trusting in a mixture of grace and works.

In spite of the emphasis on Christian living, many failed to live according to biblical standards. Divorce, remarriage and drunkenness were normal in the Palawanos' old way of life, and they continued to be major problems in all of the churches. The missionaries and the church elders were very concerned about the condition of the churches and constantly exhorted the people to lay aside these old ways and follow the new way in Christ. The wayward church members would repent and function outwardly as Christians for a while; but often, they would fall back into their old ways until they were once again challenged and revived, starting the cycle all over again.

Even though there were faithful individuals who were true believers among the Palawano people, the Palawano church was like a building that lacked the correct foundations. Large cracks appeared continually in the upper walls. The missionaries and church leaders spent their time running from church to church, trying to patch up the gaping holes. The problem, however, was in the people's basic foundational understanding and acceptance of the Gospel.

Because most had turned to Christ for deliverance from their difficult lives and had never seen their own personal sinfulness and inability to please God, they had not realized that their only hope

was to trust in God's provision for all sinners through the death, burial, and resurrection of Christ. If they had trusted only in Him for God's acceptance, then their faith would have produced godliness and obedience to the commands of Scripture, not in order to obtain salvation, but as the fruit of true saving faith.

My wife and I, along with our two children, began our work as missionaries with New Tribes Mission in 1965 in the Philippines. We worked with the Palawano tribe over a period of ten years. My responsibility was to see the elders and the churches brought to maturity through further instruction from the Scriptures.

Extensive hiking over the trails with the more zealous church elders was the only way I could reach and teach the more than forty small churches scattered among the mountains and jungle. Through these visits to the Palawano churches, it soon became evident that the majority of the professing believers were confused and uncertain about the basic foundations of the Christian faith. They agreed with the necessity of Christ's death for man's salvation. However, most thought that Christ's death only secured a part of their salvation and that they were responsible to obtain the remainder of their salvation by obeying God. .

The true spiritual condition of the people became apparent as I began to question them concerning their basis for salvation. I usually began by asking, "What must a person do to be saved?"

They were often reluctant to answer, but after some encouragement and direct questioning of individuals, they would begin to respond. Some answered, "Trust in God," and some said, "Believe on Christ."

To these answers, I replied, "What if a person truly believes and puts his faith in Christ as his Savior, but he does not attend church? Could he truly be saved?"

Many answered emphatically, "No!"

Others said, "Yes, if a person truly believes, he is saved, even if he does not attend church."

"But," I added, "what if that person is not baptized?"

Only a few thought that a person could be saved without baptism.

I then added what seemed, to many, to be the deciding point, "But what if that person who truly trusts in Christ were to get drunk or commit adultery? Could he really be saved?" Only a few in each congregation believed that such a person could be saved, and even they had grave doubts.

In addition to questioning, I found another method to be effective in determining what the Palawano church elders and Bible teachers believed. I would first teach them the truth and then contradict the truth by teaching error. In the Palawano culture, it is improper to contradict a teacher, because this could cause the teacher to lose face and become embarrassed. This, in turn, would cause the person who had contradicted the teacher to also be embarrassed. Even so, these church leaders needed to be taught to stand for God's Word, regardless of the cultural discomposure caused by confronting a teacher with the truth. False cults were increasing on the island, and these Palawano church leaders were faced with the endeavors of these false teachers to lead them and their congregations into error. I needed to be sure that these Bible teachers really understood the Gospel, that they were personally trusting only in Christ, and that they would be able to stand firm against false teachers. Of course, I only used this method after months of teaching these men. This method would not have been effective if used in the beginning of my association with the Palawano

leadership. They would have verbally agreed with me in spite of what they actually believed in their hearts.

On one occasion, approximately one hundred Palawano elders and teachers had gathered for our monthly conference. I had taught for many hours from the Scriptures on salvation by grace through faith alone. Then, without warning or explanation, I began to teach faith plus works as the way of salvation. Then I paused abruptly and pointed to one of the men and asked him, "Is what I have just said correct? Is it true that sinners are saved, not only by faith, but by their good works?"

The tribal teacher hesitated and then finally answered, "No, it is wrong. We are saved by faith alone."

Feigning surprise, I continued to question him, "Do you mean to say you are telling me, the missionary, that I am wrong?"

Hesitatingly, he said, "Yes, you are wrong."

Still not giving them any clue to my real thoughts, I turned to another man and said, "He says that what I said was wrong. Do you agree or disagree?"

He answered, "What you said was wrong."

I then asked him, "How long have you been a Christian?" His answer indicated he was a much younger Christian than I.

"Oh!" I said, "I have been a Christian for many years. I have also been to Bible college. Do you still think I could be wrong?"

Again, he answered that I was wrong.

Even then, I did not show agreement or disagreement but turned to a third man and asked him what he thought. Much to my surprise, he said, "You are right!"

Thinking he had misunderstood, I repeated what I had said previously, stating that we are saved not only by faith but also by our good works.

Again, he said that my statements were correct.

I then asked him, according to my usual procedure, to give scriptural proof for his statement. To my even greater surprise, he turned to Ephesians 2:8-9. Hoping he would understand his mistake once he read these verses, I asked him to read them to all present. He did so and concluded by saying, "There it is. We are saved, not only by faith, but by our good works also."

Many of the men listening were now smiling, but I was looking to the Lord for wisdom in what to say to avoid embarrassing him.

I asked Perfecto, for that was his name, to read Ephesians 2:8-9 once again. He did but still maintained that these verses were teaching salvation through faith plus good works. I knew to simply tell him he was wrong would not establish the truth in his mind. It was important that he see for himself what these verses actually teach.

I said to Perfecto, "Those verses do not seem to be saying what you claim they do. Read them once again very slowly to yourself so you will understand what they really mean."

While we waited, Perfecto read the verses through slowly. Finally, he looked up at me with a look of great surprise and said, "No, I am wrong! We are not saved by faith and works, but by faith alone through God's grace."

The Palawano situation which I have described is not an isolated one. Multitudes throughout the world are members of evangelical churches but have no firm biblical foundations on which they build their hope for eternal life. Illustrations could be given from many areas of the world, including our own home churches, where confusion and syncretism have occurred through the sincere, but unwise or careless, ministry of Christian workers.

From South America, Dave Brown wrote in 1988 about the Guajibo churches in Colombia:

> *"The Guajibos have a long history of missionary activity. As early as 1650, the Jesuits made missionary trips into this territory which covers almost the entire eastern plains of Colombia. They were particularly interested in the Guajibo tribe, as it was the largest in this area (today numbering about 15,000). When the Jesuits entered the area, the Guajibos were still nomadic; but with the progress of time, they have now settled in small permanent villages. About 1958, news of a new religion called the 'Evangelical Way' began to trickle into this area. It immediately attracted widespread attention; and before long, with the arrival of more information, many began to accept this new way of life. Today, almost thirty years later, this new influence from the outside world has made its mark on the Guajibo tribe. Many native-style, thatched-roof churches can be found throughout the region with religious meetings being held regularly.*

> *"In each locality, a semi-annual evangelical conference is held. The first one I visited was attended by 700 Indians, some having traveled as far as a three days' walk. We were the first white missionaries to visit the area; and yet, here were 700 people gathered together to sing and preach to each other. Was there really any need for us as missionaries? Was this not a New Testament church in action? It was only the assurance that God had led us here that kept us.*

> *"With the passing of time, serious problems have come to the surface in the Guajibo church. We are finding that they never really understood the message in the first place. Even those who seem keenest have hang-ups in the fundamentals of salvation. They quote catechismal answers to questions but do not understand the substitutionary work of Christ. 'Having a form of godliness, but denying the power thereof...' (2 Timothy 3:5). And so, we have been forced to look back at the mistakes and failures of the past to try to determine where we are now and to look to God for divine direction for the future."*

How is it possible that people who attend church and have been taught the Gospel still do not understand that salvation is by the grace of God alone? Are we missing something in our preaching?

Shepherds should know their flock

While it is true that the Gospel can be understood and refused, there are other reasons why people can be part of evangelical churches but not be truly saved. One is because many pastors, youth leaders, missionaries, and Christian workers do not check the spiritual foundations of those whom they are teaching. Even when Christian workers do make the effort to find out what people

are really understanding and trusting in for their salvation, few are willing to confront people with their true condition before God.

It was only through persistent questioning that I found out that some of the Palawano church elders and many members were ignorant of basic biblical truths and had misunderstood the way of salvation. The majority of the people had been trusting in a false message for over ten years, but the missionaries who had taught them were unaware of the misunderstanding in the people's minds. Certainly, we must be wise in questioning people; but many Christian teachers are so cautious not to offend that they rarely, if ever, find out the truth about their congregations.

Some Christian teachers think that knowing a person's spiritual condition is not their responsibility because they believe it is something which should be totally between a person and the Lord alone. But the Lord has given His people not only the responsibility to preach the Gospel to the unsaved but also the responsibility to be shepherds of the flock of God. How can we protect, strengthen, and feed the flock of God if we do not even know who are the sheep and who are the goats?

I freely admit, as one who is a Bible teacher and has served as a missionary and as a pastor, that it is much more comfortable to teach from the pulpit than to face people on an individual basis in order to meet their real needs. Nevertheless, if we are to have an effective ministry and follow in the steps of the Chief Shepherd, we must have one-to-one contact with the flock.

The Gospels contain many accounts of our Lord Jesus' personal contacts and ministry with individuals. Three well-known encounters are Nicodemus (John 3:1-12), the Samaritan woman (John 4:1-26), and the rich young ruler (Matthew 19:16-22). In each of these encounters, Jesus made clear their true spiritual condition, and then He applied the correct spiritual remedy from the Word of God. The Apostle Paul's ministry also involved personal contact and exhortation (Acts 20:20, 31; Colossians 1:28).

Throughout the mission fields which I have visited, I have found a great reluctance on the part of many missionaries to seriously undertake this important task of knowing the true spiritual condition of each person under their care. Yet, it is unwise to instruct people in Christian living, merely hoping they have been born again. If we allow mere professors to act like God's children, even though they have no genuine faith in Christ, the result will be their everlasting damnation. This was the case in the Palawano churches. The great majority of professing Palawanos did not understand the Gospel. They had been instructed to live like Christians, but many were not children of God. Had they not been alerted to their grave danger, they would have gone on in this condition to an eternity without Christ.

One Sunday morning, after I had been teaching the Word of God in an evangelical church in Sydney, Australia, an elderly man said to me, "I am in deep trouble. I need to speak with you." Not knowing him personally, I did not understand what type of trouble he was referring to. The next day, I visited him in his home. As I sat talking with him, he said, "Your preaching has disturbed me. I have been a member of the church for forty years, but I do not know the Savior." Later, I learned that, even though some fellow church members had wondered if he was saved, they had never questioned him. Most presumed he was a child of God. How sad if he had not finally faced up to his true condition before God!

An elderly Palawano man who had attended meetings for months came down to visit us from his little hut on the side of the hill. As we sat talking, I asked him, "Grandfather, what are you trusting in for your acceptance by God? What is your hope?"

He replied, "Grandchild, haven't I been coming to the meetings? When you pray, I close my eyes. I try to pray. I can't read, but I try to sing." And truly he did. He used to sit right at my feet and stare up into my face as I taught God's Word. He tried to do everything as I did it. But this old man had not understood the Gospel. He thought the things done in the meeting were a ceremony or ritual to please God in order to be accepted by Him.

I said to him, "Grandfather, if that is your hope, if you are trusting in what you are doing, then God will not accept you. When you die, you will go to Hell. God will not receive you because of these things." We continued to talk for some time about these matters before he returned home. Later, some of the people came and told me that Grandfather was angry and he was not going to come to any more meetings.

I thought, "That's good. That's a beginning. At least he now knows that attending meetings will not save him."

I began visiting Grandfather in order to teach the foundational truths of the Gospel to him personally. He listened attentively, and he did eventually begin once more to attend the meetings. But even when my wife and I moved from that area to live and teach in another place without any Gospel witness, he still had not made a clear profession of faith in Christ.

Sometime later, we returned to visit the church in the area where this old man lived. Stepping out of the Mission plane, I asked the tribal people who had run down to the airstrip to welcome us, "Is Grandfather still living?

They said, "Yes, he is. But he is blind and crippled."

Immediately, I made my way up the hill to his little old, rickety hut and sat down with him. He was pleased that I'd come. After visiting with him for a while, I said to him, "Grandfather, you are going to leave this world very soon. What is your hope? In what are you trusting for your acceptance by God?"

He answered, "Grandchild, it is like this. When I stand before God, I am not going to say to Him that I am not a sinner. God knows that I am."

I thought, "Well, praise the Lord! He has been taught that much of God."

He continued, "I am going to say this to God, 'God, You see Your Son there at Your right hand? He died for me!'" And then turning to me, he said, "Grandchild, won't God accept me because of Him?"

I answered, "Grandfather, He certainly will!"

Cultures and people differ. Not all cultures respond to questioning, regardless of our persistence. Nevertheless, it is important to find out what they understand and what they believe. If there is a more appropriate and cultural way to get this information than by questioning, it should be followed. But, regardless of our methods, we must ascertain the true spiritual condition of the people, for only then will we know the correct spiritual medicine they need from the Word of God.

What is the Gospel?

Another reason why some people in evangelical churches remain unsaved is the way in which the Gospel is presented. Many dedicated Christians present the Gospel in such a way that unsaved, unprepared people do not understand that they deserve only God's judgment, that salvation is

completely God's work, and that sinners are unable to contribute anything towards their own salvation.

Romans 1:3 tells us that the Gospel is God's good news *"concerning His Son Jesus Christ our Lord."* It is God's assurance *"that Christ died for our sins according to the Scriptures, and that He was buried, and that He rose again the third day according to the Scriptures"* (1 Corinthians 15:3-4).

The Gospel is first and foremost about Christ. It is the message of the finished, historical work of God in Christ. The Gospel is a work of the Godhead alone. Christ was *"smitten by God"* (Isaiah 53:4). *"It pleased the LORD to bruise Him; He has put Him to grief."* The Lord made *"His soul an offering for sin"* (Isaiah 53:10).

Many confuse the Gospel, God's work FOR us in Christ, with God's work IN us by the Holy Spirit. The Gospel is entirely objective. The Gospel is completely outside of ourselves. The Gospel is not about the change which needs to be made in us, and it does not take place within us. It was completed in Christ, quite apart from us, almost two thousand years ago. The Gospel is not dependent on man in any way. The Gospel is distorted when we turn people's eyes to what is to be accomplished in them. We were not and cannot be involved in any part of Christ's historical, finished, redemptive work. The sinner must be taught to look completely away from himself and trust only in Christ and His work of salvation.

The following is a portion of an article written by missionaries who are truly saved and very sincere, but the way they presented the Gospel is incorrect. In this article, they are giving an account of a conversation which they had with a tribal lady. They wrote, *"Every Wednesday night, we visit Biaz' parents. We read a portion from Genesis and talk about it and ask questions. One night, Biaz said, 'I am so scared because the bad is in me, and I don't want God to throw me into the fire.'"*

It is clear from this quote that Biaz was a soul prepared for the Gospel. There was an acknowledgement of personal sin and a fear of God's judgment.

But what was the answer of the missionaries? They told Biaz, *"If you ask Jesus to throw the bad out of your liver and give you His Spirit, then you belong to Him and you don't need to be frightened any more, and you will go to Him."* Instead of the missionaries telling Biaz the historical, objective message of the Gospel as God's complete provision for her sin and God's coming judgment, they turned Biaz' attention to what needed to be accomplished within. What they taught Biaz was not the Gospel.

Unscriptural terminology

We distort and confuse the Gospel in people's understanding when we try to present the Gospel using terminology which turns people's attention to what they must DO rather than outward to what God has DONE on their behalf in Christ. We should use terminology which directs repentant sinners to trust in what has been done FOR THEM through Christ, rather than directing their attention to what must be done IN THEM.

Common terminology says, "Accept Jesus into your heart." "Give your heart to Jesus." "Give your life to Jesus." "Open the door of your heart to the Lord." "Ask Jesus to wash away your sins." "Make your decision for Christ." "Ask Jesus to give you eternal life." "Ask God to save you." These modern and commonly-used phrases confuse people's understanding of the Gospel.

As we prepare people for the Gospel, we must bring them to the point where they realize they can do nothing. But even when people do understand their inability to do anything, many evangelists, missionaries, and preachers tell enquirers things such as, "Now, you must give your heart to Jesus." Having told them they are unable to do anything, they then tell them what they must do. What is the result? Confusion about the Gospel! People's interest and concern is turned inward to their own experience, instead of outward to trust only in Christ's death, burial, and resurrection on their behalf.

Methods and terminology used in evangelism all over the world have so distorted the Gospel that Christians need to be taught afresh the basic fundamentals of God's saving work in Christ, so their presentation of the Gospel will be according to the Word of God. Even though many people have been saved under present evangelistic methods, many others have not clearly understood the Gospel. The message they heard so emphasized man's part in conversion that God's perfect finished work and complete provision for helpless sinners in Christ was not understood and believed.

If people's attention is directed inward to their own doing, even those who are truly saved will often lack assurance of salvation. The question will constantly arise within their hearts, "Was I sincere enough? Did I do it correctly? Did I truly receive Christ? Did I really give my heart to Jesus?"

I have taught students in Bible College who were concerned and confused over these issues. One day, a student came to me deeply troubled. She talked with me about her conversion. She was concerned, "Did I do it in the right way? Was I really sincere? Did I really accept Jesus into my heart?" These questions plagued her. She had finally decided that, just in case she had not done it in the correct way, she would check with me to see what she should do.

At her conversion, she had realized she could do nothing to save herself. But the evangelist told her she must ask Jesus into her heart and give her life to Christ. From that time on, she was constantly concerned as to whether or not she had done all that she should have done. As I talked with her, I explained that it wasn't a matter of whether SHE had done it correctly or not, but whether the LORD JESUS CHRIST had done everything correctly on her behalf. Did He satisfy God? If so, was she trusting, not in her own doing, but in Christ's finished work on her behalf?

The Gospel is not man accepting Jesus as his Savior, but that God accepted the Lord Jesus as the perfect and only Savior two thousand years ago. The Gospel is not man giving his heart or his life to Jesus, but that Christ gave His life, His whole being, in the place of sinners. The Gospel is not man receiving Christ into his heart, but that God received the Lord Jesus into Heaven as the mediator of sinners. The Gospel is not Christ enthroned in the human heart, but that God enthroned the Lord Jesus at His right hand in Heaven.

Do we see the great distinction between these two messages? One is subjective and puts the emphasis on what man must do. The other is objective and puts the emphasis on what Christ has already done. The sinner is only to trust in what has already been done on his behalf. The Lord Jesus cried, *"It is finished."* He did it all. He took upon Himself the load of sin, the full responsibility for the sin of mankind. Because Christ paid the complete debt, God raised Him from the dead and accepted Him into Heaven. The resurrection was God's sign to all that He accepted the Lord Jesus Christ forever as the perfect Savior. God is satisfied. Is the convicted sinner? Will he rest the whole weight of his soul's salvation on Christ's acceptance by God as the perfect Savior? Will the sinner cease once and for all trying to do anything to save himself? Will he trust only in God's Son for salvation?

Some would call this type of Gospel presentation "Easy Believism." When they present the Gospel, they consider it is necessary to place before sinners the need to take up the cross and follow Jesus and the necessity of crowning Jesus Lord of their lives. Some preachers believe that, by insisting on this, they prevent people from making false professions. The answer to false professions, however, is not found in adding to the Gospel by requiring the sinner to promise to follow, obey, and suffer for Christ. There aren't any strings attached to the Gospel. The answer to true conversion does not lie in these additions; it lies in the correct preparation of the sinner's mind and heart for the Gospel. The Holy Spirit accomplishes this as the sinner hears and understands from the Scriptures that he is lost, helpless and hopeless, and stands condemned before God, who is his righteous, holy Creator and Judge.

Dependence on external, observable actions

This confusion regarding the presentation of the Gospel has another serious consequence. Multitudes, whose salvation is doubtful, assure themselves of their acceptance by God because, sometime in their life, they did what the preacher told them to do. They made their decision. They went forward and did what was required of them. Even though their lives have not been changed by the power of Christ and their way of life reveals an unconverted spirit, they still take refuge in what they did. They are trusting in what they did and not in what Christ has done. Multitudes of mere professors are resting their acceptance by God on their action of going forward or praying a prayer in response to the appeal.

Because much evangelistic preaching is subjective and experience-oriented, the attention of the hearers is placed on themselves and their personal response to the preaching. Christians excitedly report the salvation of little children, teenagers, and adults, taking it for granted that they have understood the Gospel and are truly converted, simply because they have displayed an outward decision for Christ.

In most evangelical circles, it is the norm to require people to publicly indicate their decision for Christ by raising their hand, standing, or walking to the front of the building, and praying a prayer of acceptance of Christ. The majority of Gospel preachers and Christians place so much emphasis on the invitation and people's outward response, that many Christians are now convinced that it is an integral and vital part of the ministry of the Church. On one occasion when a relative of mine clearly preached the Gospel but did not give a closing appeal, a Christian lady when leaving the meeting expressed her disapproval by the remark, "He didn't even give people the opportunity to be saved!" The danger is not that people are given the opportunity to publicly express their faith in Christ. The danger is the emphasis before and after the invitation which causes people to rest their salvation on their own personal actions in response to God, rather than on the actions of Christ which are declared in the Gospel.

When addressing this subject during a seminar with missionaries in the Philippines, I made the statement that I had never led any of the Palawano believers to the Lord, and I carefully explained what I meant. I had not asked the Palawanos to pray and to verbally accept Christ in my presence, nor did I tell them that they needed to pray a prayer of acceptance in order to be saved. I simply preached the Gospel and then exhorted the Palawanos to place their faith completely in Christ and the Gospel. Where, how, and what they actually did at the time of their conversion was not the important thing.

One missionary in the seminar strongly disagreed with my statement, "A person does not need to pray in order to be saved." When she objected, I replied, "Then I have led many people astray. I told the Palawanos that if they simply believed the Gospel and trusted in Christ, they would be saved. But I did not tell them that they must pray. According to what you are saying, I must now ask the Palawano believers if they prayed when they believed. If they did not, then I must tell them that unless they do, they will be lost."

Some people use Romans 10:9-10 to substantiate their claim that a person must make a verbal acceptance if he is to be saved. But this would then mean that mute people or those on their deathbeds who are beyond speaking would be unable to be saved. In addition, it would mean that unless a person was with someone else to whom he could confess with his mouth the Lord Jesus, he, too, would not be able to be born again. The first section of Mark 16:16 says, *"He who believes and is baptized will be saved."* Does this mean that baptism is necessary for someone to be saved? Of course not! The first part of Mark 16:16 must be interpreted in the light of the rest of the verse, *"but he who does not believe will be condemned."* All such Scriptures must be interpreted in the light of the unmistakable emphasis of the whole Bible – salvation in Christ is received through faith alone and is not dependent on any action of man.

On one occasion, during a conversation with another missionary, he told me how, many years earlier, he had come to assurance of salvation. His assurance came unexpectedly at the close of a meeting when the preacher asked everyone who was saved to raise his hand. Since, at that time, the man did not know if he was truly saved, he tried desperately to keep his hand down, but it was forced up by a power outside of himself. He related that, because of this experience, he never again doubted his salvation. Yet another Christian told me how she was assured of salvation through an unusual experience. When confronted by a wild, vicious bird, poised to attack her, she looked it in the eyes and said, "You can't touch me for I am a child of God." Because the bird did not peck her, she felt certain from that time that she was indeed in the family of God.

Experiences, regardless of their vivid and startling nature, should never be the grounds for believing that one is saved. The Word of God alone must be the foundation for assurance of salvation. John says of his Gospel, *"But these are written that you may believe that Jesus is the Christ, the Son of God, and that believing you may have life in His name"* (John 20:31). Each Christian is responsible to make certain that his preaching and evangelistic methods focus on Christ and His death, burial, and resurrection as the only firm foundation for his hearers' assurance of salvation. Just as the physical eye does not behold itself but sees only the object on which it is focused, so true faith looks only to Christ. We should never accept any outward act of a professed convert as the basis for acceptance as a born again person. The only scriptural basis for receiving a person's claim to salvation is his understanding and faith in the foundational truths of the Gospel.

In Palawan, a wizened, almost toothless old Palawano lady, who had been sitting for more than an hour on the front porch of our house, finally got around to her reason for visiting. Smiling, she said, "Grandchild, I am trusting in Jesus."

Even before she spoke, it was evident that she had something to tell me because she had patiently waited until all of our other visitors had gone home. Even though I had guessed that her news was related to her faith in Christ, it did not lessen my excitement and joy when she declared her dependence on the Savior. My natural reaction was to reach out and hug her, but Palawano decorum and culture, as well as a fear that such an action would seal her in a sincere but unfounded faith, restrained me. To immediately accept her testimony, without carefully questioning her, would

not have been judicious. She might have been following the other members of her family who had already come in the preceding days to express their dependence on Christ and His redemptive work. For her own sake and for the fledgling church in that area of Palawan, I had to do whatever I could to ensure that her faith was resting on the foundations of Scripture which I had endeavored to lay down.

"Grandmother," I answered her, "It gives me great joy to hear that you are trusting in the Lord Jesus as your Savior. But why did you trust in Him? Why do you need the Lord Jesus?"

"I am a sinner," was her immediate answer.

"But Grandmother, why do you say that? You love your family. You are kind and a very hard worker."

"Yes, but I am a sinner before God," she insisted.

"But Grandmother, even though you are a sinner, why is it that you need the Lord Jesus? Why did you trust in Him? What has He done for you?"

"Ah, Grandchild, He was the One who died for me. He died for my sins."

Tears of joy filled my eyes as I replied, "Grandmother, I am so very glad to hear what you have said, for God's Word says that all those who trust only in the Lord Jesus as their Savior, believing that He died for them and then rose again, have all their sins forgiven by God and will never go to Hell. They have eternal life and will be received by God into Heaven."

How different was the testimony of this illiterate tribal woman compared to that of my wife's aunt, who went forward in response to an altar call at an evangelistic meeting in Australia. We were excited to think that this may be the first of Fran's relatives, outside of her immediate family, to be converted. So, while visiting with her, Fran began to question her regarding her profession. It soon became obvious that her aunt was taken up with her own personal feelings and experience rather than the historical accomplishments of Christ on her behalf. In an endeavor to determine her aunt's real grounds for assurance, Fran asked her, "Aunty, why did you go forward to the invitation of the preacher? Was it because you realized that you are a sinner?"

"Sinner? I'm not a sinner!" she exclaimed.

In spite of her lack of understanding of even the basic truths of Scripture, Christians had accepted her as having been saved simply because she had responded to the invitation.

Regardless of how careful we may be in questioning professing converts, there will always be those, as portrayed in the parable of the sower, who will appear to be Christians but will fall away after a time. Being fully aware of this danger is all the more reason why we should do everything we can to retain the purity, simplicity, and objectivity of the Gospel message, so that people will rest in the rightness of Christ's actions, and not their own.

3

People Unprepared for the Gospel

We have already used the biblical analogy of building to illustrate the work of preaching the Gospel. In addition, the Lord used the analogy of farming in His Word to teach us the correct procedures for doing His work. Therefore, I would like to tell you a parable about a farmer and his sons.

A man, leaving home for a period, left his sons with instructions to plant good seed throughout all of his fields. He provided them with the good seed and promised to return at harvest time.

Over the years their father had written a book in which he recorded his experiences as a farmer. He explained how he had worked with each different type of soil. He recorded how he dealt with various weeds and conditions which hindered the growth of the good seed. Some of his accounts told of useless soil which produced only weeds and thorny bushes, and of other soil which, if properly prepared, had proven to be productive. His book indicated that all soil, even the best, needed lots of preparation and constant care if it was to yield a good harvest.

The sons were glad to obey their father, so in accordance with his command, they set off for the fields. They took with them the book and the good seed.

Arriving in the fields, they found large trees and an undergrowth of tangled vines and thorny weeds. Even the fields where their father had worked previously were now filled with weeds, and the ground was rocky and hard.

Feeling despondent, the sons took up their father's book and reread his last command. Yes, it was clear. They were to sow the good seed in every field. Therefore, as best they could, they set about to do what their father had commanded. One son cut away some of the undergrowth. After he had removed some of the weeds, he began to plant the good seed. Another son chopped down some of the trees, while another tore away the undergrowth with his bare hands before he put in the good seed. Each tackled the job with enthusiasm and vigor. They were passionate about farming but had little success.

With great devotion to their father's command to sow the seed, they experimented with many different ideas and methods. Although their ideas seemed to bring results for a little while,

eventually, the weeds choked most of the new plants or they died because of the hard rocky ground. Only a little of the seed actually took root and grew.

Meanwhile, their father's book, containing the account of his experiences and farming methods, was cherished but not applied to their own work.

Finally, in desperation, the sons took up their father's book and began to read how he had experienced problems which were exactly like their own. They carefully read his methods of preparation before he planted the good seed. Then, following his example, they chopped down the trees, dug up the weeds, ploughed, fertilized, and watered the ground. Once the ground was broken up and well prepared, they planted the good seed.

As a result of following their father's recorded methods and principles, more and more seed took root and flourished.

Unprepared ground

In Jeremiah 4:3, the Lord says, *"Break up your fallow ground, and do not sow among thorns."*

This verse teaches a spiritual principle which is emphasized continually throughout the Scriptures. It also highlights one of the greatest failures in most evangelism. The majority of evangelists, preachers, and teachers at home and on the mission field do not spend sufficient time preparing the minds and hearts of people before they offer the Gospel to them. The Gospel seed is usually sown into hard, unplowed, poorly prepared, thorny ground. In many cases, the results are professions which last only for a short time. There is little permanent growth and fruit.

In the Parable of the Sower in Matthew 13:3-8, some seed fell on the wayside, some on shallow ground, and some among the thorns. This seed was soon taken away, withered, or choked. Some people believe this parable is teaching us that it is our responsibility to sow the seed of the Gospel, regardless of the condition of the hearts of our hearers. It is true that there will always be the types of people illustrated by the Parable of the Sower. Even some who claimed to believe and follow our Lord Jesus were false professors. But what is Jesus really teaching through this parable?

Was Jesus teaching that we should sow the seed on unprepared and rocky soil? Did the farmer plan to sow seed on the wayside? Was it his intention to sow seed among the thorns? Did he think he would receive a harvest from seed sown on shallow, rocky soil? Of course not! This farmer had prepared the ground in order to plant it with good seed. His purpose was to plant the seed only in the ground which he had prepared. He did not intentionally throw good seed onto unprepared ground. However, as he sowed the seed on prepared ground, some of it fell on unprepared soil. None of the seed which fell on unprepared soil yielded a harvest. The main point Jesus is teaching through the Parable of the Sower is that good seed grows well and bears fruit only in prepared soil.

The human heart is not naturally good soil for Gospel seed. The history of man recorded in the Scriptures makes it clear that no descendant of Adam is naturally inclined towards God or His way of salvation. *"There is none who understands; there is none who seeks after God"* (Romans 3:11). *"And the way of peace they have not known. There is no fear of God before their eyes"* (Romans 3:17-18). *"The carnal mind is enmity against God; for it is not subject to the law of God, nor indeed can be"* (Romans 8:7). These verses clearly teach that the unsaved person's heart and attitude is hostile towards God. The unsaved person doesn't see any reason why he should submit

himself to what God says. Furthermore, he is unable, in his own strength, to do what God requires of him.

The natural person may follow false religions and serve man-made gods or even what he believes to be the true and living God. Some will gladly accept a gospel which sounds like the true Gospel of Christ. According to the Scriptures, however, no person seeks the true and living God or can come to Christ by faith unless God first seeks him out by His Spirit through His Word (John 6:44-45).

Felt needs

In recent years, in many missionary circles, an unscriptural emphasis has been placed on felt needs as the basis for the presentation of the Gospel. Some teach emphatically that, if the Gospel is to be acceptable, meaningful, and relevant to our hearers, we must first discover and understand their felt needs and then offer the Gospel as God's answer to these felt needs.

Those who stress felt needs as the key for understanding and accepting the Gospel are confusing the results and blessings of the Gospel with the Gospel itself. Remember, the Gospel is the message of the finished, historical, redemptive work of God in Christ. The Gospel was not given by God to satisfy the natural desires of any human being, regardless of his culture. Jesus Christ's prime mission in the world was not to make people happy, peaceful, secure, or even to provide them with a sense of belonging and feeling loved. These basic human desires are also important to God, but they are not the issues in the presentation of the Gospel. They are the fruit of the Gospel and should be experienced in the lives of those who believe the Gospel. The Gospel which we preach, however, is not sent by God as good news to those whose basic quest is to be happy, peaceful, secure, healthy, or who simply want to go to Heaven. These are natural desires and may also be the fruit of the evil, self-centered nature of man. Even the most ardent atheist or depraved criminal usually desire these things.

Offering the Gospel on the basis of natural desires or culturally felt needs places man and his desires at the center of our message. Thus, man and his happiness are enthroned; and God's objective through the Gospel, when presented this way, is to satisfy man's needs, whatever man feels them to be. This is not scriptural. God does not exist for man. Man exists for God. *"You are worthy, O Lord, to receive glory and honor and power; for You created all things, and by Your will they exist and were created"* (Revelation 4:11).

Did Jesus come into this world to meet felt needs? No! He came to settle the problem of sin. John wrote, *"And we have seen and testify that the Father has sent the Son as Savior of the world"* (1 John 4:14). The angel told Joseph, *"You shall call His name JESUS, for He will save His people from their sins"* (Matthew 1:21). *"The Son of man has come to seek and to save that which was lost"* (Luke 19:10). The mission of our Lord was to deal, first and foremost, with the matter of man's separation from God because of sin. Sin is an affront to God and His position as sovereign creator and ruler. This is why the Son said to His Father, *"Behold, I have come to do Your will, O God"* (Hebrews 10:9). Jesus fulfilled His mission by suffering the righteous judgment of a holy God.

Jesus did not try to meet the people of His day on the basis of their understanding of their needs. In Jesus' day, the natural desire of the average Jew was for a king or political figure who would deliver Israel from the oppression of their enemies. After Jesus had fed the five thousand, He

realized that the people were going to try to take Him by force and make Him their king, so *"He departed again to the mountain by Himself alone"* (John 6:15). The following day, the crowds looked for Jesus because they wanted to be fed. Jesus, however, did not respond to them on the basis of these felt needs. Instead, He told them their real needs as God saw them. He offended so many by His message that John tells us, *"From that time many of His disciples went back and walked with Him no more"* (John 6:66). Most Jews rejected Jesus' assessment of their needs, for they did not see their great need of a Savior to release them from sin which was controlling their lives and leading them to eternal separation from God.

Paul records that the Gentile world was more interested in human wisdom and philosophy than in salvation from the depravity and condemnation of its sins. To both the Jew and Gentile, unprepared by God, the preaching of the Cross was irrelevant and foolish. Yet Paul did not accommodate the Gentiles' quest for wisdom or the Jews' desire for signs and miracles. Paul preached the Gospel, God's power which saves believing sinners. He said, *"but we preach Christ crucified, to the Jews a stumbling block and to the Greeks foolishness"* (1 Corinthians 1:23). Paul reminded the Corinthian believers, *"And I, brethren, when I came to you, did not come with excellence of speech or of wisdom....my speech and my preaching were not with persuasive words of human wisdom"* (1 Corinthians 2:1, 4). Paul knew the felt needs of the people in wicked Corinth were not sound foundations for the Gospel. Paul knew that *"the natural man does not receive the things of the Spirit of God, for they are foolishness to him; nor can he know them, because they are spiritually discerned"* (1 Corinthians 2:14).

The Holy Spirit came into the world to convince the world of sin, righteousness, and judgment (John 16:8). Jesus came to call sinners to repentance (Matthew 9:13). God *"commands all men everywhere to repent"* (Acts 17:30). The biblical basis for the Gospel is a sense of our sinfulness before God and the recognition that only God's mercy and grace can provide us with forgiveness of our sins. No culture naturally recognizes this spiritual need.

When the majority of Palawanos first professed conversion, they had responded because of culturally felt needs and not because of spiritual needs taught by the Holy Spirit. They embraced Christianity for the wrong reasons. Being animists, they were convinced that their well-being, physically and materially, was dependent on their ability to placate and manipulate the spirits to keep the spirits happy and contented. Many who professed conversion took a similar attitude towards God. They interpreted God and what He wanted from them according to their own cultural worldview. They tried to please God and gain His acceptance by being baptized, reading the Scriptures, and meeting together to sing and pray. They tried to keep what they understood to be the Christian rules so they would experience God's blessings on their lives.

Previously, when they believed the spirits healed them, they offered a thanksgiving feast. They believed this was necessary so the spirits would be satisfied and not do them any further harm. Later, when they attributed their healing to God, many believed it was obligatory to go to church and give a thanksgiving testimony telling all that had taken place during their sickness and healing. Such testimonies usually concluded with the words, "Therefore, God is really true." Because they syncretized their old beliefs about the spirit world with their limited understanding of God and Christianity, they thought that the Lord's healing was the greatest proof that God was real, just as in previous years they had trusted in the spirits and their power to heal. God's power and goodness in healing them and meeting their physical needs were extremely important to them and the basic reason for their faith in Him. But when it appeared that God failed to answer their prayers, many

turned back to the spirits and the witch doctors to meet their felt needs. Their Christianity did not last because it was based on felt needs instead of spiritual needs revealed by God.

Having said this, I am not implying that the Lord does not care about people's feelings or their needs. He does, but He knows that a person's needs cannot be met unless he first allows God to meet his primary and greatest need – to be reconciled to God. Because God cares about people's feelings and hurts, we should also. Even so, if we really want to be ministers of good to them, we must prepare sinners to see their real needs from God's perspective.

Although the presentation of the Gospel should not be based on felt needs, missionaries must have a good knowledge of the culture of the people whom they are teaching. Jesus and the Apostle Paul presented the Gospel within the cultural context of their hearers. In the same way, missionaries should use appropriate cultural illustrations and idiomatic expressions to communicate effectively within the cultural context of their hearers.

In addition, we need to be aware of the cultural felt needs of the people so we can, through corrective teaching, guard against misunderstanding and syncretism as we teach them the Scriptures.

Ignorance and misunderstanding

The heart must be prepared by God for the reception of the Gospel. Man's evil heart, with its natural, self-centered desires, is not fertile soil for the good seed of the Gospel. Furthermore, the preaching of the message of salvation through Christ will not bear fruit where people's minds remain in darkness, unenlightened to spiritual realities. Saving faith rests on the comprehended truth of God.

In the book, *Through the Looking Glass* by Lewis Carroll, the Queen tells Alice:

> *'Now I'll give you something to believe. I'm just one hundred and one, five months, and a day.'*
>
> *'I can't believe that!' said Alice.*
>
> *'Can't you?' the Queen said in a pitying tone. 'Try again: draw a long breath, and shut your eyes.'*
>
> *Alice laughed. 'There's no use trying,' she said: 'One can't believe impossible things.'*
>
> *'I dare say you haven't had much practice,' said the Queen. 'When I was your age, I always did it for half an hour a day. Why, sometimes I've believed as many as six impossible things before breakfast.'*

One eminent Bible teacher quoted this dialogue, pointing out that unregenerate people are mistakenly convinced that the meaning of faith is, "Take a long breath; close your eyes to facts, to reality, and believe."

God always works within the realm of the mind. Truth is presented to the intellect to be heard, understood, and believed. It is surprising that, in spite of the emphasis of the Scriptures on the need for truth to be understood, many Christians do not see it as a basic necessity for true saving faith.

The main reason for the confusion among the Palawano people was their ignorance of the Gospel as well as their ignorance of the truths which are given by God as the only preparation for the Gospel.

One day, I was hiking with a missionary who felt I expected the tribal people to understand too much biblical truth before I would accept them as true children of God. We were discussing the confusion in the minds of the Palawanos regarding the way of salvation.

He made the statement, "When I was saved, I didn't know anything."

I replied, "If you didn't know anything, you didn't get saved. Tell me, what did you do when you got saved?"

"I trusted in Christ," he answered.

"But why did you trust in Christ and not Mohammed or Buddha?"

"I trusted in Christ because I knew that He died for me."

I questioned further, "But why did you need someone to die for you?"

"I knew I was a sinner going to Hell," he answered.

"Well, it appears you did know something after all," was my response.

In the parable of the sower, the Lord Jesus said, *"When anyone hears the word of the kingdom, and does not understand it, then the wicked one comes and snatches away what was sown in his heart. This is he who received seed by the wayside"* (Matthew 13:19).

When Philip met the Ethiopian eunuch and heard him reading from the Prophet Isaiah, Philip asked, *"Do you understand what you are reading?"* (Acts 8:30). Philip recognized that this man could never exercise true saving faith unless he first understood what the Word of God teaches about salvation.

When a person is saved, he may not know some scriptural truths, but he will know certain facts. He will know that God is the righteous, holy Judge of all. He will also know that he is a sinner before God and that he can do nothing to save himself. Furthermore, he will know that Christ died for him to pay the complete price for the forgiveness of his sins and that Christ rose from the dead. This is the Gospel which the Apostle Paul preached. *"I declare to you the gospel which I preached to you, which also you received and in which you stand, by which also you are saved, if you hold fast that word which I preached to you – unless you believed in vain"* (1 Corinthians 15:1-2). This is the Gospel which must be heard, understood, and believed if a person is to enter into God's salvation.

One day, two Palawano men who were teachers in their local church sent a message to me, asking me to come and baptize them. I was not aware that these men had not been baptized as almost everyone had been baptized many years earlier, when they first professed to believe.

A Filipino trainee missionary accompanied me to their village. We also sent a message to the leading elders from another, more established church, requesting they meet us in the village where these two men lived. My companion and I agreed not to raise the question of baptism but to teach on salvation by grace through faith alone.

We taught for two days both publicly and privately, focusing our teaching on the sinful, helpless condition of man, the Gospel, and justification by faith alone. The two men who had

requested baptism were in the public meetings and also the group discussions. We purposely did not raise the matter of their desire to be baptized because we were not convinced they really were clear on salvation by grace alone. If through the teaching they realized they were unsaved, we wanted them to be able to decide not to be baptized without any embarrassment. If they raised the matter of their baptism, we would question them, in order to determine what they were trusting in for their salvation.

At the close of the final meeting, the men asked publicly if they could be baptized. Knowing the misunderstanding which most of the Palawanos had about baptism, I asked the men why they wished to be baptized.

Regardless of all the teaching we had given on salvation apart from works, one of them answered, "So that I will really know God."

I asked him to open his New Testament to John 14:6. "Ontoy," I asked, "Does your Bible say, 'The river is the way, the truth, and the life. No man comes to the Father but by baptism?'"

He answered, "No."

I said, "Ontoy, if you die and you are trusting in baptism to get you to God, you will go to Hell. God will not accept you."

After some more teaching, we returned home. Several months later, Ontoy hiked from his village to our home for some medicine. As he stepped onto our verandah, I took his hand and, looking into his face, I asked," Ontoy, how is it with you? Do you now know the truth?"

Ontoy replied, "Yes, I know the Lord!"

He continued by saying, "Brother, when you told me that I would go to Hell if I was trusting in baptism, it was like a knife in my liver. I love you, and it hurt when you spoke to me like that. But I want to thank you for telling me the truth. I would have died and gone to Hell. Now I am trusting only in Christ."

Both of those men came to a clear understanding of the Gospel and trusted in the Lord Jesus as Savior. Their testimonies were very clear when, at a later date, some of the Palawano church elders baptized them.

Faith is not some mystical feeling. It is not mere hoping or blind chance. Faith is not intellectual suicide. It is not contrary to reason. Saving faith is based on objective, historical, biblical facts. Saving faith is well grounded. True faith rests on the sure Word of God. The Gospel therefore must be understood if it is to be believed to the saving of the soul. If the sinner is to exercise true saving faith, there must be enlightenment by the Holy Spirit through the Word of God.

The salvation which God offers sinners rests on a simple understanding and faith in the Word of God concerning the death, burial, and resurrection of the Lord Jesus. God, in the person of Christ, stepped into history and acted on our behalf. He lived, died as our substitute, and rose again. A person exercises faith when he looks away from all self-effort to the saving history of Christ and depends only on Him and His work of salvation on the sinner's behalf.

4

Foundations for the Gospel

The Gospel is God's good news about His Son. But to whom does God offer this good news? Whom does God call to eat the bread of life? To whom does He offer the water of life?

It is clear from God's Word that He offers good news to those who know they are spiritually poor. He offers bread to the hungry, water to the thirsty, rest to the weary, and life to the dead. God's good news is meant for all, but the person unprepared by God will never accept God's Gospel of grace. God knows that, and He tells us not to throw the pearl of the Gospel before swine, that is, those who sense no need to be saved from their sins and have no appreciation of God's mercy (Matthew 7:6).

Matthew says in his Gospel, *"Now it happened, as Jesus sat at the table in the house, that behold, many tax collectors and sinners came and sat down with Him and His disciples. And when the Pharisees saw it, they said to His disciples, 'Why does your Teacher eat with tax collectors and sinners?' When Jesus heard that, He said to them, 'Those who are well have no need of a physician, but those who are sick. But **go and learn** what this means: "I desire mercy and not sacrifice." For I did not come to call the righteous, but sinners, to repentance.'"* (Matthew 9:10-13). Because the Pharisees were self-righteous, Jesus did not invite them to come to Him. He told them to first, "go and learn." What were they to learn? They needed to learn that they were unable to offer God anything which could satisfy His holy and righteous demands and therefore they were in need of the mercy of the Lord. It is only to those who are heavily laden with the realization of their sinfulness before God that Jesus gives His gracious invitation, *"Come to Me, all you who labor and are heavy laden, and I will give you rest"* (Matthew 11:28).

God sent John the Baptist to do this necessary work of preparing Israel to receive their Messiah and His Gospel (Matthew 3:1-12). But the self-righteous religious leaders refused to accept John's message of condemnation. They remained obstinate, unwilling to consider the truth. Luke in his Gospel says, *"And when all the people heard Him, even the tax collectors justified God, having been baptized with the baptism of John. But the Pharisees and lawyers rejected the will of God for themselves, not having been baptized by him"* (Luke 7:29-30).

Jesus also said to the people of His day, *"For judgment I have come into this world, that those who do not see may see, and that those who see may be made blind"* (John 9:39). Those who realized they were spiritually blind would be given spiritual understanding through the truth which

Jesus spoke, but those who, like the Pharisees, refused to acknowledge their ignorance would remain forever in spiritual darkness. When Jesus said this, *some of the Pharisees who were with Him heard these words, and said to Him, 'Are we blind also?' Jesus said to them, 'If you were blind, you would have no sin; but now you say, "We see." Therefore your sin remains.'"* (John 9:40-41). The proud Pharisees believed they were already enlightened and that they understood perfectly the will of God. They felt no need to receive spiritual sight, for in their own estimation, they could already see quite well. They claimed to be guides of the blind (Romans 2:17-20). Why, they felt, should they allow this man to teach them? Because they didn't see their great need and instead claimed they already had spiritual sight, they were left to perish in their blindness. They never understood the grace of God available through the Gospel.

When addressing the same hardened Jewish leaders after Christ's resurrection and ascension, Stephen said, *"You stiff-necked and uncircumcised in heart and ears! You always resist the Holy Spirit; as your fathers did, so do you"* (Acts 7:51).

Nicodemus came seeking Jesus, but Jesus did not immediately tell Nicodemus the good news of the Gospel. Instead, Jesus said to him, "Nicodemus, you must be born again" (John 3:1-7). Teaching about the necessity of the new birth is not the Gospel. The Gospel is God's good news that Christ died for sinners, He was buried, but after three days God raised Him from the dead (1 Corinthians 15:1-4).

Like his fellow Pharisees, Nicodemus was depending largely on his birth as a son of Abraham for his acceptance by God. Knowing this, Jesus first faced Nicodemus with the impossibility of his entering God's kingdom by virtue of his Jewish birth or his own goodness. Jesus then told Nicodemus the Gospel (John 3:14-16). One can only appreciate Christ's work on his behalf if he has first realized the impossibility of saving himself.

While on a visit back to Palawan, I was asked to teach a seminar for some of our missionaries on the chronological approach to evangelism and church planting. During one of our sessions, I emphasized that, if a person's mind is filled with his own self-righteousness, he will not see any need or feel any hunger for the Gospel.

A young Palawano man who was attending the seminar could not understand this particular point. One morning, this young man ate breakfast with us, part of which was scrambled eggs. After we had finished eating, I turned to him and asked if he was hungry and if he would like something to eat. He assured me he didn't feel like eating anything. Nevertheless, I continued to insist. I told him that my wife, Fran, would be only too glad to get him something to eat.

Realizing what I was aiming at, Fran also assured him that it wouldn't be any problem for her to cook some scrambled eggs. Again, he thanked us but declined our offer. Feigning sincerity and concern, I repeated the offer and tried to get him to let Fran cook some scrambled eggs for him.

By this time, he thought I was crazy. Emphatically, he said, "But I am not hungry."

"That's right," I answered, "You ate a good breakfast. You are not hungry. You have no appetite for food."

"Oh! Now I see!" he exclaimed.

As it is in the natural realm, so it is in the spiritual. As long as people are filled with their own self-righteousness, it is useless to try to force the Gospel on them. The Gospel is for the hungry, for

the thirsty, and for the weary. It is for those broken before God through a realization of their own sinfulness.

How is a person brought to this realization? How is the heart of man prepared for the Gospel? The Holy Spirit uses the Word of God to prepare the mind and heart of a person for the Gospel. But what particular part or message from God's Word accomplishes this preparatory work?

The knowledge of God

Years after missionary work had begun in a highland tribe in Papua New Guinea, some of the people announced that they were not going to tithe anymore. Why? Because they had decided that they had repaid God enough for giving Jesus to die for their sins.

The judicial system of this group was based on a monetary pay-back arrangement, so it is easy to see why they thought they had to recompense God for giving Jesus to die for their sins. But why did they think it was possible to pay God back for the gift of His Son? What didn't they understand?

These people obviously had failed to comprehend the nature and character of God as revealed in the Old Testament and finally in the Gospel. They thought God was like the spirits and human beings. Because they demanded pay-back, they thought God did also. To have told them that salvation is a gift would not be sufficient. They needed to see, through the Scriptures, the true nature and character of God. If they were to see God as He really is, they would have also seen themselves as helpless and hopeless sinners. In the light of God's majesty and their own depravity, they would have understood the futility of every endeavor to pay God back.

Furthermore, they had failed to comprehend the consequences of sin. Through the teaching of the Old Testament, beginning with God's warning to Adam regarding the tree of the knowledge of good and evil, *"in the day that you eat of it you shall surely **die**"* (Genesis 2:17), they should have realized that death, eternal separation from God, is God's just judgment on sinners. This emphasis on death as the only payment for sin continues through the Old Testament historical accounts of God's judgment on sinners and ends with the New Testament account of Christ's death as the only satisfactory payment for sin. If the tribal people had understood the Old Testament emphasis on death, they would have also recognized that only the death of Christ could pay for sin and satisfy God who is holy and righteous.

Another example is the Aziana tribe in Papua New Guinea. These people were sun worshippers. Missionaries claiming to preach Christianity preceded New Tribes missionaries into this area. But in spite of being missionized, the Aziana people had no clear understanding of the God of the Bible. They thought He must be similar to their sun-god.

In their ceremonial worship of the sun, they killed a pig, cooked a mixture of its liver and blood in a piece of bamboo; and, as the sun set, they gathered together to worship and appease the sun. The priest first ate of the cooked blood and liver, after which all present partook. The priest also spat some of the mixture at the sun to blind it, so their sins would not be seen and avenged. They believed this would appease the sun, a malicious and malevolent god, and make their souls invisible to it.

When the first missionaries to the Aziana people taught them to commemorate the Lord's Supper, the people gave it the same name as this feast to the sun. They believed that, by partaking

of the Lord's Supper, they were appeasing God and blinding Him to their sins. But these people would never have misinterpreted the Lord's Supper in this way if they had been taught and understood who and what God is. They would have realized that God is not malicious in His intents, that He cannot be appeased like their heathen deities, and that He, the omniscient, immutable God, can never be blinded to man's sinfulness. These people were not prepared for the Gospel because they did not have an understanding of the holiness and righteousness of God. Because they had never been exposed to the knowledge of God, they did not see themselves as incapable of doing anything which would please God.

Job, David, and Solomon all stated the truth: True wisdom begins with a solemn appreciation of who and what God is. *"The fear of the LORD is the beginning of wisdom"* (Psalm 111:10). Only those whose senses have been tuned to know and accept something of God's nature, character, and sovereign position are prepared for the Gospel.

If God is not truly God, as revealed foundationally in the Old Testament and finally in the New Testament through Jesus Christ, then there is no need for the Gospel. Only those who are enlightened through this revelation of God as a righteous and holy God who hates and punishes sin will see their need for the Gospel.

Because God is man's sovereign Maker, He is also his Owner, Lawgiver, and Judge. If this is not true, then man is a free agent and cannot be called to give an account of himself to God. Man's great desire to be free to live only for himself and the satisfaction of his selfish, depraved, insatiable lusts has caused him to hate, flee from, and endeavor to destroy the knowledge of God, his rightful Master.

But even when people understand that God is their Owner, Lawgiver, and Judge, if God is not also seen as holy and righteous, then there is no need for the Gospel. God is not someone who will tolerate, overlook, or forgive sin without full retribution. God is perfectly righteous. His own holy character is the standard for goodness; therefore, anything which does not agree with, or is contrary to what He is, is sin. Anything less than what God is, is totally unacceptable to Him.

God's holiness and righteousness are clearly revealed in history by His consistent hatred and judgment of the least departure from His holy standard. God will not overlook sin. All sin must be paid for. *"The soul who sins shall die"* (Ezekiel 18:4). Because God is righteous, He will never lower His standard of holiness or accept anything less than the full, righteous payment for sin.

As long as people are ignorant of God's holiness and righteousness, they will never understand their desperate need for the grace of God in Christ. They may give lip service to the Gospel, speak about Christ, attend church, sing hymns, read the Bible, pray, and even seek to serve Christ, but they will still be unsaved. Man is by nature self-righteous and will never let go of his pride and self-confidence until he realizes God's infinite holiness and righteousness. The unsaved religionist does not understand God's holiness and righteousness, for he is constantly trying, by his own good works and religious activities, to place God in a position where God will feel obligated to accept and bless him.

This knowledge of God, which man naturally hates and seeks to escape, is nevertheless man's greatest need. Apart from a knowledge of God, man will never truly repent, believe, and be saved. A revelation of God's nature and character is prerequisite to the realization of one's own unrighteousness and abject helplessness to escape the just judgment of God. It was only after Job received clear awareness of God's character that he said, *"I have heard of You by the*

hearing of the ear, but now my eye sees You. Therefore I abhor myself, and repent in dust and ashes" (Job 42:5-6).

Isaiah, when called to be God's prophet, needed a realistic assessment of himself and his people. Only then could he speak in true humility against the sinfulness of the nation. How then did the Lord show Isaiah his true self and the iniquity of his nation? Isaiah was given a vision of the Lord in all His sublime glory, sovereignty, and holiness. The immediate effect on Isaiah was to cry, *"Woe is me, for I am undone! Because I am a man of unclean lips, and I dwell in the midst of a people of unclean lips; For my eyes have seen the King, the LORD of hosts"* (Isaiah 6:5).

All people, regardless of their religious or cultural background, must be led down this road of the revelation of God. Only an understanding of who God is will produce true self-knowledge, genuine repentance, and saving faith.

Jesus said, *"No one can come to Me unless the Father who sent Me draws him; and I will raise him up at the last day. It is written in the prophets, 'And they shall all be taught by God.' Therefore everyone who has heard and learned from the Father comes to Me"* (John 6:44-45). Every person who ever comes to Christ for salvation comes because he has been taught, through the revelation of God's character as revealed in the historical sections of the Scriptures, that God is holy and righteous and will not overlook sin.

The Law

The Law is yet another means which God uses to prepare the sinner for the Gospel and the realization that, without Christ, he will perish.

By the fall of man and through subsequent history, man has been made aware of his sinfulness through revelations of God's holy character and will. Why then was the Law given? *"The law entered that the offense might abound"* (Romans 5:20). The Law was brought in to classify and clearly define sin. God gave the Law to fully expose man's sinfulness and, thus, to prepare the human heart for the Gospel. *"The law was our tutor to bring us to Christ, that we might be justified by faith"* (Galatians 3:24). God gave the Law to Israel, not to save them, but to show them the impossibility of salvation by human goodness. *"By the deeds of the law no flesh will be justified in His sight, for by the law is the knowledge of sin"* (Romans 3:20). *"The law brings about wrath"* (Romans 4:15). The Law reveals God's wrath against sin and shows that man can only approach God if the complete, righteous demands of His Law are paid in full.

Jesus told the self-righteous Pharisees to go and learn that sinners are saved by God's mercy and not by their own sacrifices to God (Matthew 9:13). How were the Pharisees to learn this? Who or what was God's ordained teacher? How could they see their true condition before God as helpless sinners needing a Savior? It was through a correct understanding of the Law!

The Jews had the written Law of God, but the scribes and Pharisees had given it such a carnal interpretation that it did not convict them of their inner heart attitudes. They did not understand the Law as God intended it to be understood. If they had, they would have realized the impossibility of anyone ever obeying it perfectly; and they would have seen their own unrighteousness. They would have then been prepared for Christ and the Gospel.

Jesus taught them the correct interpretation of the Law (Matthew 5:17-28). But even though Jesus taught them to understand what God's laws really meant, the Jewish leaders would not allow

the Law to judge and condemn them. If they had, they would have been broken in heart and truly repentant.

John the Baptist also gave the right interpretation of the Law as preparation for the Gospel. But the religious leaders rejected both the ministry of John the Baptist and of Jesus. Why? Because their correct interpretation of the Law exposed the true condition of the scribes' and Pharisees' hearts. They rejected this preparatory ministry of the Law, and therefore, they rejected Christ and the Gospel of God's grace (Matthew 5:17-28).

Jesus' conversation with the woman of Samaria is yet another example of the necessity of preparing a person for the Gospel by the correct use of the Law. After Jesus had gained her attention by speaking about her felt need for water, He brought her face to face with her real need. Jesus said to her, *"Go, call your husband"* (John 4:16). Jesus knew this woman would never be prepared to trust only in the grace of God until she faced the truth that she had transgressed the Law which forbids adultery.

Jesus' method of dealing with the rich young ruler provides another lesson for us. Unless a person faces the truth about his sin and condemnation before a holy God, he will not recognize his need for the Gospel.

The rich young ruler, secure in his own apparent goodness and ability to keep the Law, came to Jesus and asked Him what he had to do to inherit eternal life (Mark 10:17-22). Through this young man's greeting Jesus recognized immediately that he was a soul unprepared for the Gospel. This young ruler greeted Jesus as a fellow human being, by saying, "Good Teacher." He had never been enlightened by the Law to realize that *"No one is good but One, that is, God."* He was unaware that all the goodness and righteousness of man, when judged in the light of the perfect goodness and righteousness of God, is nothing more than a bundle of filthy rags (Isaiah 64:6).

Because Jesus recognized this young man's lost condition and his lack of preparation for the Gospel, He did not offer him the grace and forgiveness of the Gospel. Jesus had not come to call a self-righteous, rich young ruler to repentance; He came to call sinners to repentance. Before this young man could understand that the Gospel of God's grace was the only way by which he could enter eternal life, he first had to be taught his sinfulness and unrighteousness in God's sight.

What did Jesus use to reveal this man's true heart condition? Did Jesus use some cultural felt need to lead him into genuine repentance? Did Jesus tell the young man, "Smile, God loves you?" Did He ignore his lack of conviction and immediately introduce him to some easy steps to eternal life? No! Jesus used the Law to expose the covetousness which held him captive.

Because this man had asked what he must do to inherit eternal life, Jesus told him what God required him to do. Being self-righteous, this man believed he could be saved by doing and didn't need God's mercy as a sinner. Therefore, Jesus quoted some of the Law to him.

The rich young ruler's response evidenced his lack of understanding of the perfection of God. He immediately claimed that he had kept these laws perfectly from childhood. Knowing this young man's true spiritual condition and his secret love of money, Jesus said, *"Go your way, sell whatever you have and give to the poor."* Through this command, Jesus was confronting this young man with the practical realities of the second great commandment, *"You shall love your neighbor as yourself"* (Mark 12:31).

Then Jesus said to this ruler, *"Come, take up the cross, and follow Me."* This command was based on the first great commandment, *"You shall love the LORD your God with all your heart, with all your soul, with all your mind, and with all your strength"* (Mark 12:30).

What was the young man's response? Did he turn and repent? Did he, like the publican in the temple, acknowledge that he was a sinner and needed God's mercy? No. He rejected the revealing, condemning ministry of the Law. He turned away, clutching his riches as his greatest treasure. He went away grieved, but apparently unrepentant for his covetousness. Those who reject the message of the Law cannot receive the Gospel.

The majority of the Jews rejected the preparatory work of the Law given through Moses and also taught by John the Baptist, Jesus, and the apostles. Even though they had received the written Law of God, they were self-righteous and trusted in a mere outward conformity to the Law. Because they clung to their self-righteousness, refusing to accept God's verdict on them, they were not prepared to come by faith alone and trust in the grace of God. In contrast, many of the Gentiles, who had been without the direct written message from God, accepted the condemnation of the Law and saw the reality of their spiritual bankruptcy. Therefore, they were ready to turn in faith to Christ and the Gospel as their only hope (Romans 3:19).

The hymn entitled "JEHOVAH TSIDKENU" was written by R. Murray M'Cheyne and is his testimony to the way the Lord taught and prepared him through the Law to see his need of the Savior. ("Jehovah Tsidkenu" means "Jehovah our Righteousness.")

> *I once was a stranger to grace and to God;*
> *I knew not my danger, I felt not my load;*
> *Though friends spoke in rapture of Christ on the tree,*
> *JEHOVAH TSIDKENU was nothing to me.*
>
> *When free grace awoke me by light from on high,*
> *Then legal fears shook me, I trembled to die;*
> *No refuge, no safety in self could I see,*
> *JEHOVAH TSIDKENU my Saviour must be.*
>
> *My terrors all vanished before the sweet Name;*
> *My guilty fears banished, with boldness I came*
> *To drink at the fountain, life-giving and free;*
> *JEHOVAH TSIDKENU is all things to me.*

The professing believers to whom I first ministered in the Philippines had never judged themselves according to the perfection and holiness of God as revealed in the Law. Because they had not been exposed to the correct ministry of the Law, they were trusting in a mixture of works and grace. They were offering God their own sacrifices of good works instead of accepting God's mercy in the Gospel of Christ.

Referring to the time in his life when he was one of the leading Pharisees, Paul said, *"I was alive once without the law, but when the commandment came, sin revived and I died"* (Romans 7:9). Paul was a self-righteous, self-dependent man. He did not see himself as being spiritually sick or needing a Savior. However, when God the Holy Spirit faced Paul with the holy and righteous claims of the Law, he realized he was unspiritual and a slave to sin (Philippians 3:4-9; Romans 7:14). Paul wrote, *"Has then what is good become death to me? Certainly not! But sin, that it might appear sin, was producing death in me through what is good, so that sin through the*

commandment might become exceedingly sinful" (Romans 7:13). Because Paul had been prepared by the Law, he was ready to trust only in Christ.

As long as people are ignorant of the perfect righteousness of God, they will endeavor to save themselves through their own imperfect righteousness. Paul said of his own countrymen, *"For they being ignorant of God's righteousness, and seeking to establish their own righteousness, have not submitted to the righteousness of God"* (Romans 10:3).

If a person is ignorant of the righteousness of God, then he will go about trying to establish his own righteousness. Once he sees the holiness and righteousness of God as revealed by the Law, however, he will completely abandon any trust in his own goodness as a basis for acceptance by God. Once a person has been enlightened by the Holy Spirit through the Word of God, he will say, "If that is what God is like and if he demands perfection from me, then I give up. I will no longer try to merit His favor by what I do. I am unable to obey His holy commands and so please Him." Then, and only then, is a person's heart ready to receive the good news that, *"when we were still **without strength**, in due time Christ died for the ungodly"* (Romans 5:6).

Our responsibility

Today, in most evangelical circles, the usual practice is to present some verses and evidences of man's need and then swiftly turn to the Gospel. Following this quick presentation of man's need, a great deal of time is spent endeavoring to persuade the hearers to turn to Christ. Our great mistake is turning quickly to the remedy without spending sufficient time preparing people for the Gospel.

Because Western society to a large degree has maintained a facade of Christianity, most Christian workers presume that people already have the foundations for the Gospel. We assume they already have a basic understanding of God and His nature and character. However, the vast majority of people in so-called Christian countries have little biblical knowledge of God. Of the relatively few in our countries who do attend church, most have a humanistic and unscriptural concept of God. Regardless of this tremendous lack, the average preacher spends little time on this all-important, basic subject.

It is small wonder that there is little respect for God and spiritual matters in our day. All true spiritual revivals and movements of the Spirit of God have been the result of the acknowledgment of who God really is. This alone brings true contrition of heart, genuine repentance, faith, worship, and holy living. If evangelists and preachers spent more time teaching about the true nature and character of God and less time trying to convince sinners of the advantages of coming to God, we would hear the question asked more often by repentant, anxious sinners, *"Sirs, what must I do to be saved?"* (Acts 16:30).

While we may agree that there must be a preparatory work done in the heart of a sinner before he will trust only in Christ, some may be of the opinion that this is God's sovereign work in which we have no part. It is clear from the Scriptures that God prepares man's heart through His Word. *"'Is not My word like a fire?' says the LORD, 'And like a hammer that breaks the rock in pieces?'"* (Jeremiah 23:29). The Holy Spirit uses the Word of God to convict the world of sin, of righteousness, and of judgment (John 16:8). God has entrusted us with the proclamation of His message (2 Corinthians 5:18-20).

We are responsible to prepare our hearers through the Scriptures by correctly applying the Law before we offer the Gospel to them. I remember beginning to teach a new weekly home Bible study

with a couple in Australia. Before I started teaching that first night, the husband interrupted me and said, "Now, just a moment. Before you say anything, I have something to say."

"OK, go ahead," I replied.

He said, "I reckon that if a person keeps the Law and does exactly what it says, he will be all right and will be accepted by God."

When I agreed with him, his head almost swelled visibly. Turning to his wife, he bragged, "There you are. I told you so. That woman at the City Mission didn't know what she was talking about. She told me I couldn't be saved by what I did."

I told him, "I agree with what you said so I want to write it down." So I wrote down, "Wim said that if we obey the Law and do exactly what it says, God will accept us and we will be OK." Of course, at that point, Wim didn't realize that he did not have the ability to obey the Law because he had been born a sinner. After I had written these words, I put the piece of paper in the front of my Bible. My plan was to produce it at an appropriate future date.

After a few months of weekly chronological Bible studies, beginning in the book of Genesis, we finally reached the story of the giving of the Law. It was obvious from Wim's questions and answers that the Lord was working in his life. As we continued studying the Law, giving the spiritual meaning and application of each of the commandments, Wim was listening carefully. Finally, one night, he interrupted my teaching and said, "I haven't got a hope. I break all of God's laws every day."

Praise God! Wim's spiritual eyes had been opened to see his own sinfulness and inability to please God by personal obedience to the Law. This knowledge had come to him through the study of the Old Testament stories and the Law which revealed the holy and righteous character of God. Later, during our Bible studies, Wim saw that Christ alone had kept the Law and, through His death, had provided a way of salvation for sinful, helpless sinners.

What would have been the result if I had given the Gospel at the beginning of our Bible study, without first exposing Wim to the demands of God's holy Law? Wim would not have clearly understood the absolute necessity of the Gospel. He was not prepared for the Gospel. He felt no need for the grace and mercy of God. He was self-righteous and therefore self-dependent. Possibly, he would have professed faith in Christ, but in his heart, he would have still been dependent on his own efforts and self-righteousness.

Not only has the Gospel been committed to us, but the preparation of souls for the Gospel has also been committed to us. We need to take this seriously. Paul wrote to Timothy, *"We know that the law is good if one uses it lawfully, knowing this: that the law is not made for a righteous person, but for the lawless and insubordinate...according to the glorious gospel of the blessed God which was committed to my trust"* (1 Timothy 1:8-9, 11). Paul knew that the Gospel would not be meaningful without the right application of the Law. The right use of the Law is the means to prepare sinners for the Gospel. The Law is God's appointed schoolmaster to lead the self-righteous to Christ.

We should, through the correct use of the Law, bring people to see that they need a righteousness equal to the righteousness of God, for only that will satisfy a holy God. The question then arises, "Where can I find this righteousness which will satisfy God? How can God be satisfied with me? I have broken His Law. I am condemned to everlasting punishment. How can my debt of sin be paid? How can I be justified and declared righteous before my perfect Judge?"

While some are of the opinion that this preparatory work is the sovereign responsibility of God, others believe that the Gospel should be immediately preached to all, regardless of their lack of preparation, because the Gospel is the power of God unto salvation. They believe the Gospel will prepare the sinner's heart and also save his soul. The Gospel is indeed the power of God unto salvation, but to whom? Romans 1:16 says it is the power of God unto salvation *"for everyone who believes."* Who will trust only in the Gospel and be saved? Only those whose hearts have been prepared like the good soil – those who have been convicted and prepared by God and have been taught by the Holy Spirit to agree with God about their sin, Christ's righteousness, and God's coming judgment (John 16:8-11).

One Sunday morning, a Palawano woman came to our house for the first time. Many years earlier, she had heard some of the Word of God, but for a long time, there hadn't been any missionaries in her area. We had just built a house and had started teaching God's Word in a location about a two or three hours' walk from her home. She came to see us and said excitedly, "I have been out of God for ten years, but now I want to come back into God." By this term "out of God," she meant that she hadn't been attending Christian meetings and doing all the things she associated with being a Christian. By the term "come back into God," she indicated that she was going to attend the meetings once again, sing, pray, and listen to the teaching of God's Word.

I talked with this woman on several occasions about Christ and His death for sinners, and I asked her about her own personal faith in Christ and His death. She said, "Yes, I am trusting in Christ." Nevertheless, her emphasis was on the fact that she had at one time been in God, that she had been baptized, and that she knew many hymns and prayed. She no longer had a New Testament, but she wanted another one because she was coming back into God. Unless specifically asked, however, she never spoke about the death of Christ for sinners.

I said to her, "All of the things you speak of are good in their place, but they will not save you. Only Christ can save you." Again and again when speaking to her, I emphasized Christ's death for sinners.

She answered, "Oh, yes, the previous missionary told me that Christ died. Yes, I believe that."

I thought, "Maybe she is truly saved."

When she returned a week or two later, she said, "I am so happy to be able to sing the hymns, pray, and attend meetings. I am so glad to be back in God."

Once again, I reminded her of Christ's death as the only way back to God.

She answered, "Yes, I remember that." But then she asked the new believers in the area if they had been baptized. When they said that they had not been baptized, she told them that they hadn't even started on the way.

Each time she visited and boasted of her good works, I reminded her about Christ's death as the only way to God. From her attitude, it was clear that Christ's death was not meaningful to her. It seemed as if she thought, "I will be all right if I can only remember that part about Christ dying for sins and rising again."

On several occasions, my wife heard me reminding this woman of Christ's death for sinners. Finally, Fran said to me, "I can't understand you. You are doing the very thing you would tell other people not to do."

I questioned, "What's that?"

She replied, "You keep telling that woman the Gospel, but she is not prepared for the Gospel. She doesn't understand her need of the Gospel. She is not thirsty. She is not hungry. Her heart is not prepared for the Gospel."

My wife was right. I determined that when this Palawano woman returned, I would not remind her again of the Gospel. She needed to be taught the Law in order for her to comprehend her great need of Christ, and Christ alone, as her righteousness.

Shortly after this, she returned. I sat down to talk with her at about one o'clock in the afternoon. I began in Genesis and reminded her of the main stories in the Old Testament which provide the foundations for the doctrine of God, man, and sin. Because she had been attending the meetings, she needed only to be reminded of most of these stories.

As we went through the stories, I emphasized the holiness of God, His hatred of sin, man's sinfulness, and especially the fact that God's Law requires death as the payment for sin. I wanted to make it clear to her that God would accept no compromise. I applied these truths to her personally by telling her that baptism, hymn singing, church attendance, reading the Scriptures, or any other thing that she could do would not pay for her sin.

About five o'clock that afternoon, she was frustrated and desperate and began to cry. Although Palawanos do not like to be seen crying publicly, she cried because she was so overcome by the hopelessness of her position before God.

While she was crying, I was silently praying, "Lord, give me wisdom. What should I say to her? I don't want her to mentally agree with what I have shared from your Word but not trust only in Your Son and the Gospel. Lord, save this woman! Bring her to that place where she sees her salvation is only in Christ, so she will put her faith in Him and never again in herself or anything that she can do."

Finally, I said to her, "God requires death, but isn't there somewhere you can find the payment instead of you dying? Isn't there someone who could pay it? I can't pay it for you because I, too, deserve to be separated from God because of my sins."

For a time, we sat there in silence. Finally, she looked up at me through her tears and answered, "Jesus."

Joyfully, I replied, "Yes, Jesus. He's the only One."

That woman's whole attitude was changed from that time. Gone was her boasting and trust in anything else except the Lord Jesus Christ. How sweet the name of Jesus sounds to a believer's ear! He is the answer.

Christian, it will thrill your soul, if, through the correct teaching of the nature and character of God and the Law of God, you give the Holy Spirit the opportunity to prepare people for the Gospel, for then they will trust only in the Lord Jesus as the One who died for them and fully satisfied God on their behalf.

5

Divine Building Principles

During our early years with the Palawanos many came to understand justification by faith through God's grace. Many who had previously been mere professors of salvation were saved, and others received assurance and clarity regarding their personal salvation. Not only was I teaching justification by faith, but other missionaries among the Palawanos had also realized the true condition of the Palawan churches and were endeavoring to strengthen the basic foundations of the people's faith. What a thrill to see the people trusting in Christ alone!

How could these babes in Christ best be nurtured and fed? With so many people to teach, I felt like a doctor dispensing vitamins to an undernourished and starving people. Our itinerant teaching program was totally inadequate to meet the needs of these young believers and build them up in the faith. Therefore, I decided to switch from a predominantly topical teaching approach to verse-by-verse exposition. I relocated my family to the middle of an area with six small churches and began to give these Palawano churches concentrated expositional teaching.

Because the congregations of these six churches were a mixture of saved, mere professors, and a few who didn't even claim to be children of God, I started teaching expositionally through the Gospel of John. Starting with great enthusiasm, it soon became apparent that my hearers were not ready for an expositional study of John. They could not understand any of the verses containing direct references or allusions to people or stories from the Old Testament because they had never been taught the basic Old Testament historical sequence of events as one complete story.

The following examples show a few of the problems I encountered:

- John 1:1, *"In the beginning was the Word."* Even though the people may have heard about the beginning from previous missionaries, it was vague and uncertain in their minds. So I had to go back to Genesis 1 and teach about the beginning of time.

- John 1:1, *"And the Word was with God."* After explaining that the Word is yet another title for the Lord Jesus, it was obvious that the Palawano people did not understand that Jesus was with the Father before the beginning.

- John 1:3, *"All things were made through Him."* The people did not understand that God in Genesis 1 was three Persons – God the Father, God the Son, and God the Spirit.

- John 1:11, *"He came to His own."* This meant little to the Palawanos without the background of the call of Abraham, the Messianic promises, and the history of Israel.

- John 1:14, *"And the Word became flesh and dwelt among us, and we beheld His glory."* This alludes to the Old Testament tabernacle and the Shekinah glory wherein God lived in the midst of Israel. The Palawanos didn't know these stories.

- John 1:17, *"The law was given through Moses."* The people had insufficient knowledge of the chronology of the Bible story, and they didn't know where the Old Testament and New Testament characters fit in the sequence of events. They questioned if Moses and John the Baptist were contemporaries and wondered if Jesus was on the earth at the same time as the people mentioned from the Old Testament.

As these few examples show, the Gospel of John is full of references to the Old Testament. Due to the Palawanos' sketchy understanding of the Old Testament, I had to intermittently break off the exposition of John's Gospel in order to teach the Old Testament story or truth to which John referred or alluded. This piecemeal form of teaching was frustrating for me as the teacher and confusing for my hearers.

I was forced to conclude that a clearer and less complicated way to teach the Scriptures must exist. A major forward step had been made when I turned from predominantly teaching topically to direct verse-by-verse exposition of the New Testament books. Nevertheless, it was now apparent that choosing any book and teaching it expositionally was not the complete answer to teaching the Scriptures clearly. What was the answer?

One book

The Scriptures were written with a definite beginning and a definite ending. Between the beginning and ending are incidents which, when taught and understood in their historical sequence, form one complete, cohesive, intelligible story. If one were to teach the contents of any other book, he would naturally start at the beginning and follow the forward movement of the subject as the author develops and brings it to its logical conclusion. Little wonder we had difficulties when teaching the New Testament to the Palawanos!

Previously, I had approached the Bible as a book which contained the message of the Gospel. I now began to consider the Bible holistically – as God's complete, unified message to all mankind. I realized the Old Testament is not a compilation of interesting stories to be used only as types which pointed forward to Christ or illustrations of New Testament truth. The Old Testament is the logical introduction, foundation, and authority for the story of Christ recorded in the New Testament. The Old Testament is by far the most important source of interpretive background material for the historical accounts of the New Testament. Just as God has given us two lips and both are necessary for clear verbal communication, even so both Old and New Testaments are indispensable for the communication of God's complete message to the world.

One story

The whole Bible is God's message about His Son, the Savior. God's chief purpose in writing His Book was to reveal Christ. The Old Testament is the preparation for Christ. The New Testament is the manifestation of Christ. The Scriptures reveal Christ from Genesis to Revelation. Jesus said to the Jews of His day, *"You search the Scriptures, for in them you think you have*

eternal life; and these are they which testify of Me" (John 5:39). The entire Scriptures find their meaning in the Lord Jesus Christ. Jesus Christ is the origin, the substance, and the object of all divine revelation.

His-story, that is, the story of Christ, begins in the first verse of Genesis, for He was there in the beginning. At the fall of man, the Son of the virgin is promised – One who will overcome Satan and deliver his captives. The story of Christ then continues through the entire Old Testament in numerous types and prophecies. The New Testament records the fulfillment of these prophecies through His birth, life, death, ascension, and present glory. The story of Christ as told in the Gospels is the sequel to the Old Testament.

The Gospel of Matthew opens with the story of the birth of Christ, not as the beginning of the story but as the fulfillment and consummation of all that was written previously. Matthew connects the story of Christ with Abraham to whom God had given the promise, *"in you all the families of the earth shall be blessed"* (Genesis 12:3). This, and all the other promises given to Abraham, were to be fulfilled through Abraham's Seed, *"who is Christ"* (Galatians 3:16).

The Gospel of Mark launches almost directly into the life of Christ, but Mark is nonetheless careful to remind his readers that this story is not the beginning but the fulfillment of that which was *"written in the Prophets"* (Mark 1:2).

Luke traces the genealogy of Christ to Adam (Luke 3:23-38). By doing this, Luke shows us that the story which he wrote cannot be understood by reading only of Mary and Joseph or of Jesus born as a babe in Bethlehem. To clearly understand Luke's Gospel, we must also be aware of Adam's part as the first man in the historical drama of the Bible.

John's Gospel tells the ongoing story of the Word. The story of the Word begins in eternity. It continues in the Word's creation of all things and then in His incarnation (John 1:1-3). The future story of the Word is told in the Revelation, where He is described as being *"clothed with a robe dipped in blood"* (Revelation 19:13).

When Jesus saw the need to explain the necessity of His death to two sadly disillusioned men on the road to Emmaus, He turned back to the Old Testament, *"And beginning at Moses* [Genesis to Deuteronomy] *and all the Prophets* [the remainder of the Old Testament]*, He expounded to them in all the Scriptures the things concerning Himself"* (Luke 24:27).

The Christ-story cannot be clearly taught or understood apart from its God-given beginnings found only in the Old Testament. Therefore, it is our responsibility to teach the beginnings in the Old Testament and then teach the fulfillment in the New Testament. In the Old Testament, God has given types which so clearly point forward to Christ and redemptive analogies to prepare people to understand the New Testament story of Christ. These Old Testament types of Christ and redemptive analogies point to and interpret the birth, life, death, burial, and resurrection of the Lord Jesus Christ.

Biblical redemptive analogies

Instead of emphasizing the Old Testament redemptive analogies as the basis for the understanding of the Christ story, some missionaries seem to depend more on redemptive analogies found in the cultures of various ethnic groups.

A young missionary en route to his homeland for furlough passed through Australia. As I talked to him, it became obvious that he was discouraged with the lack of progress in his missionary work. When I asked if he had presented the Gospel to the people, he told me that he hadn't. My next inquiry was why he had been such a long time in the tribe but had not yet begun to evangelize. The reason he gave was that, in spite of all his searching, he had failed to find the cultural redemptive analogy or what he thought was the God-given key for their clear understanding and acceptance of the Gospel. Because he failed to find the key or redemptive analogy, he didn't have confidence to preach the Gospel to those lost tribal people. Since he was returning to the USA, I asked him what the redemptive analogy or God-given key to open the door to understand salvation is in the American culture. Because he didn't know, I replied, "According to what you believe, it won't be of any use for you to tell your fellow Americans the Gospel until you find the key."

If God has placed such an effective medium of blessing within some cultures, then surely we can expect that the Lord has placed them in all. If God has indeed given redemptive analogies which are hidden within the cultures of primitive peoples to serve as the keys to open their understanding to accept the Bible, God, Christ, and salvation, then we must never cease in our search. But how will we know when we have found the right key? Who will be the judge? What will be our criterion or standard of judgment? If we come to the conclusion that we have found the key because we see tribal people understanding and accepting the Gospel, how do we know there is not yet another even more suitable key prepared by God and waiting to be used to unlock the cultural door for an even greater movement to God and the Gospel?

Cultural stories and rituals which resemble or illustrate Bible stories and Old Testament rituals and ceremonies can be useful in explaining the Gospel but they are not the God-given keys to open the people's understanding of the Gospel. These stories and rituals are most likely remnants of the truth which the whole human race knew before the dispersion at the tower of Babel. They have been passed down orally in many primitive societies and have been greatly changed and grossly distorted. The truth of God once known has been deliberately set aside for the lies of Satan (Romans 1:18-32). One of the clearest illustrations of this would be the widespread use of blood as a way of appeasement and sacrifice. This knowledge originated with the blood sacrifices which God ordained after the fall of man. Blood sacrifices, once commanded by God as the only way of approach to Him, are now used in many tribal cultures as sacrifices to Satan and evil spirits.

Missionaries should know all they can about the culture, folklore, and beliefs of the people they are reaching for Christ, and they should use carefully selected illustrations and redemptive analogies when teaching God's Word. These, however, are not substitutes for the preparation of the hearts of sinners through the proclamation of the Scriptures. Cultural analogies and illustrations, regardless of their clarity, cogency, or incredible biblical parallelism, should never take precedence over the scriptural redemptive types and analogies. Cultural redemptive analogies are no substitute for the God-given redemptive analogies of the Old Testament which so graphically typify Christ and His work of redemption. Some secret significance or evil connotation may be hidden in cultural analogies of which the missionary may be totally unaware. If the missionary depends too much on cultural analogies, rather than biblical analogies, he may unwittingly guide the people into grievous misunderstanding, error, and syncretism. In addition, overemphasis on cultural redemptive analogies may cause the people to believe that the missionary is confirming and giving credence to their beliefs.

Jesus told the Pharisees that the truth of God's Word sets Satan's captives free from sin's bondage (John 8:32), and He declared in His prayer to His Father, *"Your word is truth"* (John 17:17). Paul

charged Timothy to *"Preach the word"* (2 Timothy 4:2). The living and enduring Word of God, the imperishable seed, when believed, results in souls being born again (1 Peter 1:23).

No evidence exists in the Scriptures to prove that God's Word is effectual for the release of tribal people from Satan's dominion only when interpreted by cultural redemptive analogies. God has provided us with spiritual weapons with which we are to fight Satan, demolish his strongholds, arguments, and pretensions which set themselves against the knowledge of God (2 Corinthians 10:3-5).

God's revelation for the world

The biblical redemptive analogies given by God to Israel were also for the whole world. *"For whatever things were written before were written for our learning, that we through the patience and comfort of the Scriptures might have hope"* (Romans 15:4). God has not spoken directly to the Gentiles, but He has chosen to speak to the Gentiles through His Word given to Israel and the Church. All people must come to God's light shining from the Scriptures. By the infinitely wise and sovereign appointment of God, all of the redemptive story and the beginning of the Church of Jesus Christ are set within the cultural, geographical, and historical framework of the nation of Israel. Therefore, no one can clearly understand the story of the New Testament without a basic knowledge of Israel's origin, development, and history from the Old Testament.

The Lord created the nation of Israel for Himself, so that He could use it as His witness and channel of blessing to all of mankind (Isaiah 43:1, 10-12, 21). The Lord's promises to Abraham, the father of the nation of Israel, indicated that God's blessings through him and his seed would extend to *"all the families of the earth"* (Genesis 12:1-3). This promise was fulfilled through Christ, the promised Seed, but also through the Scriptures, entrusted to Israel as the only revelation of God to the world. All other nations were left in ignorance, without God and without hope, unless they were willing to accept truth and wisdom which was given through God's chosen channel, Israel. The Lord said to Israel, *"You only have I known of all the families of the earth"* (Amos 3:2). In contrast, the Gentile nations, prior to Pentecost, are spoken of as *"a people I have not known"* (Psalm 18:43).

The Bible alone is God's revelation to the world. This is the foundational truth of Christianity. A major cause for the growth of Buddhism, Hinduism, Islam, and many other false religions in societies once strongly influenced by the Judeo-Christian faith can be attributed to the writings of liberal and modern writers. Although they claim to be Christians, they teach that truth is not limited to the Hebrew-Christian Scriptures but is also found in the writings of other world religions. Animistic people believe that truth is based on folklore and revelations from the spirits.

The Christian missionary's responsibility is to clearly establish, through teaching the Scriptures, that God's revelation of truth for all people was given through no other nation except Israel and those men appointed by God to write the New Testament. Therefore, if the tribes and nations of the world are to know the truth and the blessings of God, they too must turn to the Bible as the only genuine and complete divine revelation. This revelation of God began with the Old Testament and was completed with the New Testament revelation in and through Israel's Messiah, Jesus of Nazareth. *"God, who at various times and in various ways spoke in time past to the fathers by the prophets, has in these last days spoken to us by His Son, whom He has appointed heir of all things, through whom also He made the worlds"* (Hebrews 1:1-2).

The Bible then is one book. The Old Testament is the introduction and only sound basis for the understanding and interpretation of the New Testament story concerning Christ and His redemptive work.

But has God only told us what to teach and left how we teach up to us? As my search continued, it became clear that the Lord wrote the Scriptures not only to tell us what to teach but also to demonstrate principles and guidelines as to how we should teach His message to the world. His methods of teaching are the best; and He means for us to study and be guided by them when we teach His Word to others.

The literary form of the Bible

God is the greatest teacher, and all intelligent beings are His pupils. No one can escape from His classroom, the universe. The angels, and even Satan and his demons, are subject to God's divine teaching process (Ephesians 3:10). The voice of God is heard in innumerable ways throughout all creation.

Man, created on earth by God and for God, was intended to be the willing pupil of God. God's voice of wisdom says, *"To you, O men, I call, and my voice is to the sons of men. O you simple ones, understand prudence, and you fools, be of an understanding heart"* (Proverbs 8:4-5).

The omniscient Teacher wrote a Book to teach and lead mankind into the full understanding of truth about Himself and His perfect will for all created beings. Because He created man, He understands perfectly the functions of man's mind. God knows how best to captivate the human imagination and lead people to a clear comprehension of truth.

The author of a book must decide what literary style he considers most suitable for his subject and his readers. The author of children's books must approach his subject in a form suitable for his topic, considering the limitations of a child's mind; whereas a person writing for adults must choose a method of presentation suitable for the topic of his book and the intelligence of its prospective adult readers.

The divine Teacher, perfectly knowing His subject matter and human pupils, chose the most suitable literary style for His Book. This Book has been entrusted to the Church, the Body of Christ. The Church, God's representative on earth, was given the Bible to take God's message of reconciliation to the world (2 Corinthians 5:18-20). Nevertheless, the Church has generally acted like a teacher who, having been given a well-prepared teaching manual, ignores the method and style of presentation chosen by the author and completely revamps and reorganizes the subject matter in his own teaching format. In most cases, teachers of the Scripture in every department of the church, from the Sunday School to the mission field, have failed to consider and follow God's form of teaching so clearly demonstrated in His teaching manual, the Bible.

History

That which God recorded in the Scriptures actually happened in time and space. God spoke. God acted. God interacted with real, historical human beings. The contents of the Bible are relevant to all people in every age, regardless of their culture, because the Bible is a book of case histories. We are able to identify with those people whose lives are recorded in the Bible. God interacted and spoke to real people – people like us.

God has revealed Himself through His acts in history. When God needed to remind Israel of His true identity, He pointed them back to His historical relationship with their forefathers. The Lord said to Moses, *"Thus you shall say to the children of Israel: 'The LORD God of your fathers, the God of Abraham, the God of Isaac, and the God of Jacob, has sent me to you. This is My name forever"* (Exodus 3:15).

The Lord constantly reminded His chosen people, "If you wish to know who I am and what I am, then remember how I acted in relationship with your fathers Abraham, Isaac, and Jacob. Remember how I acted in my relationship with you as a nation. Recollect how I delivered you out of Egypt. Look what I did to the Egyptians through the plagues which I brought on that sinful nation. Remember how I delivered you at the Passover and at the Red Sea. Don't forget how I treated you in the wilderness. Did any of My promises fail? Call to mind how I brought you into this land which I promised you. Remember that I brought judgment upon you because of your idolatry and took you away into Assyria and Babylon but restored you to your own land in fulfillment of My promises."

God revealed Himself as He walked through history with man. Cited in the Scriptures are numerous incidents relating to events in Israel's history through which God revealed His nature and character (Exodus 3:13-15; Deuteronomy 7:18-19; 8; 11:1-7; Psalms 105; 106; 111).

Because God actively revealed Himself within the context of the historical events recorded in the Scriptures, Israel's leaders and prophets constantly rehearsed and reminded the people of Israel of their history.

Israel's faith rested on God as revealed through His historical acts. This is seen in their continual remembrance of their deliverance by God out of Egypt at the time of the Passover. The faith of every generation was to be built on the firm foundation of the God of history who had revealed Himself as Israel's Redeemer on that memorable night in Egypt (Exodus 12:24-27). Each successive generation of Israelites was taught the historical facts regarding God's redemption of them as a people. Each individual Israelite had to exercise faith if he was to enter into the salvation of the Lord, but this faith was not in some personal, subjective experience. It was faith in the Lord of history, the Redeemer of their nation. As the Israelites participated by faith in the Passover celebrations, they were signifying their faith in the God of Israel, the God of redemption, the God of history, the God of Abraham, Isaac, and Jacob. They looked to an historical event which had brought salvation to them as a nation. They knew and trusted in God as He had revealed Himself in history.

God has not only shown what He is like in action in the Old Testament, but also in the New Testament. When God planned to show mankind finally and completely what He is like, He stepped into history in the person of Jesus Christ, His Son. What did Jesus answer when Philip said, *"Lord, show us the Father, and it is sufficient for us"*? Jesus said, *"Have I been with you so long, and yet you have not known Me, Philip? He who has seen Me has seen the Father"* (John 14:8-9). The disciples needed to understand that Jesus was God in action. He was God – living, talking, walking, and speaking before them. If they wanted to see what God was like, they must look to, listen to, and believe on the Lord Jesus. *"No one has seen God at any time. The only begotten Son, who is in the bosom of the Father, He has declared Him"* (John 1:18).

God was in action in the Old Testament as Jehovah. God was in action in the New Testament as Jesus Christ. God was also in action in the Acts of the Apostles in the person of the Holy Spirit.

The apostles' emphasis

The apostles recognized the Old Testament as God's record of His involvement in the world and especially with His chosen people, Israel, in preparation for the coming of the Savior. The Old Testament was the Bible of the early Church. The apostolic preaching recorded in the Acts first emphasized God's historical acts in relationship to Abraham, Isaac, Jacob, Joseph, Moses, David, and the nation of Israel. The apostles then linked these acts of God in the Old Testament to the revelation of Himself in the history of His Son, Jesus of Nazareth. The apostles interpreted the whole of Christ's advent, life, death, resurrection, present glory, and all future revelations of His majesty on the basis of the historical accounts and prophecies of the Old Testament. They used the Old Testament to authenticate the claim of Jesus of Nazareth to be the Christ. For them, the story of Christ began long before they met Him beside the Sea of Galilee or at the River Jordan where John was baptizing. The faith of the apostles and those who believed the apostles' message rested on the basis of the testimony given concerning the Christ from the Old Testament. They taught the Old Testament and its history and the events which they had so recently experienced in the company of Jesus of Nazareth as one story.

This method of teaching is clearly evident, beginning with Peter's sermon on the day of Pentecost. Another classic example is the sermon of Stephen in which he gives an account of Old Testament history beginning with Abraham. Stephen climaxes his sermon with a brief account of the nation of Israel's attitude toward God's final messenger, the Lord Jesus. Acts 8 records the story of Philip who met the Ethiopian eunuch when the eunuch was reading Isaiah 53. Philip linked this Old Testament portion of Scripture to the events which had so recently taken place at Golgotha and brought this man to an understanding of the Gospel. (Note also Acts 2:22-36; 3:13-26; 7; 10:34-43; 13:16-41; 17:2-3.)

The Church's responsibility

The Old Testament Scriptures, which prepare the mind to see the need and purpose for the incarnation, have been badly neglected by the Church. Multitudes misinterpret the whole purpose of Christ's ministry and death because they have little, if any, understanding of the biblical reasons for His coming. If those who declare the Gospel in homes, churches, Bible studies, and Sunday schools and the greater world community were to teach the beginnings of the redemptive story from the Old Testament before they teach its fulfillment in the New Testament, many more would clearly understand the advent of Christ as God's plan for their salvation. But while Christians continue to ignore this divinely revealed order of teaching, the confusion in the minds of many concerning Christ and His mission will continue.

Of recent times, many missionaries, pastors, and other Christians have taken the time to teach people the Old Testament beginnings of the Christ-story and have carefully followed the unfolding historical drama to its consummation in the New Testament. Upon completion of this teaching program these Bible teachers have testified to the great clarity in their hearer's understanding of their helpless and sinful condition and of Christ's full provision for their salvation through His death, burial and resurrection.

In contrast, many have launched almost immediately into the story of Christ with little preparation from the history of the Old Testament. Some, after many years, have found that their message was outwardly accepted but not truly understood.

Bob Goddard, Sr., wrote the following about the Ava tribal people of Paraguay:

> *The Jesuit priests established colonies with many of these Indians over 400 years ago. The Jesuits were banished by the political leaders, and the Indian colonies were abandoned. In those days, the Mamelucos of Brazil made raids into Paraguay and carried off many Indians as slaves.*
>
> *The results of all this are reflected in the culture and religious beliefs of these Ava people. Religiously, they are willing to accept God and Jesus Christ, as they did from the Catholics years ago. They simply add them to their innumerable list of gods which is continually increasing.*
>
> *This was unknown to our missionaries when they first presented the Gospel to the Avas. Since there were those who were willing to accept their teaching and professed to be Christians, it seemed there was progress. However, as the years passed and very little sign of the reality of changed lives was observed, it was found that they did not understand the Gospel.*
>
> *A study of their culture and religion has brought us to the conclusion that we must begin with Genesis and lay a foundation upon which to build so that they can understand who God is, what sin is, how man fell through sin and can be saved only through faith in God's Son, Jesus Christ.*

The God of Christianity is the God of history. The faith of Christians is based on God's great revelatory acts, beginning with God's acts of creation and culminating in the historic, redemptive acts of the Lord Jesus Christ in His birth, life, death, resurrection, and ascension to glory. Therefore, it is our responsibility to teach His-story. Just as Israel's teachers kept the history of Israel, wherein God acted, alive in a real and meaningful way as the basis of the faith of all succeeding generations of Israelites, so we are to teach. Not only should we teach the New Testament history of God's redemptive acts in and through our Lord Jesus Christ, but also the Old Testament history wherein God revealed Himself as the God of creation, judgment, and salvation. Just as each individual Israelite was to look back to God's actions in history as the basis of his faith, so must we. For example, to remind us of God's central act of history on which we rest our faith, we have been given the Lord's Supper. *"Christ, our Passover, was sacrificed for us"* (1 Corinthians 5:7).

The Church must teach the historical content of the Scriptures so that people will not look to some subjective, personal experience as their hope of salvation. They should look instead to the objective reality of the living God as He has revealed Himself in and through biblical history and to Christ's historical redemptive experiences on their behalf (2 Corinthians 5:18-20). When the historical content of the Scriptures is ignored, people become absorbed with their own subjective experiences rather than with the objective historical saving experiences of Jesus Christ as their representative. What we teach and emphasize to our hearers will become the foundation and basis of their faith. If our emphasis is on personal experiences, the people will be looking to inner experience as the basis for their acceptance before God. But if our message is biblical history, culminating with God's historical saving work in Christ, their faith will depend on the reality of Christ's accomplishments for them, completely apart from themselves and their own experience. They will look to God's finished work in Christ on their behalf.

The message we are given in the Bible to take to the world is not a list of doctrines or topical points about God. What we declare is that which actually happened in time and space. It is real. It is factual. It is history. When we bypass or ignore the historical content of the Scriptures in which

God has revealed Himself and divorce the words of God from their historical context, we are overlooking God's basic form of revelation. Furthermore, we are robbing the Bible of its strongest argument and reason to be recognized and accepted by the world as the only authentic revelation of God. God has stepped into the world's history, not once, not twice, but repeatedly. God has acted. God has spoken. God has not left man without a witness. He has revealed Himself to man as He has walked through history, not only as the Jehovah of the Old Testament but also as Jesus Christ of the New Testament. This marks the basic difference between the Hebrew-Christian faith and all other world religions, both past and present.

When Christian theology is stripped of the historical acts of God and presented to the Muslim, the Buddhist, the animist, or adherents to other world religions as a list of doctrines, Christianity then appears to be a mere alternative – the Western man's philosophy of God. Furthermore, Christian doctrines, taken apart from their historical revelatory content, can be easily adopted and added to the existing, established concept of God and religion. The result is syncretism, a wedding of pagan and Christian doctrines.

The Bible proclaims that the God of history is the one and only Creator, almighty Judge, and Savior of the world (Isaiah 43:9-17). There is only one true historical religion, that is, the religion of the Bible which was revealed and guided through history by God Himself. All other religions are false and are the deceiving work of Satan. The greatest safeguard against syncretism, misunderstanding, spurious converts, and an experience-oriented religion is the teaching of the Word of God as God has given it with all of its historical content. Therefore, we must not teach a set of doctrines divorced from their God-given historical setting; but rather, we must teach the story of the acts of God as He has chosen to reveal Himself in history. People may ignore our set of doctrines as our Western philosophy of God, but the story of God's actions in history cannot be refuted.

God uses this biblical, historical presentation of Himself to convince people of the truth of the Scriptures. Through this, people understand and are convinced that the God of Christians was not created through the speculations and vivid imaginations of Hebrew or Christian philosophers. Instead they can understand and believe that He is indeed the living, personal God who was and is involved in the history of the whole world. He is the God who is here. He is the God who knows them personally and knew their ancestors, even though they had never heard about Him (Acts 17:24-29). It is particularly important for people of other cultures to understand that the Christian God did not originate in the mind of some Western religious leader and that He is not the invented product of the Christian religion.

This then should be the content of our message to the nations, for this has been entrusted to us by God. Through teaching, we are to make all men aware of God's acts in history wherein He has revealed Himself. These historical revelations are for all people and have been recorded and preserved by God as the basis for saving faith.

6

Building Chronologically in Evangelism

In 1962 the Lord had used Paul's ambition *"And so I have made it my aim to preach the gospel, not where Christ was named, lest I should build on another man's foundation"* (Romans 15:20) to challenge me to leave full-time evangelism in Australia. As a result God led us to the Palawano tribal people where He also began to show me that people's hearts needed to be adequately prepared to hear the Gospel. In 1973, while still ministering among the Palawano, God used this verse once again to challenge me to go to a new area in Palawan which was without a Gospel witness. I was eager to put the biblical principles for teaching the Scriptures that God had taught me into practice in an area untouched by the Gospel.

As I prepared to begin this new work farther south, I had some trepidation. Would I find after a few years that my methods and teaching produced the same misunderstanding of the Gospel, syncretism, legalism, and inadequate Old Testament foundations for the understanding of the New Testament with which I had grappled for so many years among the Palawano churches? What needed to be included in my evangelistic teaching program to prevent such misunderstanding?

It had become clear to me that when evangelizing one should follow the teaching guidelines demonstrated in the Scriptures. These teaching principles have been discussed in the previous chapters. In order to consider the logical and biblical reason for the teaching program which I am about to introduce, a brief summary is in order.

1. The Scriptures taught in evangelism must expose our hearers to the revelation of God's nature and character in order to prepare them for the Gospel. When evangelizing, one should teach in such a way that the hearers will judge themselves in the light of the biblical concept of God.

2. Because God chose to reveal Himself through His acts in history rather than by mere declarations and propositions, our evangelistic teaching must include the historical sections of Scripture wherein God has shown His true nature and character.

3. The Law must be part of our teaching as we prepare hearts to trust only in Christ, for *"by the law is the knowledge of sin"* (Romans 3:20). If we want to avoid syncretism, legalism, and a mixture of works and grace, we must use the Law in the

correct way so that the consciences of our hearers will be exposed to the Law's convicting and convincing power.

4. The goal of all true evangelism is to see people trusting only in the Lord Jesus Christ and His saving work on their behalf. If our hearers are to understand and correctly interpret the story of the Gospels concerning Christ, we should provide adequate Old Testament Christological background information.

5. During evangelism, our hearers should be taught the basic history and culture of Israel, for only then will they be able to understand the story of the Jewish Messiah, the Old Testament redemptive types which Christ fulfilled, Christ's position as the Son of David, King, and righteous Judge of Israel, His specific ministry to the lost sheep of Israel, and His final rejection by His own people.

The Lord had taught me that these biblical teaching guidelines are essential when evangelizing. How then could I be sure that all of these necessary aspects would be included in my evangelistic teaching program? Where could I find a teaching format which included each biblical teaching principle?

Considering each principle brought me to the conclusion that the best way to evangelize is to begin in the beginning and teach chronologically through the Scriptures to ensure that people understand the story of Christ and are properly prepared for the Gospel.

This first section of the Chronological Teaching Outline, which is for evangelism and emphasizes salvation, is referred to as Phase 1. As the following chart shows, Phase 1 begins in Genesis and concludes with the ascension of Christ, as recorded in the book of Acts.

Old Testament	Gospels	Acts	Epistles
Phase 1 Designed to teach: Unbelievers Mixed groups with both unbelievers and believers Believers who have not yet been taught through Phase 1			

Phase 1 for unbelievers

The Old Testament Scriptures provide the foundational revelation of God. God is sovereign, omnipotent, omniscient, omnipresent, holy, loving, righteous, merciful, and immutable. God is man's Creator, Lawgiver, Judge, and Savior. This revelation of God begins in Genesis 1 and continues through the historical development of the human race and through the lives of the patriarchs, beginning with Abraham. God's nature and character are further revealed by His judgments on Pharaoh and Egypt, the deliverance of Israel from slavery, and God's care for the Israelites in their journey to Mount Sinai. The Lord's sovereign position as man's Creator, Lawgiver, and Judge is solemnly reinforced by the giving of the written Law. The disclosure of God's nature and character continues through His judgments on rebellious Israel, tempered by His mercy and ever-watchful preserving care. Through the ministries of Moses, Joshua, the judges, the

kings, and the prophets, God fully manifested that it is His prerogative to condemn the guilty and forgive the repentant.

The Old Testament covers the dispensation of Law. This does not mean that the grace of God was not exhibited during the Old Testament era. The salvation of sinners, beginning with Adam and Eve, has ever and only been through the infinite grace of God. But even though the grace of God is evident in the Old Testament, the sovereignty, righteousness, holiness, and judgment of God are even more noticeable. Through the Law given to Israel, God revealed Himself as the Holy One who will not condone sin or allow it to go unpunished. God's Law was given during the Old Testament era to expose the innate depravity of the human heart and God's holy anger against all who break His commandments. Therefore, there is no better or more straightforward way to bring an unsaved person face to face with the demands of God's holy Law than to expose him to the Old Testament portions in which God used the Law to teach and prepare the Israelites to see their helplessness and need of a Savior (Romans 3:19-20).

Is it necessary to teach all of the Old Testament to unsaved people before teaching them the life and saving work of Christ? No! It is quite unnecessary, for the greater part of the Old and New Testaments is addressed to believers. The main purpose of the Gospels, on the other hand, was to lead unsaved people into the knowledge of Christ's life and work of redemption. John said of his Gospel, *"these are written that you may believe that Jesus is the Christ, the Son of God, and that believing you may have life in His name"* (John 20:31). It logically follows that, when evangelizing, one need only teach those portions of the Old Testament which are the foundations for the story of Christ from His birth to His ascension. Sufficient of the Old Testament story should be taught so that when Old Testament historical and geographical data, prophecies, personalities, and illustrations are referred to or used as illustrations by the Gospel writers, the hearers will already know the stories and so be able to clearly understand the meaning of and reason for the reference.

Following the flow of biblical history

Because God has chosen to reveal Himself within the framework of history, the Scriptures will be most clearly taught if we follow the flow of history from Genesis to Revelation.

The Chronological Teaching Outline presented in this book is based on the historical sections of the books of the Bible which record this forward movement of history. (See chart on Page 54.)

It takes too long to teach

One of the most common complaints regarding the form of teaching suggested in this book is that it takes too long to teach.

This is the day of speed and easy ways to do everything. Precooked frozen meals, instant desserts, and microwave ovens help make sure everything is on the table in a matter of minutes. Every conceivable gadget to speed up the process of daily living is available.

The same type of thinking has made inroads into the Christian church and is often applied to evangelism, church growth, and every other area of church life. The easy, quick and popular way is preferred to the longer method of systematically teaching the Scriptures. The quick method may

appear to bring rapid results, but like seed in the parable of the sower that fell on unprepared ground, the unprepared professors soon fall away (Proverbs 21:5).

While Christians should be open to learn more efficient and effective ways to do their work, they must never forget that God's power is manifested and His work is accomplished by the declaration of God's truth in the power of the Holy Spirit. There is no other way. God does not change His methods to fit in with modern thought and so-called advancements. *"For I am the LORD, I do not change"* (Malachi 3:6). This is true of God's nature, and it is also true of His ways of working.

The Flow of Biblical History	
The Books of Historical Movement	**Other Books Written During these Periods**
Genesis	Job, Psalms
Exodus	Leviticus, Psalms
Numbers	Deuteronomy, Psalms
Joshua	Psalms
Judges	Ruth, Psalms
1 and 2 Samuel	Psalms
1 and 2 Kings	Proverbs, Ecclesiastes, Song of Solomon, 1 and 2 Chronicles, Isaiah, Hosea, Joel, Amos, Obadiah, Jonah, Micah, Nahum, Habakkuk, Zephaniah, Psalms
Daniel	Jeremiah, Lamentations, Ezekiel
Ezra	Haggai, Zechariah
Nehemiah	Esther
Malachi	
Matthew, Mark, Luke, John	
Acts	James, 1 and 2 Thessalonians, Galatians, 1 and 2 Corinthians, Romans, Philemon, Ephesians, Colossians, Philippians, 1 and 2 Peter, 1 and 2 Timothy, Titus, Hebrews, Jude, 1, 2 and 3 John
Revelation	

Man's greatest need is to hear, understand, and respond to the pure Word of God. God's power is inherent in His Word. It was through His Word that the Almighty God brought order out of chaos, light out of darkness, and life to a lifeless world. And it is by His Word that the Lord exposes the wickedness of the human heart, brings life to the dead spirit of man, delivers Satan's captives, and gives sight to the spiritually blind (Isaiah 55:10-11; Luke 4:18; John 8:32; 1 Peter 1:23-25).

The Christian's responsibility is to teach God's Word in total dependence upon the Holy Spirit. No amount of human wisdom, ingenuity, or high-pressure evangelistic methods can hasten the work of the Holy Spirit and the conversion of a soul. It is not our responsibility to determine or try to force the time of the new birth. We are to faithfully teach all that has been committed to us and leave the work of transformation to the Lord.

One of the greatest faults in the ministry of the Church worldwide is the unwillingness to take the time to teach unsaved people over a long period of time and allow God the Holy Spirit to do His work of enlightening, convicting, and leading people to the type of faith in the Lord Jesus Christ which will give them the assurance to say with Paul, *"I know whom I have believed and am persuaded that He is able to keep what I have committed to Him until that Day"* (2 Timothy 1:12).

Jack Douglas, missionary to the Pawaia tribe in Papua New Guinea, commented, "To teach right through from Genesis took a long time and much effort, but it was well worth it. The Pawaians know what they believe and why."

Most witnessing programs lead Christians into brief, face-to-face encounters with the unsaved. Insufficient effort is put into preparing the non-Christian to either understand the real reasons for or the meaning of the Gospel. Usually, just a few verses, such as Romans 3:23, are quoted to the unsaved and the person is then urged to make his or her decision for Christ.

The Scriptures make it clear that one person may be given the responsibility by God to sow the seed, another to water it, and yet another may reap the harvest (John 4:36-38; 1 Corinthians 3:6-7). In most methods of evangelism today, the person who sows is also expected to reap immediately. Truly the Lord is not limited. His Word is mighty to save, and He often does use the same person to both sow and reap. But our responsibility is to be sure that we are faithfully preaching all He has told us from His Word so that people are scripturally prepared for the Gospel. Then we can trust Him to give the increase.

The most effective witnessing programs are those which allow Christians to teach God's Word systematically and to depend upon the Holy Spirit to do the work in His time. God's children should get to know unsaved people, establish Bible studies in their homes and teach consistently, even over weeks or months, those things which God has recorded in His Word as the foundations for the Gospel.

Tell the Gospel to the prepared

I have already given the reasons why the basic structure of the Old Testament should be taught to unsaved people before they are taught the New Testament story of Christ and the Gospel. But it must not be inferred that I am suggesting that no person can be saved until he has heard and understood all of the Old Testament outline presented in this teaching program. Nor am I saying that the teacher must not give the Gospel to a person prepared for the Gospel until he has been

taught the proposed outline. We must not be bound by an outline, but we should be guided by biblical principles which are clearly taught throughout the entire Word of God.

If, at any point during the teaching of the Old Testament outline, an individual in a group of people is spiritually enlightened to his lost condition before God, the teacher will need the spiritual discernment to know when he should give that awakened sinner further private teaching on the birth, life, death, and resurrection of the Lord Jesus Christ. Just as it is wrong to press the Gospel on those who have not been prepared by God, it is equally wrong to withhold the Gospel from those who have been taught by God, who are broken in spirit, and who are hungry for the mercy and forgiveness of the Savior.

Undoubtedly, some people will come to understand and will be well prepared by the Holy Spirit to receive the Gospel before the teaching of the Gospels is to begin. When I was faced with this situation, I took the individual aside from the group and questioned him carefully to see if he clearly understood the basic truths concerning God, His holiness, hatred and judgment on sin, and the person's own sinful condition in God's sight. I first tried to determine if the person was truly convinced of his sinfulness and inability to save himself and if he understood and accepted God's Word. I then briefly, but carefully, told him of God's complete provision for sinners through the holy birth, life, sacrificial death, burial, and victorious resurrection of Christ. If a person is truly prepared by God, faith in Christ will surely be the result of hearing and understanding the Gospel (John 6:44-45).

A young Palawano man named Kamlon was attending meetings where I had been teaching the Scriptures chronologically for about three months. One day, Kamlon came to me and said, "I am going to begin praying to your God." I had not prayed with the Palawano people during our teaching periods, but they knew the Roman Catholics prayed, and they had seen us giving thanks for our meals in our home.

I asked, "Kamlon, do you think that by praying you will be able to reach God? Don't you remember how God put Adam and Eve out of the garden and put His cherubim there with the flaming sword? Could praying remove the flaming sword? Could talking to God get them back into the garden?"

He answered, "No, it couldn't."

I asked, "Then why do you think that by praying you will be able to come to God? What is the punishment for sin?"

He replied, "Death."

We had already reached the story of the giving of the Law in our group meeting. So we talked together about the Old Testament stories which illustrate that death is God's righteous judgment on sin.

I said, "God requires death. It is a fixed price." This term, "fixed price," had been used during our teaching and is the term used in the Philippines when vendors indicate that they will not bargain for an article. In some larger stores, when a person begins to bargain, the sales assistant will often say, "Sorry, fixed price." They won't bargain because all the articles are at a fixed price. So I said to "Kamlon, God's price is fixed. God requires death. Prayer is not the price God requires. He will accept nothing less than death, which is separation from God."

Kamlon continued to attend the daily times of teaching; but, about one week later, he again came to speak to me. "Kalang Kayu," he addressed me. (This name, meaning Big Tree, was the name given to me by the tribal people because of my height in comparison to theirs.) "I realize now," Kamlon said, "that praying will not get me back to God. But, what am I going to do? I know from God's Word that I am a sinner. I am sure of that. I know that I am going to Hell. What can I do?"

Praising God in my heart for what the Holy Spirit had taught this man, I replied, "Kamlon, you have asked me what you can do. Tell me, what is the price to be paid?"

He answered, "Death."

I said, "Kamlon, if you want to pay for your own sin, then you must go to Hell. You will be separated from God forever. The punishment for your sin will never end."

He stood there looking thoroughly miserable and finally said, "Then I will have to go to Hell."

Immediately, I thought, "No, you won't." I knew that Kamlon had been taught by God. Through the Old Testament Scriptures, he had seen the basic truths about God, himself, and his sin. He was prepared to understand the Gospel and to trust in Christ alone for salvation.

"Kamlon," I said, "Come up and we will sit on the veranda." We went up and sat down. Then I questioned him, "Do you remember how that in the garden, after man sinned, God promised to send One who would be the child of a virgin? God promised that He would destroy Satan because he had brought man under his control."

He answered, "Yes, I remember."

I then reminded him of the story of Abraham. I asked, "Do you remember how God promised the Savior through Abraham?"

He replied, "Yes, I remember that."

I went over the key Old Testament stories which point forward to the coming Savior. Then, on the basis of these Old Testament stories and God's promises concerning Christ, I said, "Kamlon, the Savior has already come."

During the next hour or so, I briefly told him the story of Christ. When I finally came to the point where Christ died in our place, I told Kamlon, "God knew you would be born. God knew you would be a sinner. God knew you would deserve everlasting punishment because of your sinfulness. And God knew He could not save you unless that debt of sin was completely paid. The Lord Jesus, because of His great love, agreed to come and take the responsibility of paying for all of your sin."

When I spoke of Christ's death on the cross, Kamlon said with a great big smile on his face, "Then if He died for me, I don't have to die. He is my debt-payer."

Right there and then, his soul rested in the truth of the Scriptures. He trusted in Christ as his debt-payer. He accepted the fact that what he could not do, God had done for him.

Dennis and Jeanie O'Keefe who are missionaries to the Molbog tribe in Southern Philippines wrote the following about a young tribal man to whom Dennis taught the Scriptures chronologically.

"Almost every day, either coming or going to his rice fields, Saya would stop by my office for a cup of coffee, and we would talk. Precious were those times. He was

beginning to understand real biblical truth. Present in his conversation was an awakening realization that he could not meet God's requirements and would be punished eternally for his sins and his sin nature.

"After I had taught in other villages, it was time to continue with Saya. So, in one day, Saya and I went from the tabernacle to the Cross. What a joy! All the pieces of the puzzle came together in the man Christ Jesus. He was stunned. As his mind raced from Genesis 3:15 to John 19:30, '...It is finished...,' we sat in silence for a few moments. Then he said, 'Do you mean to say that He carried on Himself my sins?'

"God has done this, and it is beautiful in our sight. All of us can rejoice in the new horizons which have been made possible by God's grace demonstrated in this one man."

Brief encounters

I trust it is obvious all the way through this book that I have in mind situations where people can be ministered to over an extended period of time. This is possible in well-programmed missionary work, Sunday schools, Bible classes, and the ministry of the local church. But what does one do when he only has a short time to preach to people?

While we should never be bound to any teaching outline, we should always be guided, even in brief encounters, by biblical principles. One clear principle which we have already discussed is that only those prepared and drawn by God the Holy Spirit can and will come to Christ. God does not do what He commands us not to do. He does not throw pearls before swine.

We should not press the Gospel on unprepared people. But there is a great difference between the general public declaration of God's historical work in Christ for the whole world and the personal application of that work to an individual. A preacher in a public gathering, speaking to a mixed group of people whose hearts' condition he does not and cannot know, may have complete liberty to present the Gospel and all of God's gracious invitations to repentant sinners. Even so, he should always be aware that only those taught, convicted, and broken by God through His Word and the work of the Holy Spirit, will believe and appropriate the saving message of the Gospel. Those who reject the foundations of the Gospel – that is, the holy and righteous, but merciful, character of God, and the sinful, lost, and helpless condition of every man outside of Christ – cannot trust in the saving historical work of God the Son and be born of the Spirit. Therefore, even in public Gospel meetings where the speaker may not have the opportunity to teach the same people again, the preacher should emphasize the nature and character of God and the demands of the holy and righteous Law of God before God's good news of the Gospel is offered.

In the book of Acts, when Paul entered a Jewish synagogue, he first reminded his hearers of the Old Testament foundational history wherein God revealed Himself and His promises regarding the coming Redeemer. Having done this, Paul then presented the claims of Jesus of Nazareth to be the long-promised Messiah and showed that Christ's death and resurrection authenticated Him as God's appointed Savior for all who believe. Immediately, there was a division between Paul's hearers. The prepared ones longed to hear more; the hard-hearted and self-dependent rejected his message. Those who responded were taken aside and taught further by the Apostle, so that their faith would rest on a clear exposition of Old Testament Scriptures in the light of the new revelation in Christ.

In other situations where Christians have only a brief opportunity to witness to an individual – on a train, a bus, a plane, in a store, on the street, or at their home – the same biblical principles should be followed as much as possible in the limited time available. Rather than having a hit and run ministry in brief encounters, Christians should try to keep in contact with people and follow up with continued teaching, preferably in a Bible study. If that is impossible, then good literature may be used which will lead them through the Scriptures and bring them to a clear knowledge of Christ.

In one area where we worked as missionaries in Palawan, the local witch doctor was an elderly woman. Her husband was gravely ill and no longer able to walk. Day and night, he lay on his sleeping mat.

I passed their house daily on my way to teach a leper who was the brother of the witch doctor. In the beginning, I stopped to greet them, to inquire about the man's health, and to ask if we could be of any assistance. At first, they resisted our offers to give them medical help, but after some time, they relented. Following this, I took the opportunity to stay for a while to introduce the Bible as the Word of God and to speak of God, the only eternal supreme being. Very soon after this, they sent a message through their grandson saying that they did not want to hear anymore about God. Following this incident, they could barely bring themselves to bid me the time of day. Their antagonism to us and our message was obvious in their whole demeanor.

The Palawano custom for a married man requires him to leave his own locality and live with his wife in her home area. But if he becomes very ill or knows that he does not have long to live, he will generally ask to be taken back to his own people. When the witch doctor's husband realized his death was imminent, he was carried back to the home of his relatives.

Sometime later, we were greatly surprised when some of his relatives walked three hours to request me to come and tell the dying man about God. This invitation was certainly evidence of God's work in his life.

Rejoicing in the possibility that maybe the little seed previously sown in his mind had been used by the Holy Spirit, I went immediately with his relatives to the house where he was. He was close to death, but he was still able to whisper brief responses to my few questions.

Sitting close by his side, I leaned over him and began to explain, "What I am about to tell you are not my words or the thoughts of people, but the words of the only true and living God."

Inwardly, I have never felt more helpless than I did that day. I was calling on the Lord to give me wisdom and clarity and to give the dying man understanding, conviction, repentance, and faith.

I continued, "God tells us in His book that He created all things." I elaborated on this, adding, "God also created the first man, Adam, who was the father of the entire human race." I wanted this man to understand that this included the Palawanos and therefore him.

The old man appeared to be listening as I continued, "God placed Adam in a beautiful garden. In this garden, God had planted two very important trees, the Tree of Life and the Tree of the Knowledge of Good and Evil." After explaining in very simple terms the meaning of these two trees, I said, "God warned Adam that disobedience would bring death. Death not only means physical death but also everlasting separation from God in a place of punishment."

At this point, I suggested that he rest and think about what I had said. This also gave me an opportunity to teach his relatives who had gathered in the house.

Returning to him after a short while, I asked if he understood what I had told him so far. He assured me that he did, so from Genesis 3, I told of the temptation and fall of man. I then explained Genesis 3:15, "God promised that one day He would send a Savior who would destroy Satan and deliver man from his power. God put Adam and Eve out of the garden. They were shut out, away from God, without any way to return, unless God Himself made a way for them."

I then related the story of Cain and Abel to this old man. I emphasized, "Both Cain and Abel were born outside of the garden and were sinners because of their father, Adam. They were separated from God and could not escape the judgment of God against them for their sins, unless God Himself did something to save them."

The old man moved his position slightly in order to catch every word. I went on. "These truths apply to all people, and what is most important, they also apply to you. Because you, too, are a descendent of Adam, you were born away from God, cut off from the Tree of Life."

I paused and then explained how God instructed man that, if he wished to approach God, he must take a lamb and kill it. I stressed, "They had to come to God in the way which God had instructed them. They had to kill the lamb. Its blood had to be shed. Now, the blood of the animal could not pay for sin. But the blood had to be shed to remind the ones who offered the sacrifice that they deserved to die and that only God could save them. Their faith had to be in God, not in themselves or anything that they could do."

Then I briefly told the story of how Cain refused to come God's way and was therefore rejected, whereas Abel came God's way, trusting in God's mercy and promises and was accepted by Him. Having laid this groundwork, I applied all of these truths personally to my hearer.

"There is no way you can save yourself. Your sin must be paid for by everlasting separation from God. He will not accept anything less. Only God can save you. Like Abel, you must accept God's way if you want to be saved."

"Be warned. Don't be like Cain and think that you can come to God in your own way."

The old man looked thoughtful, and I said, "I will let you think about what you have heard, and then I will tell you what God has done so that you can be forgiven of all your sins and be saved from the punishment you deserve."

Returning a short while later to his side, I asked him a few questions, and he acknowledged, "Yes, I am a sinner." He then requested, "Tell me what God has done for me."

My heart was filled with joy as I unfolded, in the most uncomplicated way I could, the story of the Gospel.

"God sent His only Son into the world to be your Savior. Christ was born of the virgin, just as God promised. He lived a perfect life. The majority of people rejected Him and crucified Him. He could have destroyed them all and returned to Heaven, but He allowed them to nail Him to the cross so that He could pay for the punishment for all of the sins of mankind."

I reminded this old man who was so close to eternal damnation, "God's punishment for sin is everlasting separation from Him in terrible punishment."

Then I said, "When Jesus was dying on the cross, He called out, 'My God, my God, why have You forsaken Me?' Why do you think the Lord Jesus was forsaken by God? The Lord Jesus was

forsaken and died to be the Savior of sinners. The Lord Jesus died for you to take your separation so that God could forgive all of your sins and give you everlasting life."

I quoted John 3:16 and shared with him the story of the resurrection.

Sitting close by his side and looking into his face which already had death etched on it, I told him, "The Lord Jesus can see you right now, just where you are lying on your sleeping mat. If you trust in Him and accept His payment on the cross for your sin, God will forgive you for all your sins."

There was a note of urgency in my voice as I continued, "If you accept him, you will not go to the place of everlasting punishment, but to Heaven to be with God forever."

"Don't be like Cain," I implored him. "Don't think that you can come to God in your own way. Your sin has to be paid for, and there is only one payment that God will accept; that is, the payment the Lord Jesus Christ made for you when He was forsaken by God because of your sins."

"Do you understand? Do you want to ask me any questions?" I inquired.

With barely a whisper, he answered, "Yes, I understand." He seemed to be deep in thought as he closed his eyes.

Hiking back through the jungle to our own home in the gathering darkness, my heart was calling on the Lord in His great mercy to save that man.

A short time later, we were visited by some of this old man's relatives who told us that the man had died in the early hours of the morning after my visit. But before he died, he had told them to tell the Big Tree (my tribal name) that there was no need to worry about him because he was trusting in the Lord Jesus who had taken the punishment for his sin. Praise God for His great mercy and the simplicity of the Gospel!

Situations vary greatly. Sometimes we may not have even as much time as I had with this dying man. We should do whatever we can in the time given to us by the Lord to make the Word of God clear and plain and trust the Lord to use whatever we are able to say in brief encounters. But whenever possible, it is our responsibility to teach in such a way so that people will know why they must come to Christ and so that they will trust only in Him and His death on their behalf.

Phase 1 for mixed groups – unbelievers and believers

Many groups and churches, like those which we first taught in Palawan, are confused regarding the way of salvation. Phase 1 has been effectively used to teach such churches and groups. Many individuals, who previously thought they were children of God, have been enlightened to their true condition through the Old Testament revelation of God's holiness, His demands for perfection as revealed through the Law, and His terrible judgments on rebellious sinners. Then, through the story of the Gospels, they have seen for the first time that they have no need to work for their salvation, for Christ has provided all that God righteously requires.

I wish I had understood this when I first began to teach the tribal churches in Palawan. I tried to straighten out their understanding by first teaching justification topically and then expositionally from the Epistle to the Romans even though they did not have solid Old Testament foundations. In spite of the difficulties I faced in teaching and they faced in understanding, many Palawano church members were eventually enlightened to their lost condition and came to trust in Christ. But how

much more simple and clear the teaching and learning process would have been if I had followed the divinely revealed order and taught chronologically through the Old Testament as preparation for the Gospel of grace revealed in the New Testament!

Years later, after I had seen my mistakes and had taught the Scriptures chronologically in another area of Palawan, I returned to the area of our initial labors to teach chronologically from Genesis to the ascension of Christ. After teaching them for a short time, some of the elders came to me and asked, "Why didn't you teach us this way from the beginning? This way of teaching makes everything so much clearer!" They could now see how everything they had been taught previously from the New Testament fit together with the Old Testament and was one comprehensive whole. I readily agreed with them, because it was also obvious to me that those whom I had taught chronologically from the beginning had a clarity of understanding of the Scriptures and the Gospel far beyond those taught only topically or expositionally from the New Testament.

The following material was written by Tim Cain and Larry Richardson, concerning the Puinave Indian work in Colombia.

> "When we went into the Puinave work, we went with the assumption that there was a legitimate New Testament Church which lacked good teaching. But the more we understood of the language and the people, the more we realized there were some real problems. We came to the conclusion that the majority of the Puinave who called themselves 'Christians' were, in fact, spiritually dead. Here are some of the things that we observed:
>
> A) The 'elders' tried to force the younger generation to conform to 'Christianity.' Christianity to them meant (l) no smoking or drinking, (2) going to meetings daily, (3) going to conference, (4) giving a testimony by confessing a few sins or promising to live without sin from now on, and (5) getting baptized.
>
> B) The people did not have an in-depth understanding of the Word of God. They knew a few Old Testament stories and a bit more from the New Testament, but they had no idea of the chronology of the stories or their significance.
>
> C) There was no spiritual growth.
>
> D) The people continued to practice witchcraft. The witch doctor was condemned, but his methods were not.
>
> E) Genuine conviction of sin was not apparent.
>
> F) The death of Jesus seemed to be something additional that God deemed necessary.
>
> "We began to step back in our minds, trying to find where we should start teaching, and we found ourselves back at the beginning. The chronological approach was of great inspiration and help to us.
>
> "As I (Tim) began to teach, I apologized to them for the confusion we had caused by not beginning at the beginning, and I promised that I would try my best to do it right this time.
>
> "We taught up to the ascension of Christ, and all along, the people showed great interest. But nothing happened.
>
> "What do you do but go over it all again?

"On the third time through, they began to spontaneously voice their understanding and acceptance.

"Alberto, one of the village leaders, told me he had come very close to going to Hell. He said he had 'played church' for thirty years and that his baptism was 'just a bath.' But now, he understood that it wasn't what he had done but what Jesus had done for him that made him right with God.

"One very old tribal man stood up at the end of one of our teaching sessions to testify. Standing there in all that noise and confusion, he said, 'I finally understand. I am a very bad sinner, but Jesus paid the price for my sin with his death.' The people around him tried to get him to sit down but he said, 'No, I want to say this!' He went on to share a clear testimony.

"Another man, who is a deacon in one of the Puinave churches, also testified, 'Up until now, I have always thought that God would accept me because of the things I have done for Him. I was baptized. I helped call the people together for meetings. I always got lots of food together so we could receive the people well when we hosted conferences. I always participated in the pre-dawn prayer meeting. I'm sure those are the things God saw upon my heart, because they are the things I was offering to Him in order to be able to approach Him. But now I understand that those things are just like the fruits Cain offered God, so I have removed them and replaced them with the blood of Christ. That's what God sees now upon my heart. That is what I am offering to God now, just like Abel slew the animal long ago.'

"In another Indian conference, we were also teaching from the first part of the Bible chronology. Alberto, who had been a believer for a year or so at the time, was helping teach, and he was also translating into Curipaco for those who did not understand Puinave. He and I both felt this particular group was not yet ready to apply what we had been teaching to salvation. Therefore, we closed the last meeting simply with an exhortation for the listeners to think carefully about what they had heard and to ask themselves what it was that they might be offering to God. Suddenly, without my even noticing it, an old lady stood up way back in the shadows and began to speak in Curipaco. In a moment, I became aware that something was going on and waited for an explanation. It was soon forthcoming. Alberto turned and told me, 'That old lady says she has found her offering – the blood of Jesus Christ, which He shed on the cross. That's what she will offer to God.'

"These people had previously received topical teaching from other missionaries and had read from the New Testament for many years, so this was not by any means their first exposure to Christianity."

Many churches throughout the world are a mixture of saved and unsaved. People who attend church are at different stages in their spiritual experience. This has been evident to me in the churches in Australia where I have served as pastor. Some church members are saved but lack assurance of their position in Christ. Others are not saved but are convinced that they are. After many years of church attendance, many believers lack understanding of the history and chronology of the Old Testament and so lack the background for understanding much of the New Testament.

What is the answer? Exposition of God's Word chronologically! Many who have taught the lessons for Phase 1 to mixed groups – saved and unsaved – have testified to the great benefit their hearers have experienced regardless of what stage they were at in their spiritual understanding. Correctly teaching and expounding the Old Testament stories has strengthened believers in their

understanding of Old Testament history, their appreciation of the nature and character of God, and has given them a fresh insight into their own unworthiness and a greater appreciation of God's mercy and grace in Christ. Many who were unsure of their salvation or deluded regarding their position before God have come to a firm and settled faith in all Christ has done for them to meet all God's righteous demands.

7

Correct Foundations for Teaching Believers

This book thus far has emphasized biblical guidelines for evangelism. At this point, I would like to turn our attention to biblical principles for teaching believers.

When I was teaching among the Palawano, monthly Bible conferences were of prime importance in my teaching program. Each month over one hundred elders and Bible teachers from the scattered Palawano churches would gather to be taught. These conferences were aimed at establishing the leaders and, through them, their churches in a basic understanding of the complete revelation of the Scriptures.

Because I had been schooled in traditional Bible teaching methods, the majority of my early teaching ministry at these monthly Bible conferences was done topically. I would teach on topics based on many different verses throughout the Bible.

It became evident to me from the practical difficulties I encountered that topical teaching was not the best form of Bible teaching for these Palawano conferences. Why? One factor was that topical teaching demands a high level of literacy, and these church leaders were poorly-educated. In addition, topical teaching uses verses from many locations in Scripture, but these church leaders were not well conversant with the location of the individual books in the Bible. And of primary concern, these Palawano church leaders lacked a basic understanding of the overall progressive and historical biblical revelation.

Many of these practical difficulties were accentuated due to the poorly-educated people whom I was teaching. However, the major problems I found with topical teaching are equally relevant whether one is teaching poorly-educated or well-educated people.

In this chapter, I will first share some of my experiences with tribal believers which impelled me to look to the Scriptures for a more logical and practical method of teaching the Word of God. After pointing out the problems perpetuated by an over-emphasis on topical teaching, I will show from the Scriptures that progressive revelation is fundamental when teaching believers. If we are to successfully teach biblical topics, believers must first be taught progressively through the Scriptures. Finally, I will introduce the 7-phase teaching program laid out in this series of books.

Topical teaching is difficult to follow.

The men who attended the Bible conferences were mostly poorly-educated and inexperienced in the Scriptures. They wasted much time as they searched for the numerous references necessary to establish the doctrine being taught.

When I gave a Scripture reference, there would immediately be a great deal of mumbling and whispering. They could not easily remember the reference given, so they were continually inquiring what the reference was from whoever was sitting near them.

When the first ones to find the verse located it, they would often begin reading the section audibly, laboriously sounding out letters and words.

Instead of paying attention to my teaching, they were absorbed in inquiring from one another what the reference was or trying to find the verse or trying to read the passage which they were so pleased to have found. Instead of their minds being occupied with the subject being taught, they were repeatedly distracted because they had to find the portions from many parts of the Bible.

Difficult to record, review, and reteach

After attending the monthly Bible conference, the Bible teachers were to go back to their congregations and teach them the same truths they had learned during the conference. In order for them to teach their congregations, these Bible teachers needed to have a way to review what they learned. In order to review the subject matter, they needed to write down all the references and make notes regarding which part of the verse had to be emphasized.

The church leaders' attempts at taking notes were usually terrible. The notes they made were of little use for review and too sketchy for them to use as a guide in teaching others. The notebooks which I provided for them were soon dirty and tattered and falling to pieces, especially after being tucked up between the palm-leaf roofing in their huts.

Nevertheless, they struggled to do their best to take notes. They wrote down each reference, carefully and painstakingly forming the letters and figures with a stub of a pencil or their modern bull-pin, as they called their ballpoint pens. Admittedly, after much practice, they did improve, and the younger men became quite proficient in note taking, but what an unnecessary and time-wasting exercise.

Eventually, I typed and duplicated simple notes for them. These were a great help, but they caused other problems as these men tried to reteach the outlines in their home churches. If only I had taught them the Scriptures expositionally in line with the way in which God revealed His Word! The teaching, learning, reviewing, and the passing on to others of that teaching would have been relatively easy for them to follow.

Difficult to focus on only one phrase in a verse

Often, in topical teaching, only a phrase or a few words from a verse are needed to establish the doctrinal point being taught. This is a difficult concept for many people to comprehend. It was certainly troublesome for the Palawanos who tend to view subjects as a whole rather than in separate parts. This particular problem came to my attention after I had prepared a book of doctrines to be taught in the churches. I would teach a topic from this book to the church leaders,

and they would return to their churches and teach the same subject to their own village congregations.

During one conference with these men, I taught from this book of doctrines on the nature and character of God. The following weekend, according to my custom, I hiked to a tribal church to give on-the-spot teaching to the whole church and to check how the elders were handling the teaching which had been assigned to them. On Sunday morning, I listened as one of the tribal elders began to teach. He turned to the point in the outline, "God is love." Under this heading, various references were listed, one being John 3:16. The elder read this verse, and then he began to teach. First, he emphasized that God is love from the words, *"For God so loved the world."* According to the topical outline he had been given, that was as far as he was to go in John 3:16. But he continued. He went on to teach on the incarnation, basing his comments on the words, *"that He gave His only begotten Son."* And he didn't stop there. He continued reading, *"that whoever believes in Him should not perish,"* and he emphasized the necessity of faith in Christ and the perishing condition of those who do not believe. He finished reading *"but have everlasting life,"* and concluded his exposition of John 3:16 with comments on the certainty of everlasting life and the bliss of Heaven for all believers.

While he and his hearers were enjoying God's Word just as God had recorded it, I was frustrated and disappointed. I wanted him to teach as I had taught him at the conference from my book of topical, systematic theology. I wondered if they would ever be able to teach God's Word correctly. To teach it correctly, I reasoned, was to teach it analytically and topically.

As I sat there feeling I had failed and wondering what was the best way to train them to become able teachers of the Word, it suddenly occurred to me that the Holy Spirit wrote John 3:16 just the way the tribal elder had expounded it. Why then arrange it under subject headings? How much more straightforward and uncomplicated teaching and learning would be if all of the Scriptures were taught expositionally just as they have been revealed and recorded.

We make the teaching and learning of the Scriptures unnecessarily hard when we insist on topical teaching as our primary method of instruction. Western culture approaches most subjects analytically. We feel it necessary to dissect everything, examining and categorizing each portion. But many cultures do not approach the teaching and learning process in this way.

When the Lord prepared the Scriptures, He had all people in mind. If He had planned to speak only to us Westerners and had asked us what literary form His writing should take, our answer would probably have been, "A systematic theology." Wisely, the Lord did not do this. The Scriptures were not prepared in an analytical, topical form, for apparently this is not the preferable way to teach God's Word, even in Western culture.

While these things were going through my mind, the tribal elder proceeded to expound the next verse listed in the outline, and I began to observe the different people in the congregation. Across the aisle, a precious old lady who dearly loved the Word of God was holding her New Testament close to her face, trying to read it in the dim light. Other women were trying to follow the references and keep their attention on the speaker, in spite of the constant distractions caused by crying babies, wriggling and whispering children, and surly, growling dogs. The men and boys were all seated on my side of the palm-leaf and bamboo chapel. All ages were present. As I watched them, I wondered how much they really understood. Did they understand enough to be built up in true heart knowledge so their lives would reflect the character of the Lord? How much

would they remember during the week? Would they be able to review the teaching in the quietness of their houses scattered through the jungle?

The Palawano believers were encouraged to pass God's message on to others during the week when they were working in their fields, washing clothes, pounding rice, visiting, or just sitting around the fire at night. I also wondered if they understood clearly enough to be able to do this.

As I looked at this congregation with all ages and differing reading and writing abilities, I realized that our complex teaching methods hinder the spread of the Word of God by the average person. We feel we have to arrange the Scriptures into individual topics and under, what we think, are suitable headings. How much more simple it would be if they were taught verse by verse and book by book! They would not need to turn to verses all over their Bibles or write down numerous references. At home, reviewing the section studied in the meeting would be greatly simplified. Discussing and sharing the portion with others would be much easier. Preparing for the coming meeting would be uncomplicated, for they would only have to read the next portion of Scripture instead of many scattered verses.

Difficult to retain cultural order of leadership

Most of the young Palawano men had attended elementary school, but only a few of the older ones had any schooling. The young men's exposure to Western-style education enabled them to follow topical teaching more easily and to teach the truths again, using the topical method. This meant that some of the younger men had to take the position of leading teachers in the churches. According to their culture, however, such leadership positions belonged to the older men.

Many missionaries find themselves dependent on younger men to teach and lead tribal churches because the difference between the young and the old, educated and uneducated, is unnecessarily accentuated by the analytical, topical approach which is taught to them as the primary method of teaching the Word of God. Younger men, however, lack the natural experiences of life which prepare one to be a wise instructor. In many cultures, the young men would not be granted the respect so necessary for a church teacher and leader. Many missionaries can testify to the heartache of seeing young, promising leaders ruined for the ministry through pride, adultery, and a host of other vices and inconsistencies.

Large sections of the Scriptures overlooked

We all have a tendency to ride our own hobby-horse and gravitate to the subject or doctrines which we feel are most important. The result is that large sections of the Scriptures are usually overlooked in many churches, while other parts of the Bible receive most of the attention.

In Palawan, the tribal teachers taught the same topics and passages over and over. Rather than teach unfamiliar, unexplored sections of God's Word, they returned frequently to the same verses or topics.

Misinterpretation of verses out of context

Due to topical and doctrinal sermons on isolated Scripture portions, many who have been Christians for a long time are not able to interpret even familiar verses in the context of the book or epistle of which they are a part. The reason for this is obvious. The majority have seldom, if ever,

been taught the wider context of these well-known verses. Having never been introduced to the basic framework of biblical progressive revelation, they may understand verses, or even chapters or sections of Scripture which deal with some particular topic, but they do not understand the Bible as one book. They do not comprehend the great necessity to interpret all Scripture in the light of the whole of progressive revelation.

This was emphasized to me by the sermon of a sincere tribal man on Matthew 24:2, *"And Jesus said to them, 'Do you not see all these things? Assuredly, I say to you, not one stone shall be left here upon another, that shall not be thrown down.'"* After reading this verse, he pointed to the rocky hills surrounding the grass-roofed chapel where he was standing. He solemnly warned the people that when Jesus comes again to judge the world, all of the stones on the hills around them would be cast down. "Not one will remain upon the other," he emphasized.

While I sat there trying to still my inner turmoil at his incorrect interpretation, the truth dawned on me that he was not to blame. I was to blame. I had led him to scattered verses when teaching a doctrine or developing a topic, but I had not consistently taught the Scriptures in such a way that he could understand the need to interpret verses in context or how to do it.

It was through such incidents that I was prompted to turn from using the topical teaching approach to the more simple and direct method of verse-by-verse exposition in order to help the people understand Scripture in its immediate context. But this, too, proved inadequate, for the believers had not been taught the Old Testament Scriptures which provide the background and foundation for the New Testament. They did not understand God's Word as one book.

God's teaching

God's fundamental form of teaching throughout all history is clearly progressive. God gradually unfolded the Bible's message over the ages. This God-controlled unfolding of truth has been likened to the growth of grain, *"first the blade, then the head, after that the full grain in the head"* (Mark 4:28). God chose to make known His nature and character, His plan for the world, His purpose of redemption through Christ, and all other spiritual matters through progressive revelation.

God's basic method of teaching can be likened to the way an artist paints a picture. An artist does not begin painting in one corner of the canvas and immediately complete every detail. Instead, he will often do an initial, simple, light sketch of the whole picture. To an onlooker, the picture in the early stages will be indistinct. Even when studied, it may not be clear just what the artist intends to include in the final product. But, as the artist continues to work on the picture, here a little and there a little, the details begin to develop with greater clarity. This process continues until the final strokes are applied and the picture is complete.

This is how God painted His picture of the drama of redemption. He began the sketch in the early chapters of Genesis. Genesis 3:15 is a simple, undetailed sketch of the whole picture of the redemption story. Sharper, clearer details were then added by God in the call and life of Abraham. More color and features were put onto the canvas in the offering of Isaac and the perfect lamb substitute which God provided. Jacob's dream, the Passover, the manna from Heaven, the water from the smitten rock, the giving of the Law, the building of the Tabernacle, the brazen serpent, Joshua's victorious ministry, and other historical events are all strokes of the Artist's brush as He painted the background of the picture. The Master Painter continued adding details as He guided

the events of Old Testament history toward the revelation of Christ, the main subject of the painting. Obscure images and lightly sketched areas suddenly emerged when Jesus came to live, die, and rise again. But even then, the canvas did not contain the whole picture. Through the apostles, the Holy Spirit continued the painting. The final strokes to God's picture were made when the revelation of Jesus Christ, given to John on the Isle of Patmos, was added.

God never taught all there was to know about any particular doctrine or subject at one specific time. He often revealed some new area of truth, but He never immediately gave the whole truth regarding any one subject.

God's method of teaching can be compared to the way most people prefer their meals served. A man would be surprised if he went home to find his wife had prepared a meal consisting only of potatoes and if he heard her say, "Today, we are having potatoes. Tomorrow, we will have beans. The day after tomorrow, we will have just meat on the menu." Who would be happy with that type of menu? We usually like a meal to consist of different types of vegetables and some meat. This is how God feeds us from His Word when we study it just as He has given it. Turn anywhere in God's Word, and you will readily see that one verse can give information, either directly or indirectly, about many different subjects. Whole books could be written by carefully examining and expounding one verse. Just as there are many facets on a diamond, a verse, when scrutinized under the guidance of the Holy Spirit, will reveal many different points of truth relating to many different doctrines.

During some seminars with missionaries, I have asked an individual to turn in the Bible to the doctrine of the Holy Spirit. I have requested that another turn to the doctrine of Man, another to the doctrine of Satan, and another to the doctrine of the Church. Some people have started to open their Bibles, and then hesitated. They could not turn to a specific doctrine, because the teaching of doctrines is not grouped together in the Bible. All doctrines begin in seed form in Genesis and are progressively revealed, little by little, throughout the Old and New Testaments. It is impossible to turn to a complete doctrine by turning to one place in the Bible.

Let's consider God's method of revelation and instruction in the life of every individual He prepared for His service during the history of the Old Testament. We see that He revealed truth and instructed each one in a clearly progressive manner. When God created Adam, it was God's desire and purpose that Adam should be taught to know Him, in all His sovereignty, majesty, and glory. How then did God begin to teach Adam? What method did God use? Did He systematically and topically teach Adam all there was to know about Him, his Creator? No! How mundane and limited God's first revelation to Adam appears to be! God said, *"Be fruitful and multiply; fill the earth and subdue it; have dominion over the fish of the sea, over the birds of the air, and over every living thing that moves on the earth"* (Genesis 1:28). The Lord then told Adam what he and Eve were to eat. In this initial revelation, God did not even speak directly of Himself. Yet, by what He commanded, God revealed basic and important truths about Himself. By commanding Adam to be fruitful and to multiply, the Lord clearly declared Himself to be Adam's lawgiver and the master of every area of life. By authoritatively placing Adam as His vice-regent over the whole earth and by commanding Adam to have dominion over every living thing in the earth, He was showing Adam that He, the Lord, is the rightful owner of the earth and all things in it.

After God had placed Adam in the Garden of Eden, He again spoke to him and at that time commanded him regarding the Tree of Life and the Tree of the Knowledge of Good and Evil. This was but a further revelation of God's role in His relationship to man. By the solemn declaration that

death would be the inevitable punishment for disobedience, God was showing Adam that He alone is God, the judge and executor of righteousness in the earth. These are the only accounts that we have of the words of God to Adam before Adam's disobedience. But as God met with man, it would seem that He planned to teach Adam progressively, adding slowly to those initial revelations of His will and plan, according to Adam's ability to assimilate the information given to him.

How did God teach Abraham when He called him? Did God call Abraham and say, "Now, Abram, before you leave Chaldea, I want to tell you all of My plans for you and your descendents?" Is that what God did? No! Abraham went out, not knowing where the Lord was leading him. God revealed only what was necessary for each stage of Abraham's experience. Through progressive revelations, God taught Abraham, adding knowledge to knowledge, for Abraham was to walk by faith.

Further illustrations of God's progressive teaching method are evident in the stories of Jacob, Joseph, Moses, and the nation of Israel. Surely, even by these examples, it is obvious that God's basic way of teaching in the Old Testament was progressive – a slow, careful, building process.

The Lord Jesus Christ's teaching

The Lord Jesus did not teach His disciples everything there was to be known about any one subject at one particular time. He taught His disciples progressively. Look, for example, at John 14. The Lord began comforting and encouraging His disciples (verse 1). He then spoke of His future ministry of preparing dwelling places for His children (verses 2-3). This was followed by a discussion with Thomas and Philip about the way to see and know the Father (verses 4-11). After this, He spoke of the need for obedience and the coming Holy Spirit (verses 12-17).

The Lord Jesus usually included many relative subjects in His discussions with the disciples, but He dealt with none exhaustively. Having introduced a subject or some aspect of a subject, He would then leave His disciples to think about it. Often, a question by the disciples would raise the subject again at a later date. If expedient, the Lord would then give His disciples more information, but even then, He would not tell them all there was to be learned and understood about the matter.

The Lord never gave out mere information. Rather, He presented transforming truth which needed to be understood and appropriated. Even at the close of His earthly life, He said, *"I still have many things to say to you, but you cannot bear them now. However, when He, the Spirit of truth, has come, He will guide you into all truth"* (John 16:12-13).

The Holy Spirit's teaching

When the Holy Spirit came, how did He teach? Did He immediately reveal to the disciples all there was to be known about the New Testament Church and Christian living? Did He teach them topically and exhaustively on everything which God planned to reveal to the Church? No!

Again, it was progressive teaching, for God was continuing His usual form of revelation. It was a building process. Foundational truths, partially revealed or hidden in the Old Testament, and truths introduced by the Lord Jesus yet not fully revealed before His ascension, were slowly and carefully taught by adding knowledge to knowledge so the Church would be brought to *"the stature of the fullness of Christ"* (Ephesians 4:11-16).

The apostles' teachings

Because God has revealed all truth progressively, the apostles based their teaching and writings on God's previous revelations in the Old Testament and His more recent revelations through His Son, the Lord Jesus. Their writings cannot stand alone, for they are the continuation and culmination of God's progressive revelation which He first initiated through Moses. All that the apostles wrote and taught was on the basis of the Old Testament.

The following portions from Paul's writings illustrate that the principle of progressive revelation continues on through Acts to the book of Revelation. Because of progressive revelation, it is impossible to clearly teach believers the New Testament without first introducing them to the Old Testament.

Imagine a believer who has not been given Old Testament foundational teaching, trying to understand a portion such as 1 Corinthians 5:6-8, *"Your glorying is not good. Do you not know that a little leaven leavens the whole lump? Therefore purge out the old leaven, that you may be a new lump, since you truly are unleavened. For indeed Christ, our Passover, was sacrificed for us. Therefore let us keep the feast, not with old leaven, nor with the leaven of malice and wickedness, but with the unleavened bread of sincerity and truth."* How could anyone possibly understand these verses without the necessary Old Testament foundational knowledge?

In 2 Corinthians 3, Paul contrasted the ministry of death through Moses and the ministry of life brought by Christ. He said, *"unlike Moses, who put a veil over his face so that the children of Israel could not look steadily at the end of what was passing away. But their minds were blinded. For until this day the same veil remains unlifted in the reading of the Old Testament, because the veil is taken away in Christ"* (2 Corinthians 3:13-14). This whole chapter, and particularly these verses, cannot be understood except in the light of the Old Testament.

What about the Epistle to the Galatians? How could anyone understand Paul's arguments about law and grace apart from a proper foundation in the Old Testament? The churches in Galatia, through the influence of the Judaizers, had turned away from interpreting the Scriptures according to the historical order of progressive revelation. When combating this error, Paul reminded them of the sequence of historical events recorded in the Old Testament through which God progressively revealed the doctrine of justification. In Galatians 3, we are told that the Judaizers were emphasizing obedience to Moses and the Law as necessary for salvation. They were saying, "Yes, Christ's death is necessary for salvation, but believers must also keep the Law." How did Paul meet their arguments? Paul took his readers back into Old Testament history and showed that the doctrine of justification can only be understood according to progressive revelation. Paul wrote, *"And this I say, that the law, which was four hundred and thirty years later, cannot annul the covenant that was confirmed before by God in Christ, that it should make the promise of no effect. For if the inheritance is of the law, it is no longer of promise; but God gave it to Abraham by promise. What purpose then does the law serve? It was added because of transgressions"* (Galatians 3:17-19).

What was Paul doing? He was showing that the Law cannot supersede God's covenant of grace and faith as the way of justification, because grace and faith were revealed before the Law was given. Paul reminded the churches in Galatia of the order God used to progressively reveal these two doctrines. The Gospel was first preached to Abraham; and 430 years later, the Law was given through Moses to reveal sin as exceedingly sinful. The full revelation of the Gospel was finally

given through Christ. This same Gospel was preached to Abraham. All believers are the children of Abraham by faith and are not dependent upon the keeping of the Law for salvation. Therefore, Paul made it clear that the sequence of historical events is vital in our interpretation and understanding of the Word of God.

Consider the doctrine of the Holy Spirit. In this present dispensation, we cannot appreciate what God has done for us through the indwelling of the Holy Spirit unless we first understand the work and ministry of the Holy Spirit in the Old Testament. The joy and liberty which are rightfully ours as part of the body of Christ are only experienced if we first understand that, during the old dispensation, the Holy Spirit was only **with** believers. Now, He is **in** us. The doctrine of the Holy Spirit can only be comprehended on the basis of progressive revelation.

This is equally true of the doctrine of adoption. In Galatians 4, Paul taught that the Old Testament believers were like small children in the Father's household. Numerous laws and rituals controlled their every action. We, in contrast, have been placed into the family of God as adult sons. We share the Spirit of the Son, in contrast to the limited relationship which the Holy Spirit had with believers in the Old Testament. Our position through adoption can only be appreciated if we understand the historical and chronological development of God's relationship with believers as revealed in the Scriptures.

Consider Paul's letter to the Romans. As he introduced his main subject, the Gospel of God, he immediately reminded his readers that the Gospel was *"promised before through His prophets in the Holy Scriptures, concerning His Son Jesus Christ our Lord, who was born of the seed of David according to the flesh"* (Romans 1:2-3).

In Romans 1:18, Paul began to teach the doctrine of man's sin. He did this on the basis of the beginnings of history when the true knowledge of God was common to all men (Genesis 1-11). From this original revelation, Paul affirmed that man deliberately turned to gross idolatry and moral perversion.

In Romans 2, Paul proved the total depravity of all mankind by referring to the Law given to Israel at Mount Sinai and written in the hearts of the Gentiles.

In Romans 3, Paul quoted extensively from the Old Testament and then pointed to what the Law said as the final proof that all the world is guilty before God (Romans 3:19). He then maintained that the doctrine of justification which he taught was the same message to which the Law and the Prophets witnessed (Romans 3:21).

In Romans 4, Paul sited Abraham and David as examples of two sinners who were justified by faith.

In Romans 5, Paul laid the foundation for the doctrine of identification with Christ. Again, he pointed back to the Old Testament and showed that in Adam all sinned and all died. Death reigned as king over all because of the disobedience of the father and federal head of the human race. With these foundations, he then taught that Jesus Christ our Lord was prefigured in Adam and that He is the second Man. Just as Adam represented us as the federal head of the human race, so Christ was appointed by God as the new beginning, the federal Head of sinners, whom He represented by complete obedience to His Father, both in life and in death. Paul did not try to teach this liberating truth of the believer's complete identification with Christ apart from its Old Testament foundations.

If Paul taught Old Testament foundations when teaching believers, why should we think we can teach believers successfully without first laying the substructure on which all New Testament

doctrines rest? It is impossible to clearly and correctly teach the New Testament to believers without adequate Old Testament foundations.

God's progressive revelation

The best way to teach God's Word is to follow His progressive form of revelation. We should first lay good foundations for the believer's faith and then build truth on truth, knowledge on knowledge. Bible doctrines can be most clearly understood if they are first seen in their beginnings in Genesis, then traced through the Old Testament historical accounts in which they were progressively developed, and then finally taught in their fullness in the New Testament.

God's progressive revelation of all truth has also been in conjunction with His historical acts in both Old and New Testaments. Therefore, all doctrines have an historical setting. New Testament doctrines are woven into the historical story of the Scriptures. The worldwide tendency is to teach Christians the doctrines of the Bible, divorced from their God-given progressive and historical setting. This has resulted in doctrinal confusion in many sections of the Church. This is most clearly seen in the rapid growth of the Charismatic Movement, where doctrine is interpreted by personal experience, rather than according to its historical setting. The majority of doctrinal misinterpretations are due to failure to understand the historical, progressive revelation of truth in the Bible. Because so many endeavor to teach Bible doctrines almost exclusively from the New Testament, bypassing their beginnings in the Old Testament, many believers have a clouded and imbalanced interpretation of Bible doctrines. Doctrines can only be clearly understood in the light of their historical revelation and development.

Foundations for the topical approach

Western culture and education use an analytical approach to almost every subject. Since most subjects are treated in this way, it seems to be automatically accepted by Christians that if one really wants to know his Bible, he must analyze and categorize every part of the Word of God.

While there is a definite need for analysis in our study, the first and greater need is for a holistic approach to God's Word. This method of studying and teaching the Scriptures holistically has been called the synthetical approach, in order to distinguish it from the analytical method. The synthetic begins with the general and looks at the whole rather than individual parts. Analysis begins with the specific and then moves to the general.

Imagine trying to instruct a primitive tribal man in watchmaking and repairing. If he had never seen a watch nor understood its function as one instrument, he would find it impossible to understand the position and purpose of each separate part. The wisest procedure would be to first show him a complete watch. Following this, we could point out the minute parts and explain their individual contribution to the whole. This, too, is how we should approach and teach the Scriptures. The general, panoramic view provides the foundation for a more specific, analytical investigation.

The need for this holistic teaching of the Scriptures, before topical teaching is given, is clearly demonstrated by the experience of a missionary friend planning to go to the Philippines. When he returned to his home church to prepare his gear and await the time of departure, his pastor asked him to teach an adult Bible study. He decided to begin in Genesis and teach an overview of the Old Testament, leading into the New Testament. Later, when he met me in Manila, he said, "The more I taught, the greater the excitement and enthusiasm of my class. Even though these people had

attended our church for many years, in all that time, they had never been taught the Scriptures chronologically and panoramically. At the close of one of the lessons, a lady asked, 'Why hasn't our pastor taught us like this? I have been hearing sermons all of my life but only now am I beginning to understand the Bible as one book!'"

New Christians usually struggle for many years with a vague understanding of the Scriptures as one book. The majority of preachers seldom, if ever, teach historically and chronologically through the entire Bible. Sermons on individual texts and topics and even expositional teaching of passages of Scriptures and individual books limit one's understanding of the Word of God to certain sections and scattered verses. Through a panoramic study of the Old and New Testaments, however, the Bible can be seen as one volume.

Teaching Bible topics should have an important place in our program, but it should be used only with those who have already been taught the Scriptures as a whole. If this is our normal approach, then topical teaching, when needed, will be far more effective. The truths we emphasize through topical teaching will be clearly understood and appreciated in the context of the whole of God's revelation.

Topical teaching in the Word of God is usually remedial. This is clearly evident in the ministry of the prophets whom God raised up to remind Israel of the righteous and holy laws which had been given to them in orderly progression through the ministry of Moses. The major part of the prophetic teachings is taken up with the topic of Israel's and Judah's rebellion and the warnings of God's coming judgments unless they returned in true heart repentance and obedience to the body of revelation already in their possession. The topical, remedial writings of the prophets are really interruptions in the straight line of God's progressive revelations pointing forward to Christ, the coming King and His kingdom.

Topical teaching then should be used when there is misinterpretation or disobedience to the Scriptures or when there is a need to emphasize or clarify some particular doctrine. If a problem arises in the church, the Bible teacher should temporarily change to topical, corrective teaching.

Paul's letter to the Corinthians is another example of topical, corrective teaching. Paul is basically reminding the Corinthians of what he had already delivered to them as the body of revelation which they must believe and obey. His initial teaching to the Corinthians was the same as in every place. His teaching was based on the Old Testament Scriptures (Acts 18:4-5; 1 Corinthians 10:1, 11). To these, he added the teachings given by the Lord Jesus while He was here on earth (1 Corinthians 11:23). His instructions to them were then completed by adding the revelations which the Holy Spirit began on the day of Pentecost (1 Corinthians 2:1-13). It was from this complete body of revelation that Paul drew his corrective, topical teaching in an effort to remedy the situation in the church at Corinth.

Thus we see that corrective topical teaching is much clearer when it follows this basic pattern of progressive revelation. Because God has revealed all doctrines progressively, the simplest and clearest method to emphasize a particular doctrine is to trace its development from Genesis through to the Revelation. If, for example, the need is to teach on marriage, there is no better way than to begin in Genesis, just as Jesus did when He answered questions regarding marriage (Matthew 19:3-6). After reminding our hearers of God's original purpose for marriage, as shown in Genesis 2, we can then turn to other Scriptures on marriage in their chronological order. We could teach on Deuteronomy 24:1, where Moses permitted the rebellious Israelites to deviate from God's ideal standard for marriage, and then Matthew 19, where Jesus comments on this portion from

Deuteronomy. Finally, we should teach the apostles' instructions relating to marriage from the Epistles, where God's original plan and standard for marriage are reaffirmed.

Imagine a church where the basic teaching method is to consistently teach God's Word as one complete book. The teachers methodically cover all the Word of God so that the congregation will continually advance in their understanding of the whole revelation of God in both Old and New Testaments. But problems are bound to arise at some time within the church; so, at these times, it will be necessary to digress from the usual teaching program and give topical, corrective teaching. If the Word of God has been taught consistently as one whole, it will be relatively simple to draw the necessary corrective topical teaching from many parts of Scripture. The Bible teacher will be able to say to those who have been taught the overall plan of Scripture, "Do you remember what we learned previously in 'such and such a Scripture' about this particular subject?" Because they have been taught the Scriptures holistically, the teacher will be able to draw from the entire Word of God as the authority for his topical, corrective teaching.

Foundations for expositional teaching

Thankfully there are concerned pastors and Bible teachers throughout the world who recognize the limitations and problems connected with topical teaching and sermonizing. Accordingly their usual form of teaching is expositional. This usually includes expounding passages of Scripture or the exposition of complete books, particularly New Testament books.

There is no doubt that this form of teaching is far superior to sermonizing or constant dependence on the topical approach. However, problems remain. One is that a great many preachers seem to teach with the assumption that their hearers have a similar knowledge of the Scriptures as they do. Through their studies, preachers often have been taught Bible history and have come to understand the individual contribution of each book of the Bible to the whole. In contrast, the average Christian usually has a very limited and fragmented understanding of individual books and the Bible as one volume. Therefore, unless believers are first taught the Bible chronologically, they will be unable to clearly understand the constant allusions and references from the Old Testament which will be encountered as they are taught the Scriptures expositionally. Nor will they be able to appreciate the contribution that the book being studied makes to the whole of Scripture.

Before teaching expositionally, pastors should first make sure that their congregations have been taught the Scriptures holistically. Only then should they feel confident that their hearers will be able to keep pace with them as they expound the Scriptures and quote verses from other books of the Bible. Through first being taught events and selected books expositionally to form an overview of God's Word, believers will have formed a framework in their minds of biblical history and have a basic understanding of the flow of progressive revelation. With this background knowledge, Christians are more suitably equipped to appreciate and understand verse-by-verse exposition of passages and complete books of the Bible.

Foundations to understand the Law and Grace dilemma

Believers need to be taught the Old Testament so that they will be able to clearly distinguish the difference between the dispensation of Law and the dispensation of Grace. Old Testament foundations are necessary in order to understand the place of the Law during the Church age.

Believers will only be able to see the difference between Law and Grace if they are given a basic knowledge of Israel's position under the Law prior to the cross. Legalism, which is prominent in many churches and devastating to the believer's faith and walk, can only be avoided by teaching progressively from the Old Testament into the New Testament. If there is a clear understanding of the purpose of Law in the Old Testament, there will be little danger of the misuse or misinterpretation of the Law in the New Testament. It will be obvious that no one was ever justified or sanctified by the Law and that believers are fully dependent on God's grace alone for salvation and the Christian walk.

Furthermore, unless the Old Testament history of Israel is first taught, it is difficult to understand the Jews' attitude toward the Gentiles at the time of Christ and the time of the early Church. Why were the Jewish leaders so angry at the suggestion of the Lord Jesus that the Gentiles could also be recipients of the grace and blessings of God? Why did the Church in Acts face such dilemmas regarding the matter of accepting uncircumcised believing Gentiles into full fellowship? Why was it necessary for the Lord to give Peter a special and thrice-repeated vision before he would take the Gospel into the home of a Gentile? Why was Paul hounded from city to city by the descendants of Abraham? Why was it necessary for Paul to constantly address the topics of Jew and Gentile, Law and Grace, and circumcision and uncircumcision? The answers to these questions are found in Old Testament history.

Foundations for the Christian walk

Once people profess to be saved, most teachers are so zealous to see these new believers living and serving like Christians that they give them little time to grow in knowledge and experience. They are expected, in a very short period of time, to function in the Church alongside of those who have been Christians for many years.

Just as the unsaved must be prepared for the Gospel of God's grace in salvation by a revelation of God's nature and character, so believers need to be prepared to walk humbly with the Lord by deeper insights into God's nature and character.

The truth of the verse, *"The fear of the LORD is the beginning of wisdom"* (Proverbs 9:10) should not only be applied to the unsaved but also to the believer and his growth in holiness. *"Oh, fear the LORD, you His saints! There is no want to those who fear Him"* (Psalm 34:9). The fear of the Lord in the life of the believer should not hold dread of condemnation or wrath, for there is *"no condemnation to those who are in Christ Jesus"* (Romans 8:1). However, through the knowledge of God in His holiness and glory as revealed in all the Scriptures, the Bible teacher should prepare foundations for the believer to respond to scriptural exhortations to godliness. The believer should continually advance in genuine awe and solemn appreciation of who and what God is. Only this will produce true biblical humility, brokenness of spirit, meekness and contriteness of heart. The fear of the Lord is the preparation for the life of holiness and obedience to which the believer is called.

The scriptural truths necessary for a victorious and holy walk can only be understood, appreciated, and correctly appropriated if seen and interpreted in light of God's glorious nature, character, and eternal purposes as revealed in all the Scriptures. God must be seen by the child of God to be the supreme reason for everything he does. The believer should respond to the scriptural exhortations to holiness out of love and worship of God. The biblical basis for the believer to pursue holiness is epitomized in the words, *"Be holy, for I am holy"* (1 Peter 1:16). The Apostle

Paul says to believers, *"Therefore, whether you eat or drink, or whatever you do, do all to the glory of God"* (1 Corinthians 10:31). The foundation for worshipful service to God is a Bible-oriented appreciation of God's supremacy, majesty, and holiness.

Believers need to come to know who God is before they are taught the things they must or must not do as believers. Anything less may produce counterfeit experiences which will lead people to glory in their own humility and dedication. Exhorting believers to holiness before they have these necessary foundations can easily lead them to mere outward conformity and perfunctory obedience based on the false foundations of human determination and fleshly dedication. Anything which the believer does for any reason other than genuine love and appreciation for who God is and what He has done is unacceptable to God even when the believer's actions are based on some command from the Word of God.

Many sincere missionaries and Bible teachers lead believers into legalism because they fail to apply these biblical guidelines to their teaching methods. They immediately begin teaching new believers the dos and don'ts of the Christian life. They seem to think that, if they simply tell these new believers that they are indwelt by the Holy Spirit and some other positional truths, then this knowledge will bring the liberty and power to obey God's commands to holiness. Admittedly, these truths are vitally important and should be taught to believers, but the fact remains that spiritual growth is a process. Growth cannot be forced. It is the result of God's Word being understood and received in the heart. It is the result of God's Word dwelling in our lives (Colossians 3:16). The Word of God must be planted in the mind and heart in order for it to take root and grow (James 1:21). The growth of the believer comes not only through the knowledge of the written Word, but also through a deep and personal relationship with the Living Word, the Lord Jesus Christ (2 Peter 3:18). The believer must be *"rooted and built up in Him"* (Colossians 2:7).

The believer should grow spiritually through the teaching and appropriation of God's Word just as the human body develops and grows through eating and digesting good food (1 Peter 2:2; Ephesians 4:11-16). The human body develops slowly from infinitesimal beginnings. At birth, a child has all the potential of the adult, but there must be development and growth before the latent potentiality of the child can be exhibited. Forcibly overfeeding a child or immediately giving it the food of an adult will not promote growth but rather will inhibit its progress. What is true in the natural is equally applicable in the spiritual realm.

The faithful servant of God must be careful and patient, just as God has shown Himself to be patient while teaching and preparing men for His service. Let us not forget how long the Lord took to teach and prepare Abraham before He finally gave Abraham the promised son, Isaac, and even then, there was more training for the patriarch. We need to contemplate God's patient work in preparing Joseph in an Egyptian prison, Moses in the Midian desert, Joshua as a servant to Moses, David in the wilderness constantly hounded by Saul, John the Baptist in the wilderness, Jesus as a Nazarene carpenter's son for thirty years, the disciples' three years of training, and Paul's three years of training in Arabia. These are but a few examples of God's faithful, patient, slow work of teaching and preparing His most useful instruments. Since the divine Teacher feels it necessary to take time to instruct and allow His students to grow, we, too, need to take the time to see people well taught, not only in the New Testament but also in the Old Testament. *"For whatever things were written before were written for our learning, that we through the patience and comfort of the Scriptures might have hope"* (Romans 15:4).

When Paul taught the truths for the Christian walk, he did so on the basis of the Old Testament Scriptures. To the Corinthians, he said, *"Moreover, brethren, I do not want you to be unaware that all our fathers were under the cloud, all passed through the sea"* (1 Corinthians 10:1). Paul did not want them to be ignorant of these Old Testament accounts. Why not? Because, he said, *"these things became our examples, to the intent that we should not lust after evil things as they also lusted... Now all these things happened to them as examples, and they were written for our admonition, upon whom the ends of the ages have come"* (1 Corinthians 10:6, 11). Paul's presentation of God included God's historical revelations to the nation of Israel. Paul reminded Timothy that, from a child, he had known the Holy Scriptures, which Paul assured Timothy, are able to make a person wise unto salvation through faith which is in Christ Jesus. Paul continued by saying, *"All Scripture is given by inspiration of God, and is profitable for doctrine, for reproof, for correction, for instruction in righteousness, that the man of God may be complete, thoroughly equipped for every good work"* (2 Timothy 3:16-17). It should be clear to all Bible teachers that Paul is speaking of the Old Testament Scriptures as well as the New Testament revelation.

What then is the best way to teach in order to give believers a knowledge of God as a basis for the Christian walk? We must teach all of the Scriptures according to the divinely provided pattern laid out in the Word of God. If we do not see and understand the teaching principles in the Scriptures, we will not be convinced of their importance to the spiritual development and growth of believers. The progressive, building approach to teaching will seem unnecessarily long and arduous. The quicker, more efficient way will seem to be, "Forget about the majority of the Old Testament and other introductory Scriptures. Just get on with the job and teach the Christian life." This attitude is akin to the one which says that the teaching of the Old Testament historical sections to unsaved people takes too long. In most cases, it is not the time factor which influences our thinking that way, but a lack in our understanding of scriptural teaching methods and our failure to appreciate the Lord's purpose for writing the Scriptures as He has.

Foundations for future teachers

It is the responsibility of every Bible teacher to teach God's Word in such a way that the fellowship of believers will be able to interpret all doctrines in light of God's complete revelation. But does this mean that a Bible teacher or missionary who teaches believers in order to see them established as a New Testament church must teach every single verse of the Word of God, beginning in Genesis and concluding with the Revelation? No! That is not his responsibility.

The Bible teacher's primary responsibility is to lay the foundations. He should train and equip the local congregation and give them the responsibility to continue building on the foundations which he has laid down for them from the Word of God (1 Corinthians 3:10-15; Ephesians 4:11-13; 2 Timothy 2:2). The one who lays the foundations is responsible to make sure that the foundations he lays are wide enough to support all that must be taught later by the other teachers. If the foundations are inadequate and lacking in some way, then the teachers who follow will not have the necessary basis for teaching the whole counsel of God. The builder of the foundations must lay the theological, historical, dispensational, and doctrinal foundations which will support every part of God's revelation, so that the future local teachers will be able to correctly expound and interpret the entire revelation of God and all doctrines in both Old and New Testaments.

Which then is the simplest way to do this? Should we have doctrinal check lists and check the doctrines off as we teach them? No, because if we do, the future teachers will be as bound to our

doctrinal outlines as they are to their Bibles. Rather, every ambassador for Jesus Christ should determine that, when teaching believers, he will be guided by the divine principles exemplified in the Word of God. By closely following divine principles, the teacher will have done all in his power to bind his hearers' hearts and consciences to the complete Word of God and its glorious Author.

Since the biblical guidelines which we have discussed should be applied, not only as a basis for evangelism, but for teaching believers, our methodology should not change when moving from evangelism into establishing a church. That which applies to one applies to the other. If we use the holistic approach for evangelism but use the topical approach to teach the tribal church, they will inherit all the problems and deficiencies so evident in the understanding of many established churches throughout the world. Furthermore, if we, by example, give the tribal church the impression that the correct way to teach God's Word to believers is to teach topically, then they will probably follow our example. In years to come, the holistic, chronological approach to the Bible and the understanding of God's form of progressive revelation will rarely, if ever, be given a place in their teaching program. If we have formed convictions concerning these principles for our own ministry, then we will want to make sure the churches formed through our efforts will continue to teach the Scriptures expositionally and holistically, covering the entire Bible as one Book just as God has given it.

The chronological teaching program

Because of the need for a panoramic and progressive teaching program for believers, the Lord led me to expand the chronological teaching outline beyond Phase 1 which is primarily for evangelism (see Chapter 6) to include 6 additional phases. These 6 phases are designed to guide the missionary and then the tribal teachers as they establish new believers and instruct maturing believers in their understanding of the whole Word of God. The phases are best taught in order, because each builds on the foundations laid in the previous phase. (See chart displaying the Chronological Teaching Program on Page 81.)

Each of the phases will be presented in greater detail under separate cover, but a brief explanation of each is in order at this point to help the reader to understand the teaching program for believers.

Phase 1 (for unbelievers and believers)

There are many believers in churches who have not been taught the Scriptures holistically. Beginning from the time they were saved, these Christians have almost always been taught topically. Thus, their understanding of the Scriptures is fragmentary, for it is made up of isolated verses and portions of Scripture. They do not understand the Bible as one Book. In this type of situation, it is far more effective to begin in Phase 1, laying the correct foundations, and, on this sound basis, continue building scripturally. The Old Testament section of Phase 1 should be taught, uninterpreted by the New Testament, so that believers will see and understand the progressive development of God's revelation.

Believers who have been taught Phase 1, either as members of a mixed group of saved and unsaved or as a separate group of only believers, have greatly benefited by seeing the chronological and panoramic view of the history of redemption. Through it, they have been taught the basis of the

Chronological Teaching Program			
Old Testament	**Gospels**	**Acts**	**Epistles**
Phase 1 Unbelievers Mixed groups (with both unbelievers and believers) Believers			
Phase 2 New believers			
		Phase 3 New believers	
			Phase 4 New believers
Phase 5 Maturing believers			
		Phase 6 Maturing believers	
			Phase 7 Maturing believers

faith and salvation of Old Testament saints. They have also received the Old Testament background necessary for a correct interpretation of the New Testament. The teaching of Phase 1 has also demonstrated to believers how to evangelize by first teaching the Old Testament to convince people that they are hopeless and helpless sinners, rather than trying to persuade them that they need a Savior while they are still content in their sin or trusting in their own self-righteousness.

Don and Janet Schlatter, who ministered to the Lawa tribal people in Northern Thailand for many years, saw the Lord save a great number of the Lawa. The Schlatters taught these believers to function as members of indigenous church fellowships. After many years of teaching these believers, Don taught Phase 1 to the Lawa churches. Don wrote,

> *"We praise God for the response in some of the older churches to the chronological presentation of Bible truth. We are going through the Old Testament passages which form a foundation to Christ's coming. One elder said it this way, 'Before, you taught us from the middle to the top of the tree. Now we are hearing about the bottom of the tree.' It brings into focus much which was confusing before. How we thank God for bringing this need to our attention. Lawa believers in sixteen villages are now hearing the Word, and we are trying to present it in a logical fashion in every place."*

Mike Henderson, a missionary with the Aziana tribe in the highlands of Papua New Guinea, noted a change of emphasis in the ministry of the church elders and teachers and a change in the type of teaching illustrations they used after they had been taught Phase 1.

Prior to being taught the Old Testament, the Aziana tribal teachers limited their illustrations of God's judgment on sin to local experiences within the tribe. They did not know the Old Testament accounts of the revelation of the character of God, so when they wanted to give historical proof of the scriptural picture of God, they looked for evidence and verification in the local happenings within the tribe. But local incidents which initially appeared to the tribal people to be God's judgment on individuals were dimmed through the passing of time. Different accounts and distortions of the incidents also undermined their usefulness as warnings to those who disregarded the Scriptures. All of this changed once the Aziana teachers had been taught the Old Testament. They were able to use illustrations of actual written historical happenings with the accompanying interpretation in the Scriptures. Their teaching of the New Testament became punctuated with Old Testament historical accounts of God's judgment and gracious provision which could not be discounted nor changed. They were able to use the Old Testament writings for the purpose they were recorded by the Lord.

Phase 2 (for new believers)

Phase 2 is a review of the material covered in Phase 1, with altered themes and the addition of other Old Testament stories which are necessary foundations for Acts to Revelation, Phases 3 and 4.

Phase 2 focuses on Christ fulfilling all the Old Testament prophecies concerning the promised Redeemer and satisfying all of God's righteous and holy demands on the behalf of all who trust in Him. Whereas the emphasis of Phase 1 was on salvation, the emphasis in Phase 2 is on the security of the believer and all that they enjoy in their new relationship to God through Jesus Christ.

Phase 2 also emphasizes the Holy Spirit's ministry. The promises regarding the giving of the Holy Spirit, found in the Old Testament and the Gospels are brought out during Phase 2. This

serves as an introduction and foundation for the Acts of the Apostles (Phase 3) and for the remainder of the New Testament (Phase 4). As believers understand the Holy Spirit's power throughout all of history and how He accomplished God's purposes in the world and in the lives of His children, they will be prepared to understand and appreciate the coming of the Holy Spirit on the day of Pentecost as the permanent Indweller, Comforter, Motivator, and Enabler of all believers.

The introduction and foundations for a full appreciation of the incredible solemnity of God indwelling the human bodies of believers as His temple are found in the Old Testament. Just as the cross cannot be fully appreciated except a person is exposed to the terrors of the righteous judgments and Law of God seen in the Old Testament, even so, the wonder of God indwelling believers cannot be fully appreciated by those who have not been taught about the glory of God manifest in the Tabernacle and the Temple.

Missionaries who have taught new believers Phase 2 testify to the benefits and blessings received.

When Jack and Isa Douglas were teaching Phase 2 to the Pawaia tribal believers in Papua New Guinea, they wrote,

> *"We wish you could see the believers in the tribe. It is a joy to see them so happy and enjoying the Lord. They have had so little teaching about 'living' because we have carefully avoided setting up a system of 'works' – do this, don't do that, and you will go to Heaven. Instead, we have been pointing to God, the Creator, holy, righteous, wise, loving, powerful, and His work of redeeming us. The believers really seem to appreciate this truth and actually get excited about it. Shouldn't we all? It's absolutely wonderful! They laugh with joy at the fact that Jesus will come to take us to Himself. Jack is teaching the Old Testament background, showing how it all points to the Savior. The last time through (Phase 1), there was growing despair. This time through (Phase 2), there is growing joy. The believers love to express their joy through praise, prayer, and song. There is no set order. The prayers are fresh and real. 'There is no one like You.' 'No one else could have saved us.'*

> *"It makes sense to build on a good foundation. The new believers will also be able to follow the same principles in their teaching program."*

Ron Jennings wrote regarding the Higaonon tribe in Mindanao, Philippines.

> *"We found Phase 2 to be an essential part of the program, because it was an in-depth review for some who had missed some meetings in the beginning and for the old people who found it difficult to remember all that they were taught in Phase 1. The people were so excited to see the direct spiritual application of each Old Testament story to Christ. This really strengthened their faith. Others came to a realization of their salvation in Christ during Phase 2."*

Notice that Ron said some others were converted during the teaching of Phase 2. Even though this is not the main purpose of this phase, it is an important point to consider. Where the Gospel has been preached for the first time and many have made professions of faith, it is good to allow a settling time before beginning to teach on the Christian's responsibilities. Phase 2 provides this opportunity, for a large part of it is a review of the material taught during Phase 1, evangelism. Those who may have been caught up in the excitement and emotion of the movement to Christianity but are not truly converted will once again hear the foundations for the Gospel and

may be saved. More importantly, it will be a time when the believers can bask in the sunshine of God's gracious and full provision for them in the Lord Jesus Christ.

Merrill and Teresa Dyck in Venezuela reported blessing when teaching Phase 2 to the Pumé tribal people.

> *"It has been exciting to get together with the Pumé believers each day! What a thrill to see them grow in the Lord and begin to understand their security in Christ! Just a short while ago, we finished our Phase 2 studies with them from the Old Testament. The numerous Old Testament accounts served wonderfully to show them their standing in Christ. As Enoch was taken up to Heaven, so will we also go to Heaven. As Noah escaped the judgment on the ancient world, we too will escape judgment and Hell. As Lot was warned and found refuge, so have we been warned and saved. What joy to see these believers grasping these different truths!"*

Phase 3 (for new believers)

Phase 3 is an elementary exposition of the basic portions of the book of Acts, telling the ongoing story after Christ's ascension, showing the fulfillment of all the promises concerning the Holy Spirit and giving the historical background necessary for understanding the Epistles.

The book of Acts tells the story of the geographical spread of Christianity from its beginnings in Jerusalem, the capital of Israel, to Rome, then the capital of Gentile dominion. Just as the Old Testament provides the necessary foundations and background for the New Testament, the book of Acts is the introduction to the writings of the apostles.

George Walker, a missionary in Papua New Guinea, wrote about the blessings received by the Bisorio tribal Christians when taught Phase 3.

> *"We used Phase 3 for the overview of Acts. I don't know exactly how long it took us. I would guess maybe four months or so. We followed your outline right along with a few minor changes here and there to meet some of the needs of the Bisorios. As we taught Acts in Phase 3, the Apostle Paul really emerged as a hero in the Bisorios' eyes. Thanks to the teaching of the Book of Acts before the Epistles, Paul has walked into the hearts of the Bisorios."*

Phase 4 (for new believers)

Phase 4 is a simple exposition of the basic portions of each of the remaining books of the New Testament with emphasis on the function of the New Testament Church and the walk of the believer.

When George Walker was teaching Phase 4 to the Bisorio people in Papua New Guinea, he wrote,

> *"We are teaching the Bisorios the Book of Romans (Phase 4). Whenever we read what Paul has written, the believers are very attentive. We are now in chapter 5. They (and I!) are really enjoying it. They really love the Apostle Paul. They just love his honesty and 'calling it as it is' as they are taught the Book of Romans. I really thank the Lord for their attitude toward Paul, in receiving wholeheartedly what he says. As our Lord said, Paul is His apostle and servant to the Gentiles, and '...he*

who receives whomever I send receives Me; and he who receives Me receives Him who sent Me' (John 13:20)."

Phase 5 (for maturing believers)

The emphasis in Phase 5 is on the sanctification of the believer. Phase 5 begins in Genesis and concludes with the ascension.

Phase 5 is aimed at the maturing believer who has already been taught the other four Phases. The Old Testament portion deals particularly with God's sanctifying work in the lives of His servants and His people Israel as a basis for teaching a life of fellowship to God's children. In the Gospels, it emphasizes the spiritual training received by the disciples through their fellowship with the Lord Jesus.

Dave and Patti Hodgdon, on behalf of the Lamogai team, wrote:

> *"It was a thrill to minister together and see tribal people put their faith in Jesus as their Savior. Likewise, to see them continue to grow in their faith and see Christ's life in them through the indwelling Holy Spirit was exciting. But before our ministry among the people was completed, we had to ask ourselves, 'What is our responsibility to teaching the Old Testament Scriptures as well as a more complete look at the Gospels?' God impressed our hearts that there were many important lessons found in those portions of the Bible that we had not yet fully taught to the people.*

> *"Although the task of studying, writing and teaching lessons from the Old Testament and Gospels was long, there were so many important lessons to be learned from the lives of those spoken of in the Old Testament. Many of the future events of Israel that we had briefly shared while teaching through the New Testament were also able to be uncovered and declared more fully. As we taught the believers, they were challenged by what they learned from the lives of the Old Testament saints. They were also impressed with the many promises God made to Israel and the understanding they received about future events only confirmed what they had learned from the New Testament. The Phase 5 curriculum was a very important element in the believers continued growth to maturity."*

Phase 6 (for maturing believers)

Phase 6 covers the book of Acts in a verse-by-verse exposition of the whole book. The emphasis is on the Holy Spirit's guidance, training, and sanctifying work in the early Church and the life of the Apostle Paul.

Phase 7 (for maturing believers)

The purpose of Phase 7 is to teach expositionally through the remaining books of the New Testament. The emphasis once again is on the Church and the walk of the believer.

Be careful how you build

Paul reminded the Corinthian church, *"you are **God's** field, you are **God's** building."* He reminded the pastors and teachers that they, like Paul, were *"**God's** fellow workers"* (1 Corinthians 3:9).

Nothing has changed! The work of evangelism of the world and the building of the Church of Jesus Christ does not belong to some denomination or mission organization. The building of the Church is not our project. Jesus said, *"I will build My church, and the gates of Hades shall not prevail against it"* (Matthew 16:18).

Realizing the importance of this work of laying the foundations of Christ by evangelism and then building on those foundations through the instruction of God's children, Paul solemnly warned all who would presume to be God's fellow workers. He said to be very careful how we build because *"the fire will test each one's work, of what sort it is"* (1 Corinthians 3:9-15).

God, the Architect and Master Builder of His Church, has provided His Word to be our greatest and most powerful tool as we prayerfully labor with Him. Paul was vitally aware of this as he spent his final days in a Roman prison. Knowing that his death was imminent, Paul wanted to leave final instructions for Timothy to whom he had entrusted his work. Paul wrote to Timothy, *"I charge you therefore before God and the Lord Jesus Christ, who will judge the living and the dead at His appearing and His kingdom: **Preach the word!**"* (2 Timothy 4:1-2).

What then will we do? We are now so very much closer to that *"glorious appearing of our great God and Savior Jesus Christ"* (Titus 2:13). Will we be found faithful workmen at His coming? Will our work stand the test of the all-seeing eyes of the risen Christ, the Judge? John said that the eyes of the glorified Christ were as *"a flame of fire"* (Revelation 1:14). In demonstration of His knowledge of all things, the Lord Jesus said to each of the seven churches in ancient Asia, *"I know your works"* (Revelation 2:1). What then will He say of our work done in His Name?

We can be certain that all that is done in accordance with His Word will be acceptable to Him. The seven phases of the Bible teaching program which are taught in detail in successive volumes in this series have been prepared to guide you in this endeavor. May the Lord give you wisdom as you teach the Scriptures chronologically for evangelism and then to God's children according to the historical, progressive form chosen by God.

Part 2

Preparation and Guidelines for
Teaching the Scriptures Chronologically

8

Pre-Evangelism

Even before the building inspector was sent to officially inspect the old apartment building, the decision had already been made by the city mayor to demolish and replace it.

As he viewed the building from his car, the inspector nodded his head and said to himself, "Yes, it's had its day. No use keeping this one." Yet he knew that it was not as simple as that. The occupants would fight to preserve the building which they called home. Convincing them that their old home was not safe and needed to come down to make way for a new building would take time and patience. Yet he knew he must try. "If I can only get the people to see the building through my eyes," he said, "and if only I can give them a little understanding of the benefits of a new building, then maybe they will listen."

Stepping onto the stairs at the front of the building, the inspector grasped the railing to steady himself. With a crash, the railing gave way and fell to the sidewalk. As though prearranged, windows from apartments on several floors were flung open, and heads popped out. "What do you think you're doing?" one person yelled. "Be careful down there!" another bellowed. "This is our home you are pulling apart."

This incident, although only a story, reminds me of the time period in missionary work which we will be referring to as pre-evangelism.

Pre-evangelism defined

In the first section of this book, evangelism (also referred to as Phase 1) was defined as the period during which Genesis to the ascension is taught to bring the lost to a realization of their true condition before God and to teach them God's perfect and complete provision in and through the Lord Jesus Christ.

Pre-evangelism, as I am using the word, is the period preceding evangelism. It begins with the missionary's initial entry into his chosen field of labor and will continue through culture and language study until the missionary begins evangelism by teaching the Scriptures to unbelievers.

Pre-evangelism is not the time of actually building through teaching the Scriptures. It is, rather, the time of planning and preparing to build.

The Process of Church Planting →		
Pre-evangelism	**Evangelism** Phase 1, Genesis to the Ascension	**Establishing the Church** Phases 2-7

When we take the Gospel to the unsaved, whether it is to people previously exposed to the truth or to the unevangelized, we must realize that we will not be building on vacant land. The ground on which we propose to erect a new building has long been occupied with well-fortified dwellings erected by Satan and his hosts (2 Corinthians 10:4). Satan's buildings are not safe habitations but are "death traps" for all who trust in them. Nevertheless, the occupants have been deluded so they cannot see the danger that they are in, a danger that is obvious to us who have been enlightened by the Holy Spirit.

> **Principles Appropriate for Any Teaching Situation**
>
> The pre-evangelism steps described in this chapter are designed for those working in a cross-cultural setting. Some of you reading this book are not planning to teach in a cross-cultural setting. Do the principles of pre-evangelism apply to you? Yes! Pre-evangelism for you will be to build bridges of friendships and cause people to think about their need to study God's Word. Although these chapters on pre-evangelism are designed for the cross-cultural missionary, read them to glean principles and ideas for outreach in your own cultural setting.

Choosing a location

Pre-evangelism will include choosing the location where we intend to erect a new spiritual building, making friends with the occupants of the present building, and then patiently working to help them look realistically at the condition of their place of refuge. Through the teaching given in pre-evangelism and Phase 1, we hope they will become increasingly disenchanted with their old home and that they will allow the Holy Spirit to pull it down, piece by piece, and in its place erect a totally new building designed by God Himself.

The glorious building which we have been called to erect, under the direction of the Holy Spirit, is the Church of God. We are God's agents in the building of this holy temple *"for a dwelling place of God in the Spirit"* (Ephesians 2:22). Every individual who is saved through our teaching will become a living member of this Church – the Body of Christ (1 Corinthians 12:12-13).

From the divine perspective, nothing can hinder the completion of the universal Church of our Lord Jesus Christ. Our hearts must be fixed on His unchangeable promise, *"I will build My church, and the gates of Hades shall not prevail against it"* (Matthew 16:18).

From the human point of view, however, the work in a specific location can be hindered. How? Through our ignorance, carelessness, or lack of dependence on and obedience to the Holy Spirit, God's appointed foreman over the whole construction of the building. The Lord Jesus did not leave it up to man alone to organize the building of His Church throughout the world. Rather, He sent the Holy Spirit to direct every worker in each aspect of building the Church, including where he should work and what he should do.

The Holy Spirit said to the prophets and teachers of the church at Antioch, *"Separate to Me Barnabas and Saul for the work to which I have called them....So, being sent out by the Holy Spirit, they went"* (Acts 13:2-4). These two "foreign" missionaries went out in obedience to the Holy Spirit, trusting Him to guide them to the right places and the right people as they continued the building of the Church among the Gentiles.

Later, when Paul was on his second missionary journey, this time accompanied by Silas, they *"were forbidden by the Holy Spirit to preach the word in Asia"* (Acts 16:6). Following this, they planned to begin building in Bithynia, *"but the Spirit did not permit them"* (Acts 16:7).

Just as it was vitally important for the apostles to begin their work in the right place at the right time, it is equally important that we, too, depend on the Holy Spirit as we select the location where we will live and begin our pre-evangelism work. The whole progress and success in evangelism and the development of the future church often depends upon these early decisions, for the location of pre-evangelism will be the likely place where we will eventually teach Phase 1.

Neutral location

An incident from our own missionary experience may help to illustrate the far-reaching problems which may develop through choosing the wrong location to live and begin pre-evangelism activities. When we moved to the third area where we ministered in the Philippines, we built our house on the land of an elderly headman, and we began our work in his home and in the homes of his relatives. When we first moved into this area, we were so pleased to be received cordially by the people on whose land we had built our house that we failed to observe the local village factions and disputes. Unknown to us, there was longstanding animosity and competition between the leader on whose land we built and another local headman. By living and beginning our work where we did, we unwittingly placed ourselves in one of the opposing camps. This created barriers to reaching the other group. Once we became aware of the situation, we tried in every way we could to become friends with this other group, but we were never able to find complete acceptance with them.

If possible, we should have located in a no-man's-land in order to distance ourselves from this longstanding feud. Our failure to do this hindered the opposition group from accepting us and accepting the Word of God. Because the leader and his relatives near whom we lived accepted the Scriptures, the rival leader ordered his people to cling to the old ways. He threatened to ostracize any of his people who attended meetings and believed the Gospel. How important it is to begin your work in a location considered to be neutral ground by the different factions and rival leaders which are invariably present in tribal societies!

Natural movement

Furthermore, when choosing a location for pre-evangelism, we need to consider the direction in which the Bible teaching and the witness of future converts will most naturally move. Our influence and the spread of the Gospel are more likely to move along well-beaten paths before they begin to reach out over the seldom-trodden tracks. If possible, it is best to begin in a place from which Bible teaching will most naturally move to other areas.

Many things influence the general movement of the tribal population – terrain, language, trade, work opportunities, hostilities between villages, different leadership in villages, intermarriage, and family relationships. In Palawan, there was little interaction between those of the west coast and the east coast due to the mountain range which runs almost the entire length of the island. The natural flow of the population was toward the closest coastline where the people were able to fish, collect sea foods, trade, and find work.

Future outreach

Another point to consider in the beginning of the work is whether you will begin teaching in more than one location. Will you concentrate your efforts locally or will you also begin in other outreach areas?

Before you begin elsewhere, it will be judicious to consider which districts would be the closest and most suitable areas of outreach for the future tribal church. You do not want to rob the future church of natural opportunities for witness. We as missionaries must plan to turn the work of outreach over to the future church. Therefore, we should determine the most likely people, villages, and areas which would be the first to be naturally contacted by future converts and permit these untouched ones to become the future "mission field" of the indigenous church.

In looking back over his evangelistic outreach among the Aziana tribal people of Papua New Guinea, Mike Henderson wrote:

> "The Aziana tribe is a small group of about 1,000 people, located in three main villages. I thought it would be best to try to reach all three main villages at the same time to give all an 'equal' chance to hear.

> "One of these villages had real animosity towards our mission presence, so before I began teaching, I made an extra effort to overcome that with friendship. This village seemed to be receptive when I asked to teach them at the same time that I would be teaching at the other two villages. So I started Phase 1 outreaches in all three villages.

> "Two of the villages were a 45-minute hike from the village where I lived. I would teach in one village per morning. I quickly found that hiking to the more distant villages, waiting for them to gather, teaching the lesson and then hiking home ate up most of the morning. It also meant I spent three days per week teaching one lesson. Because I was starting three Phase 1 outreaches at the same time, there were no believers who could help with follow-up or whom I could disciple in how to teach.

> "As time progressed, I could see that the village where I'd tried the hardest to gain their confidence was the least receptive. Sometimes I'd get to their village

and find they had gone off for the day without sending word to me. Gradually they fell further and further behind in the teaching. It was discouraging to go there, but I continued because there were a few who came consistently and seemed interested.

"In looking back, I think doing three outreaches at the same time overtaxed my energy. I was the only one involved and didn't have time to properly prepare both lessons and translation. As time went on, I dropped the lesson preparation and only did translation which turned out to be a significant setback for future outreaches. Two of the villages did respond well and started to meet together so that lightened my workload. But only a few responded in the more resistant village, and they were too weak to stand firm against the pressure of the rest of the village.

*"I have often thought that it would have been better for that one village to have **seen** the results of the Gospel in the other villages rather than **hearing** it at the same time. I believe they would have been more open to hear if they seen the results of the Gospel in the lives of others from their tribe. Had they seen the results first, they probably would have invited us to teach. At their invitation, I could have taken new believers with me to help in the outreach and to be discipled in how to teach. As it is, the door to that village has remained shut for many years."*

Untouched by religious influence

One other point that should be considered as we choose the location to begin our work is whether heretical religious groups have already established themselves in the area. If so, it is usually wiser to begin with those people least affected by the false teachers and their doctrine. After the work has taken root in the untouched areas, it may then be possible to reach those who are under the influence of the false teachers.

The importance of this approach is underscored by a prayer request from native believers living in a remote area of Papua New Guinea. They asked for prayer for their outreach to a group of religious people where hostilities to the evangelistic effort had broken out. The Bible teachers involved in this evangelistic outreach are from native churches whose members live interior on steep, jungle-covered mountains. They too were at one time influenced by the teachings of the religionists.

When the missionaries first arrived in this area, they noted that the churches of this religious group had the strongest influence along the only road in the area where they had established their churches. The missionaries made a wise decision. They located interior in a remote area where the leaders of this religious group rarely visited. When the people interior heard and believed the Word of God, the leaders of the religious group immediately endeavored to hinder the spread of the Word of God among those whom they viewed as their constituents, living in the mountains and down at the road. But God's Word taught in dependence on the Holy Spirit spread like wild fire, bringing life and freedom to multitudes. Many churches were established with young believers overflowing with joy and appreciation for their Savior. Some of them even ventured to approach stronger members of this religious group to share their faith. Some believed and a little meeting house was built. Almost immediately persecution broke out. Spurred on by their

leaders, the religionists beat some of the believers and burned their meeting place. Gradually, the persecution died down and lay dormant for several years.

However, persecution broke out again when a group of Bible teachers accepted an invitation to teach Phase 1 to some who had continued as members of this religious group. The religious leaders forbid their remaining adherents to listen to the message of God's Word. Although they have no real jurisdiction over them, they also ordered the evangelists to go back interior and to keep their message to themselves.

Surely it is evident that the missionaries' strategy was correct. If they had begun their work beside the churches of this religious sect, they would not have seen the same rapid growth of the church as they did by going to the people in the mountains who were not under the constant influence of this false religion.

Finding acceptance

Whether we realize it or not, we begin our pre-evangelistic work in our initial contact with people. How we act during those early days will have lasting effects on our ministry and our acceptance or rejection by those we want to reach with the Gospel.

Be friendly

The missionary who is perceived as being amiable and friendly will usually find that people desire to be in his company. In most cases, foreigners are a novelty to people living in remote areas. This can be to our advantage if we handle it correctly for the glory of God.

If, however, we are looked upon as being dull, morose, uninterested in them and their activities, or if we appear to be completely engrossed in our own work of setting up house and studying, it is unlikely that, when we are ready to begin evangelism, many people will be interested in listening to our teaching.

A prime example is what happened each time the pilot flew into our mission station in Palawan. He always had a ready smile, a friendly wave, and a spoken greeting – sometimes just an "hello" in English. The people welcomed him even though he was unable to speak their language. An old leper, unable to run down to the airstrip with the rest of the community, always sat in the doorway of his hut just to receive a friendly wave from the pilot.

In contrast, another missionary hiked in to visit us. We were not at home when he got there. When we arrived, we found, much to our surprise, that the tribal people had done contrary to their usual practice and had not fed the visitor. When we inquired from our tribal friends why they had not offered him something to eat, they replied, "He didn't smile at us, and he wouldn't speak to us."

If we want people to accept us, we must show ourselves to be friendly, interested, and interesting. Perhaps this sounds as if we are trying to "sell ourselves to the people." Rather than view it that way, however, admit that very few of us seek out those whom we consider to be boring or those who show little or no enthusiasm for the things we consider to be important. We feel unacceptable and, therefore, uncomfortable. Let's face it; we won't have people to teach if they don't "like" us and if they keep away from us.

Be interested in them

Drop in often to see the people when they are in or around their homes. Show interest in the things that the people are interested in. Make an effort to see where they work and how they do their work. Visit them when they are playing or relaxing. Go hunting or fishing with them.

Short, frequent visits are often best in the beginning when one is still very limited in the language. Even though we may not be able to say much in the early stages of language learning, we can build bridges of friendship and draw the people to us in many different ways. Interest in their crafts, recreation, and daily activities should be genuine and enthusiastic. People all over the world respond to those who accept them and evidence appreciation for their abilities. Our conduct must be genuine; otherwise, our friendliness will be hollow and easily recognized as hypocritical. Our facial expressions and general attitude are often more important in demonstrating our true attitudes than even our words.

Genuine Interest

It is a challenge for us to be genuinely interested (let alone fascinated) by the things the people are interested in. Year after year the Gerai love to talk about what stage the rice has reached in its growth process. You can see the gleam in their eyes when they report that the "needles" have emerged from the soil. I found that I needed to ask the Lord to make me genuinely interested and to genuinely enjoy talking about this year after year.

It really is impossible, I have found, to fake genuine interest. The more my mind was engaged in my own interests, the harder it was to be engaged in their interests. Distraction is a significant problem. With e-mail and so much media access, our minds can easily and frequently be on things far away, and view the time needed to develop friendships with the people as a waste and a bore.

Recognizing this challenge gives new meaning to the picture of Christ coming to earth and taking the low position of a human being and entering into life at its lowest and most mundane level.

– Larry Goring, NTM Field Ministries Coordinator

Be interesting to them

Their desire to visit us also needs to be encouraged. We may play a musical instrument, sing, tell stories, or do other things which will interest them and cause them to consider us as enjoyable company. We were never lonely when we were living among the Palawanos. We enjoyed showing them photographs of our family and our homeland. We also showed them pictures of other lands and talked about the grandeur and wonders of the world.

Such activities, if carefully planned, will not only be enjoyable for them and us but will also provide opportunities to prepare the people for evangelism. While the pre-evangelism period is rightly considered as the time when we prepare ourselves to do our work, sufficient time and thought are not always given to ways in which this time may be used to prepare the people to appreciate us as those who really care for them personally, to help them relax in our presence, and to encourage them to feel confident to ask and answer questions and have discussions with us.

It is important to include both young and old, male and female, in your circle of interest and friendship. The servant of the Lord should be like his Master and show love to, and interest in, everyone.

I would encourage you to create a friendly environment and make the people aware that what you plan to teach is something which is relevant and extremely important. Build slowly toward evangelism, generating excitement and enthusiasm about the teaching which you plan to give them.

Thought-provoking discussions

Before the foundations can be laid for any great building, much preparatory work must be done. The land must be cleared of all obstacles and excavation done in readiness for the foundations. This is also a necessary work in preparation for preaching the Gospel. If we lay the foundations for the Gospel on the shifting sands of religious and cultural superstition and ignorance, then the cunning maneuvers of Satan will soon undermine and destroy the building.

In the first part of this book, I emphasized the necessity of preparing the ground and then laying solid biblical foundations through teaching Phase 1. It is on the solid foundations of truth (John 8:32) that we will begin erecting a new building by teaching systematically according to the progressive form taught in the Word of God.

Is there anything you can do during the time of pre-evangelism in preparation for teaching Phase 1? Absolutely! As you gain adequate language ability and establish good relationships, you can begin preparing the people for evangelism by causing them to think about their spiritual condition and religious beliefs.

Make people think

Pre-evangelism is **not** the time to try to change their thinking or present biblical alternatives. This should wait until you have presented the Bible as the authority for all your teaching. Nevertheless, you can begin a preparatory work for evangelism by initiating thought-provoking discussions, designed to stir the people from their spiritual inertia and complacency and cause them to question their accepted cultural and religious presuppositions.

Thought-provoking topics, raised correctly during pre-evangelism, will help to unsettle the people's well-established, religious thought-patterns. If this is accomplished, then the people will be more inclined to accept God's answers in the Bible concerning Himself, creation, man, the spirit world, the origin, purpose, and future of human life, the meaning of sin and its payment, and many other related subjects which you will present in Phase 1.

As you introduce the following topics, it may also assist you in language and culture study by providing religious vocabulary necessary for teaching the Scriptures and by giving a clearer insight into the minds and beliefs of the tribal people.

Sample pre-evangelism topics

The topics listed below are themes for discussion. You should not sit down and simply ask about these topics, one after the other. Rather, you should interweave these topics into conversation during visiting time spent with the people. Through your culture study, you will probably already know what the people believe about these topics. So as you initiate discussions

about these issues, keep in mind that your purpose is cause the people to question the validity of their religious beliefs.

- **Creation**
 - The world
 - o The origin of the world
 - o The length of time the world has been in existence
 - o The time when the world began
 - o The process that took place when the world began
 - o Where they were when the world began
 - o The basis for their ideas about the origin of the world
 - The stars *(Initiate similar discussions about other parts of creation, such as the moon, the sun, clouds, lightning, thunder, rain, rainbows, mountains, rivers, rocks, ocean, animals, fish, birds, trees, fruit, and flowers.)*
 - o The origin of the stars
 - o The length of time the stars have been in the sky
 - o The time when the stars began to exist
 - o The maker of the stars
 - o The process by which the stars were made
 - o The purpose for which the stars were made
 - o The basis for their ideas about the stars
 - The orderliness of creation
 - o The reason the sun rises and sets each day
 - o The reason the moon follows the same pattern year after year
 - o The reason the seasons come and go
 - o The reason trees bear fruit in one season but not in another season
 - o The reason the grain grows in the correct season
 - o The reason everything in creation is under control so that the sun and the seasons follow an orderly pattern
 - o Whether someone is responsible to keep creation under control
 - o The identity of the one who is responsible to keep creation under control
 - Bad things in creation
 - o The reason some trees have poisonous fruit
 - o The reason useless weeds exist
 - o The reason thorny trees and plants exist
 - o The reason animals kill one another

- **God**
 - God's existence
 - Whether there is a God
 - The origin of God
 - God's age
 - God's location
 - Where God is
 - Where God lives
 - God's character
 - Whether God is good
 - Whether God is bad
 - Whether God is always good or always bad
 - What God is like physically
 - Whether God is male
 - Whether God is female
 - The characteristics of God's body
 - Whether God has a body like ours
 - What God needs physically
 - Whether God has physical needs similar to our needs
 - Whether God wears clothes
 - The kind of clothes God wears
 - Whether God needs to eat
 - The kind of food God eats
 - Whether God needs to drink
 - The liquid that God drinks
 - Whether God sleeps
 - The time when God sleeps
 - The place where God sleeps
 - God's activities
 - What God does
 - What God's work is
 - God's relationships
 - Whether God is married
 - Whether God has children through His marriage
 - The number of children God has through marriage
 - God's communication
 - The language God speaks
 - Whether they have heard God speak

- God's omniscience and omnipresence
 - Whether God can see and hear people all of the time
 - Whether we can hide where God cannot see us
 - Whether God knows what we are thinking

- God's requirements for people
 - Whether God cares about what we do
 - Whether God wants us to do certain actions
 - The actions God wants us to do
 - Whether God wants us to say certain things
 - The words God wants us to say
 - The process by which we know what God wants us to do
 - Whether God has told us what He wants us to do

- God's relationship/attitude toward people
 - Whether God loves us
 - Whether God hates us
 - The reason God loves or hates us

- God's friends
 - Whether God has friends
 - The identity of God's friends

- God's enemies
 - Whether God has enemies
 - The identity of God's enemies
 - Whether God's enemies are stronger than God

- God's power
 - Whether God is strong
 - How strong God is
 - Whether God is weak
 - How weak God is

- God's immortality
 - Whether God can die
 - The results which would come about if God died

- **Unseen spirits**
 - The existence of spirits
 - Whether there are unseen spirits
 - The origin of the unseen spirits
 - Where the unseen spirits live now
 - The identity of the unseen spirits
 - The names of the unseen spirits

- o Whether the unseen spirits have power over what happens to people
 - The leader of the unseen spirits
 - o Whether the unseen spirits have a leader
 - o The name of the leader of the unseen spirits

 - What the unseen spirits are like
 - o Whether the unseen spirits have bodies
 - o Whether the unseen spirits are male or female
 - o Whether the unseen spirits are big or small
 - o Whether the unseen spirits are good or bad
 - o Whether the unseen spirits are strong or weak
 - o Whether the unseen spirits are stronger or weaker than God

 - The relationship between the unseen spirits and God
 - o Whether there is a relationship between the unseen spirits and God
 - o Whether the unseen spirits are friends with God
 - o Whether the unseen spirits are enemies of God

 - The abilities of the unseen spirits
 - o Whether the unseen spirits can see people
 - o Whether the unseen spirits can hear what people say
 - o Whether the unseen spirits know what people are thinking

 - The relationship between the unseen spirits and people
 - o Whether the unseen spirits love or hate people
 - o Whether the unseen spirits get angry with people
 - o The reasons that the unseen spirits get angry
 - o The activities that the unseen spirits do when they get angry
 - o The process by which the unseen spirits can be appeased

 - The requirements the unseen spirits have for people
 - o Whether the unseen spirits want people to do certain actions
 - o The activities that the unseen spirits want people to do
 - o Whether the unseen spirits want people to say certain things
 - o The words that the unseen spirits want people to say

- **Human beings**
 - The beginnings of human beings
 - o The process by which the first humans came into existence
 - o Whether the first humans were created
 - o The identity of the one who created the first humans
 - o The number of humans who were created
 - o The reasons the first humans being were created

- The first people
 - The identity of the first people
 - The names of the first people
 - The physical characteristics of the first people
 - The physical characteristics of the first people compared to the physical characteristics of people who live now
 - Ways that the first people were different from people now
- The differences between people groups
 - The reason people are different colors
 - The reason people are different sizes
 - The reason people speak different languages
- The characteristics of people
 - Whether people are good or bad
 - Whether all people are good or bad
 - Whether some people are good while other people are bad
- People's sinful activities
 - Activities which are bad for people to do
 - Attitudes which are bad for people to have
 - The identity of the one who told people what is good and what is bad
 - The reason people act in a mean way
 - The reason people quarrel
 - The reason people steal
 - The reason people tell lies
 - The reason people kill one another
 - Consequences for being bad
 - Consequences for being good

- **Life after death**
 - Sickness and death
 - The reason people get sick
 - The reason people die
 - Whether death can be averted
 - The process by which a person can avoid death
 - Dying
 - The process a person goes through when he dies
 - The place people go when they die
 - The place of the dead
 - Whether there is more than one place of the dead
 - Characteristics of the place of the dead

- o Whether the place of the dead is a good place or a bad place
- o Whether there is a place of punishment
- o Characteristics of the place of punishment
- o Whether there is a Heaven
- o Whether Heaven is a real place or a spiritual place
- o Characteristics of the pleasures in Heaven
- o The identity of the one who made Heaven
- The basis of where a person goes when he dies
 - o The identity of the one who decides whether a person goes to Heaven or to the place of punishment
 - o The basis for deciding whether a person goes to Heaven or to the place of punishment
- The state of the dead
 - o The identity of the one who controls the dead
 - o Activities that those who have died can still do
 - o Whether the dead can hear
 - o Whether the dead can speak
 - o Whether the dead can see
 - o Whether the dead can walk
 - o Whether the dead get hungry
 - o Whether the dead get cold
 - o Whether the dead get tired
 - o Whether the dead get lonely
 - o Whether the dead get angry
 - o Whether the dead get frightened
- Resurrection
 - o Whether those who have died can come back to life again
 - o When those who have died come back to life
 - o Whether people who are still alive will be able to see those who have died when they come back to life
- Contact between the living and the dead
 - o Whether those who have died can make contact with people who are still alive
 - o Whether people who are still alive can make contact with those who have died
 - o The responsibility of people who are still alive to those who have died
- Their attitude towards death
 - o Whether they are afraid to die
 - o The reasons they are afraid to die
 - o The reasons they are not afraid to die

- The authority for their understanding of death
 - o The basis for believing the things they say about the dead.
 - o Whether they have known someone who has died and then come back to life who could explain what death is like

The purposes for discussing these topics

As you discuss these pre-evangelism topics, keep your purposes firmly in mind. You are raising these topics:

- To gain information which will assist you as you prepare lessons for evangelism.

- To stir up your hearers' minds and imaginations to think about God as revealed in creation and about other spiritual subjects.

- To endeavor to show the people how little they actually know about God and the unseen spiritual world.

- To show the people the confusion which exists in the world regarding spiritual matters.

- To help the people realize the absolute necessity of a divine revelation if they are ever to know the truth about spiritual matters which cannot be known by natural observation.

Dos and don'ts for discussions

During pre-evangelism, **do not** correct the people, irrespective of what they say. If you do, they may withdraw, or they may respond by saying what they think you want them to say.

As they answer your questions during pre-evangelism, add further questions, such as, "How do you know that what you are saying is really the truth?" If they answer, "Someone said it was true," ask them, "How did that person know? How can you be sure you have been told the truth?" The purpose of these discussions is to endeavor to shake their confidence in what they have always considered to be the only source of wisdom regarding spiritual matters.

When you are discussing these topics in a group, try to get as many people as possible to participate. Do not be concerned, however, if they do not wish to contribute to the discussion. While it is good to do everything possible to encourage them to participate in these discussions, it is unwise to pressure them to the point where they will be embarrassed or annoyed. Sometimes missionaries bring unnecessary pressure on people who, although listening, do not yet wish to expose their thoughts.

Agree with any of their comments which are correct and based on their natural observation of creation. Creation is God's voice to the world (Psalm 19:1-6). According to Romans 1:20, material creation teaches two basic points of doctrine: (1) God is truly God, for He is the Creator of all things, and (2) God is almighty. Therefore, agree with the people on whatever truth they have learned about God from nature because all people should observe these things quite apart from the Bible. During pre-evangelism, however, do not back up these truths with Scripture. Wait until you have introduced the Bible and are teaching creation from Genesis 1.

I suggest that it is better if you do not quote or show the Bible at all during pre-evangelism. Although some missionaries validate their presence in the tribe by stating that they have come to teach the people from God's Book, I believe it best not to show the Bible. Showing them a Bible without teaching what the Bible is may result in the book itself being very mysterious. The Bible could become like a fetish. If you show it, you should teach what it is. To explain what the Bible is means teaching about God and how He gave the Scriptures. I believe it is best if the missionary never shows the Bible or talks about it until he introduces it as his authority in Lesson 1 of Phase 1. All of the discussions in pre-evangelism are preparation for the introduction of the Scriptures.

If the people ask you questions relating to spiritual matters which cannot be known by simply observing nature, it is better not to answer during pre-evangelism. Should they, for example, ask where God is, it is best to say that this question will be answered at a later date, or turn the question back to them again by asking them what they think. Another way to deal with questions like this is to ask another question, such as "Why do you ask me where God is? I am a man just like you. Can you see God?"

Later, when teaching the Scriptures, it is profitable to remind them of the question they asked and the answer which you gave. You will then be able to explain, "I did not answer your question because no one can know where God is unless He tells us. He has told us here in His Word that He is everywhere."

Avoid quick, unauthoritative answers

Prior to and throughout all stages of your teaching, encourage a spirit of inquiry, expectancy, and excitement. At the same time, beware of prematurely satisfying their desire to learn by giving little pieces of biblical information before you actually begin teaching the Word of God.

Quick answers and fragments of scriptural truths, without the proper Bible background, may give your hearers the false idea that they now know what Christianity and the Bible teach. They will probably not understand, but they will think they do. They may verbally accept Christianity without a true heart understanding, or they may become apathetic. Worse still, they may outrightly reject the Bible and refuse to be taught any more, thinking that they already know what the Bible teaches. A little information at the wrong time can cause immovable barriers. Quick "fixes" can immunize people against accepting the truth.

Furthermore, it is unwise to give doctrinal information from the Bible before we have introduced the Bible as our sole authority and basis for our teaching. If we do, then we may appear to be projecting ourselves as the authority and source of spiritual truth. The people may conclude that we are claiming to be the masters of truth, just as teachers of other religions, witchdoctors, and all other spiritual charlatans claim. The people may then be forced to choose sides between following their former teachers and following us. Their decision at this point will not be whether or not they will believe the Bible, but whether they will believe and follow us, accept some other religious teacher with whom they may have contact, or cling to their old culture and religion.

It is better if we order our ministry so the people will realize that we are not asking them to believe or follow us. So before you give any answers to spiritual questions, you will first need to

introduce the Bible as the source and authority for all of your teaching and be ready, at that time, to begin teaching the Scriptures. When the tribal people do finally make a choice, it should be based on a genuine understanding of the Word of God and its authority as God's voice in the world. So during pre-evangelism, do not claim to be the authority. Rather, merely raise topics that cause them to think about their beliefs.

If you are persuaded you should let them know that you do have the answers, then tell your listeners that, when you are proficient in the knowledge and use of their language, you will tell them the correct answers. Explain to them that the answers you will give are not your own but have been taught to you by someone who knows the answers to everything. This should suffice until you begin evangelism.

People who have had some Bible teaching from other sources may have scriptural comments when discussing pre-evangelism topics. Should they do this, ask them, "How do you know what you are saying is true?" If they answer that a certain missionary said it or a particular mission or denomination teaches it, ask them, "How can you know what the missionary or mission is teaching is really the truth?"

Remember, we are raising these discussion topics in order to help them realize the absolute necessity of a divine revelation. If they believe Christian doctrines because some missionary said it (even if that missionary happens to be you), it is not biblical faith. They must know and depend on the Word of God alone.

You may illustrate the necessity for an authoritative revelation by talking about a town or city which most of the people have never seen, but which some of the people have visited. I used Manila as an illustration.

I asked, "What is Manila like?"

One man answered, "Well, I don't know. I've never been there."

"But what do you think it is like?" I asked.

I got them talking about what they thought the city of Manila might be like, and then I asked, "But how can we really know what Manila is like?"

Since one or two of the local tribal people had been to Manila, I said to the others, "Don't you think the best way to know what Manila is really like would be to ask those who have been there? They have seen it. You can try to imagine what Manila is like, but wouldn't it be better to ask those who have actually seen it? They can tell you the truth."

Apply this by asking them, "Were your forefathers or any of you alive when the sun, moon, stars, and earth first appeared? Did the Muslims, the Catholics, or anyone who is now living see all things when they began? Is there someone here who has died and come back to life who can tell us the truth about death and what happens after death?"

Through this type of illustration and questioning, try to show your hearers the great necessity for an authoritative revelation from someone who was there and saw what happened, someone who really knows. We need to get underneath their superficial answers and cause them to wonder, question, and doubt their present beliefs. I found that the people began to question themselves, "Yes, how can we be really sure? This is what we've been told and always believed, but how can we really know?"

Man's futile reasonings

Endeavor also to get the people to consider just how untrustworthy man's natural ideas and unfounded imaginations are regarding the form, nature, and character of God. In Psalm 50:21, God says to the wicked, *"You thought that I was altogether like you."* Apart from a divine revelation, man will always create gods which think and act like man.

Illustrate the impossibility of knowing God by natural intuition or perception by asking them questions about one of your family of whom they have no previous knowledge through photographs or verbal description. Choose a close relative, such as your father, mother, brother, or sister, who is quite unlike you in build and coloring. If you choose a close relative, the tribal people will be more likely to presume that the person about whom you are questioning them looks like you do.

I used the illustration of my mother. I chose Mum because she was short in comparison to me.

I asked them, "What do you think my mother is like? Is she tall or short?"

"Oh, she's tall."

"Is she dark or fair?"

"Ah, she is probably fair like you."

I went through a series of questions like these. I then said, "You are trying to determine what my mother is like by looking at me, aren't you? But you can't be sure that you are right. You are only reasoning according to what you see. How can you know what my mother really looks like? There is only one way. I can tell you. I've seen her. I know her." And I told them what she looked like and showed them a photograph.

Conflicting views

As you have discussions with the people about their beliefs, if they have conflicting ideas, bring this to their attention. Remind them of these contradictions just prior to beginning evangelism. Don't make them feel that they are being ridiculed, but point out the inconsistencies in their thinking in order to alert them to their need of a definite revelation from God.

Keep an account of any particular topics which they find baffling and for which they seem to be seeking answers. This list of topics will be particularly helpful in arousing and holding the interest of the people when you begin evangelism.

Use every opportunity

Utilize every possible opportunity to discuss the suggested subjects with the people. Even short contacts need not be wasted. We need to be constantly alert for ways of stirring up people's minds to consider spiritual subjects in preparation for evangelism.

For example, you may be giving a tribal person a drink, or you may be with a group when they are getting their water supply. Initiate discussions about who the giver of rain is, or what

would happen if there was no water. If they acknowledge that God is the giver of water, agree with them. But if they do not know who the giver of rain is, then leave the issue unanswered. You will teach the answer later through the creation story. On the other hand, they may give some spirit the credit for rain. In that case, ask them how they know that they are correct in their belief.

Use everyday, ordinary opportunities. For example, you and the people may be eating fruit which has seeds. Taking a seed in your fingers, ask someone, "What type of tree will grow if I plant this seed? Is it possible for a totally different kind of tree to grow from this seed?" No doubt, they will assure you that it is an impossibility. A conversation such as this about seeds lays the groundwork for what they will be taught in Genesis 1:12 regarding each seed reproducing only after its own kind.

Medical work and first aid can provide opportunities to question them about the wonders of the human body and its maker. One of the basic truths of Scripture is that *"the life of the flesh is in the blood"* (Leviticus 17:11). After giving first aid to someone who has cut himself, ask questions about blood, such as "Why is it important to prevent excessive bleeding?" Without any reference to Scripture during this time of pre-evangelism, explain that the life of the body is in the blood. The birth of a child provides a natural opportunity to ask questions about who created and gives life to every person.

We had a constant flow of visitors to our home in Palawan. Some stopped in on their way to or from their gardens. Others came to trade or ask for medical assistance. We also visited the people in their homes. There were always opportunities to prepare the way for the teaching we planned to give.

Use natural events

Tribal people are very aware of nature because their lives are so closely related to it. The testimony of God through creation is usually evident to tribal people even before we come to live with them. During this time of pre-evangelism, it is important then that we make proper use of God's voice through creation to stir the people's minds and consciences in preparation for the teaching of the Scriptures.

One beautiful night, up in the mountains of Palawan, overlooking the moonlit Sulu Sea, I had an excellent opportunity to direct the attention of my tribal hosts to the power and wisdom of God evident in creation. I had spent a number of days with the Palawanos while building a house. The Scriptures had never been taught in that area, and we planned to move there so we could begin teaching the people. The native house in which I was staying didn't have any walls, so the panorama of the star-studded sky was clearly visible. How beautiful it was, and what an opportunity to ask the tribal people questions.

"How far are the stars away from us? How big are they? How many are there? Where did they come from?" We also talked about the moon and how it reflects the light of the sun. In an informal way, I was preparing them for the teaching of Genesis 1.

I recommend that this type of casual, unstructured teaching which we begin in pre-evangelism be continued in evangelism and maintained when teaching the Church. Pre-evangelism activities should pave the way for future evangelistic meetings, and the form used in

the evangelistic gatherings should be the basis for the way in which church meetings will be conducted.

Jesus used every opportunity

The Lord Jesus taught people at every opportunity. It didn't matter who they were, where they were, or what time of the day it was. He taught Pharisees and Sadducees in the temple or the synagogues, Nicodemus during the night, the rich in their luxurious homes, a sinful Samaritan woman at midday by the side of a well where she had come to draw water, and the crowds by the lakeside while He sat in a boat. The Lord taught His disciples on the mountainside, in a boat while crossing the lake, in an upper room, walking through the streets of Jerusalem, and in the garden when His enemies were about to arrest Him. The Lord Jesus even spoke words of truth to Pilate whose prisoner He was, and He counseled the women who wept for Him as He made His way to Calvary.

The Lord Jesus asked questions, answered questions, rebuked, encouraged, and offered salvation. He spoke words of forgiveness to the repentant and prophesied coming judgment on all who, like Jerusalem, refused His words of wisdom and truth. He never missed an opportunity to speak as God's messenger to the world and to God's people.

"For the Son of Man has come to seek and to save that which was lost" (Luke 19:10). *"I am the good shepherd. The good shepherd gives His life for the sheep"* (John 10:11). Jesus, the Good Shepherd, commissioned all who serve Him by preaching His Word, *"As the Father has sent Me, I also send you"* (John 20:21). The work of a shepherd requires a 24-hour vigil to care for and protect the flock. The missionary's role as a shepherd begins while the sheep are yet "lost," for it is through the missionary that the Chief Shepherd seeks out and draws the lost sheep to Himself.

The Apostle Paul used every opportunity

The Apostle Paul also exemplifies the diligence and unceasing protective care which the missionary must have for all who are under his ministry. He reminded the Ephesian church elders, *"You know, from the first day that I came to Asia, in what manner I always lived among you"* (Acts 20:18). *"Remember that for three years I did not cease to warn everyone night and day with tears"* (Acts 20:31). When writing to the Thessalonian believers, Paul likened himself and his companions to a gentle mother caring for her children (1 Thessalonians 2:7).

We, too, need to be constantly alert for ways of stirring up people's minds to consider spiritual subjects. Natural events will provide openings for us to initiate discussions relating to God and spiritual matters.

Satan has used every opportunity

In many unevangelized societies, Satan, with his varied deceptions, has had a head start of thousands of years over the message of the Gospel. The world is asleep in the lap of Satan, and he will do all he can to keep it there (1 John 5:19). Satan does all in his power to keep his captives satisfied and totally committed to the particular system of lies to which he has

cunningly bound them. He does not want people to think or consider biblical alternatives. If people begin to reason logically and consider their need for answers different from those which they have already accepted, there is a good possibility that the truth, when heard, will take root, grow, and finally replace the ignorance and lies through which Satan formerly controlled their lives.

Because Satan has been present in every culture long before the messengers of the Cross and because he works relentlessly to hold and bring everlasting destruction on his prisoners, it is imperative that every missionary be dedicated to his task 24 hours a day. Otherwise, valuable opportunities to undermine Satan's kingdom and prepare people for God's Word will be continually lost.

Challenge the lies of Satan

What a formidable enemy Satan is! Is it possible for his power to be broken over the people to whom God has sent you? Yes, but only through the power of God! Nevertheless, God has chosen to do this work through His dedicated servants. In total dependence on the Lord give yourself wholeheartedly to be used as an intercessor on behalf of those to who you have been sent. Call constantly on the Lord to demonstrate His grace and power in and through you on their behalf. Seize and utilize every opportunity to bring into question the lies of Satan that have blinded their hearts and minds to the truth (2 Corinthians 4:1-7; 10:3-5).

Use the time during pre-evangelism, before you begin teaching the Scriptures, to wage a definite campaign against Satan and his whole deceitful system. I suggest that you do this astutely in the beginning and only more openly when well into evangelism. It is unwise to openly attack people's religious beliefs before they have been given an alternative through understanding biblical Christianity. Nevertheless, during your contacts with the people while in pre-evangelism, carefully build their understanding, interest, and desire to know and to learn. By doing this, your daily visiting times will easily lead into the more formal teaching sessions of evangelism.

Begin pre-evangelism sessions

Throughout pre-evangelism, especially after you have gained language and culture fluency, you should use everyday casual visits with the people to prepare them to hear the message that you have come to tell them. In addition, two or three months before you plan to begin evangelism, I suggest that you start to have regular pre-evangelism meeting times with the people.

When you know that you will soon be ready to begin evangelism, start to extend your daily, casual visiting times in their homes into longer and more definite pre-evangelism meeting times. In the beginning, do this on a weekly basis and then more often as you draw nearer to the commencement of evangelism.

Purpose of pre-evangelism sessions

Pre-evangelism sessions, if conducted correctly, can be a wonderful precursor to evangelism.

Many people groups are totally unaccustomed to meeting as a combined group or sitting quietly and concentrating on information being given by one person. Pre-evangelism sessions give the people the time to adjust to being taught in a group setting.

Children, especially those who may never have gone to school, find this particularly difficult and their antics can be very distracting and trying to all the adults. You will need lots of tact and patience to deal wisely with young and old to prepare them to listen well and to digest what they will hear in Phase 1. I found it helpful to speak directly to the children explaining to them why they should listen carefully to God's message. In addition, I made the adults responsible to help keep the children under control.

Without the learning period of these earlier sessions, distractions during Phase 1 lessons, particularly in the early stages, can totally disrupt the teaching program. It helps if the people are already aware how they should act in a public meeting situation.

A further reason for these pre-evangelism sessions is that they help alleviate the possibility of your hearers going through information overload at the beginning of Phase 1. This problem can be largely forestalled by using these earlier sessions to teach the people the geographical and cultural setting of the Bible stories.

Furthermore, and most importantly, these pre-evangelism sessions can be utilized to cement what you initiated in your visitation times. Added emphasis can be placed on the importance and the absolute necessity of having a trustworthy and all-sufficient answer to the many unknowables that you have discussed with the people over the preceding months.

Reach everyone

Initiate your discussions with the group in such a way that you are preparing all ages to listen to the message of the Bible. Aim questions and statements at all different age groups. Explain everything on a level which includes all the children whom you consider old enough to understand the Gospel. Direct some of your questions to the children. If the missionary includes everyone from the beginning, all ages will gradually become accustomed to taking part by answering and asking questions.

Cultural restrictions may limit who will become actively involved in public discussions. In some societies, it is not customary or allowable for the women to take part in such discussions, or it may be unacceptable for the children to speak. If this is the case, take steps to involve these people at a different time when it is culturally permissible for them to participate. Lady missionaries and missionaries' children may need to spend time separately with the tribal women and the young, initiating discussions and encouraging the women and children to participate.

Time of day for pre-evangelism sessions

While casual visits may be made any time of the day when there is some form of activity in or around the people's homes, most cultures have a daily time or times when visiting is acceptable and often expected. This culturally acceptable time for visiting will probably be the most suitable time for pre-evangelistic sessions and for future evangelistic meetings.

The time most suitable for them may not be the most convenient time for you or your family. It is vital that you adapt to the tribal schedule so that the people will be able to meet. To schedule sessions when the people usually eat, rest, work, or go fishing is unwise. It would also be unwise to schedule meetings during the time of day when it usually rains.

A missionary in Papua New Guinea found that the most suitable time in the tribal people's daily routine was early in the morning. During this time, just after they had awakened, the people sat around their smoky fires to talk and eat before going to work in their gardens.

The Palawanos with whom we worked usually went to work in their rice fields or gardens quite early in the morning, before the heat of the day. At about 10 o'clock, they would begin to return home, carrying rice, vegetables, and fruit gathered from their fields, gardens, or the jungle. On their way home, they would collect their bamboo water containers which they had left at the streams on their way to the fields in the morning. Others would carry limbs of trees for firewood. They would arrive home with everything they needed for their first meal of the day. Following their meal, they would sit or lie around the floor, talking or sleeping. By about 1 p.m., most would have eaten and rested, but it would still be too hot to return to work in the fields. Later in the day, during the monsoon seasons when it rained in the afternoons, the people would go fishing for their evening meal. They would net the fish which were swept helplessly down the raging streams caused by the flash floods which generally reached our part of the river from 3 to 5 p.m. All things considered, the most suitable time for the people to gather together for meetings was about 1 p.m.

Location of pre-evangelism sessions

After having responded to the Lord's call "Go ye" and after having arrived on the mission field, some missionaries take the attitude, "Well, here I am. I have obeyed the Lord's command, and I have arrived. Now it is the responsibility of the people to come to me to hear what I came to tell them." This attitude is wrong. The command to "Go" is still relevant, even after the missionary has arrived in a foreign country.

While there may be situations when it is preferable for the people to gather at the home of the missionary or in a specially-erected building, it is usually better to conduct pre-evangelism sessions in the people's homes or wherever the villagers most naturally and commonly gather. It may be under a large shady tree in the center of the village or at the town plaza during the hottest time of the day. It may be in the home of the chief or some other influential village leader after the day's work has been done. The locale may change according to the seasons and the work being done by the people. During harvest time, it could be at the edge of their fields where they gather to rest and eat during the hottest time of the day. Scattered communities will often congregate in weekly market places.

Broaden the people's understanding

Most tribal people are locked into their own small geographical and cultural world with no one to help them see the real outside world. Therefore, utilize the whole of the pre-evangelism period, and especially the pre-evangelism sessions, to expand the people's minds and imaginations. Begin during pre-evangelism to prepare them to understand the stories of the

ancient, historical Bible world and to come to terms with the complex, modern world which threatens to engulf them and their culture.

Use pictures as educational tools

Well-chosen, clear pictures are of great assistance in this important and necessary preliminary work of expanding their perception to assimilate the multiple cultural differences depicted in the stories of the Bible. The appropriate picture introduced at the right time during the pre-evangelism sessions will also be of great assistance as you ask questions and channel conversations into a particular topic you wish to discuss as you prepare them for the teaching of the Word and as you challenge them to think about their religious presuppositions.

Magazines, such as National Geographic, are an excellent source for pictures. Picture books of your own country and other countries are also very useful. Large-sized posters and pictures are often obtainable through travel agents or from some embassies. Colored pictures are best. Cut-out pictures from magazines should be clear, simple, and uncomplicated. Cut away complicating details, for example, a tree behind an animal which appears to be growing out of its back. We found it best to sort the pictures according to their subjects and paste them into scrapbooks or, if too large, onto cardboard or cloth. It is preferable to have smaller books covering the same subject rather than one large scrapbook, because it is then possible to hand smaller books to different people in the group so they won't need to crowd around one book. If there is only one, they may lose interest because others are taking too long to look at it, or they may snatch the book away because they consider it their turn to see it.

The collecting, cutting out, and pasting of the pictures into scrapbooks is a project which you may ask Sunday schools and youth groups to do as a way of sharing with you in your missionary work. If you pass this responsibility on to others, be sure to explain the type of pictures you need and how they are to be sorted; otherwise, the books prepared for you may be of little use.

Gather pictures of nature for scrapbooks. Topics should include the stars, moon, sun, lightning, rainbows, majestic mountains, great rivers, trees, flowers, animals, birds, and fish. Use these pictures as you channel the conversation into the particular topic you wish to discuss as preparation for the time when you will teach the doctrinal truths revealed through the acts of God in creation.

Pictures of the wonders of nature (such as, Niagara Falls, the Grand Canyon, snow and ice, the ocean) are useful if you want to direct their attention to the glory and power of the Creator. Guiding them to think through how the wonders of nature came into existence helps prepare the way for the future teaching about the omnipotence and omniscience of God as revealed in Genesis 1. For example, after showing them a picture of one of the wonders of creation, ask, "When do you think that this great and wonderful part of the world came into existence? Did someone create it?" If they answer you, then ask, "How do you know that your answer is true?" Leave the answer until you have introduced the Scriptures and can teach authoritatively about creation. Do not give them only your word to believe. During pre-evangelism, only speak of God and His omnipotence if the people, of their own accord, have already acknowledged Him as the almighty Creator. If they have not, wait until you have introduced the Bible as your authority and source of your knowledge of God and His attributes.

Pictures of great buildings and modern inventions, such as cars, airplanes, ships, submarines, and rockets, can acquaint the people with the modern and complex world in which they live.

The world religions are another good topic for scrapbooks. During pre-evangelism sessions, show pictures of religious buildings and objects of worship held sacred by the Hindus, Buddhists, and Muslims. Use the pictures to initiate discussions about the beliefs that other people have concerning God and other spiritual matters. Include the beliefs of other tribes near and far, as well as the beliefs of Muslims, Hindus, and Buddhists. Tell them that people all over the world believe there is a God because of the created things which they see about them, but they have many conflicting views concerning Him. Show appropriate pictures as you explain about idol worship, about animals that are worshiped as God, about different types of sacrifices, and about the various ways that people have of appeasing and worshiping God and the spirits. Make clear that these are some of man's ideas and imaginations about God and spiritual beings which they are unable to see.

Collage Pictures

In preparation for teaching on creation, we made up separate collages for the different things in creation, such as plants, birds, insects, fish, and animals. As the base for the collages, we used long sections of craft paper which we joined together. The collages varied in length from 6 to 15 feet. We cut pictures out of *National Geographic* magazine, *Big Backyard* magazines and other magazines which had vivid pictures. We glued the pictures onto the craft paper.

We showed the collages, discussed them with the people, and left them pinned up where everyone could see them for a few days.

In discussing the collage pictures, we would explain, for example, "You yourselves know the many names of birds. And in this area there are many types. But in our place, there are many more types of birds that don't live here. And in other places of the world, there are types of birds that don't live in our place. There are many, many kinds of birds. Some of them are black or white or red or yellow or green. Some of them stay on the ground. Some of them make their nests in trees or in huge cliffs. Some of the birds in our place make their houses on the beach in the sand. There are many, many types of birds."

Even though we could only show a limited amount of each species in each collage, the people were amazed at the variety.

– Paul and Linda McIlwain, NTM missionaries to the Ata Tribe, Papua New Guinea

For example, I said to the Palawano people at this stage, "You see your cow over there. Do you think that cow could be God?" They really thought that was a ridiculous suggestion. I continued, "Well, some people honor the cow as being God."

They said, "Oh, no. Nobody could believe that."

I replied, "Yes, they do, and many of them are educated people."

I then showed them some pictures of the magnificent buildings in India and asked, "Could you erect buildings like these?"

They answered, "No."

With a smile, I said, "Well, maybe the people in India who claim that the cow is God are right after all. They are able to build magnificent buildings. Maybe they are right about the cow. Do you think that you had better treat your cow better in the future?" I soon assured them that I did not believe that the cow was God, but I did not tell them at this stage what I did believe about God.

I then talked with them about the contrasts between the beliefs of the Hindus, the Muslims, and the Catholics concerning God, using pictures of temples and mosques to hold their attention and illustrate what I was speaking about.

After this, I asked the people, "How can we know the truth? Is the cow God? Are the Roman Catholics right? Are the Hindus right in their beliefs, or are the Muslims correct? Were your forefathers right? How can we know the truth concerning God? What happens after we die? Maybe you can tell us, Grandfather. Have you died and come back again?"

"No, I've never died and come back," the old man sitting close to me answered.

"Neither have I," I said as I continued to challenge their thinking about how to know truth.

Use pictures of modern Israel

Show them pictures of modern Israel, such as Jerusalem, Bethlehem, Nazareth, the Sea of Galilee, and the Jordan River. Show these pictures simply as places of interest. Do not refer to Israel's connection with the Bible at this stage because you have not yet introduced the Bible.

The tribal people may have heard the name of Israel mentioned on radio. Some of the Palawanos had listened to English news programs even though they could understand very little English, and they had heard the name of Israel and other countries mentioned. They were very interested to learn something about these countries.

As you show them pictures of modern Israel, point out the contrast between the largeness of Jerusalem and the small tribal villages, the mud-brick houses in Israel and the bamboo and timber tribal houses, the dry barren terrain of Israel and the fertile jungle areas where most tribal people live, the robes worn in Israel and the very different attire worn by the tribal people. Similarities between the tribal culture and those of Israel are useful points of interest. The Palawanos seemed to be more fascinated by similarities than they were with those things which were in contrast to their own culture. The people do not need to know at this stage why you are putting particular emphasis on the culture of Israel.

Use pictures of ancient Israel

In addition, after you have talked about modern Israel, begin to talk about ancient Israel. Show pictures of ancient Israel, including stone houses, walled cities, wells, different types of clothing, robes, and veils, earthenware household utensils, writing materials such as scrolls and seals for documents, animals such as sheep, donkeys, camels, and horses, chariots and the armor and weapons of Roman soldiers. Because you have already introduced modern Israel, you can use this as a basis for explaining to the people how the Israelites did things in ancient times. Apply the teaching principle of moving from the known to the unknown in every stage of your teaching. If you educate the people regarding unknown areas of biblical culture during

pre-evangelism, it will save time and be far less confusing during evangelism when you tell them the stories of the Bible.

Introduce biblical culture foreign to the people's way of life by pointing out contrasts or similarities between the local methods of doing things and those of Bible times. The Palawanos carry drinking water to their homes in sections of bamboo. When someone was passing our house on the way to get water, it was a good opportunity for me to say to them, "Using bamboo as a water container is a good idea because bamboo is plentiful here in Palawan. It is easy to make into a water container and is very clean. But in other countries, they do not use bamboo to carry and store their drinking water. When I was a boy and lived out in the country, we had large galvanized tanks in which rainwater was collected." At this point, I would show a picture of a large tank alongside a country house in Australia. Continuing on, I might say, "Many years ago, and today in some remote areas of the land of Israel, (point out Israel on the world map), they collect water in wells which they have dug in the ground. They carry the water from the wells to their houses in large earthenware jars which they have made from clay, hardened in ovens. They are like the ones in this picture." While showing Palawanos a picture of water jars, I would also explain how water jars are made.

Other aspects of Bible culture can be introduced in the same way. For instance, you can introduce the spears, shields, and armor used in Bible times by first making reference to the local weapons.

When introducing the culture of Bible lands during pre-evangelism, do not show Bible story pictures. Wait to show them as something new and interesting during evangelism. If the people are shown Bible story pictures during pre-evangelism, the pictures may become so well-known and commonplace that they will no longer be useful evangelism teaching aids.

Show pictures of lands surrounding Israel

Show pictures of countries which are part of the Bible story, such as the Red Sea, the Sinai desert, and the lands and culture of Egypt, Syria, Lebanon, Iraq, Turkey, Greece, and Italy.

There are many Muslim people living close to the Palawanos so it was easy for me to direct the Palawanos' attention to Muslim countries by asking, "Do you know where the Muslim religion began?" This opened the way to begin showing pictures of Muslim countries and the people who live there.

Display pictures

Do not display all your picture scrapbooks at the same time. After you have used a scrapbook to target the subject you want the people to think about, place it where the people can look at it and hopefully be reminded of the subject which you emphasized through the pictures. Release a new book before the interest in the first one begins to wane. I suggest you take the new book to the pre-evangelism sessions and also to the tribal homes. Choose a book which covers the particular subject you plan to discuss on that occasion.

In the same way, after you have used a poster to draw their attention to some subject, put it on the wall where the people can see it. Don't put all your posters up at the same time. Display only a few at a time, and do it in keeping with the particular subject which you want to discuss

with them. Change the posters often so they do not become so familiar that the people begin to ignore them.

Besides helping to prepare the people for evangelism, pictures will assist you as you elicit new vocabulary for your immediate use as well as words necessary for your future teaching of the Scriptures.

Literacy Program Helps to Accomplish Pre-evangelism Goals

Materials which have been gathered and prepared for literacy programs can be helpful during pre-evangelism. Pictures gathered for literacy can play a dual role, in beginning to expand the worldview of the people to include new concepts and ideas and in developing their understanding of the wider world and the scope of history.

Post-literacy Scripture-related reading materials, such as, "Animals of the Bible," "Plants of the Bible," "How the Jews Lived," and other such reading material in the language provides an excellent complementary element to the Bible teaching, encouraging a wider background and a deeper understanding of the context of Scripture.

The literacy program itself, in opening the world of reading and writing to previously illiterate peoples, is a huge step in expanding their worldview, greatly increasing their capacity to understand and assimilate new concepts. The written word itself becomes another whole realm of communication of spiritual truth from God to them.

– Linda McIlwain, NTM Literacy Consultant Coordinator

Use maps as educational tools

Reading maps will be a new skill for most tribal people. It is helpful to teach them how to read maps during pre-evangelism sessions. This will assist them to comprehend the shape and size of the world and prepare them for when you use maps in telling the story of the Bible.

Printed maps last much longer if they are pasted onto thin cloth and covered with plastic as further protection. If you are drawing your own maps, do so with indelible ink on cloth. It is important that maps are large enough so that even those toward the back of the group can clearly see the details. The advantage of drawing your own maps is that they will be much clearer without all the details normally included in printed maps but quite unnecessary for our purposes.

Introduce maps in the following way:

1. Draw a simple picture of the tribal village or the most important part of the village on a chalk board or on paper. If possible, draw the picture detail by detail as the people watch.

 - Begin by drawing the house where they are gathered at the time. State clearly that the house you are drawing is the one in which they are meeting. You may want to introduce a little humor by drawing a stick figure of the owner. (A decision will need to be made whether stick figures or some other form of art will be used by the missionary. It is good to keep to one art form so that, even if the people are unable to read the picture in the beginning, they will eventually learn.)

- After drawing the first house, ask, "Whose house is the nearest to the one we have already drawn?" Add it to the drawing.

- Continue to draw houses, rivers, mountains, and any other distinct landmarks, moving in a widening circle until the local area has all been included.

- Keep the people involved fully by asking for help point by point. To make it more interesting, you may invite some of the people to actually help do the drawing.

- Leave the picture map in a place where the people can still view it.

2. Draw another map of the village, but use symbols instead of pictures.

- Draw a map of the same area as covered with the picture map. Use a new piece of paper or the chalk board. Use a symbol, such as a square, to mark the first house which was drawn in the picture. Place the symbol in the same position where it was placed on the picture map.

- Use a house symbol to mark each house.

- Continue adding all other details in the same order as used in the picture.

- For all future maps, use the same symbols as you used on this symbol map of the village.

3. After the village map is completed, show them a map of their district, state, or province.

- A printed map may be used, or you may draw this map.

- Point out their village and any other geographical data which will be of interest to them.

4. Show them a map of their country.

- Highlight their district on this map.

- If they know the name of their capital city or any other town, river, mountain, etc., be sure to point to these on this map.

5. Show them a map of the world.

- Highlight their country and district on the world map.

- They will also be interested if the missionary points out his homeland.

6. Draw a simple, undetailed map of Bible lands.

- Include on the map of Bible lands all the countries that will be covered by the complete story of the Bible. This would include Egypt in the south to the Black Sea in the north, and from Babylon in the east to Spain in the west.

- Since this map will be used as the main teaching map, make sure it has a clear outline.

- Mark only the main towns and details necessary to tell the story of the Bible. (Although all the lands covered by Paul in his missionary journeys are to be included on this map, avoid unnecessary details by omitting the names of the cities he visited. You should add these when they are needed in Phase 3.)

- Write both the modern and biblical name on the countries included in the map. It is important that the people realize that the Bible countries are real countries which remain until today.

7. Highlight on the world map the area covered by the map of Bible lands. Do this by coloring the section.

You should use these same maps that you introduce during pre-evangelism later when you teach the story of the Bible. The people will already be familiar with them. Eventually, these will be the same maps that the tribal believers will use when they have evangelistic outreach.

9

Guidelines for Evangelism

Six months before Fran and I were married, Fran's father kindly offered to build a house for us. The portion of land chosen for the planned house needed a great deal of preparation. Fran's father and I worked hard to remove the large eucalyptus trees growing on the land. When this was completed, a bulldozer was brought in to excavate the site and prepare for the foundations. Finally, we began to dig the trenches and prepare the levels for the concrete footings which would support the foundations. Because I was ignorant concerning the necessary depth and width for the trenches and because I was impatient and excited about our approaching marriage, the work of preparing the ground to begin the foundations seemed to be endless. I wanted construction to begin quickly. I couldn't wait to see the house completed. Were it not for the stringent requirements and checks by the city building inspectors, I would have had the construction begun before everything was properly prepared.

As you approach the time when you will begin evangelism by teaching Phase 1, Genesis to the ascension for unbelievers, you will need to ask yourself if you have completed all that is necessary for preparation to begin teaching the Scriptures. It is easy to be pressured into teaching before you or the people are ready to begin. What then are the indications that it is time to begin evangelism?

Language

Before beginning to teach the Word of God, you must first be able to understand, converse fluently, and reason clearly in the tribal language.

In the first part of this book, we discussed how vitally important it is for us to preach a pure Gospel in order to avoid confusion in the minds of our hearers concerning faith and works. Even if our understanding and presentation of the Gospel is flawless, however, our hearers are still likely to misunderstand the message of the Bible if we begin teaching before we are competent in their language. These two – an unscriptural presentation of the Gospel and insufficient fluency in the receptor language – are the greatest contributing factors to the confusion among so many indigenous people regarding the Christian message of salvation.

Several things may pressure you to begin teaching before you are sufficiently experienced in the language. For one, you may feel constrained to begin teaching because of the great need of the people about you to hear the message of salvation. I well remember the burden and frustrations I felt when studying language in Palawan. At times, I broke down in tears and cried out to the Lord to hasten the day when I would be able to teach His Word to the people all around me who so desperately needed to be taught the truth.

Added to this may be the tribal people's insistence that you tell them the real purpose for your coming to live with them. The people recognize that you have come to live among them in conditions very difficult for you and so unlike your homeland. They want to know why you have chosen to come to live among them.

A further pressure is the fear of what Christians at home will think if you do not soon do what they have sent you to do. They are supporting you in prayer and finances, and they want to see that you are preaching the Gospel.

Nevertheless, despite these pressures, beware of rushing into teaching before you can communicate precisely the message of the Scriptures.

Language Ability

Clear teaching of the lessons demands a high level of language ability. It is not merely a matter of being able to prepare a written draft of the lesson and stand up and present it to the people. A teacher must also be able to constantly transition from presenting the narrative to explaining and applying the truth in an expository way. Because all languages do this in different ways, the teacher must be able to understand and use the natural discourse features of the language in order to avoid confusing the message.

A high degree of language ability is also needed for the teacher to comprehend, answer, and discuss questions that the people may have and to be able to discern the true level of comprehension and possible areas of misunderstanding. Opportunities to discuss the lesson and give further explanation are often available outside the formal lesson teaching time, and can be vital for some individuals to understand the truth. In order to take full advantage of these opportunities, a teacher must have a high degree of communication ability in the language.

– Linda McIlwain, NTM Culture and Language Acquisition Coordinator

The following section from an article written by Doug Schermerhorn, a New Tribes missionary in Panama, tells of the Emberá tribal people's misunderstandings because he and his co-worker felt constrained to begin teaching before they were able to do so in the tribal language.

"In February 1982, Jamie Enemark and I moved into the village of Nuevo Vigia. One year ago, we first approached the village about the possibility of living there. Both Jamie and I were excited. We were new missionaries and did not know what we were going to face in the coming months.

"There were several professing believers who wanted Jamie and me to teach them. After all, was not that the reason we had come? Neither of us spoke the Emberá language, and so we were forced into teaching in Spanish, even though we knew that they would not clearly understand. This was a very difficult time for us as we realized that we were not communicating, but yet we were trying our best to fulfill what they had asked of us.

"As we progressed in the Emberá language, while still unable to teach in it, we were able to ask more questions to find out what they understood from our teaching. The following is a conversation I recorded between Cesar Contrera and me in March 1983.

" 'Does God have a father?' I asked.

" 'I don't know,' he replied, 'but He must have had one since Mary is His mother.'

"I then asked him about the creation of the world.

" 'God made the world,' he began, 'and everything in it. According to the Bible, it was all ocean and dark when He first made it. Then He separated the waters and made land.'

" 'And the light?' I asked.

" 'Oh, it was dark until Jesus came because it says Jesus is the light,' he answered.

" 'Then there weren't any people before Jesus?' I queried.

" 'Well, there must have been, but they must have been different. I really don't know,' he added.

" 'And the flood?' I inquired.

" 'It was some time after Jesus, but I don't know when,' he answered.

"As we learned more and more, we realized how confused they really were. Salvation, to them, was basically giving up their sins, trying to do what is right, and going to meetings. 'I used to be a believer' is a common statement heard among the Emberá people. Their basic reason for becoming believers is to rid themselves of their present problems. Their relationship to God is not what concerns them but, rather, how to live in peace in this life."

Once these two missionaries had learned enough of the Emberá language, they began teaching the Phase 1 outline. What was the result?

Doug wrote, "It is hard for the Emberá people to believe and leave their system of works behind, but we are encouraged as we see men and women really trusting in Christ for their salvation."

Culture

Awareness and insight into the tribal culture should accompany language fluency. We especially need to be cognizant of their basic religious and spiritual beliefs so that we can anticipate possible misinterpretations and syncretism which may result from our teaching and, thus, be able to perceive the appropriate corrective teaching.

Although understanding culture is important, however, beware of the extreme of withholding teaching until you are fully aware of all the intricacies and meanings of their cultural and religious beliefs. If, during teaching, you continually question the people and listen carefully to the elicited and spontaneous responses of your hearers, you will continue to gain new insights into their culture, better understand their thinking, and be able to give whatever supplementary teaching is necessary in order to correct possible distortions of your message.

> **Culture and Language Acquisition – Becoming and Being**
>
> To devote yourself to the careful study of the lives of the people is to give priority to the context (the "nest"!) into which God will give birth to His church. Given this eternal purpose, your study becomes much more than the tedious gathering of cultural data and meaningless facts. Knowing the soil and demonstrating God's genuine interest in them by loving and learning is the first important ministry of church planting.
>
> Culture and Language Acquisition is primarily a time of learning – of coming to a point of *knowing and understanding* the language and culture of the people. But the greater test will be our going beyond knowing and understanding to *becoming* and *being;* becoming and being someone that you are not now; changing some things about yourself for the purpose of reaching the people God loves. Christ himself is the foremost example of this and is a pattern for us.
>
> The process we often refer to as "culture study" is really a study of how we might become "*incarnate*" (real people in the flesh) among the people we have come to reach – laying aside privileges of status, taking on new forms – *becoming* that usable instrument that God wants.
>
> – *NTM Culture and Language Acquisition Manual* (2004)

The people

During pre-evangelism, you have been deliberately preparing the people to hear the truth from God's Word. You have worked to gain acceptance and to make the people think.

To determine whether the people are ready for evangelism, consider the following questions:

o Do the people welcome you to join in with their general conversations and activities, or are they reticent and unwilling for you to participate?

o Does a general hush come over a group when you approach, or do they welcome you and then carry on just as they would normally?

o Has there been a growing freedom among the people to discuss their own spiritual beliefs with you?

o Does there appear to be an increasing willingness to question the foundations and authority for their cultural and religious presuppositions?

o Are the people increasingly free to admit their lack of knowledge regarding spiritual matters?

o Is there a growing interest in knowing who God is, where He is, what He is like, and the answers to other questions which you have raised during pre-evangelism?

o Do they speak more freely of and draw your attention to the wonders of nature?

o Has it dawned on them that the spiritual questions you have asked them cannot be merely answered by human intelligence or natural observation but must come from a higher and greater intelligence outside of the human race?

Although I would urge you to do all you can to prepare the people for evangelism and not to begin until you observe some of these visible signs that they have responded to your pre-evangelism ministry, bear in mind that people and cultures differ. Some express verbally and overtly their feelings while others carefully hide them. Therefore, if you have done whatever you can to prepare the people for the introduction and teaching of the Word of God but they show little enthusiasm, do not be downhearted or look on the mere outward appearance.

The Lord Jesus said of the coming Kingdom of God, *"It is like leaven, which a woman took and hid in three measures of meal till it was all leavened"* (Luke 13:21). This may also be the case with the work of God in the lives of the people whom you have tried to stir up to consider the necessity for a revelation of truth from God. Move ahead into evangelism, trusting the Lord to use His Word to break down their hardness and cause them to see their need of the truth of God.

Feeling unprepared

Before we leave this question of when to begin, I must give a serious warning. Some missionaries, although prepared in every way to begin teaching, do not feel that they are able to do the job. They lack confidence for the mammoth task ahead. They feel totally inadequate to communicate in another language the teaching from Genesis to the ascension.

An illustration comes to my mind. While teaching my daughter and son to drive, I noticed that, whenever they approached a crowded intersection, they would begin to feel inadequate. They worried and wondered if they would be able to handle the car with so much traffic going in different directions. When they mentioned this to me, I answered, "Don't worry about the situation ahead. You cannot drive there until you get there. By the time you get there, it will probably be altogether different from what you see now, for the cars ahead of you are also moving. Give attention only to what you should be doing now and leave future decisions until you need to make them."

Yet another illustration comes from my own experience. When I first learned to drive a car and needed to drive a long distance, it seemed to me to be a formidable undertaking. "How could I drive so far?" I reasoned. But then I realized I could only drive meter by meter, little by little, and, if I continued to do so, then eventually I would arrive at my distant destination.

This is how we need to approach the teaching of Phase 1. Certainly there is a lot of material to cover, and it will take months before we arrive at the conclusion. But if we teach carefully, little by little, dealing with each section and problem as it arises, making sure that we teach each part clearly so that it is comprehended by the people, then eventually we will successfully teach through to the end. As the old adage says, "Don't cross your bridges till you come to them."

Above all, remember that your feelings of inadequacy do not hinder the might and power of God's Word working through you, if you, by faith, look away to His complete sufficiency through the Holy Spirit who lives within you. *"Not that we are sufficient of ourselves to think of anything as being from ourselves, but our sufficiency is from God, who also made us sufficient as ministers of the new covenant"* (2 Corinthians 3:5-6).

This dependence on the Lord must never lead to carelessness on our part but to increasing diligence and effort to be a workman who meets the Lord's approval. *"Be diligent to present*

yourself approved to God, a worker who does not need to be ashamed, rightly dividing the word of truth" (2 Timothy 2:15).

The where and how of evangelistic meetings

What and how we teach the Word of God and how we relate to the people we are planning to reach are all vitally important if we are to successfully evangelize. But there are other important factors we also need to consider. The times we choose to meet, the location of the gathering, and how frequently we decide to meet will all have a great impact on our evangelistic outreach, either for good or for bad.

When to meet

Toward the end of the time of pre-evangelism, you began pre-evangelism sessions, meeting with the people when it was most convenient for them. During these sessions, you asked questions, discussed meaningful topics, and enjoyed happy companionship with the people. I recommend that you use that same time of day to teach Phase 1.

It is best if you move from pre-evangelism sessions to evangelism without any break between them. You do not want the people to think that you have changed from your informal form of visiting and are now beginning church services.

Where to meet

You conducted the pre-evangelism sessions in the place where the villagers most naturally and commonly gathered. Continue to meet in that same place.

If evangelism is primarily done in the home of the missionary or in a church building, then some of the tribal people will probably believe they have joined the religion of the missionary and have become Christians because they are coming to the missionary's home or into some special building. This is especially true where the people have been "missionized" but not truly evangelized.

By going into their homes, sitting where they sit, and communicating within the framework of the tribal culture, we are showing them, by example, that the message of the Scriptures is meant to be taught and practiced within the structure of their culture. We should not act in any way which would make the tribal people believe that the message of the Bible is an extension of Western civilization and belongs to our culture or that Christianity is something which needs to be practiced only in certain places or at certain times during the week.

> **Church Buildings**
>
> If the people are putting pressure on you to build a church building before they are believers, perhaps you could encourage them to construct a school building for literacy. You could meet there while you are teaching Phase 1. Resist the pressure to "have a church." Having a church may soothe their consciences, for they would think that they were pleasing God. You can help avoid this misconception simply by avoiding having a church building.
>
> – Mike Henderson
> NTM missionary to the Aziana Tribe, Papua New Guinea

By going to them where they are, we are setting a good example for those who will be the future believers. We are showing them the importance of reaching out with God's Word into the homes of the unsaved. Our life and work will be far more effective if our ministry is conducted where and when the people normally gather according to their own culture.

The importance of going to people when and where they usually gather was impressed on me when I was visiting a mission station deep in the rugged mountains of Papua New Guinea.

For a long time, the missionaries had been conducting weekly meetings in a small building behind one of their homes. They had done all they could to get the people to come to the meetings, but few attended.

On the night of the meeting, the missionaries lit a lamp and took it to the meeting place. After a wait of fifteen minutes or so, some young unmarried men came and shyly entered the room. A short time later, some young single women arrived. Soon after, some of the boys stood up and ran outside, only to quickly return. This was followed by lots of giggling from the girls, and some of them also went outside for a short time. As I sat watching, I wondered if they would ever settle down so that the teaching could begin.

Teaching Locations

Family, clan and other social subgroups among the people are an important consideration regarding where to meet. It is important to find neutral ground for teaching.

In some villages, social restrictions mean that some individuals would never enter the house of certain other individuals. When we taught in the Gerai tribe in Indonesia, we began our teaching in two longhouse "public" locations. Later we tried to combine the two groups into one. The result? The group that was displaced almost entirely stopped coming to the teaching because the meeting location was no longer neutral.

It is also important to use a teaching location that is large enough to accommodate anyone who might want to attend. Certain individuals may only come if they can come in late and if they can enter in a way that does not embarrass them.

– Larry Goring, NTM Field Ministries Coordinator

Since I did not understand the situation, I began to question the missionaries concerning their meeting strategy. After some discussion, during which time the young people continued to charge in and out of the building, it was evident that, as sincere as the missionaries were, they were not evangelizing the people when and where they would normally gather.

I knew that, in this tribal culture, the men usually slept in a community house, separate from their wives and families. Therefore, I asked the two missionaries if it was acceptable for them to go to the men's community house. They assured me that it was permissible. I then suggested to them that, instead of having the meeting in the building which they had erected, it might be better if they were to go to the men's house where a large group of men were already gathered.

The question arose, "How then could the girls be taught the Word of God?" The girls were not permitted to enter the men's house, and the missionary men could not enter homes if only women were present. Through further discussion, it was decided that the girls could be taught in the houses of some of the men who had decided to live as a family unit with their wives and children rather than in the community house with the other men.

I encouraged these two young missionaries to try this new approach that very night. After explaining the new arrangements to the girls who were present, we picked up the lamp and headed for the men's house, preceded by the excited boys. We could hardly find a place to sit

when we entered the men's house, and it wasn't long before other men from surrounding family houses joined us. It was close company, but the time and location were ideal for teaching.

How often should we teach?

Teach as often as the people are willing to meet and be taught, daily if possible. There is much material to be presented to and learned by the people. The more frequently they meet, the sooner you will be able to teach everything you plan to from the Old and New Testaments.

Our attitude toward gathering for meetings will greatly affect the attitude of the people. If we repeatedly cancel meetings, the people will follow our example. If, on the other hand, we show that the teaching of God's Word takes top priority in our daily schedule, the people are likely to be influenced by our zeal. In addition, if they have learned to accept, respect, and maybe even love us, they will not want to disappoint us by being absent.

Because of the great spiritual need of the lost, we ought to be eager to teach God's Word as often as possible. Furthermore, because we never know when, through some problem or difficulty, we may have to leave an area, we need to make good use of our time and do all in our power to teach the people the Word of God.

> **Scheduling**
>
> Before you start the teaching program, consider the people's schedules. Are there gardening events or other major events that could distract them and disrupt teaching for long periods of time?
>
> Consider also your schedule as missionaries. What other projects are in your daily schedule that may interrupt teaching? What will be coming up in the next 6 to 8 months? When you start teaching, you want to be able to continue teaching till certain phases are finished.
>
> – Mike Henderson
> NTM missionary to the Aziana
> Tribe, Papua New Guinea

I remember how sad I was when we left Palawan, but my heart was lifted in thankfulness to the Lord that, by His grace, I had labored diligently day and night to give the people the message of the Gospel and to teach the believers the truth. There was much more which needed to be done, but, as the plane flew out of our station, I looked down at the houses scattered in the valley below and worshiped and thanked the Lord that, by His grace, I had fulfilled my responsibility as an ambassador of Jesus Christ.

We found it helpful to make it clear to the Palawanos that we would not be living with them forever. Early in our teaching ministry, we emphasized to the Palawanos that:

(1) God's message is the most important message in all the world.

(2) God had sent us to them with this message.

(3) There was a great deal which God wanted to teach them, and it would take a lot of time to tell it all to them.

(4) There were many more people to whom God wanted us to take His message.

(5) We planned to stay with them approximately three years, after which we would go to tell others.

(6) Therefore, it was important that they give time every day listening to God's Word to them.

By frequently reminding them of these points, the importance of taking time to listen to God's Word really gripped the Palawanos.

Situations vary, so you will not tell the people where you work the same thing that we told the Palawanos. Nevertheless, it is important that you communicate to them that you do not plan to settle down and become the permanent teacher or pastor of the church. Handle this carefully, because it can be disappointing to some tribal people to realize that you plan to move someday.

The fact that we are transient does not mean that there must be a time when we completely relinquish responsibility for the churches raised up through our ministry. The apostles never ceased to take responsibility for their children in the faith (Acts 15:36; 2 Corinthians 1:23-24; Galatians 4:19-20). In spite of our move out of the area in Palawan where there were established churches, for a time we were able to make monthly visits to teach and encourage the believers and instruct the church leaders. And when we were no longer able to visit them regularly, we were confident that other missionaries had taken over that responsibility.

No Longer Resident among the Ata People

The Ata church leaders were very involved in the decision about when we missionaries should no longer be resident among them. We wanted them to sense the point when they would be ready to handle each aspect of the work, and we discussed openly with them that we would not want them to ever feel as though they had been abandoned.

The time came when they did indeed express that they felt confident in their understanding of God's Word and that, in reliance on the Holy Spirit, they would be able to continue on in their responsibilities to feed and shepherd the churches in their care.

They also shared with us the ongoing role they would like us to play in their development as a mature church. They asked us to commit to visiting at least every 6 months for the first couple of years to provide further teaching from sections of God's Word not yet covered in the Phase teaching, and also to be an encouragement to the elders. In the absence of any other avenues open to them, they also asked for some continuing practical help in the area of ensuring that they could obtain the printed materials that they need, such as literacy primers and Bible lessons. These conditions we were only too happy to agree to, and it has been a joy and privilege to visit them regularly in the ensuing years.

– Paul McIlwain, NTM Church Planting Coordinator

What form should evangelistic meetings take?

Maintain the dialogue approach which you established during pre-evangelism. There are many benefits when the people ask and answer questions, discuss the Scriptures being taught, and express their views during evangelism. By maintaining a dialogue approach during evangelism, you will find that:

(1) Their interest level will be higher.

(2) They will be more relaxed.

(3) They will learn more quickly.

(4) When they become believers, they will be well prepared to function according to New Testament body principles.

Some of the people, through preoccupation with other activities, shyness, or slowness of mind, will need direct encouragement from the missionary to listen and participate.

While my wife and I were visiting in Senegal, a missionary asked us to accompany him to his evangelistic meeting with a group from the Budik tribe. The meeting was held at night outside the people's mud-brick houses. When he began speaking, some of the young women had their backs toward him. They were chatting and giggling and were obviously preoccupied with some task.

This missionary asked many questions to gain and hold the interest of the people and to ascertain whether or not they clearly understood his teaching. Both men and women answered, but these young women, busy with their work, seemed to be oblivious to the teaching. They were engrossed in their own conversation and activity.

Finally, the missionary directed a question to them. They didn't hear him immediately, so he asked them again. This time, some looked around. Still not receiving the response he wanted, he asked with a smile, "What are you doing over there anyway?" There was a lot of laughter from the girls but still no answer. Wanting to make sure that they, too, were listening, he moved over to where they were. This amused the whole group.

The girls were preparing vegetables for their families' late evening meal. The missionary commended them for their conscientiousness, encouraged them to listen while they worked, and then returned to his teaching.

Authoritative evangelism

There is a common form of Bible study where each person gives his own ideas about the portion of Scripture under consideration, following which, the leader summarizes the different thoughts and interpretations given by those present. This is not what I am suggesting when advocating a dialogue approach. Any method of teaching which fails to give authoritative answers from the Word of God is not biblical.

Anyone who teaches God's Word is to speak as God's ambassador, not in order to bind people's consciences to him or his interpretation, but in order to present the Scriptures as the final authority.

During pre-evangelism, you initiated discussions to ascertain the religious and cultural beliefs of the people about God and spiritual matters. This type of discussions should not continue into evangelism. If the people continue to express their own religious beliefs during evangelistic meetings, I recommend that you gently remind them that the purpose for meeting is not to compare their beliefs with the teaching of the Bible, but rather, to listen to God's Word which is the only reliable source of spiritual truth. To do this, you may need to remind them of the topics you discussed with them during pre-evangelism, of what other people, tribes, and religions believe, of the confusion in the world regarding spiritual matters, and of the fact that only God can give the answers and that He has done so in the Bible. These reminders will help reinforce the reason for gathering together which is to hear what God says, and not what they or anyone else thinks is the truth.

Keeping all of this in mind, we need to be constantly alert during evangelism to learn new things about the culture and beliefs of the people. Many times, the people do not really open up

and reveal their true beliefs until the truth of the Scriptures begins to take effect in their lives. Maintain a balance between allowing the people to freely express themselves and an authoritative ministry in the power of the Holy Spirit which declares God's truth regardless of what anyone says or thinks (1 Thessalonians 1:5; 2:4-5).

The Bible – the sole authority

One way in which you can emphasize that you are not the authority and that all your knowledge of spiritual things comes only from the Bible is to always keep an open Bible before you when teaching. Even if there is not a translation in the vernacular, it is a good practice to keep a Bible in the national language, or even in English, open before the people. Quote the actual Scriptures when teaching, and point to the verse being taught.

I recall one group of Palawanos, approximately thirty people plus a dog or two, crowded into a small, rickety house. It was hard to even find a space to sit down. When reading, I sat at one end where all the people could see me, and the Palawanos crowded around on either side. When I referred to the Scriptures, I put my finger on the verse being taught. Bossing, the headman of the group and grandfather to many, usually sat near my side. He often leaned over to peer at the verse which I indicated, viewing it intently and almost with a look of awe, even though he was unable to read.

I continually reminded them that I could not have known about God or the answers to spiritual matters unless God had written them in the Bible. If they asked me a question which needed to be answered at that time, I would find the verse in the Scriptures and point to it when answering. If I knew that the Scriptures gave no answer to the question being asked, I simply told them that. At times, when someone has asked me a question, another has been heard to say, "He doesn't know the answer. He has to look in the Bible."

This is a good example to set right from the beginning of evangelism. When the tribal people are born again, they will follow the example which we have given by word and action, and they will point to the Scriptures alone as the sole authority.

Some dos and don'ts for evangelism

Having made basic decisions about where, when and how frequently to meet as explained earlier in this chapter, we also need to think about other issues such as how we will actually conduct the meetings. Should we teach people to sing hymns during evangelism and lead them in prayer? What sort of atmosphere should we aim at creating in our evangelistic meetings so the Word of God will have maximum impact?

Traditional evangelism

Gospel meetings traditionally open with a few hymns or choruses, a Bible reading, and a prayer. Although most Christians seem to think these things are necessary for a successful Gospel meeting, we do not find the traditional Gospel meeting anywhere in the Scriptures. Of course, this does not immediately condemn such activities, but the fact remains that neither by a

scriptural command nor by the example of the Lord Jesus or the apostles have we been guided in our evangelistic methods. They are purely traditional. Traditions are not necessarily wrong, but they should be carefully considered to see if they are helpful or detrimental. Our traditional methods of evangelism often cause misunderstanding and confusion in the minds of unsaved people.

Rituals and ceremonies are an important part of the religious activities of dead religions. Tribal people believe their traditional rituals are a vital means of appeasing the gods or spirits and a way to build merit, attain wealth, and retain health.

Because most missionaries attach little importance to ceremony as they conduct evangelistic meetings, it does not usually occur to them that the people will probably interpret their evangelistic methods as something essential to Christianity and, therefore, absolutely necessary if one is to appease the Christian's God. Nevertheless, this is often how people who are steeped in the ritualism of a superstitious society, where every part of life has some religious significance, interpret traditional evangelistic methods.

When the missionary leads in singing, his thoughts are on the hymn's message to the unsaved. When he prays, he is thinking of the need of those before him and the power of God to convict and save their souls. When he teaches the Scriptures, his faith is in the truth and power of God's Word to bring people to salvation. The missionary does none of these activities to gain merit with God, but people who, their whole lives, have tried to build merit through repeated religious ceremonies find this difficult to understand.

Because they have no concept of the holiness of God and man's sinfulness and inability to please God, they can only interpret the missionary's activities during the Gospel meeting as merit-making ceremonies similar to their own rituals. Even if the hymns and choruses chosen do convey the Gospel message, the danger of the people thinking that, through singing, they are pleasing God far outweighs any truth they may learn through the message of the hymn. Even if the missionary explains to the people that the things they do when attending the Gospel meeting will not help them to be saved, many will still misunderstand.

The Buddhist religion, like all religions of men, is based on personal merit-building. While traveling in Thailand, a missionary began to witness to a Buddhist man sitting beside him. Because the Thai man showed interest and willingness to listen to the message of the Bible, the missionary spoke to him at length. When the missionary finally finished, however, the man said, "The most wonderful thing to me is that my son is a Buddhist priest."

Why had this Buddhist man listened to the missionary so tolerantly and with apparent interest? Was it because he was really interested in what he was being told? No! He listened to the missionary, not for his own benefit, but for that of the missionary. Just as he was gaining merit by all that he did and by his son being a Buddhist priest, so he thought the missionary was accumulating merit for himself by speaking about his Christian God. The Thai man interpreted the missionary's efforts in light of the beliefs of the Buddhist religion where everything is done in order to add to one's own personal merit.

In locations where the false gospel of salvation by works has been taught, the traditional Gospel meeting is often misunderstood. Because the people have associated being a Christian with church attendance and religious activities, they immediately think that going to the Gospel meeting helps to make them Christians. The Gospel meeting provides a false religious atmosphere. Many people feel they are Christians or will soon be Christians because they attend

the meetings of a mission or denomination. Therefore, it is better if people are not made to feel they are "attending church." Conduct evangelism meetings in the same informal way as you did the pre-evangelism visiting sessions.

Some missionaries may not see this as a problem because they reason that, as the people continue listening, they will eventually understand the truth and be saved. Although it is true that some may be saved, many more will be given a false sense of security by their "going to church," and they will not have open minds to receive the true message of the Word of God. All involved in Christian service know that many false "professors" within the church have been lulled into a feeling of acceptance by God because of their faithful church attendance. We as missionaries are responsible to guard against such false security by carefully examining our evangelistic methods and by considering alternative methods more in keeping with the Scriptures and less likely to be misunderstood and used by Satan to deceive mere "professors."

A missionary working in Papua New Guinea wrote about the need for missionaries to be alert and wise in their evangelistic message and methods:

> "Even when the missionary is able to preach a message of God's hatred of sin and judgment, the response is often, 'What shall I do? What shall I give?' Religious ritual is common in many tribes, so in the minds of tribal people, the missionary's new message must call for a new ritual. People 'have their heads washed' (baptism), they 'eat the flesh and drink the blood of their ancestor' (communion), they 'pay money' (the offering), they sing the new songs, and they listen to much 'church talk.' They think, 'So this is the ritual we should have been doing all along! We must learn to read from a black book, too!' It would be very easy here in Papua New Guinea to begin a Sunday gathering with traditional church activities, but this is surely not that for which we are aiming.

> "There is an added danger in Papua New Guinea in that many people are already looking for the proper ritual to bring in a state of material prosperity. The people reason, 'Judging from his possessions, the missionary must know the secret of material wealth, and the key must lie in his religion, especially his rituals.' To them, God not only created the heavens and the earth, but He is also busy making clothes, radios, tinned meat, cars, and so forth which the missionary is supposed to bring to Papua New Guinea.

> "This calls for a careful presentation of the Gospel. If anything is assumed, it must be that people will probably misunderstand, rather than understand, our message."

Don't create an artificial religious atmosphere

The Holy Spirit only uses truth. The work and power of God are not dependent upon a man-made religious or spiritual climate. Jesus and the apostles spoke God's truth in normal, everyday situations. They did not create an artificial setting so people could "feel" God. They trusted in the power of the truth of the message they were speaking. Paul said to the believers in Colosse that the Gospel had come to them *as it has also in all the world, and is bringing forth fruit, as it is also among you since the day you heard and knew the grace of God in truth* (Colossians 1:6).

In Palawan, I was told from many sources that a powerful witch doctor was planning to ambush and kill me, so I decided that it might be wise to confront him in an open and public place before he surprised me somewhere along the jungle trail.

We met, and he was quite cordial although he looked fearful and embarrassed in the first few moments of our meeting. When I faced him with the allegations that he planned to kill me, he denied them all.

For the next few hours, I talked to him and questioned him, but I did not offer him any biblical answers or personal opinions (just as I suggested for pre-evangelism). I asked him many questions relating to creation, unseen spiritual powers, man, and life after death. Finally, taking up the Scriptures, I briefly introduced them as God's revelation and answer to all the questions which I had asked him and for which he had no definite answers.

He seemed to be amazed that I had a book given by God which contained all of the answers to the difficult questions which I had asked. It was then that he made the startling announcement, "I will tell all of my people to follow you."

His surprise was even greater when I quickly responded, "No! That is not what I want. They now follow you, and you are not God. It is no use for them to follow me, for I am not God either."

Surprised at my refusal, he asked, "What then do you want?"

"I came to this island of Palawan, not to get people to follow me, but to make known to all Palawanos this message which is written by God. I just want to tell you all God wants you to know. Therefore, I would like you to gather your people in your house and allow me to carefully explain God's message."

He looked at me doubtfully and queried, "Is that all you want?"

"That is all I want," I reassured him. "I won't ask you to do anything else. You can smoke, chew your betel nut, fix up your fishing nets, weave baskets, make blow-guns, or do whatever you want to do while you listen to God's words."

I emphasized smoking and chewing betel nut because many Christians (including some missionaries) wrongly think that God will be offended if people smoke or chew betel nut while His Word is being taught. Thus, they have often forbidden such activities in evangelistic meetings. They do this because most meetings for the unsaved are conducted in the church building which is considered to be a place set apart for the worship of God. This is the very reason why evangelistic meetings are best conducted in homes or public places so the unsaved will not be forced to comply with the Christian standards or way of acting. Missionaries ought to give God's message to the unsaved within the normal cultural atmosphere of public meetings. Missionaries should not try to create a "Christian" setting by insisting people sit in pews, sing, stand up, sit down, close their eyes to pray, keep quiet without comment or question, and do or not do all the traditional things which we accept as normal conduct in Gospel or church meetings.

Leading the unsaved in prayer

Traditionally, in most evangelistic meetings, someone will lead in prayer. In essence, they are inviting unsaved people to join with the saved in praying to God. This is unscriptural! *"The*

sacrifice of the wicked is an abomination to the LORD, but the prayer of the upright is His delight" (Proverbs 15:8). *"One who turns away his ear from hearing the law, even his prayer is an abomination"* (Proverbs 28:9). When evangelizing, neither Jesus nor the apostles were ever recorded as having prayed with unsaved people.

The Lord Jesus said, *"No one comes to the Father except through Me"* (John 14:6). Prayer must be in Jesus' name. When believers pray, they *"enter the Holiest by the blood of Jesus"* (Hebrews 10:19). Unbelievers cannot come to God in Jesus' name, nor do the children of God have the power to bring the children of Satan along with them into God's holy presence. The unsaved must be taught that, because of their sin, they are shut out from the presence of God and that only through Christ and His death can their sins be forgiven and they be reconciled to God. How can we invite them to pray with us before they believe and are reconciled?

Praying is commonly used by Satan to make unsaved people feel and, therefore, believe that they are accepted by God. In spite of the impossibility of unbelievers entering God's presence by prayer, some Christians even encourage or teach them to pray before they are saved. This actually hinders people from facing their great need of true godly repentance and accepting Christ's saving work on their behalf.

Don't create false security

Some who do not see the seriousness of the issues involved will probably think that this is merely splitting hairs. Those, however, who are aware of the false security which these activities have given millions throughout the organized church worldwide will readily agree that these matters need to be carefully considered. Anything done in Christian service which Satan may use to make people feel accepted by God and, therefore, hinder them from facing the reality of their lost condition would be best eliminated from our evangelistic methods.

Some young Palawano men were conducting an evangelistic outreach from their local church to a village of unsaved people. These young evangelists were welcomed every week by the unsaved people of this village. The people gladly sang the hymns and joined in prayer and the reading of the Scriptures. They listened attentively to the Gospel messages, but there was no evidence of repentance. No one made a verbal profession of faith in Christ alone as their hope of salvation.

The young Christian evangelists didn't know what to do. These unsaved people seemed happy and secure. Their spiritual eyes were blind to their need for spiritual sight because they believed they could already see (John 9:40-41). They thought of themselves as already "in God." (This term was used continually by unsaved religionists in Palawan.)

One day, the young men who were conducting these meetings asked for my advice. I encouraged them to discontinue all singing and praying in their meetings because I knew that the majority of the people were trusting in doing these things, believing that, because of these activities, God would accept them.

When the young men first considered this suggestion of eliminating all singing and praying from their evangelistic meetings, they were confused. They wondered how they could conduct meetings without these activities. All Gospel meetings they had previously attended followed the pattern modeled by the previous missionaries with singing and praying.

From the Scriptures, I explained to the young men that their responsibility was to simply teach the Word of God to the unsaved and that singing and praying should only be included in meetings of the children of God. I told them, "Just gather the people together and teach them God's Word. This is what Jesus and the apostles did whenever they taught. They did not first ask the people to sing and join in prayer."

I also advised these men to temporarily withhold the Gospel. I explained, "The unsaved people you are teaching have heard the Gospel many times, but it has never meant much to them. They are quite satisfied to go through the form of meeting, singing, praying, and listening to the message because this makes them feel they are accepted by God. What they need at this stage is to be taught God's holiness, what His Law requires sinners to do if they are to be pleasing to God, and their own sinfulness and inability to perfectly obey all the words of God. They must be prepared in this way; otherwise, they will not see their need for the Lord Jesus and the Gospel."

As I talked with these young men, they understood the reasons for omitting singing and praying from the meeting. The next time they visited the village, they deliberately left their hymnbooks at home. When they met with the people, they read God's Word and then continued immediately teaching the people, emphasizing the holy and righteous character of God and the need for everyone to repent, that is, to agree with God that they were sinners and were justly condemned.

Just after the men began to teach, some of the people interrupted and asked, "Aren't we going to sing and pray?"

"No, we are not," the young men answered. Then they explained why they had decided not to sing and pray anymore in the evangelistic meetings. They told the people, "God has never asked Satan's children to sing about Him. God doesn't accept the singing of those who are not His children. He tells only His own children to sing praises to Him." (See Ephesians 5:18-20.)

"Neither does God ask you to pray to Him. You cannot come to God and talk to Him, because your sins are still between you and God." (See Isaiah 59:1-2; Ephesians 2:11-13.) "We prayed for you before we left our village, and the believers in our place are also praying that you will realize that you are sinners who can never please God."

In response, these unsaved people asked, "What then does God want us to do?"

"Just listen to and take notice of God's message to you in His Word," was the reply given.

What was the result of this different approach? Because the people were stripped of the religious activities in which they had previously trusted, they were startled into a realization of their lost condition before God.

Many Palawanos who were unwilling to forsake their animistic beliefs and Satanic worship were nonetheless ready to adopt the outward display of Christianity because they thought singing, praying, and meeting would help them to please God. A Palawano witch doctor who had attended the traditional Gospel meetings continued to pray and sing hymns many years later while still practicing his sorcery. Passing his hut at night, on my way home from teaching the Scriptures to his neighbors, I would hear him singing the hymns which he had learned many years before we had arrived.

Christians were not sent into the world with rituals. We were sent with the message of God's Word. God has *"committed to us the word of reconciliation"* (2 Corinthians 5:19), and that is all

we need. Jesus' ministry and the apostles' practices when evangelizing should be our prototypes. Their emphasis was on God's Word and the responsibility of all believers to preach it to all people everywhere (2 Corinthians 4:1-7). Nothing else was given by God, for nothing else is needed.

Those involved in evangelistic meetings

The goal of all missionary endeavors should be to plant indigenous, self-propagating churches. This can only be accomplished through the teaching of God's Word and the proclamation of the Gospel. Therefore, all missionaries located at the scene of an evangelistic outreach, whenever possible, should be present at evangelistic meetings. If there is already a local Christian church in the area, then the believers should also be encouraged to get behind the outreach to the community and to be present at all meetings. A crowd will help to draw a crowd, and unbelievers will feel much less conspicuous if they can melt into a large congregation.

It has greatly surprised and disappointed me on quite a number of occasions when visiting mission stations to see missionaries sitting at home or doing other projects which could have been done at another time, while their colleague went alone, night after night, to teach evangelistic lessons. Some had the attitude that the teacher's ministry was to evangelize, whereas their ministry was concerned with a different part of the work altogether. This approach has a number of negative repercussions:

o It portrays to any local believers and certainly to the unbelievers that the evangelistic meetings are not the main purpose for all the missionaries present in their community. The people could well question the motives of those missionaries who do not attend the evangelistic meetings. They could also wrongly interpret priorities. For example, if the missionary who does not attend the meetings is the one who does medical work, then the people may assume that the missionary considers it more important to meet physical needs than to address spiritual needs. Missionaries should demonstrate by their presence in evangelistic meetings that nothing has greater importance than the people coming to Christ.

o Missionaries miss out on showing friendship and individually welcoming people on their arrival for the meeting.

o While one can pray for a meeting even when not in attendance, the burden to pray will probably not be as intense unless the missionary is right there, sitting alongside unbelievers whose only hope of salvation from Hell is for them to be enlightened by the Holy Spirit.

o There is no greater joy in this world then to see a sinner turn from all others and trust only in the Lord Jesus. The absent missionary will miss out on seeing this miracle first hand and also the opportunity to immediately worship God for His gracious work of bringing the lost to Himself.

o The failure to accompany fellow missionaries in their evangelistic outreaches can also kill the teacher's motivation. How hard it would be for the Bible teacher to see his fellow workers relaxing at home while he goes out, maybe in the dark and rain, to teach the Word of God.

 o It is a poor testimony to the local believers when some of the missionary team do not demonstrate by their actions that there is nothing more important or pressing than the work of bringing the Gospel to people who have never heard of Christ.

 o The example set by missionaries who don't attend the evangelistic meetings could have a long-lasting effect on the future church. When those being evangelized are saved and taught that the local church is responsible for future evangelism, those not responsible for the actual teaching may think that they too have no need to be involved in the work of evangelism.

Team teaching

Missionaries with a particular tribal group often work as a team. The team on a mission station may be husband and wife, two or more singles, or two or more married couples. Participation as a team is an important part of preparing lessons and of teaching lessons.

It is best if all team members critique the lessons before they are taught. This will promote unity and give each member the opportunity to contribute to the lesson. Team members need to realize that they will be teaching for the team and be open to the guidance and suggestions of their fellow workers.

The sample lessons reflect that the Bible teacher represents the team. For example, I used the word "we" when the teacher is referring to himself to show that he is also referring to the whole team. When the missionary teaches, he needs to speak for the team, including other missionaries even if they are not actually teachers.

Regardless of who comprises the team, working together to teach each lesson is an extremely profitable method of teaching.

Even those who do not have the ability to teach one complete lesson can participate in team teaching. I suggest the teacher give opportunity to teach a small portion of the lesson to new missionaries who may not yet be fluent in the language or tribal believers who are new to the teaching role and perhaps nervous and lacking teaching skills. The new missionary or inexperienced tribal teacher could read a portion of the lesson which has been written out. He could also ask questions, note the reactions and comments of the people, and anticipate any likely misunderstandings or misinterpretations of the hearers due to an overemphasis, a lack of explanation, or any other deficiency in their

**Questions to Consider
about Team Teaching**

• Will you teach together as a team?

• Who will take what part of the lesson?

• Will you alternate teaching, with one person teaching one week and another teaching the next week?

• Will only one team member be the main teacher?

• If you have one main teacher, what part will the other team members have in the teaching sessions?

• How will team members remind the speaker to raise his voice, or speak more clearly?

• How will the other team members help to keep distractions to a minimum (e.g., handling sleepers, disrupters, crying babies)?

• What will you do if the main teacher is sick?

 – Mike Henderson
 NTM missionary to the Aziana
 Tribe, Papua New Guinea

colleague's teaching methods or lesson content. It is a tremendous incentive for a new missionary or inexperienced tribal teacher to have part in the evangelistic outreach.

Many times, when two or more able teachers are on a team, they can take turns in the primary teaching role. George Walker and Bob Kennell described their teaching approach with the Bisorio tribe in Papua New Guinea in the following way:

> *"Although our ministries overlapped, basically I (George) prepared the Bible lessons, and Bob did the Scripture translation. We then took turns teaching. For a while, when Bob was really pressed in the area of translation, I taught two lessons to his one. Later, that switched to where Bob was teaching two to my one, so that I could keep up with preparing the Bible lessons.*

> *"I would stand up and teach, using the Bible lesson and the translated Scriptures we had at the time. As I was teaching, Bob would be in the crowd with pad and pencil, taking notes and making sure I was getting across the points in the lesson. He watched for facial expressions and recorded the comments the people were making. After I finished the lesson, Bob would get up and give a review of approximately ten minutes, hitting the highlights of that particular lesson. He would also comment on the responses the Bisorios had made, 'That's a good thing you said there; but no, it was not like that; it was like this....' 'Now everybody, remember that....' We were constantly reconfirming and keeping the fog cleared out. When Bob did the teaching, I would do the observing and review. When we did these immediate reviews, we were catching the people right then and there in their areas of need before the lesson was ended and set in their minds.*

> *"When we sat in the audience, if we noticed the people were not getting the point or if the teaching was unclear, we had the opportunity to stop the 'teacher' and ask for clarification. We had the liberty to interact or emphasize a point that was being shared."*

The teaching ministry of the missionary wife

Some missionary wives become frustrated because they are not always able to have, what they call, a "real ministry." They seem to think that, in order to be involved in a worthwhile ministry, they must be teaching a class of women or children. In some cultures and circumstances, this may be necessary, but, as has already been stated, this is not the ideal method for evangelistic or church meetings. It is far better to teach family groups together.

What then can a missionary wife do to have a vital teaching ministry? The wife's teaching role on the mission field should be complementary to her husband's. One way she may be involved in her husband's ministry is by attending all the meetings when he is teaching. If tribal mothers and their children are expected to attend meetings, then surely the wife and children of the missionary should also attend. Through being there, she will be aware of the current teaching being given to the people. As she visits or is visited by the people, she can ask questions, answer questions, and discuss with them the things they are learning from the Word of God. She may do this even in her own home when she is baking, preparing meals, doing medical work, trading with the people, or teaching literacy.

Some women are so bound to their family and household chores that they do not have time to assist in teaching God's Word. This is a poor example for the tribal women who will be the wives of the future church leaders. Missionary husbands are often to blame for this when they do not pull their weight by assisting and relieving their wives of some household duties which hinder them from having time to take part in the ministry of God's Word. It is important that men be not only zealous for their own teaching ministry but also for the particular and important contribution which their wives can make to the work of evangelism and nurturing of believers.

If it is cultural for a woman to do so, a wife can further assist her husband by asking questions during the teaching sessions. These questions may be agreed on with her husband beforehand, or they may be some that she sees as necessary for clarification while her husband is teaching. If the missionary's wife sits with the tribal women and asks questions, they, too, will be encouraged to participate.

My wife was fully involved in my ministry in this capacity. She was particularly helpful in alerting me to areas which needed greater clarification. Fran was made aware of these needs by chatting with the women who were attending the meetings. During the literacy classes which she taught, she included subjects which related directly to the things being taught in the meetings. Fran greatly enjoyed these times in which she could help to establish people in the knowledge of the truth.

All believers involved after the meeting

Following the meeting, all missionaries who know the language and any local believers can be involved in discussing the lesson with the unsaved. By asking questions and reviewing the lesson, they help to recap and cement the truths introduced during the teaching session.

Pumé Believers as Part of the Teaching Team

The Pumé believers were involved on evangelistic outreach with us missionaries. After I had taught a Phase 1 lesson, I would ask one of the believers a question about something I had taught in the lesson. For example, I might ask why Abel was accepted and Cain wasn't. As the believer replied, he would further clarify and review what I had just taught. For the people, hearing the truths come from their own people brought weight and credibility to the message.

After the meetings, the believers would have a relaxed time of interaction with individuals regarding the material that had just been taught. The believers would ask what those attending had learned. They would find out, for example, what the people understood about the one door on the ark or what they had understood about God's hatred of sin. These one-on-one visits lasted about 30 to 45 minutes. The village being evangelized saw immediately that this was a very serious matter because everyone, including the ladies, was involved in making sure the truths of the lessons were clearly understood.

The tribal believers also were involved by team teaching with us missionaries. Although these believers couldn't read yet, their knowledge of the Phase 1 material was such that they could effectively teach on much of it by memory. They were each assigned a section to teach, and they enthusiastically tackled their assignment. This sent a strong signal to the unbelievers that their own people had come to believe God's Word.

– Merrill Dyck, NTM missionary to the Pumé Tribe, Venezuela

Participating in this way allows all local believers – men, women, teenagers and children – to be involved in assisting in the evangelistic effort. A time following the meeting can be organized to give opportunities for the local believers to sit and discuss the lesson just taught with one or a group of unbelievers. It is usually advisable for women to talk with women and men with men. Teenagers will probably feel much more comfortable discussing questions or the subject just covered in the lesson with someone of the same age group.

Teaching aids for evangelism

Teaching aids are excellent tools which will assist your hearers to understand the Word of God. Used wisely and at the appropriate time, teaching aids will have great impact and hold the attention of the varying age groups.

Although I believe teaching aids are invaluable, a missionary's attitude toward the people is even more important than the actual visual aids. Be sure to make everyone feel welcome and included as you teach. Do not simply rely on teaching aids to hold the people's interest. Be a good teacher.

One consideration as you develop teaching aids is whether they can be reproduced for use by the tribal teachers for use in other areas or whether it will be necessary for you to provide the teaching aids for them. Remember, you are not planning to settle down and become the permanent teacher. The following article considers some other areas which you should take into consideration.

Teaching Aids for the Tribal Teachers

It is not necessarily right to say (or infer) that the people we work with must be able to reproduce all the teaching aids we use. At the same time, neither is it necessarily right to say (or infer) that we should never use anything which they cannot reproduce. The main issue is whether or not the tribal church will be somehow paralyzed in their evangelism because of an incorrect assumption that without the aids we used they cannot evangelize. In other words, if we have used teaching aids which they are unable to reproduce in our absence, and they somehow see those things as indispensable to an outreach, then we have created a problem.

The answer, I believe, is to work through those issues with the tribal church in subsequent outreaches while we as missionaries are still with them. They need to believe, first of all, that they can reach out and share God's Word without extra teaching aids. On the other hand, their attempts to teach can be helped by teaching aids just as much as ours can be. So, in looking forward to a time when they will no longer be resident there, the missionaries need to work with the tribal church to decide:

- Which teaching aids are really helpful for the tribal Bible teachers – some of the things we have felt to be helpful may not suit their style.

- Which teaching aids will they be able to use practically – obviously in some places, the tribal people will not be able to use videos, while in other places, videos could be a successful tool because many people have VCR's in their homes.

(continued next page)

Teaching Aids for the Tribal Teachers (continued)

• Which teaching aids will the church be able to access for themselves – making or buying them.

• What avenues can be established for either the no-longer resident missionaries themselves or other missionary personnel to assist the church with those teaching aids which are considered important, but which they cannot get on their own.

– Paul McIlwain, NTM Church Planting Coordinator

Pictures

During pre-evangelism, you used pictures of nature, Bible culture, and Bible lands. These pictures can continue to be useful when teaching Phase 1 for evangelism.

Bible story pictures which emphasize the main characters, cultural details, and especially the central teaching in the story are particularly helpful for Phase 1.

If you paste pictures onto thin cloth, they will be far more durable and less likely to tear. Laminating pictures is another way to make them durable.

NTM has developed a set of pictures designed to be used with the chronological teaching program. (See below).

NTM's Chronological Picture Set

These carefully researched pictures enhance teaching. Set includes 105 pictures and is available in various sizes. Available from:

New Tribes Mission Bookstore, 1000 East First St., Sanford, FL, 32771
Phone: 1-800-321-5375
Web site: www.ntmbooks.com

Bible Pictures – Laminated (large) Set of colorful, heavy-duty laminated pictures, measuring 12 X 17. Also available non-laminated.		**Bible Pictures – Laminated (small)** This heavy duty laminated color-picture set is a perfect fit for a three-ring notebook.	
Bible Pictures – B&W Line Drawings Created from the same art work as the color pictures, these black and white drawings are 8½ X 11 and fit into a three-ring notebook.		**Bible Teaching Pictures – CD** This CD contains the Bible story pictures, both color and black-and-white line drawings, in BMP, JPG and CGM formats. PC and Mac compatible.	

Whatever Bible pictures you choose, be sure they are biblical in content. Some so-called Bible pictures for children show large animals sitting on the deck of Noah's ark or show a giraffe's head and neck protruding out of the window of an undersized ark. Whether for children or adults, Bible pictures should be realistic.

Be aware that the picture may sometimes be a distraction rather than a help. If the people discuss the picture instead of listening to what is being taught, it is far better to put it out of view. But in most cases, pictures, whether cutouts, flashcards, or flannelgraph, will be effective visual aids if they are biblical, realistic, and shown at the appropriate time.

Be sure everyone can see the pictures. When showing pictures to a group, you may need to pass them to those who are shy and always on the outer part of the circle. If possible, leave the pictures posted up in the meeting place so the people can look at them and be reminded of the truths of Scripture.

Review Chart with Chronological Pictures

When we taught the Ata people in Papua New Guinea, we made a review chart of all the chronological pictures which we planned to use in Phase 1. We used the largest size of line drawings of the picture set. We covered the pictures with contact paper, and taped them together in chronological order in a long strip. We made wooden handles for each end so that the strip could be rolled up like a scroll.

In each picture we had colored an important feature that we wanted to stick in the minds of the people. For example, in the picture of Adam and Eve when they made fig-leaf coverings, we colored just the coverings to remind the people that Adam and Eve had tried to make themselves acceptable to God. In the picture of Abraham about to sacrifice Isaac, we colored the ram, to highlight God's provision.

During the Phase 1 teaching we went through the review chart at least three times a week after a lesson, looking at each picture that had already been taught, and asking the people what it reminded them of from God's Word. Later on, we had some of the men stand up front and hold up the chart and ask the questions about each picture and help the others to answer. This was a good way to include the people and train them for the future.

– Paul and Linda McIlwain, NTM missionaries to the Ata tribe, Papua New Guinea

In the lessons, I have suggested ideas for pictures and when they could be used. Below is an example of the teacher instruction note in the lessons regarding pictures. Note that the lessons show pictures from the NTM Chronological Picture set (see above), although you could use other pictures which depict the Bible scene.

 Teacher: Show a picture of Solomon's temple.

This is Chronological Picture Number 43 – Solomon's temple.

Use pictures when appropriate in the lesson, not limiting your use of the pictures to only when suggested by the teacher instruction notes.

Maps

Display the simple, undetailed map of Bible lands which you introduced during pre-evangelism. Use it continually during Phase 1.

Keep the world map used during pre-evangelism on hand and refer to it when needed.

In the lessons, I have suggested in teacher instruction notes when to use maps. For example:

☞ **Teacher:** Point to the land of Canaan on the map.

NTM has developed a set of maps to be used with the chronological teaching program.

Chronological Maps and Charts: Included with a set of charts for teaching in Western cultures is a set of three 17 X 22 maps, in English. Available from: New Tribes Mission Bookstore, 1000 East First St., Sanford, FL, 32771 Phone: 1-800-321-5375 Web site: www.ntmbooks.com	

Chronological maps are also available in a generic form – that is, without the English cities and locations imprinted on them. Missionaries can make the blank set into a tribal language set by printing the names of places (in the tribal language) on clear labels and adhering them to the maps.

It is important that the maps are large enough to be seen by everyone. The chronological maps listed above are excellent, but they may not be large enough to be seen in some teaching situations.

Slides and filmstrips

Some missionaries have found colored slides of Bible stories to be an effective tool for teaching and review. (Slides can also be made into filmstrips.)

A missionary in Thailand took slides of things such as local scenery, animals and flowers, etc. He showed these slides during his teaching series on Genesis 1, with the hope that, as the people saw these familiar objects each day, they would be reminded of the spiritual truths illustrated through the slides.

An interesting way of reviewing what has already been taught is, one night a week, to present slides which go back over two or three stories.

Robin Griffith wrote about the advantages of preparing a taped commentary to go with filmstrips.

> *"For some filmstrips, I have prepared taped commentaries. By doing this, the narrative could be thought out ahead of time and done correctly. Then, when it is being played and questions are asked about the filmstrip, I do not lose my train of thought, which easily happens when I do not use a tape. Taped sound effects, such as sheep bleating, can also help to introduce unfamiliar subject matter. There is another practical advantage of taped commentaries. Once or twice, some bugs attracted by the light of the filmstrip projector decided to explore my vocal organs with disastrous results! One time, I lost my voice for the rest of the evening and was not able to continue my oral commentary. Tapes certainly help in such situations."*

Movies

Movies are useful primarily for review. It is unwise to show a movie before actually teaching the story from the Scriptures. Although the people may be entertained if the movie is shown first, the doctrinal points and spiritual significance of the story will not be prominent.

Be certain that any movie used is according to the Word of God and neither adds to nor detracts from the Scriptures.

Tape recordings

The missionary should record all of the lessons as he teaches the people. Having the lessons on tape will enable him to check for weaknesses and areas which need improving in his vocabulary, pronunciation, illustrations, story-telling techniques, teaching methods, and doctrinal emphases.

These recordings can also be used to:

(1) Bring regular attenders who may happen to be absent for one or more sessions up-to-date.

(2) Teach those who through sickness, distance, or some other problem cannot regularly attend the classes.

(3) Teach newcomers the portions which they missed, bringing them up-to-date with the regular class.

(4) Assist new believers when they begin an outreach to unsaved people.

Quite a number of missionaries have bought small battery-operated or hand-cranked tape players to hand out to the people, but, in other situations, the people have wanted to buy their own battery-operated tape players or recorders.

In 1985, Merrill Dyck, working in Venezuela, wrote:

> *"One morning, Pancho, a Pumé tribal man, arrived at my door. He wanted his father, an elderly man who could not attend the meetings, to be able to hear and understand the truth from God's Word. Pancho had been sharing the Word with*

his father, but he felt his teaching was 'way off.' I asked him if his father would be willing to listen to God's Word using a tape recorder. Pancho immediately responded that he would go ask his dad (who lived about four miles away) and come back to let me know. That evening, Pancho was back. His dad had said that a tape recorder would be okay.

"Having seriously considered the use of tape recorders earlier, I had sent for ten of the 'crank' models from Gospel Recordings. But, until this time, we had never been quite serious enough about it to put any tapes together. Now, however, it seemed the Pumé would have an interest in using tape recorders. We suddenly began to realize what a tremendous tool they would be. Let me explain why. The Pumé live in groups of about four to ten families. Each group lives separately, about three to five miles from other groups. In our teaching program, we had been zeroing in on one particular group. With the use of tape recorders, the Word of God could reach each village.

"I talked to Ramon, the first Pumé believer, about it, and he liked the idea at once. He was more than willing to help me teach the taped lessons. So we began! We followed closely the detailed lessons that Trevor McIlwain wrote on Genesis. I would teach a point, and then Ramon would expound on the same thing. Moving on, I would teach the next point, and Ramon would again emphasize it. We sought to make the taped sessions as alive as possible, using many down-to-earth illustrations just as I would in a regular teaching situation.

"It wasn't long before a Pumé man from an upriver village asked for a tape recorder to listen to the Word. About a week later, one of the village chiefs from yet another village came to us, desirous of listening to the taped lessons. Presently, the Word is going out by tape to three villages.

"Once each week, I visit these three villages in person to teach and obtain feedback. I spend a good deal of time questioning them to see where they are in their understanding. Their answers have clearly indicated that they are learning.

"The tape recorder has been, and continues to be, a real help in getting the Word out to the Pumé people. We are thankful that we came upon this tool to help in spreading the Word."

Jason and Shirley Birkin evangelized and established churches among the primitive, nomadic Tala Andig tribe in Mindanao in the Philippines. Tape recordings and hand-cranked tape players were an effective way to teach these people who were constantly on the move. Jason taught the people whenever they visited and stayed overnight, but the majority of his evangelistic teaching was not in person. Jason recorded the lessons on tapes and gave them to the people to take with them. The Lord used His Word heard in this way, and many Tala Andig people are now children of God.

By recording all your teaching of the seven phases, a library of tapes will be built up. These recordings will be of great assistance to the tribal church in their evangelistic outreach and as they teach the Scriptures to new and mature believers.

Tape Recordings

Tape recordings of your teaching sessions will help tremendously when the new believers begin to teach. The believers can review the tapes as part of their preparation. The tapes can also be used as backup when the new believers teach somewhere else. By using the tapes as backup, there is less chance of a wrong emphasis getting through.

– Mike Henderson
NTM missionary to the Aziana Tribe, Papua New Guinea

A number of missionaries have reported the benefits of keeping all their teaching on tape. Using these, the people have been able to hear the teaching of the various phases already covered, not just once or twice but repeatedly in their own homes.

Object lessons

Object lessons are helpful tools to capture the people's attention and illustrate biblical truths.

While visiting John and Kay Tallman, who worked with the Fore tribe in the highlands of Papua New Guinea, the value of objects as a teaching aid was clearly demonstrated to me. The Fore people could not grasp the truth that all mankind was brought into death by being broken off from a meaningful relationship with God through Adam's disobedience. I suggested that John break off a small limb of a tree and use that as an illustration.

When the teaching session began, two old men sitting in front of me were mumbling softly to one another, picking their toenails, scratching, and apparently paying little attention to what was being taught. To my left, about six women were sitting with their children and small babies. They seemed to be far more interested in their babies than the Word of God.

While I was observing the poor interest of these old men and mothers, they suddenly sat up and began to pay attention. The old men craned their necks to get a good look at what the speaker was holding, and they listened intently to what John was saying. The women forgot their babies and also leaned forward to see and hear. What made the difference? John had picked up the piece of pine tree which he had broken off and brought into the house where we were meeting. After he completed his teaching point, John laid the limb back down on the floor. Almost immediately, the old men and the women drifted back to their preoccupation with the things close at hand. Five minutes later, John again picked up the piece of tree, and the same renewed interest was clearly obvious.

In the lessons, I have suggested in teacher instruction notes some possible object lessons. For example:

 Teacher: To illustrate what death means, bring to the teaching session a branch that you have broken off of a tree. (For even greater impact, at the point when you are ready to teach this, walk outside of the meeting place, break off a limb and bring it back to show the people.) Use this branch which is broken off from its source of its life to illustrate that Adam would be separated from God, the source of his life, if he disobeyed God. Just as a branch cannot continue to live once it had been separated from its source of life; likewise, if Adam disobeyed God, he, too, would be separated from God, the source of his life.

Drama

During a story or in between stories, skits can assist in making the story more clear and vivid. Drama can hold the attention of the hearers and grip their imagination in a far greater measure than merely listening to a verbal account. Nevertheless, it is important to stay within the bounds of Scripture and what is culturally acceptable to the hearers. Drama may not be an acceptable form of communication in some cultures, but, even if it is not normally used, its understanding

and appreciation can often be developed. The tribal people can be slowly introduced to simple drama, and then its use can be increased if it proves to be acceptable and useful.

Bob Kennell and George Walker effectively used simple skits to help portray Bible stories when teaching the Bisorio tribe in the Sepik region of Papua New Guinea. George wrote the following suggestions about skits:

> "Drama is an option in teaching. It is not a must. For some tribes, drama may not even be an option, but for many, skits can aid the people in understanding the truth of the Bible lesson. Remember, however, it is not we or our skits that will accomplish the impossible in tribal lives. It is the Lord! Rely on Him to apply the truth of His Word to hearts and lives. Do not rely on your skits.

> "As you do the skits, be creative under the Lord's direction. Always be well-prepared. Props should be ready. Parts should be well-known.

> "You and your co-workers will undoubtedly be the main actors in the skits. Even co-workers who are not yet fluent in the language will be able to take part in some skits. When you need more actors than your missionary team provides, you may find some among the tribal people to fill in the gaps. Usually, 14- to 17-year-olds are able and willing, once they see how to do the skits.

> "To do effective skits, you do not need elaborate props. Keep them basic and simple.

> "Once the props are in place, set the background for the story in the people's minds before acting it out. Explain who is who and what is what. Make sure they are clear on the setting before acting out the skit.

> "As you act out the skit, trust the Lord to help you make it alive. Say your lines with meaning. Use facial expressions and mannerisms the tribal people would use. Use their idioms. Communicate in their terms."

At the close of a skit, or even between the different acts, give teaching and explanation. It is vital to give adequate interpretation of dramatic presentations in case the people have misunderstood or misinterpreted the drama. Tribal people are superstitious and deeply impressionable. The tribal missionary needs to be constantly on his guard, wise in how he uses drama, and always cognizant of the people's true feelings and thoughts.

Even if you do not use skits as a teaching aid, making the story live by voice and body expressions will hold the people's interest and portray the story more graphically. Although care should be taken not to go beyond the bounds of Scripture, use your imagination to visualize the most likely emotional actions and reactions of the biblical characters. If the people in the story were afraid, surprised, amazed, angry, or joyful, display these expressions in a cultural manner. Rather than just sitting, stand up and move around, depicting the actions of the characters from the story you are telling. This will add life and feeling to the historical account. For example, when you tell how Adam and Eve hid from God when they heard His voice calling, "Adam, where are you?" portray Adam and Eve's embarrassment and efforts to hide from God by holding up your hands and cowering against the side of the building like a person trying to hide. When telling the story of the offering up of Isaac, take a knife and lift it up just as Abraham did in readiness to kill Isaac.

Chronological chart

For teaching the Palawanos, we prepared a chart of names in chronological order. This chart included the names and events to be taught in Phases 1 and 2. We used white muslin cloth (known as calico to the British and Australians) for the chart, and we printed the names with an indelible, felt-tipped pen.

Make the chart from one long piece of cloth and attach it to the wall in the place where the meetings are held. If the building is narrow, the chart may need to be divided into two or more sections and placed in their correct order, underneath one another, on the wall. For our chart, my wife made loops at the ends and at regular intervals along the chart so that it could be easily tied to the wall.

Make the printing large enough so that all will be able to see it clearly.

> **Chronological Chart**
>
> A 17 by 66 chronological chart (which comes in three sections) is available in English through New Tribes Mission. The chart is also available in generic form, that is, without the English names on them. Missionaries can make the blank charts into a tribal language set by printing the names (in the tribal language) on clear labels and adhering them to the charts.
>
> Note that this chronological chart may not be large enough to be seen in many teaching situations.

Unroll the chart as the chronological story is taught. Keep only the section already taught and that being currently taught in the view of the congregation.

In the lessons, I have suggested in teacher instruction notes when to display names on the chronological chart. For example:

> ☞ **Teacher:** Point to the name, **"Joseph,"** on the chronological chart.

Chronological chart referred to in the lessons

God Father Son Spirit	God's Angels Lucifer	Adam Eve	Lucifer (Satan) and the angels who followed Lucifer (demons)	Cain Abel Seth Enoch	Noah Shem Ham Japheth	Babel	Abraham Sarah Lot	Melchizedek Hagar Ishmael

Isaac Esau Jacob Joseph	Moses Aaron Joshua	Judges	Saul David Solomon	Kings Jonah Prophets	John Mary Joseph	Jesus The 12 apostles	Paul	The Church

Although the stories of Melchizedek and Hagar and Ishmael would not ordinarily be told in Phase 1, it is important to include these stories when teaching people from Muslim background. Teacher notes in the lessons explain more about adjusting the lessons for Muslims.

In non-Muslim settings, the stories of Melchizedek and Hagar and Ishmael will be added in Phase 2. This chronological chart will also be used for teaching Phase 2. So when you make the

chart, you may either write the names on the chart and explain to the people that these stories will be told at a later date or you may leave a blank space on the chart and write the names in just prior to teaching Phase 2.

Not all people understand the linear concept of time as it is taught in the Scriptures. The chronological chart introduces the biblical view of time and slowly establishes this view as you continue using it throughout the teaching of the Old and New Testaments. Even so, some missionaries have felt it important to educate the people regarding time prior to introducing the chronological chart.

Time Plank

When we taught the Ata people in Papua New Guinea, we made our chronological chart in the form of a "time plank." It was about 24 feet long and had places slotted for all the names on the chronological chart. The names were on small pieces of plywood. As we came to the different names, we just hung them in their correct places.

We used the "time plank" to teach the idea of time. We had marked off the years in lots of ten from the beginning to the current time. At the beginning of the time board, we had a section painted black which was before the start of the years. We did this to show that there was a beginning and something existed before the beginning. (We planned to hang the names God, Father, Son, Holy Spirit and God's angels and Lucifer in this section as we came to them in the teaching program.)

A week or so before we began teaching, we nailed the "time plank" up in the village meeting house where the teaching would be held.

In introducing the "time plank", we said, "See this. We call this 'the time board.' It signifies years. How many years do you think have passed from the very beginning to now? Were your grandparents alive at the beginning? How about your great-grandparents? Were your big men here? No. The time before the beginning was before your big men or our big men."

We pointed out the current time period on the board. We also pointed out different times of significance to the people, such as when white men first arrived in PNG, when cars were first made, when white people first arrived in Australia and America. The people were amazed that the events which they considered significant was all close to the current time period on the time board when compared with all the rest of time – 6000 years on our time board. They said, "Look at all that time there we know nothing about."

To introduce the concept of years, we used small pieces of wood (toothpicks). We bought 6000 toothpicks. We bundled them in groups of 10, 50, 70, but left most loose in a plastic bag. When together like that, 6000 toothpicks looked quite impressive.

We explained, "This is an example of years." We showed toothpick. "This one toothpick marks 1 year." We showed, one at a time, the bundles of 10, 50, 70. "This bundle of 10 here is like 10 years. This bundle is like 50 years. This bundle is like 70 years – as many years as a man's life."

We then spread a piece of plastic on floor and discussed time. "OK. How many toothpicks should I throw down to be equal to how many years have gone by since the beginning?" We began to throw down bundles, explaining in terms the people could understand how many years each would be equal to. When we threw down 10, we said, "The school boys are just infants." When we had threw down 20 toothpicks, we said, "Some of the young men like Savole are not born yet." When we threw down another 10 "years," we said, "I am not walking. I am still a baby. And some of you like Ela and Loram are still young children." When we had thrown down 60 toothpicks, we said, "OK. 60 toothpicks

(continued next page)

Time Plank (continued)

have gone down, and Ataxa and Lelekala have not arrived yet. Only Ue and Kakalo and La'ia and Mixe were here with their fathers and brothers." We threw down 40 more, and explained, "There, 40 more go down and 100 years have been marked. None of you have arrived yet. Your mothers and fathers are young. What do you think? Have we arrived at the beginning yet? No! How many more matches do you think we will throw in?" We threw down handfuls of toothpicks until all 6000 were lying on the plastic on the floor. Then we said, "That is how many to mark all the years that have passed since the beginning. It was an extremely long time ago."

This "time plank" engendered much discussion as the people realized how much time was covered and the huge gaps in their knowledge of the past.

— Paul and Linda McIlwain, NTM missionaries to the Ata Tribe, Papua New Guinea

A prophetic chart

As you teach Phase 1, I recommend you use a chart which lists Old Testament prophecies concerning Christ. (See chart on next page.) As you teach the life of Christ from the New Testament, you will fill in the fulfillment of each prophecy, thereby reinforcing the truth that God does everything that He says He will do.

Write the Old Testament prophecies along with their Old Testament references on the chart. The New Testament references may be written in later when you come to their fulfillment, or written in beforehand and covered until you reach their fulfillment in the New Testament. As you write in the fulfillment or disclose it, your hearers will see how all of the Old Testament references were slowly fulfilled through the events in the life of Christ.

The Old Testament references are arranged to coincide with their chronological fulfillment in the lessons on the life of Christ.

Make the chart large enough to be clearly seen by the whole congregation. Smaller charts can also be made to carry and use in house meetings. If you have a regular meeting place, leave the chart up on the wall so that the people can constantly refer to it. It will be a constant reminder of the main events which you have taught from the life of Christ as well as a testimony of the faithfulness of God to do all that He says.

In the lessons, I have suggested in teacher instruction notes when to display each fulfillment on the prophecy chart. For example:

★ Tell them that God's words written by David were fulfilled.
Then read Psalm 41:9 and Mark 14:10 to them.
Then point to the Prophetic Chart and write Mark 14:10 opposite Psalm 41:9. (See example below.)

What God said about the Deliverer He would send		How God's Word came true
Psalm 41:9	Betrayed by a friend	Mark 14:10

What God said about the Deliverer He would send		How God's Word Came True
Isaiah 9:7	David's descendant	Matthew 1:1
Isaiah 7:14	Born of a virgin	Matthew 1:22-23
Micah 5:2	Born in Bethlehem	Matthew 2:1
Hosea 11:1	Be brought out of Egypt	Matthew 2:14-15
Isaiah 11:2	Some of His characteristics	Luke 2:52
Isaiah 53:4-5	Suffer for others	John 10:11
Psalm 41:9	Betrayed by a friend	Mark 14:10
Zechariah 11:12-13	Sold for 30 pieces of silver	Matthew 26:14-15
Psalm 27:12	Accused by false witnesses	Mark 14:56-57
Isaiah 50:6	Smitten and spat upon	Mark 14:65
Isaiah 53:7	Silent when accused	Mark 15:3-5
Isaiah 53:3	Rejected by the Jews	Mark 15:9-14
Psalm 69:4	Hated without a cause	Mark 15:10
Psalm 22:16	His hands and feet pierced	Mark 15:24
Psalm 22:18	His clothing gambled for	Mark 15:24
Isaiah 53:12	Die with the wicked	Mark 15:27
Psalm 22:6-8	Mocked and insulted	Mark 15:29-32
Isaiah 53:9	Buried with the rich	Mark 15:43-46
Psalm 16:10	Rise again	Mark 16:6
Psalm 68:18	Go back to Heaven	Acts 1:9

Bible translation

While most missionaries are in favor of the translation of the New Testament, some are content to settle for Bible stories, written in the missionary's own style, as the only literature to cover the teaching of the Old Testament. I recognize the usefulness of Bible stories, but, in light of the importance of the Old Testament Scriptures, I believe, wherever possible, the Old Testament Scriptures should be translated.

Although missionaries may never have the time to translate the complete Old Testament for the tribal church, they should endeavor to give the believers as much Old Testament translation as possible. Paul clearly stated that the Old Testament Scriptures are relevant and have also been provided by God for the Church. We who are living in the last days still need the Old Testament Scriptures, for they are God's voice now as much as when they were first written (Romans 15:4; 1 Corinthians 10:6, 11).

"All Scripture is given by inspiration of God, and is profitable" (2 Timothy 3:16). Therefore, Paul charged Timothy as a New Testament church builder, *"Preach the word!"* (2 Timothy 4:2).

This same responsibility has been given to us. Missionaries are to commit the Word to faithful tribal people who have the ability to teach others. But this charge cannot be given to the tribal church leaders regarding the Old Testament Scriptures if they are not translated into their own language. They will have no authority to say, "Thus saith the Lord." It is not right to elevate our rendition of Old Testament stories to a place of equality with the translated New Testament Scriptures. The phrase, "The Word of God," should only be used when referring to Scriptures translated from those originally given through inspiration of the Holy Spirit.

Furthermore, through the Old Testament Scriptures, the Holy Spirit will be able to continue teaching the functioning tribal church. He will lead them deeper and deeper into previously unseen treasures of truth in a way which will be impossible if they only have stories from the Old Testament. The growth, faith and walk of the believers will be limited, apart from a translation of at least the major portions of the Old Testament.

Just as it is not good to teach doctrine divorced from its God-given historical setting, so it is equally unwise to depend only on stories which lack the doctrinal content, interwoven, many times very subtly, into the Scriptures through the chosen words of the Holy Spirit.

To only provide a book of Old Testament stories for the tribal church is to deny them and succeeding generations the opportunity of hearing God speak through the Old Testament Scriptures, just as He has spoken to us. Our book of stories will never carry the same authority as the Scriptures. Scripture tells us that all who enter God's family have been *"born again, not of corruptible seed but incorruptible, through the word of God which lives and abides forever"* (1 Peter 1:23). God's power and life are inherent in His Word. The Holy Spirit will own His written Word in every generation (Acts 20:32).

Although it is important to have Scriptures for every teaching phase, it is not essential, nor is it usually possible, to have a completed translation before evangelism begins. For evangelism, Phase 1, it is only necessary to translate the selected portions specified for the lessons for the Old and New Testaments. (These Scripture portions are listed at the beginning of each Phase 1 lesson. These Scriptures are also listed separately in the Appendix to Volume 2.) If the translator covers only these portions, he should be able to supply the Scriptures for reading during the

teaching sessions. Additional portions may be added as they are needed for the successive phases.

Bible Translation
Its Place in Church Planting

Over the centuries Bible translation has played a key role in the spread of the Gospel. Saving faith comes through hearing and understanding the Word; Bible translation makes that Word available in a form that is understandable. When no Scripture base exists in the language where a church is to be planted, Bible translation is a fundamental part of the church planting process.

How God communicates with man

In ancient times God frequently spoke His Word orally; sometimes directly, sometimes through prophets or others. Today, however, what we know of God and His truth we know from the **written Word**. When we teach, preach and tell the story, we are expounding from that inspired written truth. Early on in our presentation of that truth, we work hard to establish that the authority of our teaching is the written Word of God (for if not, how does it differ from any other story that has been passed down through the ages?).

The Word of God translated into the vernacular of the people is the visual evidence of that truth. We demonstrate our claim that God earnestly desires to communicate with man when we do the difficult work of Bible translation. When we lay aside that difficult work and fail to produce the evidence of that claim, we cast doubt on the very truth that we teach.

A view from the hearer's bench

Under pressure to begin "the ministry," those who undertake the challenge of cross-cultural church planting frequently concede that it may be a "workable" option to begin without a Scripture base, or to use an English or trade language Scripture base. From the standpoint of the message teller, this option seems workable. First, he is confident that the text he holds in his hands is indeed God's Word. He feels confident that he can make proper application of that Scripture; and he may even be optimistic regarding his ability to deliver the message in the vernacular.

But is this arrangement really "workable" from the standpoint of those who are to receive the message? Are these assurances in the mind of the well-intentioned message teller necessarily passed along to the hearer? Probably not.

To the hearer, the message is new, somewhat strange, and probably comes in a rather disconcerting mixture of grammatical and cultural irregularities. As church planters, we pray that the hearers will understand this message, that they will believe it and commit their lives to it. But if the message is unclear, the response will not be decisive. How is the hearer to study and ponder the claims that God makes on his life? In fact, how is he even to remember that truth that he heard last night, last week, or last year?

To make this message a part of their lives, tribal hearers will need every benefit available to them. They need the opportunity to study, to ponder, to see the Holy Spirit use His Word to cleanse, convict, and direct. We know the central place of God's written Word in our own growth and development as believers. Should we expect that tribal believers need the written Word any less?

(continued next page)

Bible Translation
Its Place in Church Planting (continued)

Telling the story

Recent emphasis on storytelling as a method of evangelism and teaching has alerted us to something that seems to be universal across cultures – people enjoy and generally learn better from narrative (story-style) teaching. The example of Scripture itself not only adds weight to this emphasis but is no doubt the foremost example of it.

Good storytellers make good Bible teachers, and we should enthusiastically tell and teach the wonderful Gospel story. But our enthusiasm should genuinely be for the story itself and for the stories as told in the written accounts of Scripture. It's the Scripture that gives accuracy and authenticity to the story we tell.

Effective translations of the Scripture with all of the drama and spice of the original really do communicate the full impact of these fascinating narratives. What a powerful sword in the hand of a teacher is an effective translation in the language of the people, available at the time when people are first introduced to the Scripture and to the chronological story of the Gospel of Christ.

– Larry Goring, NTM Field Ministries Coordinator

10

Developing and Teaching Phase 1 Lessons

The chronological Bible lessons that I have developed for this series cover the key Scriptures and emphasize the truths necessary for each particular phase of the chronological teaching outline. The lessons have been written as a teaching manual for missionaries working with tribal people.

Although designed for tribal people, the lessons can be easily adapted for use in any culture, in any setting, and with all ages. I have used the same chronological approach in Australia for home Bible studies and for religious instruction in schools. The same approach has been used to teach youth groups, adult and junior Sunday school classes, daily Bible classes in schools for missionaries' children, and as the major course for Bible institutes. This lesson material has been taught by foreign and indigenous Christian workers in many countries around the world and has been translated into nearly 200 languages. Translations into other languages are presently in progress. Information about the languages into which these lessons have been translated can be obtained from New Tribes Mission.

Guidelines for adapting

These lessons have been prepared first and foremost for missionaries. They were written to guide missionaries step-by-step as they write Bible lessons in tribal languages, first for themselves and then for tribal believers as they reach out in evangelism.

It is important that you don't merely read the lessons and then lay them aside as you prepare your own lessons. If you do this, there is a great danger that you will omit vital truths that need to be taught and that you will miss important teaching goals. While critiquing teaching materials prepared by missionaries, it has been obvious to me that many had read the lessons, put them to one side, and then depended on their memories to recall the points of doctrine to be given priority.

Prepared with Transfer in View

A primary reason for revising the *Building on Firm Foundations* series was to make the lessons easier to transfer into indigenous languages. Although the lessons have always been an excellent resource, certain language features used in the original lessons hindered the process of adapting the concepts into other languages.

With input from missionaries who had adapted the original lessons along with the guidance of Carol Kaptain, NTM translation consultant, we established a list of criteria to follow, with the intent of making the lessons easier to adapt. Among those were the following:

- To change idioms to words with more literal meaning
- To clarify ambiguous constructions
- To use complete sentences
- To rewrite complex constructions (sentence level and paragraph level) so that the meaning would be clearer
- To reduce the use of passive voice
- To cut down on the number of rhetorical questions
- To make sure logic progressed from the generic to the specific
- To cut down on the wordiness and repetition
- To delete theme lines from the lesson text, making sure the theme was embedded in the text.

As part of the revision process, Carol Kaptain reviewed each lesson as it was revised, looking at it from the viewpoint of transfer. Others reviewed the lessons from other perspectives. And of course, Trevor McIlwain, the author, was fully involved in the process.

By following the above criteria and having the lessons checked specifically for translation issues, the revised lessons are easier to transfer into other languages.

– Ruth Brendle, Editor of the *BOFF* revision

I recommend that missionaries follow the lessons in the *Building on Firm Foundations* series closely to keep headed in the right direction. Check the lessons you prepare in the tribal language against the chronological Bible lessons. Check point by point to make sure you have included the correct emphasis and that you have covered all of the different truths taught in the lessons.

Dialogue teaching style

Not only do the chronological Bible lessons show **what** to teach, they also show **how** to teach. On a number of occasions when conducting seminars, missionaries have requested that I demonstrate the teaching style which I recommend by teaching them as if they were tribal people. Therefore I wrote the lessons as though I were actually addressing a group of tribal people in Palawan, an island of the Philippines.

I have deliberately written in dialogue form. Throughout the lessons you will see that I constantly encourage the people to think about something or to respond to a question. Of course the people's responses are not actually included in the lesson text. Nevertheless the dialogue style is clear, and you should be able to adapt that style for your teaching situation. It is important that we do not preach but rather teach. Our style should not be stiff and stilted but

lucid, free and spontaneous. Because most who use these lessons will be teaching as a member of a team, the lessons have been written in the plural form, except for an occasional personal illustration. Note that I used the word "we" in the lessons to show that the teacher is referring to himself as well as the whole team.

Translation versus Adaptation

Should these lessons be translated literally?

- Literally as to the meaning, but not literally as to form. Translation is the transfer of meaning.

How does the translation of these chronological materials differ from Bible translation?

- There are many similarities, but one primary difference is the degree of liberty that the translator has with these materials to contextualize and adapt to the local culture.

- Contextualizing and adapting to the local culture has to be done carefully so that the meaning and purposes of the book are adequately communicated.

In what ways should the text be adapted to the target culture?

- Illustrations: It is more important that the point of the illustration be made than to translate the illustration itself. (In translation terms, the grounds of comparison must be in focus).

- Formatting: The material should be checked to see if layout features such as indenting and boxes communicate what they were supposed to communicate. If necessary, adapt layout and order of presentation so the target readers will find it easy to understand.

- References to other cultures which may be confusing or misleading in the target culture should be adapted.

- References to other religions which may be offensive in the target culture should be adapted.

What essential elements need to be most carefully transferred in order to accomplish the intended purpose of the books?

- Ideas that form the essential core of the chronological presentation should be carefully adhered to. These core items are presented in the introduction and reiterated throughout the lessons.

- Repetition of biblical themes should be maintained. The "redundancy" has a purpose.

– Larry Goring, NTM Field Ministries Coordinator

Don't rush

Even though the lessons are written as though I were actually teaching the tribal people, you should understand that I have not included all the reiteration and expansion of each point which I would normally give when teaching. I have tried to include only that which is necessary to clearly demonstrate how to teach each part of the chronological outline. I have left it up to the teacher to emphasize, illustrate and expand the thought until he is satisfied that his hearers have clearly grasped it.

The necessity for repetition and expansion of these clear, simple points will differ according to the ability of your hearers to clearly comprehend the concepts being propounded. Therefore,

don't rush the teaching. Some teachers hurry through in order to cover a lot of material in one lesson. They give many points but communicate very little truth.

Take your time in teaching. Instead of watching the clock, watch your hearers and gauge the length of your teaching sessions by their reactions and general attitude. Be sure your listeners are thinking each point through logically with you. In the lessons, you will find that, by illustrations, explanations and questions, I constantly appeal to the people to think through each new concept.

Lesson goals

The primary goals of Phase 1 lessons are for the hearer:

- To know the basic historical facts of the story of the Old Testament and the Gospels

- To see the wonder of the nature and character of God revealed through His acts down through history and through His Son, Jesus Christ

- To recognize that because of their sin they are separated from God

- To repent as they see the great contrast between themselves and a holy God

- To realize the impossibility of them ever pleasing God by their own efforts

- To understand and believe that God has made a way for them to be restored to a right relationship with Himself through the Deliverer

- To trust in Jesus Christ as their personal Savior

In order to accomplish these goals for the hearer, the teacher will need to tell the Bible story clearly and, while doing so, to emphasize the doctrinal themes important for evangelism. These doctrinal themes are exemplified through the actions of the characters and the historical events in the Bible.

These doctrinal themes are of great importance. Many missionaries have told me that, prior to being introduced to this particular outline, they had already taught many of the Old Testament stories. But they had not previously seen, and therefore had not emphasized, the important points of doctrine which are embodied in the historical incidents recorded in the Bible.

Through the stories and the individual incidents chosen and recorded by God in the Old and New Testaments, the Holy Spirit has continually emphasized doctrinal truth by the actions and words of God, Satan, and man. The teacher's responsibility is to teach and expound these stories in such a way that each of his hearers will not only remember Bible history but will also come to a clear understanding, first of the nature and character of God, then of himself (that is, the

Doctrinal Theme Line Removed

Those who are familiar with the original version of the *Building on Firm Foundation* lessons will notice that the revised version no longer lists the doctrinal themes on a separate line in the lessons.

The theme line was never intended to be spoken, but some missionary and tribal teachers were confused, thinking they needed to "read" the theme because it was written in the lesson text. Therefore, the theme lines have been removed from the lesson text. The doctrinal themes, however, are still included as integral parts of the lesson text.

hearer's own true nature and character as God sees him), and finally, of Satan as revealed by God through the Scriptures.

Doctrinal themes emphasized in Phase 1

The doctrinal themes which are emphasized through Phase 1 are those which will show people they are sinful, condemned, and helpless before God, their holy and righteous Creator and Judge, as well as those which will generate repentance and faith and bring complete dependence on the Lord Jesus Christ as the all-sufficient Savior.

The themes are constantly repeated throughout the Phase 1 lessons. This is the main strength of the chronological teaching. Unbelievers are not immediately or easily gripped with the attributes of God and most of all they don't readily see how **who God is** relates so importantly to them.

The doctrinal themes to be emphasized in Phase 1 are:

1. The person and character of God

- **God is supreme and sovereign.**

 That God is supreme and, therefore, sovereign is probably the most important, initial truth that people need to understand. This truth is foundational to all other doctrines concerning God and all other spiritual matters, and it should be continually emphasized so that man will realize his true position in relationship to God and all other created beings. Before a person can by saved by trusting in Christ alone for his salvation, he must recognize that there is someone above him who has the right to tell him what he should and should not do. This One, his sovereign Creator, also has the right to condemn him to everlasting punishment because of his disobedience.

 God's sovereign position is evidenced in the biblical record by His authority over Satan, man, and all creation. None can prevent or question what He does. He is the great Initiator. He is the Alpha and Omega, working all things according to the counsel of His will. He is not like any creature, for He cannot be deceived, bribed, appeased, or manipulated.

 This type of supreme being is foreign to the mind of the animistic tribal person who spends his entire life trying to deceive, manipulate, bribe, or appease the spirits in an effort to keep in an agreeable relationship with them. The animist lives in constant fear of spiritual powers that do not have any right to control him. These Satanic spirits have usurped the place and authority of God. They are impostors, for God alone has the right to rule over man. We must show that God has the leading role in the history of the world. He directs the course of history, and He has the final say in the life of every spirit and every human being. He controls the future of planet earth and the universe.

 The supremacy and sovereignty of God is constantly emphasized throughout the Phase 1 lessons for evangelism. God showed His supremacy and sovereignty over Lucifer and the angels that rebelled against Him by removing them from their

former positions of honor in Heaven and the service of God. Later, when Adam and Eve rebel, God shows His sovereignty and supremacy by removing them from the garden in Eden. Other significant demonstrations by God of these same attributes were in His dealings with Cain, the people in the days of Noah and rebellious Pharaoh who dared to defy God by refusing to release the Israelites.

We must teach the Scriptures in such a way that people will be aware that God is not, as the animist thinks, a mere distant, silent observer to world events and their own personal lives, but He is an active, living, present Person who is vitally interested in all that they are and do. He must be seen as He really is, their almighty Creator and sovereign Judge to whom they will give account for all they do and say.

Since He is supreme, He must be shown through His actions in history to be always victorious, regardless of the strength or countless number of His adversaries. He overcomes all who oppose Him. He is always victorious. He stands supreme and gloriously sovereign as the almighty God.

- **God communicates with man.**

 God is not silent. He speaks to every person. We must impress on our hearers that God not only has spoken but also that God is speaking. The Bible is not just a record of what God said to people in the past. It is also God's voice to us in the present. Even when God has not actually spoken with an audible voice, He has still made known His will by His actions or by some other means. (See Hebrews 1:1.)

 While it may not always be very clear when this aspect about God has been stressed in the Chronological Bible Lessons for Phase 1, nevertheless, this is the whole point and emphasis of every lesson. God has spoken and is now speaking. If He is not speaking to us, there is little point in even considering the message of the Bible.

- **God is everywhere, all of the time. God knows everything.**

 These themes are embedded into every part of the story of the Bible (Hebrews 4:13). If taught correctly and impressed on your hearers, these truths can be a powerful instrument in the hands of the Holy Spirit to bring deep conviction of sin. Most people, until faced with the fact of God's constant presence and perfect knowledge of their every thought, word and action, are only concerned with keeping up appearances before their fellow man. Therefore, as Scripture says, *"There is no fear of God before their eyes"* (Romans 3:18).

 Examples of God being there and seeing and knowing are abundant in every Bible story. For example, the Lord saw that the wickedness of man was great in the earth in Noah's time, and God knew of Israel's plight as they toiled in slavery in Egypt. These points are great teaching opportunities, for through these events you are able to impress on your hearers that **the God who was is the God who is**. God saw, and God sees. God knew, and God knows. No one can escape from this ever-present, all-seeing and all-knowing God (Psalm 139:1-18).

- **God is all-powerful.**

 That God is almighty and should therefore be worshipped and feared has little impact on godless, unbelieving mankind. The power of nature and the ability of man to control and make his own "world" are far more significant to the majority of people than the power of God. But the theme of God's almighty power is clearly written in all human history and clearly declared in the Bible's account of creation and history. God's mighty power is evident in His destruction of the human race by a global flood and the overthrow of the cities of Sodom and Gomorrah. The Lord said to Pharaoh, *"For this purpose I have raised you up, that I may show My power in you, and that My name may be declared in all the earth"* (Exodus 9:16).

 If clearly expounded and applied to your unsaved hearers, the account of God's mighty power demonstrated time and time again in Old Testament history and in the life of Christ will be used by the Holy Spirit to humble their proud rebellious hearts and lead them to repentance.

- **God is holy and righteous. He demands death as the payment for sin.**

 We must teach that God Himself is the standard for goodness, and, therefore, anything which disagrees with or is contrary to what He is, is sin. Anything less than what God is, is unacceptable to God.

 God's holiness and righteousness are most clearly revealed in history through His consistent attitude of judgment on man's deviation from His holy standard. God will not overlook sin. All sin must be paid for. *"The soul who sins shall die"* (Ezekiel 18:4). Furthermore, because God is righteous, He will never lower His standard of holiness nor accept anything less than the full, righteous payment for sin.

 As was mentioned earlier, the animist constantly endeavors, and feels he succeeds, in appeasing, bribing, and manipulating the spirits. Therefore, the animist must see from the historical accounts of the Scriptures that God is a holy and righteous God who demands full payment for sin. He will never allow any man to approach Him unless the complete and righteous demands of His law are fully paid. He will not and cannot be manipulated.

 Even though the righteous demands of God's law could only be provided through the blood of Jesus Christ, God still accepted sinners who came to Him in faith during the time prior to the cross because Christ's death was, even then, a present reality to God (Revelation 13:8). Nonetheless, during the Old Testament dispensation, worshipers had to be reminded of what was so clear to God. Worshipers had to be constantly reminded that their acceptance by God was not at the expense of justice. God demanded the death of the sinner. Animal blood could only act as a temporary covering for sin. There could be no complete satisfaction for the offerer before the cross. There was always a consciousness of sin. Death, the wages of sin, was constantly portrayed by the death of innocent animals which had to be without blemish as a picture of God's unwillingness to accept anything less than a perfect payment for sin.

The first recorded example that we have of a man bringing an animal sacrifice is the one Abel brought. Abel's sacrifice must have been on the basis of a divine revelation. The first time God gave man permission to kill and eat animals is after the flood. Abel would not have taken it on himself to take the life of one of God's creatures and give it as a sacrifice to God unless it had been ordered by God. Abel came by faith. Faith requires a revelation from God as its basis. It is mere human presumption, not faith, which acts apart from a revelation, hoping that it will be satisfactory to God. This was the way Cain came to God.

Therefore, constant reference is made throughout the lessons in Phase 1 to God's requirement of animal sacrifices because these emphasized God's holiness and righteous demands for the death of the sinner as the payment for sin. Animal blood could not be a replacement for the death of the sinner, but it was a constant reminder that nothing less than death could satisfy God's holy and just demands (Hebrews 10:1-12).

- **God is loving, merciful and gracious.**

 God's love, mercy and grace shine most brightly against the dark backdrop of man's deliberate and constant rebellion. No sooner had Adam sinned by ignoring God's clear command and warning, but God demonstrated His love, mercy and grace. Because of His love, He exercised mercy by withholding the full judgment man justly deserved, and He exercised grace by promising a Savior and clothing naked guilty man in the skins of animals killed by God Himself. Demonstrations of God's love, mercy and grace are interwoven into every story you will tell. Even the story of Sodom and Gomorrah, where God's wrath is so prominent, portrays a merciful, loving and gracious God. God poured out vengeance, yet He delivered Lot.

 Even though while teaching the Old Testament, we will not tell of God's greatest demonstration of His love, mercy and grace which was through the death of His Son, we will constantly emphasize these glorious attributes of God. While faced with their sinfulness and a God who demands death as the payment for sin, your hearers will also have this hope – that they too may yet experience the love, mercy and grace of God.

- **God is faithful and does not change.**

 God never changes; therefore, His righteous standards never change and He always keeps His promises. The Bible stories emphasize that God's attitude is always the same toward the unrepentant and that He is consistently merciful and faithful to forgive and save all who put their trust in Him.

 The promise of a Deliverer was given soon after man sinned. Even though the human race continued to rebel, God never wavered from His plan to provide a way of salvation through Christ. Down through the years, God faithfully renewed His promises of a Savior. Abraham, Isaac, Jacob and David were personally promised that their descendant would fulfill God's promise.

 Numerous opportunities are given throughout the Phase 1 lessons to emphasize that God remains the same as He was in the beginning and therefore He can be

relied on to do all that He said He would. If there is the possibility that God will change so that He will not carry out His threats of judgment on the unrepentant and His promises of mercy for those who trust in Him, then the Bible stories have no application and are merely meaningless history of people long dead. But this is not so! As you teach, you will be constantly impressing on your hearers that the God of the Bible has never changed and will not change in any of His attitudes and dealings with human beings. As He was in the past, so He is today. This emphasis will provide the Holy Spirit with powerful truths that will enable Him to produce conviction of sin, repentance towards God and then faith in God's promises of eternal life to all who put their faith in the Lord Jesus Christ.

2. Man

- **Man is a sinner under the death penalty. He needs God and is helpless to save himself.**

 Man cannot please God by his own efforts. Only the grace of God can save him. The Phase 1 lessons will establish that mankind's sinfulness before God is based, first of all, on Adam's disobedience to God (Roman 5:12). The illustration of a limb being broken off a tree is used to show that Adam, through sin, was separated from God. Just as a limb and every twig and leaf dies when separated from the tree, so Adam and all his offspring were separated from God and are under the death penalty.

 The sinfulness of man is so obvious throughout every stage of the biblical account of man's history. Man's inability to save himself apart from God's intervention is pictured in the ark as the only way of deliverance from the world-wide flood. It is also seen in Lot being rescued by God from the destruction of Sodom and Gomorrah.

 Man's helplessness in the natural realm is used in the Scriptures to illustrate man's spiritual helplessness and the need of God's gracious provision for deliverance.

 These pictures of man's helplessness in man's history will be applied in the lessons to remind the hearers that they are helpless sinners under the death penalty and that only God can deliver them. The Phase 1 lessons conclude with the wonderful and positive announcement that, just as God intervened to rescue believers throughout the Bible story, so God has come to man's ultimate rescue from death for all who put their trust in the Savior, Jesus Christ.

- **Man can come to God only according to God's will and plan.**

 Because God is holy and supreme, He alone determines the way man can approach Him and be saved.

 Whatever man does to approach God must be done exactly the way God has prescribed. This will be taught many times throughout the Old Testament. After Adam and Eve sinned and realized they were naked, they made themselves aprons of leaves. God rejected their efforts to make themselves appear acceptable. If man

was to be clothed acceptably before God, then it had to be done God's way. God took the initiative. He killed animals, made coats from their skins and put them on Adam and Eve. Later when Cain and Abel came to worship God, Cain came according to his own way and was unacceptable. Abel came by faith, bringing a correct sacrifice, and so was acceptable to God. It had to be done God's way. This same theme is also seen clearly in the building of the ark and the Tabernacle.

This important principle in God's way of dealing with all mankind will be applied to your hearers so they will come to understand that they cannot come to God according to their own ideas or the ideas of others. They can only come to God through God's appointed way – the Lord Jesus Christ (John 14:6).

- **Man must have faith in order to please God and be saved.**

In Hebrews 11, the Holy Spirit guided the writer to list in chronological order many of the leading characters found throughout Old Testament history. The writer began with Abel and continued on to list Enoch, Noah, Abraham, Sarah, Isaac, Jacob, Joseph and Moses. Finally, knowing that those who could be mentioned are far too many, the writer concluded, *"...time would fail me to tell of Gideon and Barak and Samson and Jephthah, also of David and Samuel and the prophets"* (Hebrews 11:32).

As well as mentioning these people by name, the writer pointed out some of their most prominent accomplishments. For example, Abel offered a sacrifice that was acceptable to God. Enoch was taken to heaven without dying. Noah built the ark. Abraham and Sarah left their home to live in a foreign country. Moses stood up to Pharaoh and rescued the Israelites. Later in the chapter, the writer listed some of the incredible exploits of yet other characters who lived towards the close of the Old Testament era. But as great as the accomplishments of all these people were, none of them pleased God merely because of the extraordinary feats they achieved. Faith in God was what made them acceptable to Him. For *"without faith it is impossible to please Him"* (Hebrews 11:6).

It is vitally important then that we, like the writer of Hebrews, keep the emphasis in each story on the faith of those whom God accepted. Even though the faith of the leading characters is not usually mentioned in the stories we will be teaching from the Old Testament, we will take our model from Hebrews 11. We will emphasize that it was faith in God, or the lack of faith in Him, that determined a person's ultimate acceptance or rejection by God (Ephesians 2:8-9).

3. Satan

- **Satan fights against God and His will. He is a liar and a deceiver. He hates man.**

Satan and the angels who followed him in rebellion against God were created by God and, therefore, are dependent on, and finally subject to, His authority. They are the implacable foes of God and man. Satan uses his angels and sinful man in his efforts to establish his own kingdom and to try to destroy the kingdom of God.

Even though Satan and his angels are not often mentioned in the Old Testament text, it is good to remind our hearers of their continual presence and influence in the history of the world. We know from the New Testament that Satan is the *"god of this age"* (2 Corinthians 4:4) so we know he is always present to tempt and guide men in their opposition to God and His will.

Even so, God is always triumphant over every endeavor of Satan to destroy God's plans to bless His people and bring salvation to mankind.

4. Jesus Christ (New Testament only)

- **Jesus Christ is God.**

- **Jesus Christ is man.**

- **Jesus Christ is holy and righteous.**

- **Jesus Christ is the only Savior.**

Keep a balance

We must beware lest we emphasize these doctrinal themes to such an extent that the biblical, historical account is forgotten or diminished. Both the historical stories and the doctrine taught by them are important.

If the stories are correctly told and expounded, they themselves will become a living, vibrant revelation of the doctrines which the people must know even when we do not topically state the doctrine.

This is not to suggest that we should tell the stories uninterpreted, hoping that our hearers will understand from the biblical text what is so clear to us. As co-laborers together with God, we have been given the responsibility to expound and interpret the divine text and the recorded history. Like the Ethiopian eunuch, people need Spirit-controlled "Philips" to make the scriptural interpretation clear. Keep a balance between storytelling and exposition so that one does not overshadow the other.

Teaching the lessons

Faith comes through hearing the Word of God (Romans 10:17). "To hear" in the scriptural sense is also "to understand." As teachers, we are responsible to make sure our hearers clearly understand what they are being taught.

Hold their interest

You cannot teach people unless you have their attention. Keep your hearers' minds active and receptive by your use of cultural illustrations, questions, and even humor, as long as it does not make light of the Scriptures. Make sure that, at all times, the majority of your congregation are actively participating and actually thinking along with you while you are teaching. Proceed with calculative precision, establishing each point firmly in their minds.

Dick Sollis, former chairman of the Research and Planning Department of New Tribes Mission, wrote the following on the subject of communication:

> "A professor of communications at Wheaton College advises: 'Only one-fourth to one-third of what is spoken is remembered. Make sure your audience remembers the right one-fourth or one-third.' When we are evangelizing or teaching cross-culturally, it is probable that even less is remembered. How much longer and harder must we then labor and prepare to assure that the small percentage understood and remembered constitutes a true building block to faith, salvation, or the Christian walk."

Use illustrations

The Lord Jesus Christ, the perfect Teacher, used common everyday objects, situations and human relationships to illustrate divine truths. His stories, illustrations and parables were taken from the normal, cultural experiences of His hearers.

For example, the Lord Jesus spoke of fishermen catching all types of fish and then sitting down and sorting them. He talked about farmers sowing, harvesting and storing their grain. He spoke of shepherds caring for and seeking their sheep. He told of wayward and faithful sons and the natural love of a father. He spoke of a woman losing and searching for a coin. He told of children in the marketplace, pretending they are participants in weddings and funerals. He spoke of a traveler being beaten and robbed but cared for by a kind Samaritan. He told of a king giving a wedding feast for his son and judging and punishing his servants.

The Lord Jesus talked of lilies, grass, vines, corn, birds, fish and animals. He talked about rain, floods, winds and fair weather. He spoke of wine, water, bread, old and new cloth, houses and candles. All of these and many more natural and commonly seen objects were used to illuminate His hearer's understanding and to help them discern those spiritual things unseen by the natural eye.

We, too, should use local objects, cultural stories, and normal, everyday situations to illustrate and emphasize the meaning of spiritual truths in the Scriptures.

I have included sample illustrations in the lessons. Illustrations are in a box and identified with a candle icon. Illustrations are proceeded by a Lesson Developer note which explains what the illustration is about. This is a sample of what the illustrations look like in the lessons:

> **Lesson developer:** Use illustrations about what life might be like if there were no trees. For example:

> *What would life be like if there were no trees? What would you use to cook your food if there were no trees for firewood? What would you use to build your houses if there were no trees for posts? How would you escape from the heat of the sun if you didn't have the shade of the trees?*

The illustrations which I have given in the lessons may not fit the culture of your hearers, but they will stimulate your imagination to think of more appropriate cultural illustrations. For example, I included this illustration in one of the lessons: "You men have hunting and fishing to do. You young people like to play and swim." Because not all tribal people swim, you as the lesson developer should use an example of an activity which the people you are teaching normally would do.

> **Adapting Illustrations**
>
> Trevor's materials are remarkably universal. Often we have searched for a better illustration than he has used only to adapt his.
>
> – Wayne Gill, NTM Missionary to the Chimane Tribe, Bolivia

The lesson developer in a particular work should consider the purpose of each illustration and then develop one which is designed specifically for the people being taught. Although the illustrations in the lessons can be adapted to fit a particular teaching situation, most of the illustrations can be used with only minor adjustments.

Adapt the illustrations to make them meaningful to your hearers. Refer to real things, real activities, and real events. For example, a tribal person may be working each day on a canoe out in the jungle. Mention his name and use his canoe and his work in preparing the canoe to illustrate some point.

Even though some stories told by the missionary may be fictitious and the experiences of the characters may be beyond the everyday probability of the average hearer, it is best if everything in the story is culturally and logically feasible. For example, I told the Palawanos a story in which the main character went to Manila to see the President. This was highly improbable for many Palawanos, but it was still within the realm of possibility, because a few Palawanos had been to Manila. Although fictitious stories may be used when illustrating biblical truth, the best illustrations are those from real life.

After explaining and illustrating a point, make application to the times and lives of the people you are teaching. Interpret all Bible history in such a way that each person will see it as God's message to him. Do not leave it to your listeners to apply the truth to themselves and their situation. Apply each truth in such a way that your hearers will be certain that they cannot escape the reality of God and the truth of the Bible, either in the present or in the future.

> **BOFF Books Form Base Curriculum**
>
> The BOFF books form a base curriculum which was written as an example of how it would be taught to the Palawano people – who were South East Asian and predominantly animistic. Anyone undertaking the project of lesson development needs to have thought through how they will contextualize the material in the light of the worldview beliefs and religious influences in the target culture.
>
> – Paul McIlwain, NTM Church Planting Coordinator

Be alert for the unknown

Our familiarity with Bible stories, Bible culture, and biblical concepts makes it very easy for us to include details in the lessons which will be unfamiliar to our hearers without first giving clear explanation. Therefore, it is important that we introduce each new character, unknown object, cultural detail, and doctrinal point with sufficient explanation to make the story and truths of the Scriptures comprehensible and meaningful to our hearers.

Keep to the subject

Always hold the central topic clearly before your hearers. Even though you may digress temporarily from the main topic, carefully use your diversion as yet another illustration of the central theme.

Don't let people draw you into subjects or details which come later in the Scriptures. Answer, "That is a very good question. Later on in the story, we will learn the answer to that question."

Unnecessary details

Some teachers, in their zeal to be good teachers, crowd their lessons with many unnecessary details. While some interesting details should be included to give life and reality to the story, such details should never take center stage and so overshadow the more important aspects of the story or its spiritual message.

We should be careful lest we become overzealous in our efforts to get people to remember historical details of the story of the Bible. One missionary told me how, when he first began to teach, he insisted that all his hearers should remember what God created on each successive day of creation. After some time, one old man told the missionary, "Forget about me. If remembering all of those details is necessary, then I am certain to fail."

Some Bible teachers find it very hard to follow the biblical principle of progressive teaching. In their eagerness for people to know all the truth, these teachers forget the necessity of first laying foundations and then building, step-by-step. They find it extremely difficult to leave people temporarily ignorant of important teachings which will be taught later.

Teaching is like building. Both take time. A building is completed brick by brick, plank by plank, story by story, according to the plans of the building architect. Time must be given for concrete to harden, timber to dry, bonding to seal, and paints to dry before the builder can proceed with the next stage of the building construction.

The immediate goals for each lesson should contribute step-by-step to reaching the long-term teaching goals. Therefore, it is important not to crowd all of the long-term goals into each lesson. Every story told should move the hearers forward yet another step in their understanding of the complete story of the Bible and body of doctrinal truth.

Ask questions to begin each lesson

Tie every new segment of the story back to the portion already taught so that your hearers will see the Bible as one harmonious story. At the beginning of each lesson, you will see instructions to review the previous lesson by using the questions from the end of that lesson.

In the lessons, the instruction to review looks like this:

> **?** **Review Questions from Lesson 6.**

At the beginning of each teaching session, review the questions from the previous lesson to remind your hearers of the previous story and the doctrinal truths taught through it as the basis and introduction for the coming story. To proceed when there is misunderstanding or ignorance will only pave the way to greater confusion and possibly, in the end, spurious conversions.

Merrill Dyck wrote concerning the teaching ministry with the Pumé tribe in Venezuela:

> *"On November 8, 1982, we began to teach the Pumé people the Word of God. We met with them six days a week, hoping to see the Word really take root in their hearts and gain control of their thinking. We went through the Old Testament chronologically, hitting the main accounts, and then on through the New Testament, right up to the ascension of Christ. We found that it was necessary to do a tremendous amount of review. But the review was well worth it, because the people began to understand what was going on."*

Ask questions while teaching

Not only are review questions helpful before beginning a new lesson, but questioning the people while you are teaching has many advantages, such as:

- To help keep them alert

- To indicate if you are clearly communicating what you intended

- To make evident to you those who are understanding and those who need supplementary teaching

- To give the people opportunity to express their own thoughts.

The Dilemma of Questioning

It is very probable that the people have never had occasion for the kind of questioning we will use in teaching. The type of teaching they are accustomed to would be, for example, how an older person would teach a younger person how to make a basket, or the way they pass on their secrets about initiation rites, or even the type of teaching they may have been exposed to through church or school. If we limit ourselves to asking questions only in ways the people are used to, we will be very limited.

This dilemma is similar to the dilemma Bible translators face. How far should you go in contextualizing something which is out of the people's sphere of understanding? Concepts such as absolute truth, God's Word, God communicating with man are usually not part of most cultures we target. Neither is the way we teach.

While it is futile trying to determine what is appropriate for every situation, it is often possible and appropriate to introduce ways of questioning which have not previously been practiced in the culture. Much depends on the kind of relationship which has been established prior to the start of formal teaching. Much also depends on the teacher's skills.

– Paul McIlwain, NTM Church Planting Coordinator

You will notice that, within the lessons, I have often asked the people questions but have not included the people's answers. However, in some instances, I have provided a teacher follow-up.

For example, here is a paragraph from Lesson 7. *"God had created so many things. Was God tired from creating all that He had created? No! God doesn't get weary or sleepy like we do."* Be aware that you need to pause after asking the question and allow them to answer. After they have answered, you can follow up with further explanation from the lesson text.

Do not ask a question and then immediately answer it. If the teacher always does this, the people will not even think about a question and will simply wait for the teacher to provide the answer. So even though the lesson may show a question immediately followed by an answer, the intention is that you as the teacher will allow your hearers to answer. This type of questioning interspersed throughout the lesson is an important part of teaching and retaining the people's interest.

Always allow your hearers to answer any questions you may ask unless, of course, the question is rhetorical. Questions in the lessons which are designed specifically to cause the people to think, and not to verbally answer, are prefaced with a phrase, such as, "Think about this."

Rhetorical Questions

When asked information-type questions during teaching sessions, the Malinké people usually responded with long, awkward silences. Sometimes a brave soul would inform the rest, "He's asking us a question!" At that point, someone might quietly volunteer what they hoped was the correct answer that the missionary was looking for.

Faced with these silences, we missionaries often felt like we had failed to communicate the message. We eventually came to realize that there were other culturally appropriate ways to discover how much understanding our listeners have, without putting so much pressure on them to respond correctly to an information-type question.

Rhetorical questions are commonly used, and they serve, among other things, to emphasize or drive home a particular point. Rhetorical questions are much more likely to elicit a whole group response. We on the Malinké team found that rhetorical questions are very profitable to encourage discussion in a group situation. It is much less threatening to the people than when a teacher asks an information-type question. Discussion often can be prompted by the timely use of a rhetorical question. Various speakers will present their thoughts on a particular point, and the group will arrive at a consensus – a correct consensus if the teacher has presented the material well. All of this, of course, must be reinforced through follow-up: one-on-one or small group discipleship, where the truths from Scripture are discussed in an everyday setting, outside of the formal teaching situation.

– Paul Cheshire, NTM missionary to the Malinké Tribe, Senegal

Once you have clearly established the nature and character of each of the actors through clear interpretation of the early chapters of the Bible, you can rely more and more on questioning as a method of emphasizing the doctrines and individual characteristics of each person. After giving a clear account of a particular incident, stop periodically and ask a suitable question which will cause the hearers to think of the point of doctrine which is being stressed. For example, you may ask questions such as:

- "Why do you think He did that?"

- "How did God know what they were thinking?"

- "Why wasn't that hard for God to do?"

- "Do you think God forgot?"

- "How could Jesus do such a great miracle?"

Through questioning like this, you are teaching them to look carefully at the story and the characters to learn what God wants them to know about Himself, themselves, Satan, and the Lord Jesus. Be sure to use the questions which are interspersed throughout the lessons to cause those you are teaching to carefully ponder what you have just said to them.

Ask questions at the end of each lesson

At the close of each lesson, I have included questions which are designed to review the main points of the lesson just completed. These questions in the "Questions" section cover the basic historical details of the lesson as well as those points in the lesson which emphasized spiritual truths.

In the lessons, the "Questions" section looks like this:

Questions

1. Many times, people begin something, but then they don't finish it. Does God ever begin something and then not finish it?

 No. God always finishes what He begins.

2. God always finishes what He begins. What does this tell us about God?

 Because God always finishes what He begins, we know that God never changes. We also know that God is powerful. Nothing and no one can hinder God from doing all that He plans to do.

Note that each question is followed by an expected answer. When a question is asked like this, someone may give a very good answer which is different from the one in the text. That doesn't matter. The questions are not simply to get one particular answer but to make them rethink the lesson. Agree with the person that his answer is right and then rephrase the question so that someone will give the answer for that particular question.

Guidelines for questioning

1. Allow the people to answer in their own words.

2. Address some questions to the whole group and other questions directly to individuals. Try to involve every person.

3. Show respect by listening to whatever they say.

4. When someone answers, do not immediately agree or disagree with his answer. Ask one or two others or ask the whole group if they agree with the individual's answer.

5. Don't always correct them immediately if they are wrong.

6. Give them time to think and to discuss important points.

7. If they are unable to reply or if their answer is incorrect, ask them other questions which may remind them of the correct answer.

8. Do not grill them. The question time should not cause embarrassment.

9. Commend them for correct answers, the part they remembered, or anything else they say which is helpful.

10. Give the correct answer as specified in the lesson.

11. Explain the answer in greater detail when necessary.

"Why" Questions

"Why" questions, which are quite natural in English, pose a challenge for transfer into other languages.

In many languages, there isn't just one way to say "why." For example: "Why did Jesus get into the boat?" would be translated differently depending on the answer that is wanted.

- If the answer expected is "There were a lot of people crowding around him," the question would be posed as "What happened that resulted in Jesus getting into the boat?"

- If "Jesus got into the boat in order to teach the people" is desired answer, the question would be, "For what purpose did Jesus get into the boat?"

- If the question is being used in a rhetorical sense (implication being "He shouldn't have gotten into the boat"), a special construction would be used, such as, "Why (in the world) did Jesus get into the boat?"

It is your responsibility as the lesson developer to be sure that the "why" questions in the lessons express the correct meaning naturally in the language.

– Carol Kaptain, NTM Translation Consultant

People's questions

When you begin teaching the Scriptures, the people will have many misunderstandings about who God is, where He is, what He does, etc. Do not be concerned. Continue to teach *"precept upon precept, line upon line,... here a little, there a little"* (Isaiah 28:10). Their knowledge of God will grow through the unfolding historical drama because this is the way God has chosen to reveal Himself.

Continue to teach the story carefully and prayerfully, trusting the Lord to make Himself known in all His glory through the Scriptures. Answer only those questions which relate to the subject at hand. If they ask questions which will be answered in future lessons, tell them so and leave the answers until then. If what you are teaching makes them inquisitive, good. They will be good listeners as you continue to teach.

Forcing mere verbal agreement

Although we should make the message meaningful to the people by pointed questions, it is usually unwise to ask people if they accept and truly believe what they are being taught. This is especially true early in the teaching program. Questions of this nature may force people into a

premature decision. They may reject or accept the Bible before they really understand its message. The teacher should faithfully teach the Word, allowing time for it to take root and grow under the direction of the Holy Spirit. Human efforts to force the new birth result in mere professions of faith without true possession of the life of God. Only God can bring a soul to understanding and salvation (1 Corinthians 3:7).

This doesn't mean that we should not exhort people to accept the truth, repent, and believe the Gospel. This, too, is the responsibility of the faithful servant of Christ. In most situations, however, it is unwise to force people to answer to a human being. The teacher's responsibility is to make people realize that they stand before God and they must answer to God.

If they contradict what you teach them from God's Word, ask them what God says about the subject. The issue is between them and God, not between them and you.

Read the Scriptures

Each lesson should be taught with an open Bible, and the verses should be read to the people. Do not merely tell the narrative in your own words.

I believe that the reading of the Scriptures should be tantamount to "teaching." If the Scriptures have been read, then the truth has been taught. You still need to explain it and reinforce it, but actually reading the Scripture is a vital part of teaching the Word. A major mistake that is made constantly from the pulpit and in the Sunday school class is that the reading of the Scriptures is not taken as the first important part of the learning process. This is why the reading is often hurried or unclear. And because people don't think of the reading of the Scriptures as teaching, they read a Bible story and then retell it in their own words. It is as though God's Word is not as important as them saying it. The result? The hearers are not taught to listen carefully to the reading. Instead, they hang on what the preacher or teacher says instead of what they heard read from the Scriptures. They don't judge the teaching by the Word. One of my criteria in writing and teaching is to try to show the importance of listening to God's Word being read.

Our responsibility is to teach the Word of God. Verse-by-verse exposition of the Scriptures is the best way to do this.

In the lessons, I have indicated to the teacher which verses are to be read and when to read them by giving the instruction "Read." This is what that instruction looks like:

 Read Genesis 2:1.

It is unwise to read the whole section of Scripture which will be taught in the lesson before beginning to teach. If you read the whole story before teaching, the story will hold no surprises for your audience. One of the most important elements in the art of storytelling is suspense, so maintain an air of excitement and anticipation, keeping your hearers looking forward to what comes next.

While each story told will have its high point, each lesson is yet another step toward the final climax of the story of redemption. The story of redemption begins in Genesis 3:15 and finds its

fulfillment and culmination in the death, burial, and resurrection of the Lord Jesus Christ. Teach the Scriptures as one story, even though you are presenting it in individual lessons.

Teaching Messianic prophecies

The Old Testament Scriptures find their fulfillment in Christ (John 1:45; Luke 24:44-46). The Old Testament is like a signpost, continually pointing forward to the coming Redeemer.

In keeping with the progressive development of the story of Christ, when teaching the Old Testament Phase 1 lessons, we will continually point forward to the coming Savior. Just as the Old Testament believers looked forward to the coming of the Deliverer, teach so your hearers will be anticipating and waiting for the disclosure of the Savior's identity.

The Old Testament contains many prophecies about the coming Deliverer. However, the Old Testament does not record His name or title. Therefore, as we teach, we will not mention the fulfillment of the prophecies, nor will we refer to the coming Deliverer by His given name or titles, the Lord Jesus Christ. Instead, we will not reveal who He is until we reach the full revelation of His person and work in the New Testament.

In the New Testament lessons, you will be directed to point back to the Old Testament and remind your hearers of the prophecies which pointed forward and are completely fulfilled in Christ.

In this way, we will interpret the Old Testament by the New Testament according to the way chosen and revealed by the Holy Spirit.

In the diagram above, I have given Genesis 3:15 as an example of the way we will teach all the Old Testament Messianic prophecies. This promise is regarding the seed of the woman who will come and bruise the head of the serpent. When teaching this verse, we will tell our hearers that this promise will be fulfilled by the coming Deliverer, but we will not disclose His identity by using His earthly name and titles. In addition, we will not read the actual fulfillment in Matthew 1:23. Later in the teaching program, when we teach Matthew 1:23, we will then point back and remind our hearers of the promise given in Genesis 3:15 and emphasize the faithfulness of God in keeping His Word.

In the lessons, teacher instructions will remind you when it is time to point back to a prophecy in the Old Testament. Such instructions look like this:

★ Tell them that God's words written by Isaiah were fulfilled.
Then read Isaiah 9:7 and Matthew 1:1 to them.
Then point to the Prophetic Chart and write Matthew 1:1 opposite Isaiah 9:7.
(See example below.)

What God said about the Deliverer He would send		How God's Word came true
Isaiah 9:7	David's descendant	Matthew 1:1

Teaching Messianic types

When teaching Messianic types in the Old Testament, we will not point forward to Christ. The reason? Because there is no indication in the Old Testament Scriptures that these types are actually foreshadowing Christ.

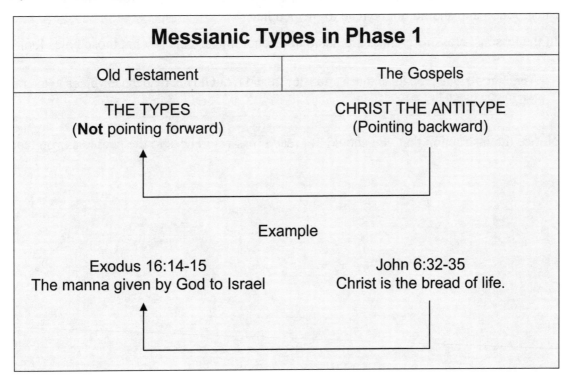

Messianic Types in Phase 1

Old Testament	The Gospels
THE TYPES (**Not** pointing forward)	CHRIST THE ANTITYPE (Pointing backward)

Example

Exodus 16:14-15
The manna given by God to Israel

John 6:32-35
Christ is the bread of life.

The example of the manna, given in this diagram, is clearly a type of Christ. When teaching about the manna in the Old Testament, we will not point forward and say that a Savior is coming, who, like the manna, will provide spiritual food for all who put their trust in Him. We will simply teach the story and the details relating to the manna in preparation for the time when we teach from the New Testament that Christ is the only spiritual food to give eternal life. From John 6:32, we will point back and remind the people of the details concerning the manna in Exodus 16:14-15.

New Testament information added to the Old Testament stories

Throughout the Old Testament lessons, I have included details and information which are not included in the Old Testament Scripture text. These added details, gleaned from the New Testament, throw more light on the story and give a better and more instructive interpretation of the words and actions of the characters and, therefore, of what actually took place in the Old Testament story.

For example, although Genesis 4:4 does not tell us that Abel came to God by faith, Hebrews 11:4 does. By including the information from Hebrews 11:4, we can correctly interpret the actions of Abel in our exposition of Genesis 4. In addition, in 1 John 3:12, we are told that Cain *"was of the wicked one and murdered his brother."* On the basis of this Scripture, we may inform our hearers that Satan led Cain to murder Abel.

It is unnecessary to inform the listeners where these added details are found in the Scriptures, unless they specifically ask. The added details are interwoven into the story as part of the exposition.

For the teacher's sake, however, I have included some cross-references so you will know where the information is found in the New Testament. These cross-references are given only for your instruction and should not be read to the people.

In the lessons, cross-references are listed in teacher notes. This is what those notes look like:

> **Teacher:** As you prepare to teach, read Job 38:4-11, but do not read these verses to the people when you teach the lesson.

Notice the instruction that you should not read cross-references to the people as you teach.

11

Lesson Layout

The lessons in the *Building on Firm Foundations* series have been written as though I were actually addressing a group of tribal people. Interspaced throughout the lesson text are directives to the teacher, such as outline points, lesson developer's notes, and teacher's notes. It is important that you understand the purpose for each feature of the lesson layout so that you can use the lessons correctly.

The following pages explain each of the elements which we used for lesson layout. These explanations are courtesy of Ruth Brendle.

Each lesson begins with preliminary material, including:

Title

Scripture for the lesson

Lesson outline

This material is designed to give the teacher an overview of the lesson.

Each lesson includes instructions to **review** the previous lesson. The **?** icon is a visual cue to indicate that the teacher should review by asking the questions from the previous lesson.

The subheading "Lesson Outline Developed" signals the start of the actual lesson which will be taught.

Bible passages to be read are signified with the open book icon 📖 followed with the word "Read" and the Scripture reference. For teachers who need more specific instructions, an option could be: "Read [Scripture reference] from God's Word." The teacher would read the passage, not the instruction.

Within the lesson layout image:

God rejected Cain and his offering but He accepted Abel and his offering

Scripture: Genesis 4:1-16

Lesson Outline

1. God is the giver of life. (Genesis 4:1)
2. Cain and Abel were both born outside of the garden. (Genesis 4:2)
3. Cain and Abel both came to offer sacrifices to God. (Genesis 4:3-4)
4. God accepted Abel's offering. (Genesis 4:4)
5. God rejected Cain's offering. (Genesis 4:5)
6. Cain refused to listen to God. (Genesis 4:6-8)
7. God judged Cain for killing Abel. (Genesis 4:9-16)

? Review Questions from Lesson 15.

Lesson Outline Developed

1. **God is the giver of life.**

 📖 Read Genesis 4:1.

 Eve knew that God is the giver of all life.

 God had formed Adam from the dust of the ground give him life. God had made Eve from Adam's rib from this verse that God gave life to Adam and Eve

 Every person is given life by God. Your life was give

2. **Cain and Abel were both born outside of the gar**

 📖 Read Genesis 4:2.

 ☞ Teacher: Point to the names, "Cain and Ab

 • Cain and Abel were born sinners because their fath

 119

Lesson 16 God rejected Cain and his offering, but He accepted Abel and his offering.

2. Cain and Abel were both born outside of the garden. ◄

 📖 Read Genesis 4:2.

 ☞ **Teacher:** Point to the names, **"Cain and Abel,"** on the chro

• **Cain and Abel were born sinners because their father, Adam, wa**

 Because Adam and Eve had sinned against God, they were put out
 den, away from the tree of life. As a result, Cain and Abel were bo
 garden, away from the tree of life.

 Lesson developer: As you develop the following illustration, be su
 ate group and country names to fit your teaching situation.

 🕯 *How did you come to belong to this particular tribe and be born in this
 place? Why do you look, think, talk and act like Palawanos? It is because of
 your parents, isn't it? If your parents were Australian and live
 you, too, would have been born in Australia and you would ha
 thought, talked and acted like Australians.*

 When God created Adam and Eve, they were perfect before God.
 obeyed Him, they would have continued to live in the garden and
 life. Their children would have been born perfect and would also h
 garden. But Adam sinned when he ate the forbidden fruit, so he w
 garden and away from the tree of life. Therefore, his children, Cai
 born sinners, separated from God, outside of the garden, and away
 life. Cain and Abel were born sinners because their father, Adam,

• **All people have been born sinners because our ancestor, Adam, was a sinner.**

 Not only was Adam the father of Cain and Abel, but he was also the father of the
 whole human race. Adam was your ancestor, and Adam is also our ancestor. Be-
 cause Adam disobeyed God and was separated from Him, all people in this world
 are born cut off from God.

• **Cain and Abel were born into Satan's family because their father
 chosen to listen to Satan.**

 When Adam decided to disobey God, he allied himself with Satan
 family. As a result, Adam's children were also born in Satan's fam
 Cain and Abel that should have been in God's image so they coul
 obey God was under Satan's control.

 God gave life to Cain and Abel, but they were not born in friendsh
 When they were born, they were already separated from God beca

 120

The **numbered outline points** are the main outline points in the lesson. These are grayed, which signifies that they are not meant to be spoken or read. They are full sentences, however, in case an inexperienced teacher does state them. The numbered points are designed primarily as a topic cue for the teacher.

The **bulleted points** are visual cues, but they are also an integral part of what should be communicated in the lesson. The bulleted points are intended to be spoken as part of the lesson.

The **lesson text** is the development of the main points, and bulleted points. The lesson text is the content of what you should teach. These lessons have transitions and flow which make sense in English as an example to show exactly what to teach and how to word it. Remember, you should **teach** this material, not merely read it.

God rejected Cain and his offering, but He accepted Abel and his offering. Lesson 16

3. **Cain and Abel both came to offer sacrifices to God.**

> **Teacher:** The verses you are about to read introduce sheep and the herd. Sheep and shepherds are very prominent in Bible stories. The ple you are teaching don't know about sheep, take time to talk abou tures of sheep and to explain the work of the shepherd.

📖 Read Genesis 4:3-4.

> ☞ **Teacher:** Show a picture of Cain bringing produce that he h and Abel bringing a lamb to offer to God.

This is Chronological Pictu and Abel bring offerings

- **Both Cain and Abel believed in the existence of God, and both ca rifices to Him.**

 Just believing that God exists will not make us acceptable to Him. that even Satan believes in God and that Satan trembles through fe thinks of God. But believing in God does not make Satan acceptab

 Even offering to God what we think is very good will not make us Him. Man can come to God only according to God's will and plan

- **God told them what they must do in order to worship Him.**

 Adam and Eve and Cain and Abel were all sinners and were separ The punishment for sin is death. Adam and Eve could not give any pay for their sins. Neither could Cain and Abel. There was no way come to God and be accepted by Him.

 But God planned a way so they could come to Him. It was not ma God who decided on this way. No one else could provide the way provided the way for them because He loved them.

 God must have told Adam and Eve what they must do if they want Him. Adam and Eve probably told Cain and Abel what God said t they wished to come to God.

 God told them that, when they came to Him, they had to bring a sh ing to God. They had to kill the sheep so that its blood would flow

 The blood of the sheep could not pay for their sin. So why did God a sheep?

123

Teacher Notes are in a grayed box, signifying that they are not to be spoken. Teacher's notes provide information and instruction for the teacher. For example, teacher notes include study information such as cross-references to read in preparation for teaching the lesson. Teacher notes also give reminders to the teacher about how to teach.

Teacher "TO DO" Notes are in a grayed box, signifying that they are not to be spoken. The pointing arrow ☞ icon is a visual cue of an instruction to do something, such as "point to the map" or "display a name on the chronological chart" or "show a picture."

Pictures: If the teacher will be using NTM's chronological picture set, the lesson developer may include in the lesson the instruction, "Show picture #" rather than the more lengthy explanation used in the sample lessons.

God rejected Cain and his offering, but He accepted Abel and his offering. Lesson 16

- **All of Adam's descendants have been born in Satan's family.**

 > **Lesson Developer:** Give an illustration to show that Adam and Ada
 > became the enemies of God. For example:

 > *Suppose another tribe over the mountains was fighting aga*
 > *They hated you, and they wanted to do all they could to hurt yo*
 > *there was a young man in your tribe who was enticed by a you*
 > *over to the enemy tribe. He married the girl and adopted their*
 > *and his wife had children. Think about this: To what tribe wou*
 > *belong? They would belong to the tribe over the mountain. The*
 > *enemies because their father left his tribe and joined the enemi*

 God is the One who gives life to all people, but we are not born in
 oneness with God. Satan has taken God's place as our spiritual fath
 us that should have been in God's image so we could know, love a
 under Satan's control from the time of our birth. We were all born
 all born Satan's children, under Satan's control and God's enemies

 It is important that you realize you were born a sinner. You were b
 from God, with Satan as your father, just as all people are.

 > **Teacher:** Make sure that the people do not think that Satan actually
 > man life and physical body.

- **Satan has told many lies to people about the beginning of the hum**

 People all over the world have many different stories about their b
 they came from and who their first ancestors were. You have your
 about the beginning. But the Bible gives the true story of how all p
 why all people were born under Satan's control. The Bible tells us
 Adam disobeyed God and allied himself with Satan, he and all his
 came members of Satan's family.

 > **Teacher:** In this lesson, you are teaching the truth of John 8:44; Eph
 > John 3:8, 10. Read these verses as you prepare to teach, but do no
 > verses to the people when you teach the lesson.
 >
 > You are also teaching the truth of Romans 5:12, "Therefore, just as
 > sin entered the world, and death through sin, and thus death spread
 > cause all sinned." Do not jump ahead in the teaching program. Do n
 > when you teach the lesson. Nevertheless, clearly teach the truth tha
 > passed to all people because Adam sinned.
 >
 > In Lessons 8 and 13, you used a branch as a visual aid to illustrate that Adam and Eve
 > were separated from God, their source of life. Use that same branch as you teach this
 > lesson to show that all people have been born separated from God.

121

Notes to the **lesson developer** are in a grayed box, signifying that they are not to be spoken. These notes explain something that needs to be considered in preparing the lesson for the specific audience. The Lesson Developer notes are not intended to be included in the tribal lessons, although, depending on the content of the notes and the audience being taught, some of the information may need to be made into a Teacher note.

Sample **illustrations** are set apart from text in a box, with a candle icon. The candle icon was chosen because candles illuminate, and illustrations are to illuminate the truth being taught in the lesson. Adapt the illustration as necessary to be culturally appropriate.

God fulfilled His promises by sending Jesus, the Deliverer. Lesson 49
Jesus grew into manhood.

8. Jesus grew into manhood.

 Read Luke 2:52.

Even though Jesus was God, He was also a real human being. Jesus grew, just as
your children grow physically and in their understanding.

• **Jesus grew to be a wise man.**

God was pleased with Jesus, and people liked Him.

Many years earlier, God's prophet Isaiah said that the Deliverer would be wise and
would have great knowledge because He would be in oneness with God the Spirit.

★ Tell them that God's words written by Isaiah were fulfilled.
Then read Isaiah 11:2 and Luke 2:52 to them.
Then point to the Prophetic Chart and write Luke 2:52 opposite Is
example below.)

| What God said about the Deliverer He would send | | How
C |
|---|---|---|
| Isaiah 11:2 | Some of His characteristics | Luke 2 |

What God said through Isaiah was fulfilled. God always remembers
Everything happens just as He says.

Questions ◄

1. In what town did the prophet Micah say that Jesus would be born?
 The prophet Micah foretold that the Deliverer would be born in Bethlehem.

2. Why did the wise men want to find Jesus?
 They wanted to worship Him.

3. Why was it right for the wise men to worship Jesus?
 It was right for the wise men to worship Jesus because Jesus was God the Son

4. To which country did God tell Joseph to take Jesus in order to escape from K
 God told Joseph to take Jesus into Egypt.

5. Why did Satan try to have the baby Jesus killed?
 *Satan tried to have the baby Jesus killed because Satan knew that Jesus was t
 ners.*

6. Although Jesus looked like other children, what great difference was there?
 Jesus was God as well as a human being.

7. Did Jesus ever do anything wrong?
 *No. Jesus never sinned, even as a child. He never thought, said, or did anything which dis-
 pleased God His Father.*

361

The notes on the right side of the page:

Notes about the **Prophetic Chart** are in a grayed box, signifying that they are not to be spoken. The star ★ icon is a visual cue with instructions about using the Prophetic Chart.

Each lesson ends with **Questions**. The questions are designed to be used at the end of the lesson to reiterate the truths of the lessons. These are also the questions which the teacher should use for review before teaching the next lesson. The question is on one line, with the answer following on another line and in a different font.

Adapting the layout

Just as the lessons are samples of what to teach and how to teach, the lesson layout is a sample that you could use when laying out your own lessons. The purpose of the format chosen, including outlining, visual breaks, font choice, point size and icons, is to make it easier to teach the material through visual clues.

You as the lesson developer should choose a format that works best for you and for the people you are working with. For some, that might mean a different layout altogether. For most, however, the sample layout that we used in the lessons in the *Building on Firm Foundations* series would work very well. If you do make changes to the format for your lessons, keep in mind that the goal of lesson layout should be to provide visual cues designed to keep the teacher on track and to help the teacher see at a glance what is to be taught at any point in the lesson.

Consider these criteria for visual cues:

o A serif font is considered easier to read than a san serif. For the sample lessons, "Times New Roman" was chosen for text because it is easier to read. "Arial" was chosen for material that is primarily for the teacher. If tribal believers will be teaching from your lessons, use a font which is familiar to them, perhaps the same font that was used for literacy or Bible translation.

o Use a point size large enough for the teacher to be able to read the material easily.

o Underlining generally makes text harder to read. In the sample lessons, no underlining is used to distinguish point levels.

o Icons are excellent visual cues. Use large-sized icons so the teacher can see them at a glance.

Write out the lesson

I recommend that you write your lessons out in full. Include the outlining, teacher instructions, etc. Study the written-out lessons when you prepare to teach, but do not read the lesson text to the people. Rather, teach the lesson, referring to the written-out lesson to keep on track and to cover all the points.

12

Bible Lesson
Preparation Process

This lesson preparation process grew out of the input of experienced lesson developers and teachers and was compiled by Linda McIlwain.

Use this lesson preparation process when following the *Building on Firm Foundations* 7-phase teaching plan. These steps are to be followed afresh each time you prepare lessons for each of the 7 phases.

A. Initial Study and Preparation

1. **Ask the Lord for help, believing that it is His message that you are trying to communicate.**

 John 14:14; 1 Corinthians 3:7; Luke 1:37

2. **Read Volume 1 of *Building on Firm Foundations* (BOFF).**

 Even if you have read Volume 1 previously, read it again before actually beginning lesson preparation. It is vitally important that you understand and are convinced that the underlying reasons for teaching chronologically are based on biblical principles. Only then will you be able to teach with conviction and persist when the teaching process may appear long and tedious.

3. **Read the introductory chapters to the BOFF phase you are planning to teach.**

 Note the teaching goals for this particular phase so you can refer back to them when you are actually preparing the lessons.

4. **Read and study the larger volume of material of which this lesson is a part.**

Read all the BOFF lessons for the phase or the book of Scripture you are preparing to teach and also read in both the vernacular and your mother-tongue the Scripture portions which will be covered in the lessons.

B. Understand individual BOFF lessons

1. Read the BOFF lesson and the Scripture portions for the lesson.

Read the Scriptures in your own mother tongue, the vernacular and the national language.

Read through the lesson at least two times and more if necessary. Read several lessons ahead of the one you are preparing to teach so that you are aware of what is coming up in the future lessons.

2. Identify and think about the goals and themes for the lesson as taught in BOFF.

Note the goals and themes. Refer to them constantly as you prepare your lesson.

3. After studying each lesson, teach it in your mother tongue.

If you have no other opportunity, teach the lesson as daily devotions with your wife, children, or colleagues. If your fellow missionaries are also involved in the lesson preparation process, then take turns teaching lessons to each other.

C. Contextualize the lessons in the language and culture.

1. Keep your target audience in mind.

Be conscious of the level of education, capacity for listening to monologue and degree of biblical background of your future audience.

You may need to adjust the amount of information to be included in each lesson. Divide lessons if they are too long for the intended group or for the length of the sessions. However, be conscious that each lesson was written as a unit. If changing the length of a lesson is necessary, then consider carefully if the lesson themes have been adequately covered. Also consider if the section you have covered can stand alone as one narrative unit.

Identify and mark in the lessons those points that could clash with the religion, culture or worldview of the people you are planning to teach. Write these in the lessons at the point where it would be necessary or most appropriate to address the particular barrier.

2. Prepare a lesson outline in the vernacular with lesson development notes.

This lesson outline should include the main content of the lesson, with all the major heading points in the vernacular. Include notes to yourself regarding illustrations, barriers, teacher's notes and teaching aides such as dramas, pictures, maps, charts, etc, that will be necessary for teaching the lesson. Check to see all that has been suggested in the BOFF lesson.

3. Write a fully fleshed-out Bible lesson in the vernacular as a preliminary draft.

Your language ability and cultural understanding should be to a level where you can write a fully fleshed-out lesson draft on your own, written word-for-word as you will teach it. Although BOFF lessons are not designed for you to translate word-for-word, they have been prepared with translation in mind. Check each point and the content of your lesson alongside the BOFF lesson to make sure you have included all the pertinent doctrinal themes, emphases, illustrations and other suggested teaching aides.

Put a teacher's note following the cultural illustrations in the lesson to instruct the native teacher to think of other suitable cultural illustrations that will speak clearly to his people.

D. Format the lessons

1. Keep the tribal teachers in mind when formatting the lessons.

Lessons should be prepared as though the tribal teacher is going to be the one teaching. All teacher's notes, cultural examples, etc., should be printed in a finished form suitable for the tribal teacher to follow. Decisions about formatting should be made in cooperation with tribal teachers as much as possible, considering what they prefer and what is easiest for them to use.

The BOFF lessons have been formatted with tribal ministries in mind. In addition, examples of lessons already formatted by other missionaries may be available.

2. Make decisions early so that all the lessons are consistently formatted.

Consider the following points during preparation of initial lessons so that a consistent lesson template is available for all following lessons:

Use of icons: Be consistent with icons. Put teacher's notes in separate boxes. Mark review question headings with a large question mark. Use a book icon to indicate when it is time to read Scripture. Use an eyeball icon or pointing hand to indicate when the teacher has to show a picture or use a prop.

Breaking up the text: Use bold headings for each point. Don't have large areas of plain text.

Table of Contents: In a volume with a large number of lessons, the table of contents may not only include the title of each lesson but also a brief summary of what each lesson is about.

Lesson Outline: It is helpful to have a lesson outline, including major headings, at the beginning of each lesson.

Headers and Footers: Include on each page the lesson number, the title of the lesson, and the page number.

Other issues to consider: You will need to decide whether or not to add pictures (full or in thumbnail) to help the teachers.

It is recommended that you use numbers and not English alphabet letters (a,b,c) for lists or outline points.

Some lesson writers have developed a 'teacher's page' to lay out what needs to be done in preparation for teaching the lessons, such as gathering teaching aides.

E. Check the lesson with mother tongue speakers

1. Explain the purpose of the comprehension check to your helpers.

The mother tongue speaker's role (ensuring naturalness and clarity of communication), and your role (the authority for scriptural truth or biblical content) should be clearly explained. A relationship of trust and openness should be developed between you, the lesson writer, and the checkers.

2. Give your helpers a general overview of what the lesson is about.

Explain the general topic and tell the story, giving them an initial overview of the material.

3. Teach each point. Don't read. Teach.

Teach each point carefully, allowing them time to understand and think about the subject so they don't become lost in too much material.

4. Do a comprehension check.

Prepare comprehension questions about each point in the lesson and then ask them of the helpers.

Some lesson writers ask the mother tongue speaker to repeat the points back to them while they record them for future reference. If you do this, remember that your helper may not yet understand the overall theme or scriptural principles being expounded.

5. Identify any communication problems.

Consider possible reasons for any difficulties in communication. Is it because of worldview issues, grammar problems, discourse features not being used correctly, poor illustrations?

6. Discuss ways to improve communication clarity.

Ask for better ways to say, explain or illustrate the problem areas you have identified.

F. Prepare the lesson for teaching

1. Complete the first draft.

This first draft is your preliminary draft including the changes you have made after checking it with mother tongue speakers.

2. Share the lesson with your tribal co-workers.

After you have taught more phases, you will be able to check this original first draft with more people. This should include reading or teaching the lesson and then asking what they understood. Adjustments to the lesson should then be made based on their comprehension and suggestions.

3. Back-translate the required number of lessons for your consultant check.

Ask the church planting consultant which lessons to back-translate. If this is the first back-translation you have done, ask the consultant for guidance on how literal to be and how to handle proper nouns, etc. Send the BTs to the consultant for content check and arrange for a translation and comprehension check.

4. Practice teaching the lesson.

Teach the lesson to your partner, or at least teach through the whole lesson on your own as practice before teaching it to the whole group.

5. Revise the lesson after teaching.

Almost inevitably, some changes will be necessary after you teach each lesson to the people in the vernacular. Because of the burden of the work at this point, it is very easy to miss out on this step.

Have a plan for this first revision. Have a partner, spouse and literate tribal listeners (particularly those from the lesson checking team) take notes while you are teaching. They should note any mistakes in the lessons or areas which did not clearly communicate the thought you intended. Later, you will have to decide the reason(s) for this lack of communication and decide whether it necessitates a change in the text of the lesson. Consider also the various aspects of your oral delivery.

6. Make decisions about printing, distributing and publishing the curriculum.

Include the people as much as possible in the work of printing and publishing the lesson materials.

The first edition may be stapled loose-leaf sheets. After lessons have been taught a few times and other necessary changes made, they can be printed in a more finished form. Initially, Phase 1 and the lessons for the other phases will probably be in small booklets. Later, phase lessons may be published in one or several volumes for easy storage and portability. Single lessons can be half-foolscap size and larger volumes could be A4 size. You should check to see what is most convenient for the teachers.

When there is a local church, then a good model is to pass on the lessons to the Bible teachers and maybe to others when they are first taught the material. It then immediately becomes theirs, and it is their responsibility to teach it to others. But outreach to others should be with accountability to the church and not left up to the individual to decide when, where and who he will teach.

G. Extra materials

Consider translating or preparing introductory materials from Volume 1 and the introductions to each book of the BOFF series as discipleship tools for the tribal Bible teachers.

Always keep in mind whether or not anything you, as the initial church planting team, have used is reproducible or accessible by the local tribal church for future outreaches. Any extra materials that you use to teach (props for dramas, videos, pictures, maps, or others materials) should either be provided by you for future tribal church planting teams or be easily reproducible by the tribal teachers.

13

Little or No Response

Among animistic tribal people who had never before been exposed to the teaching of the Scriptures or to the major religions, the initial response to the teaching of Phase 1 has usually been remarkable. Thousands of tribal people throughout the world have been enlightened as they have come to understand their sinfulness and helplessness to save themselves and have put their faith in the Lord Jesus Christ as their Savior.

But, what about places where there has been little or no response? Perhaps you are teaching people who are self-satisfied or antagonistic because they have been influenced by a false religion and have been prejudiced against you and your message through their religious leaders. Or perhaps, for other undetermined reasons, the people show little interest or enthusiasm for your teaching. Perhaps they appear to listen attentively, but few respond. What should you do?

Differing soils

Just as soils differ greatly in their productivity even though given the same care, cultivation, and seed, so nations, tribes, cities, communities, and families will differ in their receptivity and response to the Scriptures even though given the same careful preparation and message from God.

The Lord Jesus condemned the cities of Chorazin, Bethsaida, and Capernaum because, although He had done most of His greatest miracles before them, they refused to repent. The Lord Jesus clearly indicated that the heathen Gentile cities of Tyre, Sidon, and even Sodom would have been more receptive to His ministry than these Jewish cities. The Jews, through their long-standing knowledge, yet rejection of the truth of God, were hardened against the convicting message of their long-awaited Messiah (Matthew 11:20-24).

The people in Jesus' own hometown had observed His perfect childhood and, when He preached, *"marveled at the gracious words which proceeded out of His mouth."* Nevertheless, they also rejected Him (Luke 4:22-30). In contrast, the despised Samaritans received Him gladly (John 4:39-42).

Before Jesus sent His seventy disciples out to preach, He warned them that some cities and some families would be open while others would reject God's messengers and their words. Jesus said to them, *"And whoever will not receive you nor hear your words, when you depart from that house or city, shake off the dust from your feet"* (Matthew 10:14).

Numerous incidents in the book of Acts, especially from Paul's missionary journeys, also demonstrate that some groups of people are more receptive and open to the Word of God than others. One outstanding example is the attitude of the Jews in Berea compared to the Jews in Thessalonica. *"These were more fair-minded than those in Thessalonica, in that they received the word with all readiness, and searched the Scriptures daily to find out whether these things were so"* (Acts 17:11).

God knows beforehand whether or not people will receive His message, and in spite of this, He still sends His servants to preach His Word. God sent the Old Testament prophets to rebellious Israel even though He knew that the majority of the people would not repent. When the Lord commissioned Ezekiel as His messenger to Israel, He said, *"The house of Israel will not listen to you, because they will not listen to Me; for all the house of Israel are impudent and hard-hearted"* (Ezekiel 3:7).

We know then from Scripture that God has sent us to preach the Word and that people will differ in their receptivity. Still, the question remains, "What should we do if we find ourselves endeavoring to teach disinterested, unreceptive people?"

Examine your ministry and methods

The first step is to try to determine the reason why there has been little or no response. Carefully examine your ministry and methods by answering the following questions:

- How effective was your pre-evangelism in preparing the people through thought-provoking discussions? Even before you began teaching from Genesis, were the people aware that they needed alternative and more satisfying answers to the mysteries of life than their present religious system provided? Were you able to unsettle them so that they came to your meetings with inquiring minds? Or did they come with their minds already made up that you had little or nothing to offer that they needed?

- Did you do all in your power to be accepted into the community even before you began teaching? Have you maintained a quality relationship with the people so that they look upon you as a friend and one from whom they might learn?

- Did the people understand the individual stories and the story as a whole? If not, was it because you taught through the panorama of the Scriptures in Phase 1 too quickly?

- Did the Scriptures come across to your hearers like mere ancient history or myths of another world and another people, quite apart from their present reality?

- Did you consistently apply the message specifically to the people by using culturally relevant illustrations aimed at helping them see that God's Word is speaking to them personally?

- Did the people have sufficient time to assimilate each story's application and see the relevancy of the Scriptures to their lives and their world?

- Were the people sufficiently impressed by the nature and character of God exemplified in the stories? Did they begin to fear God and to judge their sin in the light of God's holiness and righteousness? If not, was it because you covered the material too quickly for their understanding?

- Did your hearers feel the fury of God's Law against themselves as transgressors? If not, was it because you brushed over the meaning of the Law, its righteous claims, and its words of judgment without helping them make a proper application of the Law to their own lives?

- Are there cultural or religious aspects in the lives of the people which hinder them from understanding or accepting the Bible message? Did you clearly understand and consistently take their culture into account? Did you apply your teaching specifically to the foundational precepts of their worldview?

- Is your ability to speak their language adequate? Could it be possible that your inadequate fluency in their language has hindered the people from clearly understanding the message of the Scriptures?

- Did you consistently hold the interest of the people by the effective use of teaching aids, such as object lessons, visuals and skits?

- Did you vary the style and pace of your lesson presentations? Were the people constantly alert, wondering what was coming next?

- Was your teaching style interesting? Did you move around as you were teaching, or did you just sit in one place? Were you animated, expressive and imaginative?

- Did the message of the Bible grip and excite you personally? If it does not excite you, you will not be able to teach in an enthusiastic, joyful and vibrant manner, and the people will not be gripped by the reality and wonder of God's message to the world.

- Did you adjust the length of your teaching sessions according to their attention span? Or did you drone on for a set time period, disregarding their boredom and disinterest?

- Did you involve the people in the lessons by asking questions, allowing them to ask you questions, and giving the opportunity for comments and discussion?

- Did you regularly spend time in the homes of the people, determining their comprehension of the stories? Did you find out if individuals were appropriating the fundamental truths relating to their position as sinners before God? Teaching should not be limited to a public declaration of truth. It should also include personal confrontation aimed at making individuals see that God is speaking to them personally through His Word.

- Are there hindrances in your own lives – self-dependence, marriage problems, lack of fellowship between team members, etc. – which may be hindering the work of the Holy Spirit through you as His instruments? (See 1 Peter 3:7.)

- Have you been faithful in praying that these captives of Satan will be set at liberty? While methods and techniques are important, we must not depend on them to prepare, convict, and lead people to the Savior, but rather on the presence and power of the Holy Spirit.

- Did you get others involved in praying? Mark Zook who worked with the Mouk tribe in West New Britain, explained how the missionary team involved their prayer partners in praying for Mouk individuals and families while they were being taught Phase 1, even before they had been told the Gospel. Mark wrote, "About two weeks before we started teaching Phase I, we sent short biographies of all the Mouk families and single people to individuals in the United States, requesting that they personally pray for 'their person or family' until the Gospel had been presented to them. This was an effective way to get people at home involved through prayer. A number wrote back to us, sharing their appreciation of the opportunity to have a personal prayer responsibility for the Mouk." The Lord answered prayer. After Mark taught them chronologically from Genesis to the ascension for the first time, more than two hundred Mouk tribal people trusted in Christ.

Review

It is essential to ascertain, step-by-step and point by point, whether the people understand the foundational doctrinal themes which we are seeking to establish through the chronological teaching program. It is only through questioning and spontaneous feedback that we can be sure that they really grasp the truths we are teaching. If vital sections or key points have not been grasped by our hearers, it is only logical to temporarily retrace our steps and review. It is useless to continue teaching more material if the fundamental points in earlier lessons have not been clearly understood by the people.

On one occasion when I was visiting some missionaries in their mountain station, they confided that they were downhearted because of the lack of response. They had taught through Phase 1 on a previous occasion and were presently teaching it again. At the time of my visit, they had reached the end of Genesis, but their hearers seemed disinterested, and they did not evidence a recognition of their need before God.

As we discussed the attitude and misunderstanding of the people, the missionary anticipated my advice and said to me, "Trevor, whatever you do, don't ask me to start all over again."

Well, that was my advice. It is pointless to continue teaching when the people have failed to understand some of the most important points of doctrine which are rooted in the early chapters of Genesis.

I explained to this missionary that he did not need to reteach in detail all he had covered previously. Rather, he needed to go back to Genesis and establish the vital truths which had been missed by the people. I suggested that, when he was sure that his hearers clearly understood these basic points, he could move forward again, tracing that particular thread of truth until he resumed his teaching at the point where he had left off.

He followed this advice, and blessing followed. People were converted as they understood their sin, its results, and God's solution in Christ.

Adjust teaching speed

What should you do if a group is eager to hear the teaching, clearly understands, is able to answer the questions but does not appropriate the truth and judge their inner hearts, manner of life, and religious beliefs in the light of the truths of Scripture? I suggest you adjust your teaching speed. Reduce the amount of historical material you cover in each session. Concentrate on making your hearers realize that what is being taught is God's voice to them in the present and that He expects them to take it to heart. It is far better to slow down or review than to rush through the historical story from Genesis to the ascension and find that people have not personally appropriated truth and have failed to comprehend their true condition before God.

Unless you have exceptional ability as a storyteller, the second time through the story of redemption with unsaved people will not be nearly as exciting or captivating. This is especially true if the people have understood the historical details but have not comprehended the significance and relevancy of the message to them and their world. It is far better to slow down long before the historical story is finished than to have to repeat it all later.

On the other hand, we must be careful lest we bore our hearers by slowing down too early in the teaching. Even though people may not realize their sinfulness before God during the teaching of Genesis, they may when they are presented with teaching about the Law in Exodus. My own opinion is that, after teaching the Law in Exodus 20, if a good percentage of the people have not begun to appropriate the truth and evidence conviction by their questions and statements, then it is time to review. During review, do not reemphasize historical details. Instead, apply the truths concerning God, His nature and character, and His attitude toward sinful, rebellious man directly to the consciences of your hearers. Review both publicly and privately.

Starting again

If you have taught through Phase 1 but haven't seen the response you expected, you may choose to blame the chronological teaching approach and say, "It may work in some situations, but it is unsuitable for our peculiar circumstances."

Should you be tempted to think this way, ask yourself why you taught the Scriptures chronologically in the first place. Was it because you were convinced that you were following scriptural principles, or was it because you thought of it as another teaching outline which just might work?

If you taught on the basis of conviction and faith, believing that teaching chronologically is the simplest and clearest way to present God's Word,

> **The Gerai people needed time.**
>
> Following completion of our Phase 1 teaching to the Gerai people, interest was very high, but the people had not had time to "put it all together." We reviewed, and then started again at the beginning and taught through the Phase 1 lessons again. As we went though the lessons, the light seemed to dawn for individuals in the group. It was kind of like popcorn popping, not all at once, but a few each day. Eventually around 200 people from the group expressed their faith in Christ.
>
> – Larry Goring, NTM Field Ministries Coordinator

then lack of results will not cause you to look for another method of teaching. Truth still remains truth even if people reject it. Remember, people may clearly understand and come under the conviction of the Holy Spirit but deliberately refuse what they have been taught (Acts 7:51-54).

Therefore, if you have completed the overview of the Old Testament and the life of Christ and there is no apparent conviction of the Spirit or little response, carefully and prayerfully consider the questions listed earlier in this chapter to determine the probable reasons.

After making any necessary changes, begin to teach again, starting in Genesis, trusting the Lord to bring spiritual understanding, heart conviction and salvation. Some missionaries have found that, even after making necessary adjustments in their own teaching techniques, the truth was only recognized by the people after hearing the complete teaching the second or third time.

Change locations

It is important to be patient and to be sure that you have done all that you can to reach people with the Word of God. However, when they have consistently rebuffed all your efforts to present the truth over an extended period, it may be wise to move to another place and give others the opportunity to hear. You should not close the door in the place where you and your message have been ignored or rejected, but at the same time, you should move on.

A young missionary couple working in Palawan was continually rejected by the people in an area where they had lived for a couple of years. They had done all that they knew to make friends with the people and to teach them, but the people seemed inflexible in their attitude.

When these missionaries asked for my advice, I encouraged them to move to another location. Because they already had an airstrip where they were presently located, I encouraged them to return to the village and visit once in a while to see if the people might change their minds.

The couple took this advice. They moved to a new village where the attitude of the people was almost the opposite from the village where they lived originally. In a short time, there were believers and an established tribal church.

Interestingly, the attitude of the previously indifferent group changed. Before they had left that village, the missionaries explained why they were moving to another location. They explained that, because of the people's refusal to accept God's message, they were taking the Good News to others who had not yet had the opportunity to hear. The Lord used this to startle and wake up quite a number of these people. When the missionaries did return, the people listened carefully to the message and were truly converted.

Rejoice in the Lord

When we see little or no results from our teaching, we should carefully examine our lives, ministry, and methods and be open to the teaching of the Holy Spirit. At the same time, we should be on the alert lest Satan use the situation to discourage and hinder us from faithfully fulfilling the ministry committed to us by the Holy Spirit. It is especially easy to become disheartened when we hear glowing reports from others who have taught the Scriptures chronologically and have seen immediate and amazing conversions.

It is possible, through lack of results, to become downhearted and be tempted to turn from biblical methods of teaching or from the Lord's place for us in His harvest field. Nevertheless,

we should remember that, in spite of the hardness and obstinacy of people to the Lord's call, there is always a remnant, be it ever so small, who will turn to the Lord. In that final day, when the harvest is all gathered in, there will be those who have been redeemed to God by the blood of Christ, *"out of every tribe and tongue and people and nation"* (Revelation 5:9).

Furthermore, whether or not we actually see the fruit of our labors during our lifetime, it is good to remember the Lord's encouraging promise to Abraham when he was still childless, *"Do not be afraid, Abram. I am your shield, your exceedingly great reward"* (Genesis 15:1). Whatever we do should be for the Lord. Nothing done for Him in accordance with His Word and in fellowship with the Holy Spirit is wasted time or effort.